Narow Menocal
Madison, 22 - I - 88

CAT. 29-X-98

John Ruskin's
Modern Painters I and II
A Phenomenological Analysis

Studies in the Fine Arts:
Art Theory

Donald B. Kuspit, Series Editor

Chairman, Department of Art
State University of New York at Stony Brook

Other Titles in This Series

John Ruskin's
Modern Painters I and II
A Phenomenological Analysis

by
Geoffrey F. DeSylva

UMI RESEARCH PRESS
Ann Arbor, Michigan

Produced and distributed by
UMI Research Press
an imprint of
University Microfilms International
Ann Arbor, Michigan 48106

Library of Congress Cataloging in Publication Data

DeSylva, Geoffrey F.
 John Ruskin's *Modern painters I and II:*
a phenomenological analysis.

 (Studies in fine arts. Art theory ; no. 5)
 Revision of thesis—Ohio University, 1976.
 Bibliography: p.
 Includes index.
 1. Ruskin, John, 1819-1900. Modern painters. Pts. 1-
2. 2. Painting. 3. Ruskin, John, 1819-1900—Style.
4. Ruskin, John, 1819-1900—Aesthetics. 5. Phenomenalism.
I. Title. II. Series.

ND1135.R83D4 750'.1 81-13009
ISBN 0-8357-1233-8 AACR2

*Thanks to Dr. Raymond Firth of Ohio University
for his help in the writing of this book.*

Contents

Introduction: The Problem of Aesthetic and of Style in *Modern Painters I* and *II*

The first two volumes of John Ruskin's *Modern Painters* constitute his first important achievement in aesthetic theory and in literary style.[1] With regard to the aesthetic theory of these two works, some of Ruskin's critics have attempted (although unsuccessfully) to interpret it as a consistent body of thought; others, however, have attempted to demonstrate inconsistencies in the major aspects of this thought. And with regard to the style expressing this aesthetic, Ruskin's only important critics, who are few, have concentrated primarily on formulating approaches for interpretation. At the present time, no successful interpretation of Ruskin's early aesthetic *as* a logically consistent body of thought and no full analysis of the style expressing it exist. In consequence, the purpose of this study is to interpret Ruskin's early aesthetic as a logically consistent theory about painting and to interpret the style expressing this theory.

Although John Ruskin's *Modern Painters* comprises five volumes, the present study is restricted to the first two, because their aesthetic and their style constitute a self-contained whole. Ruskin himself places volumes one and two together as a unit. In the "Original Advertisement" to volume two, Ruskin states that it elucidates and confirms "positions left doubtful in the preceding volume" and also that both volumes "ought not to have appeared in a detached form."[2]

The Problem in Ruskin's Early Aesthetic Theory

Not fully resolved by his critics, the fundamental problem of the aesthetic theory in John Ruskin's *Modern Painters I* and *II* is the attribution of subjective aesthetic experience to the objective painting itself. The immediate historical context of volume one contributes to an understanding of this problem.

In 1836, *Blackwood's Magazine,* criticizing the works of J.M.W. Turners's final period, charged him with distortion of nature.[3] And in 1842,

the *Athenaeum* and the *Literary Gazette,* both of which reached Ruskin in Geneva, objected to vagueness of form, incorrect application of and disharmony of color in Turner's art.[4] In general, the periodical reviewers criticized Turner's works on the basis of it being untrue to nature.[5] Consequently, Ruskin intended his first volume to be a defense of Turner's landscape painting, a defense of its fidelity to natural fact. According to Graham Hough, "the particular purpose of *Modern Painters* is to show the superior truth to nature of the modern English school, Turner especially, to the landscape painters of the seventeenth century—Claude and Salvator on the one hand, and the Dutch school on the other."[6]

As a response to the criticism of Turner, in volume one Ruskin emphasizes Turner's representational accuracy in landscape painting. This emphasis on representation constitutes the first part of the Idea of Truth.[7] Ruskin maintains that "Truth, as applied to art, signifies the faithful statement, either to the mind or senses, of any fact of nature" (III, 104). This accurate correspondence to the natural world establishes the objectivity of the landscape painting. However, Truth also comprises "statements . . . of [the painter's] emotions, impressions, and thoughts" (III, 104). Although the artist's feelings and thoughts about the natural scene he represents are subjective, nevertheless Ruskin places them on the same objective level as representation. The expression of the artist's experience and his representation of nature are both "statements" of the landscape work. In other words, the Idea of Truth projects the subjectivity of the painter, his thought and feeling, into the objective art work itself. In this sense, Ruskin's aesthetic theory in *Modern Painters I* is inconsistent.

In the aesthetic of *Modern Painters II,* written primarily in consequence of Ruskin's Italian journey of 1845, the same problem is evident. Applied to art, the theory of Typical and Vital Beauty attributes the painter's experience to the painting itself. For example, the theory of Typical Beauty projects his subjective religious belief into the objective work of art, because the external appearances (in art) of "a stone, flower, beast, or . . . man" are "in some sort typical of the Divine attributes" (IV, 64). That is, these forms symbolize the painter's religious conviction that divinity inheres in nature. The concept of Vital Beauty has a similar inconsistency. According to this theory, the appearances of nature in art express "felicitous fulfilment of function in living things" and those of man express "joyful and right exertion of perfect life" (IV, 64). In other words, the appearances of plants and animals express the *artist's* happiness and those of human beings express his joyful vitality. Since the painter's subjective experience (comprising his religious belief and his emotion) is embodied in the objective art work, then Ruskin's theory of Typical and Vital Beauty is inconsistent.

Although not always referring explicitly to the fundamental aspects of Ruskin's early aesthetic (i.e. to the theory of Truth in *Modern Painters I* and to that of Beauty in *Modern Painters II,* either indirectly or directly the critics of this aesthetic have been concerned with its major problem, the projection of experience (whether the painter's or the writer's) into the painting. Most of these critics attempt to establish a consistent relation between the two major concerns of Ruskin's theory—the painting and experience. In the next chapter, I will demonstrate that these attempts are not completely successful. Other critics succeed in demonstrating the inconsistency in his early theory and its projection of experience into art.

Concerned with the attribution of aesthetic experience to painting, Ruskin's biographers usually regard this experience as an expression of either Ruskin the man or of the artist. According to R.H. Wilenski's critical biography *John Ruskin: An Introduction to Further Study of His Life and Work* (1933), Ruskin's aesthetic expresses his personality by attributing his religious beliefs about divinity to nature and to great works of art.[8] In the biography *Ruskin: The Great Victorian* (1949), Derrick Leon briefly interprets Ruskin's theory. Leon states that the work of art is both representational and expressive; it sets forth "a faithful record of the natural world, charged with the idea and emotion with which they were first regarded by the artist...."[9] And according to Joan Evans in *John Ruskin* (1954), Ruskin's early aesthetic theory deals with naturalism in painting and with his impression of the work.[10] Thus, through concepts of expression or of impression, these biographers attempt to establish a relation between the art work itself and the elements of experience associated with it.

Several early critics attempt to establish a Platonic explanation of Ruskin's attribution of aesthetic experience to the painting. In *L'Esthétique anglaise* (1864), J. Milsand interprets Ruskin's early theory according to Platonism. In painting, reality (i.e. representation of nature) is a shadow, an image, of types and laws—of universal essences. And beauty is a reflex of divine perfection.[11] Here, the relation between form and expression in painting is Platonic. *Studies in Ruskin* (1891), by E.T. Cook, establishes a similar Platonic relation, but places it in a framework of Christian terminology. Since man's mind mirrors God's, art, expressing man's spiritual life, reflects universal laws.[12] In *The Art Teaching of John Ruskin* (1891), W.G. Collingwood interprets Ruskin's aesthetic similarly. Art represents the external as seen and expresses human emotion; but natural beauty and intense emotion are instances of natural law, the Platonic Idea.[13] In general, these interpretations of Ruskin's early aesthetic implicitly attempt to remove the inconsistency between objective representation of nature in painting and subjective expression of the painter's experience of it. That is—including

thoughts, feelings, and religious concepts—this experience is universal in the Platonic or Platonic-Christian sense and therefore—like representation—is objective.

Certain critics of Ruskin's *Modern Painters* have adopted an intuitional approach. The most recent one is Floris DeLattre's *Ruskin et Bergson: De l'Intuition esthétique à l'Intuition métaphysique* (1947). According to De-Lattre, the artist's imagination (i.e. intuition) directly perceives the divine universals and the life underlying the external forms of nature and then incorporates these universals into his painting.[14] Thus, the intuitional view attempts to avoid the projection of the painter's subjective experience into the objective art work by ascribing universality to this experience. That is, whatever is experienced intuitively is objective and therefore is consistent with the objectivity of the work.

Patricia Ball's *The Science of Aspects: The Changing Role of Fact in the Work of Coleridge, Ruskin and Hopkins* (1971) epitomizes the weakness implicit in all these interpretations, which usually impose various extrinsic perspectives (such as that of Platonism or of intuitive perception) on Ruskin's early aesthetic, in order to objectify experience and thus render it consistent with the objective painting itself. Ball implicitly denies that the projection of experience into nature and into art is a basic inconsistency in Ruskin's early aesthetic thought:

> And it would be false to conclude that he is deaf to the Romantic sermon of self-awareness and the importance of personal identity. What has happened in his work is a transference: the personal identity to be grasped is not that of the observer, but of the observed. Not his own inner being compels his "eager watchfulness", but the selfhood of all he sees around him.[15]

By attributing the elements of personality and of experience to nature and to painting itself, Ball fails to realize that neither, as objective, can embody aspects of subjectivity.

Instead of trying to rationalize Ruskin's attribution of aesthetic experience to art, other critics attempt to explain this attribution as a flaw in the aesthetic of *Modern Painters I* and *II*. Henry Ladd's *The Victorian Morality of Art: An Analysis of Ruskin's Aesthetic* (1932) criticizes Ruskin's early theory for interpolating his own appreciations, sentiments, and moral emotions into nature and into art. By doing so, he renders these experiences pathetic and ludicrous.[16] The best critical analysis of Ruskin's aesthetic of beauty in *Modern Painters I* and *II* is George P. Landow's *The Aesthetic and Critical Theories of John Ruskin* (1971). Advancing the criticism done earlier by Ladd, Landow objects to major inconsistencies in Ruskin's aesthetic of beauty. Concerned with Ruskin's theory of beauty in *Modern Painters I*, Landow argues that beauty in nature and in art cannot be both an emotion

and an objective quality at the same time, because emotion is subjective.[17] And referring to the theory of Typical and Vital Beauty in *Modern Painters II,* Landow implies that Ruskin argues for the objectivity of beauty on the basis of religion. That is he believes that Typical and Vital Beauty is objective *because* it is religious. Ruskin's belief concerning Typical Beauty—that the objective art work symbolizes the immaterial attributes of the Divine—is religious; consequently, Typical Beauty is objective. And since Ruskin's "spirit, mind, and . . . energy of life" are "informed . . . by God," then these qualities, aspects of Vital Beauty, are also religious and therefore are objective. But, Landow maintains, when Ruskin lost his religious faith in 1858, the elements of this theory concerned with the expression of belief and emotion became subjective and consequently inconsistent with his view of beauty as an objective quality of art.[18]

By basing interpretation on the assumptions of the subjectivity of aesthetic experience, of the objectivity of the painting, and of logical consistency as the criterion for the relationship between experience and the painting, both Ladd and Landow arrive at valid demonstrations of the inconsistency in Ruskin's early aesthetic theory.

In the ways outlined, then, most of Ruskin's critics unsuccessfully attempt to demonstrate that his early aesthetic is consistent, but other critics successfully demonstrate that, in the perspective of subject and object, this theory is inconsistent.

In general, then, the fundamental problem of Ruskin's aesthetic theory in *Modern Painters I* and *II* is his attribution of objectivity to aesthetic experience by embodying it in the painting itself. If a subject-object dichotomy is assumed for this theory, then a solution to this problem is not possible, because either the artist's or Ruskin's experience is subjective and therefore cannot exist objectively in the art work. Consequently, in order to arrive at an interpretation demonstrating consistency among the elements of Ruskin's early aesthetic, the subject-object distinction must be removed from it altogether.

A phenomenological approach to aesthetic theory can remove this dichotomy and can also afford a consistent interpretation of the aesthetic theory in *Modern Painters I* and *II.*

Although the philosophy of Edmund Husserl (1859-1938) did not become phenomenology until he was nearly forty, "it remains true that the central figure in the development of the Phemenological Movement was, and still is, Edmund Husserl."[19] In his comprehensive work *The Phenomenological Movement* (1960), Herbert Spiegelberg defines the two basic methods of the phenomenologist. Relevant to the present discussion, the first method is "direct intuition . . . as the source and final test of all knowledge, to be

incorporated as faithfully as possible in descriptions."[20] This method, "direct intuition" and description, is Husserl's concept of "the intentionality of consciousness," central to his *Logical Investigations* (1900-1901).[21] The "intentionality of consciousness" means its "directedness toward an object." Husserl calls such acts of consciousness "intentions," and he calls their referents "intentional objects."[22] The phenomenologist simply describes these intentional acts and whatever they are directed toward. This descriptive phenomenology completely removes the division between the subjectivity of human experience and the objectivity of the world, because both experience and the world are what consciousness is directed toward. In this perspective, experience is not a subjective occurrence, but is rather an object of consciousness—a feeling, a thought, and so on. Furthermore, the entities in the world are not objective facts, but instead are also intentional objects, toward which consciousness is directed by means of the senses.

Martin Heidegger adopts and expands Husserl's concept of intentionality. Given primarily in "The Origin of the Work of Art" (1950), Heidegger's phenomenological aesthetic theory simply interprets the phenomena that the artist's or the observer's consciousness is directed toward—or aware of—in the art work. For example, Heidegger calls the visually perceived form of the work its "earth." He calls the emotions and thoughts associated by consciousness with these perceptions the "world," the meaning, of the work. Also apprehended by consciousness, the "truth" of the work, its origin, is its essential nature—its contrast between perceptual qualities and their meanings, between "earth" and "world."[23]

In general, Heidegger's phenomenological aesthetic theory, supplemented by Husserl's concept of intentionality, can resolve the inconsistency apparent in Ruskin's early aesthetic, in which he attributes the artist's subjective experience to the objective painting. On the basis of this resolution, Heidegger's theory can then afford an interpretation of Ruskin's aesthetic in *Modern Painters I* and *II* as a consistent system of thought.

The Problem of Ruskin's Early Style

When interpreted as the reflex of the aesthetic in *Modern Painters I* and *II*, the style of the work poses the same basic problem as its theory does. That is, Ruskin's style implicitly attributes the painter's subjective experience to the objective painting itself.

This inconsistency is apparent in the style, or rhetorical manner, of Ruskin's art criticism on J.M.W. Turner's *The Slave Ship*. In this painting, slaves have been cast overboard from a slaver. Ruskin portrays the darkness of evening gathering over the waves, the ship on the ocean, and sunlight dyeing the sky and the sea red. By means of imagery and symbolism, his

passage suggests that both elements of the aesthetic of Truth are present in *The Slave Ship*. First, Ruskin's style shows that the painting is a "faithful statement, either to the mind or senses, of any fact of nature" (III, 104). Imagery depicts this objective correspondence between the painting and nature. For example, "the lurid shadows of the hollow breakers are cast upon the mist of night, which gathers cold and low, advancing . . . upon the guilty ship as it labours amidst the lightning of the sea . . . "(III, 572). And symbolism suggests that the painting embodies the second aspect of Truth—"statements . . . of [the painter's] emotions, impressions, and thoughts"(III, 104). Ruskin's final image, for instance, of "that fearful hue which signs the sky with horror . . . , and . . . incarnadines the multitudinous sea" (III, 572), symbolizes Turner's subjective thought about divine condemnation of the murderers of the slaves. These aspects of style, then, inconsistently establish *The Slave Ship* as both an objective representation of nature and as a subjective expression of Turner's thought.

Although few in number, recent critics of Ruskin's early style avoid this problem by interpreting style as an expression not of the painter's experience nor of aesthetic theory in general but rather of *Ruskin's* aesthetic experience or of his aesthetic sensibility. In "Style and Sensibility in Ruskin's Prose," John D. Rosenberg interprets Ruskin's early style "as the incarnation of sensibility," as "the unique voice of the writer, the felt presence that hovers over his pages and intones its way into our consciousness."[24] And G. Robert Stange, in "Art Criticism as a Prose Genre," interprets the style of Ruskin's art criticism as the expression of his aesthetic experience:

> The conscious prose stylists from, let us say, Lamb to Pater display the shift of direction I wish to describe. The serious writers offer us not systems, but insights, persuasive glimpses of truth. The prose writer tends to avoid the abstract in favor of the immediate: he will try to imitate a speaking voice, or express the rhythm of the mind as it responds to or perceives concrete experience.[25]

That is, the style of art criticism, including Ruskin's, describes the writer's visual perception of an art work and expresses his responses to it. Interpreting style as the expression (respectively) of the writer's sensibility or of his experience, Rosenberg's and Stange's approaches are not concerned with Ruskin's early style as the expression of aesthetic theory *per se*. Consequently, these approaches cannot be required to explain or to resolve the inconsistency in which the prose style of *Modern Painters I* and *II* suggests that the objective painting embodies the painter's subjective experience.

Martin Heidegger's phenomenological approach to prose style can implement a resolution of this inconsistency. According to "The Origin of the Work of Art" and other essays by Heidegger, "language," the equivalent of prose style, refers to the essential nature, the "truth," of the art work—its

contrast between an "earth" and a "world," between form and meaning. Correspondently, the prose writer as the observer of the work apprehends this contrast in it. But form is not objective; and meaning, including emotion and thought, is not subjective. Instead form is what the writer is visually aware of in the work. And meaning is what he mentally apprehends in it. In effect, then, prose style as "language," having the same referents as consciousness, shows what the writer is aware of in the work. Style indicates his visual and mental apprehension of the contrast between form and meaning, "earth" and "world," in the work of art. This theory of prose style can afford a resolution of the inconsistency in the style of *Modern Painters I* and *II* and can thereby implement a consistent interpretation.

At this point, the question arises: will a phenomenological study of the aesthetic and the style of these two works be not a literary but rather a philosophical analysis? On the contrary, Heidegger's aesthetic and his theory of "language" can afford a literary interpretation of *Modern Painters I* and *II*. According to William A. Gerhard and Brijen K. Gupta in "Literature: The Phenomenological Art," language enables man to be phenomenological by showing the possibilities of his existence: "Language . . . is now seen not to be a material, nor a rhetorical tool, but rather the appropriate way whereby the human being can see, and let be seen, how out of, and in, his existence he has concretized the possibilities of that existence."[26] With regard to the aesthetic of *Modern Painters I* and *II*, the possibilities of existence that Ruskin is aware of are the visual forms and the expressed significances of painting. Prose style, viewed phenomenologically, indicates as well as elaborates these apprehensions. Concerned thus with content and style in *Modern Painters I* and *II*, a phenomenological study of them based on Martin Heidegger's theories of art and of language is literary.

2

The Approach to Ruskin's
Early Aesthetic Theory

The choice of Martin Heidegger's "The Origin of the Work of Art" for interpretation of the aesthetic theory of John Ruskin's *Modern Painters I* and *II* presupposes limitations in the other aesthetic theories relevant to this one and in the criticisms of it. Approaches taken from this range of theory either are not adequate or are only partially so for demonstration of a consistency in Ruskin's theory. Most of the criticisms attempt unsuccessfully to resolve Ruskin's inconsistent attribution of his or the painter's subjective experience to the objective painting itself. Several other criticisms, however, successfully demonstrate similar inconsistencies.

Of course, several of the aesthetic theories and literary criticisms that are relevant for interpretation of Ruskin's early aesthetic do not always apply the subject-object distinction as I have. In my view, what belongs to the work is objective, and what pertains either to the artist or to the observer is subjective. For example, the religious belief expressed by Typical Beauty is subjective; however, Landow implies that such belief is objective, *because* it is religious. Since Landow's assumption of the objectivity of religious experience expressed through art is traditionally acceptable in literary criticism, in this chapter I will tentatively adopt his interpretation and, allowing his view of the subject-object distinction, will then attempt to demonstrate the merits and the limits of his analysis. For the same purpose, when justified by traditional practice, I will adopt interpretations derived from other criticisms of or from aesthetic theories relevant to Ruskin's early aesthethic.

The Background in Aesthetic Theory

In general, aesthetic theories are mimetic, pragmatic, expressive, or objective.[1]

Concerned with imitation of the physical and the ideal elements of the world, the mimetic theory of Plotinus (204/5-270 A.D.) conceives art as an

imitation of external reality, adumbrating corresponding Ideal Forms. Present not only in the world but also in the artist's soul, these Ideals are objectified in art. Beauty is the sign of the relation of the art object to "Ideal-Form."[2]

Ruskin's aesthetic in *Modern Painters* does include a theory of Ideal Beauty, because a natural objective (in a painting) having the greatest "degree of beauty" the species of that object can attain, possesses "'ideal beauty'" (III, 111). But, whereas Plotinus conceives art as the manifestation of ideal archetypes through imitations of nature, Ruskin's theory concentrates solely on the expression of generic characteristics belonging to the species of represented natural objects. Furthermore, Plotinus assumes the objectivity both of imitation of nature and of its Ideal Forms. However, in Ruskin's theory, the Beauty of painting also depends, in part, on the subjective emotion of the observer, because (he says) "any material object which can give us pleasure in the simple contemplation of its outward qualities . . . , I call . . . beautiful" (III, 109).

Defending imitation of nature, Plotinus elaborates the objective role of the artist, both in imitation and in capturing "Ideal-Form." Monroe C. Beardsley, in *Aesthetics From Classical Greece to Present: A Short History* (1966), explains this role:

> Here is Plotinus's gentle answer to Plato's doubts about imitation: a tree and a picture of a tree share alike in the Form that bestows on each whatever beauty it may possess, and such is the freedom of the painter that his picture may in fact capture and exhibit that Form even more fully than the tree.[3]

Thus, the artist imitates both the tree and its ideal archetype. Ruskin's theory of artistic creation, however, is both mimetic *and* expressive. Through landscape art, the painter must "induce in the spectator's mind the faithful conception of any natural objects whatsoever" and must "inform him of the thoughts and feelings with which these were regarded by the artist himself" (III, 133). Thus, the painter establishes Truth in the landscape work—its representation of nature and its expression of his feelings and thoughts. Although the aesthetic of Plotinus deals with beauty in art, nevertheless a comparison here with Ruskin's aesthetic of Truth is permissible, because both writers are concerned with the creation of the art work. Plotinus and Ruskin agree that art is an imitation or a representation of nature. According to Plotinus—adumbrated by imitation, the Ideal Form of the tree, its archetype, is immanent in the world. Acccording to Ruskin, however, the artist's thoughts and feelings expressed by landscape art are inherent in him. Plotinus' artist imitates the objective Form of the tree. On the contrary, Ruskin's painter expresses his subjective feelings and thoughts about objects in nature.

Ruskin's theory of Typical Beauty in *Modern Painters II* is essentially a Christian modification of Plotinus' concept of Ideal Beauty. Plotinus conceives the soul of the artist as a copy of Ideal Froms immanent in the world. Beardsley explains this relation between the artist and the Ideal: "In putting on beauty, then, matter [i.e. art] acquires a deep 'affinity' for the soul. And the soul takes joy in recognizing its own nature objectified, and in thus becoming conscious of its own participation in divinity."⁴ When the artist embodies the Ideal Forms of nature in art, then he creates beauty. In these beautiful Forms, the artist recognizes his own divine being. According to Ruskin, in art, Typical Beauty is the symbolic quality "in a stone, flower, beast, or in man." Their appearances typify "the Divine attributes" (IV, 64). Interpreted in the perspective of Plotinus, these "Divine attributes" constitute a Platonic-Christian ideality, embodied by the painter's imagination in art and manifested through the appearances of stones, plants, animals, or man. As the creator of this divine ideal in art, the painter's imagination must be a copy of these "Divine attributes." Therefore, Ruskin says that the Associative Imagination (for instance) "is indeed something that looks as if man were made after the image of God. It is inconceivable, admirable, altogether divine. . ." (IV, 236).

But Ruskin's aesthetic of Vital Beauty does not lend itself to a similar Platonic interpretation. The artist's imagination creates Vital Beauty in the painting. Vital Beauty is the expression "of felicitous fulfillment of function" by plants and animals and also the expression of "joyful and right exertion of perfect life" by man (IV, 64). That is, the appearances of plants and animals in art and those of man express (respectively) the *artist's* happiness and *his* joyful vitality. This subjective aesthetic is inconsistent with Plotinus' objective theory, according to which the artist's divine nature can be objectively embodied in art, because his being is a copy of the Ideal Forms of the world. According to Ruskin's aesthetic, the expression of the artist's happiness and his exuberant vitality through painting is simply a reflection of his own subjectivity.

In general, then, Plotinus' aesthetic, concerning imitation of actual and Ideal Forms, cannot account for *both* the objective and the subjective aspects of Ruskin's early aesthetic.

Similar in many respects to Ruskin's aesthetic in *Modern Painters I* and *II*, the theory of "ideal imitation," another mimetic theory of art, was typical of English and continental aesthetics during the seventeenth century. According to Beardlsey's explanation of this theory, " 'ideal' combines in varying proportions the essential, characteristic, and admirable." Furthermore, "ideal imitation meant, as it did in literary theory, the representation of the general rather than the individual." A representative instance of the theory of "ideal imitation" in English aesthetic theory is presented in Sir Joshua Reynolds' *Discourses on Art* (1790).⁵

The reader familiar with *Modern Painters I* knows that it contains specific refutations of certain aspects of Reynolds' aesthetic. For instance, in contrast to Reynolds' emphasis on representation of the general appearances of nature, Ruskin argues that Reynolds' basis of selection for painting, "(that general truths are more important than particular ones) is altogether false" (III, 154). This rejection of Reynolds' concept of general representation apparently establishes significant divergences in meaning between his aesthetic of painting and Ruskin's theory in volume one; hence, one might easily conclude that the former is completely inadequate for interpretation of the latter. However, such is not the case. Reynolds and Ruskin differ only on the level of representation in painting. The former affirms general representation of nature, but the latter argues for particular representation of it.

With the exception of this difference, both writers hold similar concepts of representation in landscape painting. In the section of *Modern Painters I* called "Relative Importance of Truths," Ruskin emphasizes particularity in representation, but also stresses that it must be characteristic of whatever is represented:

> Finally, then, it is to be remembered that all truths, as far as their being particular or general affects their value at all, are valuable in proportion as they are particular, and valueless in proportion as they are general, or to express the proposition in simpler terms, every truth is valuable in proportion as it is characteristic of the thing of which it is affirmed. (III, 154)

According to Reynolds' theory of landscape painting, art imitates not the particular but rather the general truths of nature, its characteristic forms.[6] Ruskin's emphasis on characteristic representation of nature partially nullifies his stress on particular representation, because he argues that characteristic Truths distinguish the species of natural objects (III, 152). Since the concept of species is a general one encompassing its individual members, consequently representation—even though specific—must be typical or characteristic of natural objects. In this sense, Ruskin's concept of representation coincides with Reynolds' concept that art must imitate the general, characteristic forms of nature. Since Reynolds' concept of general representation and Ruskin's of generic representation refer to objective qualities of the natural world, then these qualities can appear in the objective landscape painting itself.

But, in John Ruskin's *Modern Painters I*, the Truth of landscape art comprises both accurate representation of nature and expression of the painter's "emotions, impressions, and thoughts" (III,104). Although Reynolds' aesthetic can certainly afford an interpretation of representational Truth, his theory cannot interpret the expressive aspect of the Idea of Truth. According to Reynolds' theory, nature manifests its ideal, or characteristic, forms only imperfectly. By creating the painting, the artist frees these natural

forms from defects and perfects them.[7] Here, Reynolds implies that ideal forms are inherent in nature and consequently, as objective, can be embodied in the work by the artist. This theory is incompatible with Ruskin's, which concerns expression of the painter's subjective experiences—his "emotions, impressions, and thoughts"—by the landscape work.

In general, then, Ruskin's rejection, in *Modern Painters I*, of Reynolds' concept of general representation requires careful qualification. And, in *Modern Painters II*, Ruskin's rejection of other theories held by Reynolds also needs qualification. For example, referring to the procedure of the artist, Reynolds' emphasis on selective and ideal imitation of nature is based on the example of ancient models and on the mastery of rules.[8] But Ruskin, commenting on Associative Imagination, asserts that "the laws of nature he [the painter] knows; these are to him no restraint. . . . All other laws or limits he sets are at utter defiance . . ." (IV, 239)

Yet the similarity between Reynolds' aesthetic and Ruskin's theory of Associative Imagination is closer than he seems to realize. The painter's Associative Imagination chooses and perfects Ideas of nature. Ideas are perceptions of the natural world that are united with concepts about it. When creating his painting, the painter chooses "two ideas which are *separately wrong*, which together shall be right . . . , and . . . only the *conception of that unity can prompt the preference*" (IV, 234). Reynolds' painter, in order to represent the ideal forms of nature, must perfect the imperfect forms of the natural world, which, however, suggest their ideal counterparts. He imagines them.[9] Ruskin's artist, in order to perfect the defective visual appearances of nature, chooses two "which are *separately wrong*, which together shall be right." Their perfection and unity in the art work constitute the ideal natural form that Reynolds speaks about. Both Reynolds' artist and Ruskin's imagine these ideal forms, this unity and perfection of natural objects. Interpreted according to Reynolds' perspective, this act of Associative Imagination is not subjective, because the painter's *"conception of that unity"* is implicit in his two original perceptions of nature. Separately they are wrong, but together they are right. Consequently, this ideal perfection and unity of natural appearances is objective. Just as Reynolds' painter can embody the objective ideal forms of nature into painting, so also can Ruskin's artist embody perfected and unified appearances of nature into the objective work.

Although adequate for interpretation of Ruskin's aesthetic of Associative Imagination, Reynolds' concept of creative imagination is inadequate for a critical understanding of the theory of Vital Beauty, concerned with two results of the artist's creative activity—with "the appearance [in art] of felicitous fulfilment of function in living things, more especially of the joyful and right exertion of perfect life in man" (IV, 64). Reynolds' concept of artistic imagination is essentially objective. Imagination recognizes the ideal forms

implicit in nature's actual ones. But, through the appearances in art of "living things" and of man, Ruskin's painter expresses his *own* subjectivity, (respectively) his happiness and his "joyful and right exertion of perfect life"— exuberent vitality.

A representative example of the mimetic theory of art, Sir Joshua Reynolds' *Discourses on Art* appeared in 1790. The pragmatic theory was typical of Neo-classical aesthetic theory during the eighteenth century. Although emphasizing imitation in art, the pragmatic theory does so only insofar as imitation produces an effect upon the observer.

An example of the pragmatic theory is the aesthetic of Francis Hutcheson, which he presents in *An Inquiry Concerning Beauty, Order, Harmony, and Design* (1725). According to Beardsley's explanation of Hutcheson's theory, actual sense qualities of art—especially visual ones— produce "ideas of beauty," known by the observer's inner sense. This faculty perceives beauty directly, without conceptual or practical mediation. Thus, beauty is a sensation belonging to the mind but not to the external object itself.[10] In other words, beauty is the effect of the visual aspects of the art work on the observer's mind. Ruskin's aesthetic of Beauty in *Modern Painters I* also emphasizes the subjective effect produced by art on the observer: "Any material object which can give us pleasure in the simple contemplation of its outward qualities without any direct and definite exertion of the intellect, I call in some way . . . beautiful" (III, 109). This theory of Beauty corresponds to Hutcheson's concept of "ideas of beauty." Ruskin indicates the actual sense qualities of art by referring to visual "contemplation of its outward qualities." Without conceptual mediation—that is, "without any direct and definite exertion of the intellect"—these visual qualities of art produce an effect upon the observer: they "give us pleasure." Further, according to Hutcheson, beauty does not belong to the art object but rather to the mind. Similarly, since Beauty in art depends on the observer's pleasure, Ruskin's Idea of Beauty does not belong to the landscape work. Rather, Beauty is the subjective effect of the work on the observer's emotions. Beauty is his response of aesthetic pleasure.

Since Francis Hutcheson's theory of beauty concentrates only on subjective effects of visual art on its observer, consequently this theory cannot explain the aspects of Ruskin's aesthetic in *Modern Painters I* that are not pragmatic. Emphasizing the effect of art on the mind, Hutcheson's aesthetic cannot interpret Ruskin's theory of the painter of landscape art (for example), because this concept deals with the expression of his experience. Establishing the Idea of Truth in the work, the painter both represents nature and expresses his feelings and thoughts about it. He induces "in the spectator's mind the faithful conception of any natural objects whatsoever," and he informs "him of the thoughts and feelings with which these were regarded by the artist

himself" (III, 133). These feelings and thoughts are not the effects of the art work on the observer. They are not *his* responses to the work. On the contrary, he apprehends the expression, through art, of the *painter's* subjective emotional and conceptual responses to nature.

Having affinities to Edmund Burke's theory of beauty in art, Ruskin's religious aesthetic of the Theoretic Faculty (in *Modern Painters II*), like his aesthetic of Beauty in volume one, is concerned with the effects of painting on its observer. His responses to visual perceptions of the work constitute Beauty:

> For, as it is necessary to the existence of an idea of beauty, that the sensual pleasure which may be its basis should be accompanied first with joy, then with love of the object, then with the perception of kindness in a superior intelligence, finally, with thankfulness and veneration towards that intelligence itself; and as no idea can be at all considered as in any way an idea of beauty, until it be made up of these emotions . . . ; it is evident that the sensation of beauty is not sensual on the one hand, nor is it intellectual on the other, but is dependent on a pure, right, and open state of the heart. (IV, 48-49)

In *A Philosophical Inquiry into the Origin of Our Ideas of the Sublime and Beautiful* (1757), Edmund Burke presents a similar aesthetic of beauty as emotional response. According to this aesthetic, Beardsley says, "the explanation of aesthetic enjoyment is to be sought on the physiological level." The sense qualities of art cause "feelings of beauty."[11] Essentially pragmatic, Burke's aesthetic of beauty concerns, then, the effects of visual art on the observer's emotions. The sense qualities of art that are described by Burke become Ruskin's "sensual pleasure," which is the basis for an "an idea of beauty." The effect of the observer's visual perception of art and Beauty, Ruskin says, depends "on a pure, right, and open state of the heart." Beauty is an emotional response, because "no idea can be at all considered as in any way an idea of beauty, until it be made up of these emotions " These emotions are what Burke calls "feelings of beauty." And in Ruskin's theory, such feelings include joy, "love of the object" (the art work), "the perception of kindness in a superior intelligence," and "thankfulness and veneration towards the intelligence itself [i.e. God]."

Although adequate for interpretation of the aesthetic of the Theoretic Faculty, Edmund Burke's theory of beauty as emotional response is nevertheless inadequate for interpretation of the aspects of Ruskin's early theory that are not concerned with the effect of visual art upon its observer. Since Burke's aesthetic concerns the "feelings of beauty" in the observer that are caused by his visual perceptions of the art work, this theory is unsuitable for interpretation of Ruskin's theory of Imagination (for example), which concerns the expression, by art, of the *painter's* subjectivity. The images of nature in the painting reflect his mind "and are modified or coloured by its image" (IV, 223).

To a greater extent than for the mimetic or the pragmatic theories of art already reviewed, Ruskin's aesthetic in *Modern Painters I and II* lends itself to intepretation by the expressive theory of art, typical of English Romantic aesthetics during the first half of the nineteenth century. According to the expressive theory of poetry (and art), the work of art is the embodiment of the artist's creative experience—his modified perceptions, his feelings, and his thoughts. In *The Mirror and the Lamp: Romantic Theory and the Critical Tradition* (1953), M. H. Abrams outlines the two basic forms of the expressive theory:

> "Poetry," Wordsworth announced in his Preface to the *Lyrical Ballads* of 1800, "is the spontaneous overflow of powerful feelings." He thought well enough of this formulation to use it twice in the same essay, and on this, as the ground-idea, he founded his theory of the proper subjects, language, effects, and value of poetry. Almost all the critics of the English romantic generation phrased definitions or key statements showing a parallel alignment from work to poet. Poetry is the overflow, utterance, or projection of the thought and feelings of the poet; or else (in the chief variant formulation) [i.e. Coleridge's aesthetic theory] poetry is defined in terms of the imaginative process which modifies and synthesizes the images, thoughts, and feelings of the poet. This way of thinking, in which the artist himself becomes the major element generating both the artistic product and the criteria by which it is to be judged, I shall call the expressive theory of art.[12]

Thus, according to Wordsworth's theory of poetry and art, Abrams explains, the art work "is the overflow, utterance, or projection of the thought and feelings" experienced by the artist. Similarly, according to the aesthetic of *Modern Painters I,* the artist projects his thought and feeling into the landscape painting, because he must inform the spectator, through the work, "of the thoughts and feelings with which . . . [natural objects] were regarded by the artist himself" (III, 133). But Ruskin's artist also presents the spectator with an objective representation of nature; he must "induce in the spectator's mind the faithful conception of any natural objects whatsoever" (III, 133). Here, Ruskin's theory concerns objective representation of nature in land-scape painting. However, Wordsworth's theory concerns the transformation of external perceptions, because (according to Abrams) "aspects of the external world" are transformed "from fact to poetry by the feelings and operations of the poet's mind.[13] Applied to painting, this concept means that the artist does not represent nature objectively, but instead modifies his perceptions of it with feeling and thought; in this sense, his portrayal of nature is subjective. Since Wordsworth's theory concerns the artist's subjective modifications of nature, therefore this aspect of his theory is inadequate for explanation of Ruskin's theory about the painter's objective representation of nature.

Wordsworth's aesthetic can, however, afford an interpretation of Ruskin's concept of Penetrative Imagination in *Modern Painters II.* The

aesthetic of Penetrative Imagination is concerned with the creation of art (in Wordsworth's sense) as " 'the spontaneous overflow of powerful feelings.' "[14] First, the artist's Penetrative Imagination apprehends the essence, "the very central fiery heart," of his subject—an object in nature or a human being. When creating the painting, the painter then embodies the essence of the object or the person into their corresponding forms in the work itself (IV, 250-51). Actually, however, when apprehending "the very central fiery heart" of nature or of man, the painter projects his own powerful emotion into them. He then expresses this essential emotion in the painting. He projects into the work what he originally projected into nature or into man. As the result of this entire subjective process, the painting is therefore an expression of the artist. It is the expression of his intense emotion.

Ruskin's theory of Associative Imagination has a similar subjective orientation when understood in the perspective of the major variant of the expressive theory—Coleridge's aesthetic of imagination. According to Abrams,

> ... Coleridge holds that the greatest poetry is, indeed, the product of spontaneous feeling, but feeling which, by a productive tension with the impulse for order, sets in motion the assimilative imagination and (balanced by its antagonists, purpose and judgement, and supplemented by the emotion inherent in the act of composition itself) organizes itself into a conventional medium in which the parts and the whole are adapted both to each other and to the purpose of effecting pleasure.[15]

Elaborating the function of imagination as Coleridge conceives it, Ruskin's concept of Associative Imagination concentrates on the painter's unification of his separate Ideas—concepts united with perceptions of the natural world:

> By its operation, two ideas are chosen out of an infinite mass . . . , two ideas which are *separately wrong,* which together shall be right, and of whose unity, therefore, the idea must be formed at the instant they are seized, as it is only in that unity that either is good, and therefore only the *conception of that unity can prompt the preference.* (IV, 234)

According to Coleridge's theory of imagination, the basis for artistic creation is, Abrams explains, feeling operating through "a productive tension with the impulse for order." The spontaneous operation of Associative Imagination suggests this tension toward order, because, Ruskin explains, the conception of the unity implicit in natural Ideas "must be formed at the instant they are seized." Coleridge's theory of imagination assumes original, disparate materials; these, in Ruskin's theory, are the *"separately wrong"* Ideas of nature, which are the primary materials of the artist's Associative Imagination. And according to Abrams' account of Coleridge's aesthetic, imagination organizes disparate materials "into a conventional medium in which the parts and the whole are adapted . . . to each other." Likewise, according to Ruskin's theory concerning the operation of Associative Imagination, the painter—

through his spontaneous conception of the unity inherent in two disparate, *"separately wrong"* Ideas of nature—perfects them by organizing them into a coherent and unified structure, the organic form of the painting. In this form, the artist's *"separately wrong"* visual and conceptual Ideas of nature "together shall be right." Since this organic form is the result of the painter's thinking with perceptions and concepts, then the form of the art work expresses this aspect of his subjectivity. And this expression is Beauty.

Furthermore, both Ruskin and Coleridge compare the operation of creative imagination to the operation of the mind of God. According to Ruskin, the artist's Associative Imagination

> . . . is indeed something that looks as if man were made after the image of God. It is inconceivable, admirable, altogether divine; and yet, wonderful as it may seem, it is palpably evident that no less an operation is necessary for the production of any great work: for, by the definition of Unity of Membership (the essential characteristic of greatness), not only certain couples or groups of parts, but *all* the parts of a noble work must be separately imperfect; each must imply, and ask for all the rest, and the glory of every one of them imply, and ask for all the rest, and the glory of every one of them must consist in its relation to the rest; neither while so much as one is wanting can any be right. (IV, 236)

And according to Coleridge's aesthetic, Abrams explains, "all genuine creation . . . derives from the generative tension of opponent forces, which are synthesized, without exclusion, in a new whole. The imagination, in creating poetry [or art], therefore echoes the creative principle underlying the universe."[16] Correspondingly, in Ruskin's theory, by synthesizing the disparate, opposing, "separately imperfect" parts of the painting, the artist establishes its Unity of Membership, an element of Typical Beauty. In doing so, the Associative Imagination operates in a manner analogous to that of God's creative mind in the natural universe, because "this faculty is indeed something that looks as if man were made after the image of God."

Just as Coleridge's theory of art and poetry can implement interpretation of Ruskin's aesthetic of Associative Imagination, so also Wordsworth's aesthetic can afford interpretation of the aesthetic of Vital Beauty in *Modern Painters II.* This theory concerns the expression "of felicitous fulfilment of function in living things" and "of the joyful and right exertion of perfect life in man" (IV, 64). Through the forms of plants and animals and of man in art, the religious painter expresses his happiness and his exuberant vitality. Reflecting his subjectivity, the expression of the painter's happiness and vitality constitutes art as Wordsworth conceives it in the "Preface" to the *Lyrical Ballads*—as " 'the spontaneous overflow of powerful feelings.' "[17]

In general, then, the only aspects of Ruskin's early aesthetic that elude interpretation by the expressive theory of art are the objective aspects of theory in *Modern Painters I*—for instance, the theory of the painter's accurate representation of nature in landscape painting.

The expressive theory of art, prominent in English aesthetics during the first half of the nineteenth century, was gradually superseded by the objective theory, prominent during the latter part of the nineteenth century and into the twentieth. The objective theory views the art work in isolation from the artist, the spectator, and the actual world. The Victorian aesthetic of "Art for Art's Sake" is, according to Abrams, a characteristic instance of the objective theory:

> The aim to consider a poem [or an art work], as Poe expressed it, as a "poem *per se* . . . written solely for the peom's sake," in isolation from external causes and ulterior ends, came to constitute one element of the diverse doctrines usually huddled together by historians under the heading "Art for Art's Sake."[18]

Concentrating on the art work as an autonomous entity, this aesthetic cannot do justice to the scope of Ruskin's theory in *Modern Painters I* and *II*. Although the objective theory concentrates only on the intrinsic aspects of the artifact as such, the Idea of Truth in volume one characterizes landscape painting in its extrinsic relations. As a "faithful statement . . . of any fact of nature" (III, 104), the landscape painting corresponds to objective facts in the natural world. As an expression "of the thoughts and feelings with which . . . [natural facts] were regarded by the artist himself" (III, 133), the painting is a subjective reflex of the painter's experience. And since "the artist not only *places* the spectator, but talks to him; makes him a sharer in his own strong feelings and quick thoughts . . ." (III, 134), then the landscape painting causes an empathic effect in its spectator. In *Modern Painters II,* Ruskin's religious aesthetic concerns the painting not only in itself but also in its relation to the observer and to the painter. Imagination, Ruskin asserts, creates Beauty in art; specifically, "the greater parts of works of art, more especially those devoted to the expression of ideas of beauty, are the results of the agency of imagination . . ." (IV, 165). The observer's Theoretic Faculty responds to this expression, because, through art, "the operations of . . . [Imagination] become in their turn objects of the theoretic faculty to other minds" (IV, 36). Thus, since the doctrine of "Art for Art's Sake" concerns only the objective art work in itself, this theory is inadequate for interpretation of *Modern Painters I* and *II*, which concern the painting in its extrinsic relations to the objective natural world, to subjective expression of the artist, and to the subjective response of the observer.

In conclusion, none of the representative instances of the four major types of aesthetic theory surveyed is suitable for interpretation of the *entire* aesthetic in John Ruskin's *Modern Painters I* and *II*.

The Background in Literary Criticism

The critics of Ruskin's aesthetic theory in *Modern Painters I* and *II* have concentrated on the attribution of either his or the artist's aesthetic experience to the painting itself. With different degrees of success, Ruskin's critics have attempted to interpret his early theory as completely consistent, as inconsistent, or as partially inconsistent.

Some early critics of Ruskin's aesthetic in *Modern Painters I* and *II* attempt unsuccessfully to show that it concerns objective imitation of physical forms, of spiritual realities, and of the artist himself insofar as he is a copy of them.

Of minor importance in Ruskin criticism are several interpretations of his early aesthetic that are based on a theory of intuition, which can perceive hidden essences or inherent principles of the natural world. Representative of these interpretations is Floris DeLattre's in *Ruskin et Bergson* (1947). With Henri Bergson, Ruskin sets forth a concept of imagination as aesthetic intuition. The artist observes nature in exact detail, and nature reveals divine attributes, or universals, to him. Thus, through observation and intuition (i.e. imagination, or sympathy), he apprehends the essence underlying the externals of nature and experiences their life.[19] He then embodies this intuitive knowledge into the painting.

In *Modern Painters I,* Ruskin presents a minor element of aesthetic theory that seems, at first glance, to bear out DeLattre's interpretation. Ruskin compares landscape painting to portraiture, which should both represent the subject's appearance and express his "latent forces and feelings," his "peculiar and separating attributes." Ruskin continues: "And so it is with external nature: she has a body and a soul like man; but her soul is the Deity." Making the point of this analogy between portraiture and landscape art, Ruskin then argues that the painter represents the hidden operations of the spirit of nature, of God as the soul of nature. These operations are revealed to the painter. Such representation is one kind of Truth, and "according to the dignity of the truths he can represent or *feel* [italics mine], is the power of the painter . . ." (III, 147-48). Understood according to Floris DeLattre's perspective, this theory of artistic creation is intuitional. By means of his intuitive imagination, the painter apprehends divine universals underlying the appearances of the natural world. Arguing from his analogy to portraiture, Ruskin calls these appearances the "body" of outward nature. Their divine essence is the soul of nature; that is, "her soul is the Deity." The hidden operations of God in nature constitute the divine life underlying its appearances. And the painter embodies his intuition of this life into his work.

This interpretation, however, is incorrect. Ruskin's painter does not intuitively *perceive* the soul of God and His operations in the natural world.

Instead he only *feels* that the Divine and His life are immanent there. Since feeling is subjective and therefore cannot apprehend objective spiritual realities in nature, consequently the Deity of nature and His operations are universal only insofar as they constitute *general* concerns of the artist's religious emotion, an element of his subjectivity that he expresses through the landscape painting.

Ruskin's theory of Penetrative Imagination poses similar difficulties for DeLattre's intuitional approach. Apparently the artist's Penetrative Imagination does apprehend universals and life in nature—its "utmost truth, life, principle." That is, Imagination "works and tastes into the very rock heart" of nature (IV, 251). But the essential principles of nature and its life are not, as DeLattre would assert, intuitively perceived by the painter. Both the principles and the life of nature have not an objective but a subjective character, because Imagination, Ruskin asserts, "plunges into the very central fiery heart" of objects (IV, 250), into their emotional essence. Since emotion is subjective, then the artist does not intuit universal principles and their life, but rather projects his own emotionl principles and emotional life into nature and into its images in painting.

W.G. Collingwood's *The Art Teaching of John Ruskin* (1891), like DeLattre's study, considers Ruskin's theory of art to be one concerned with objective imitation. In general, art imitates natural beauty, the Platonic universals underlying it, and the being of man insofar as he is an objective copy of these universals.[20]

In particular, Collingwood asserts that, according to Platonism, sense impressions, although separate in themselves, attain order and unity through their corresponding Ideas. Sense impressions are imperfect, but Ideas are perfect. John Ruskin's *Modern Painters I* shows that art presents such Ideas, significant examples of the perfection of natural law.[21] However, Ruskin's theory of "ideal beauty" in *Modern Painters I* (for example) does not bear out this Platonic interpretation. According to the "Preface to the Second Edition" of *Modern Painters I,* the different kinds of natural landscape each have harmony of parts. And each kind has "an ideal beauty of its own; a beauty" distinctive, in the generic sense, from that of other classes of natural phenomena. In order to represent "ideal beauty" in painting, the artist must know the classes and the specific forms of natural phenomena with scientific accuracy (III, 38-39). According to Collingwood's perspective, then, such "ideal beauty" is a Platonic Ideal.

This interpretation is, however, open to question, because Ruskin's concept of "ideal beauty" in art is ideal only in the scientific sense concerning genera of botany. Although "ideal beauty" is an element of natural law, Beauty in art is not ideal in the Platonic sense, because Platonism concerns the universal archetypes of natural phenomena, whereas science concerns only

their classification according to generic categories. Consequently, although Collingwood's view suggests an identification of the Platonic Idea with Ruskin's concept of "ideal beauty" as natural law, nevertheless this identification is unjustified.

Collingwood attempts to explain another aspect of Ruskin's aesthetic of beauty in *Modern Painters I*. Ruskin maintains that a landscape painting is beautiful if it "can give us pleasure in the simple contemplation of its outward qualities without any direct and definite exertion of the intellect . . ." (III, 109). And according to Collingwood, the examples (in art) of the greatest natural beauty and of the most intense emotion in man imply the perfection of natural law.[22] In effect, Collingwood implies that the (subjective) pleasure upon which beauty in art depends is objective, because the emotion of pleasure implies natural law. In other words, just as the beauty of landscape art implies natural law and therefore is objective, so also the pleasure upon which beauty depends is objective—because this emotion implies the same law! This interpretation is, however, mistaken. Since pleasure is subjective, it cannot imply anything objective—especially natural law, which is purely categorical in the generic sense.

Collingwood also proposes an interpretation applying primarily to Ruskin's theory of Associative Imagination in *Modern Painters II*. Ruskin maintains that Associative Imagination

> . . . is indeed something that looks as if man were made after the image of God. . . . it is palpably evident that no less an operation is necessary for the production of any great work: for, . . . not only certain couples or groups of parts, but *all* the parts of a noble work must be separately imperfect; each must imply, and ask for all the rest. . . . (IV, 256)

Collingwood interprets this theory briefly. Art reflects the external as seen and expresses human feeling. Not completely able to imitate nature, art selects from nature on the basis of intellect and imagination. Selection chooses the object and the corresponding imaginative vision.[23] In this way, the "Idealism" of the artist's mind presents "analogies of divinity" in art.[24] Thus, the result of the artist's Associative Imagination, the art work, is a selection of his perceptions of nature that are "separately imperfect; [but] each must imply, and ask for all the rest. . . ." The artist's arrangement of these recollected images of nature into a perfect unity in the painting constitutes their corresponding imaginative vision. And since Associative Imagination "is indeed something that looks as if man were made after the image of God," the artist is able to present in painting what Collingwood calls "analogies of divinity," a religious vision of perfect unity comprising "separately imperfect" natural images. But, at this point, Collingwood's interpretation fails by implying that the operation of Associative Imagination and its result in art are objective. In particular, Collingwood implies that the "Idealism" of the

painter's mind is objective in the Platonic sense and therefore that the separate natural forms unified by Imagination (in analogy to the divine unity implicit in nature) are also objective. But, according to Collingwood, art expresses the artist's feeling as well as his "Idealism." However, feeling is subjective; and therefore, the rest of the artist's being, *including* his "Idealism," must also be subjective. Consequently, Collingwood's interpretation cannot achieve its implicit goal, demonstrating that Ruskin's aesthetic of Associative Imagination is objective in the Platonic sense.

Instead of attempting to interpret Ruskin's aesthetic theory in *Modern Painters I* and *II* as a consistent imitation of intuitional or Platonic universals immanent in the world, other critics concentrate on inconsistencies in this theory.

For example, according to Francis G. Townsend in *Ruskin and the Landscape Feeling: A Critical Analysis of His Thought During the Crucial Years of His Life, 1843-56* (1951), Ruskin's early aesthetic centers on the basic effects of painting on its observer. According to Townsend's interpretation, the intelligent subordination of the separate parts of nature "to a universal plan" constitutes the "system of nature." The consequence of this system is natural beauty.[25] Townsend's subsequent delineation of what he calls the "landscape feeling" explains the effect of beauty on man:

> God has so created man that he is attracted instinctively to beautiful things, i.e., to those aspects of the universe which are types of the divine attributes. Therefore, God has so made man that if he will only look with attention and humility at the world around him, he will be led inevitably to faith in God. His whole nature will be purified and ennobled by this preview of the Beatific Vision.[26]

But, Townsend argues, a circle of reasoning is inherent in the "landscape feeling"; that is, if men are not already virtuous, can art make them so?[27]

The "landscape feeling" applies first to Ruskin's theory of beauty in *Modern Painters I*. He begins his chapter "Of Ideas of Beauty" by reasoning that "any material object which can give us pleasure in the simple contemplation of its outward qualities . . . , I call in some way, or in some degree, beautiful" (III, 109). Understood in the perspective of the "landscape feeling," Ruskin's theory maintains that every aspect of the natural universe created by God and represented in the landscape painting is an origin of beauty, because (he says) "any material object which can give us pleasure . . . , I call . . . beautiful." According to the theory of the "landscape feeling," the creator of man predisposed him to respond instinctively to beauty in nature and in art; thus, Ruskin argues, "we may indeed perceive, as far as we are acquainted with His nature, that we have been so constructed as . . . to derive pleasure from whatever things are illustrative of that nature . . ." (III, 109), that is, whatever

things are typical of God's attributes. At this point, Townsend argues, Ruskin's theory of beauty becomes circular. Man's divinely created predisposition to gain pleasure from beauty in art, its manifestation of God, shows that he is already virtuous. His inherent responsiveness to divine beauty in art is a virtue. As manifestations of God's attributes in landscape art, Ideas of Beauty simply effect in the observer what is already innate in him—the refined sensitivity to divine beauty:

> Ideas of beauty are among the noblest which can be presented to the human mind, invariably exalting and purifying it according to their degree; and it would appear that we are intended by the Deity to be constantly under their influence, because there is not one single object in nature [or in art] which is not capable of conveying them (III, 111)

Interpreted according to Townsend's concept of the "landscape feeling," Ruskin's aesthetic of the Theoretic Faculty in *Modern Painters II* has the same inconsistency as the aesthetic of beauty in volume one. According to Townsend's interpretation, beauty in art is the symbolization of God's attributes by natural forms. And according to Ruskin, Typical Beauty is the "external quality of bodies" in art that is "in some sort typical of the Divine attributes" (IV, 64). The Theoretic Faculty apprehends Typical Beauty in art. Experiencing the "landscape feeling," the observer's sensibility is elevated and purified by his apprehension of these "Divine attributes":

> For this [perception], and this only, is the full comprehension and contemplation of the Beautiful as a gift of God; a gift not necessary to our being, but added to, and elevating it, and twofold: first of the desire, and secondly of the thing desired. (IV, 47)

The observer's desire for beauty in art and the work itself as beautiful are elevated by the art work's symbolization of "the Divine attributes," by "the Beautiful as a gift of God."

But again—understood according to Townsend's perspective—this theory of response to beauty in art is circular. That is, if the observer is not already virtuous, can art make him so? According to the aesthetic of the Theoretic Faculty, the observer's *desire* for divine beauty in the painting is the *virtue* elevated by it. The aesthetic of the Theoretic Faculty also concerns the observer's "perception of purpose and adaptation of . . . [the painting] to our desires; a perception, therefore, of the immediate operation of the Intelligence which so formed us, and so feeds us" (IV, 47). Apparently, then, God originally created man's desire for beauty in nature and in art. The manifestation of "Divine attributes" in art thus elevates the observer's desire, originally, however, inherent in him.

In general, by limiting his interpretation of Ruskin's early aesthetic to the subjective effects of beauty on the observer of art, Townsend is able to demonstrate the circularity of the "landscape feeling" in *Modern Painters I* and *II.*

According to Henry Ladd in *The Victorian Morality of Art* (1932), Ruskin's early aesthetic theory inconsistently projects his own subjective sensibility into nature and into art:

> It is not merely that when he objectified his appreciation of line, color and quality, these turned into abstract enormities, but that his appreciation also gathered up his sentiments and the particular group of emotions which he called moral. These, when interpolated into the organic and inorganic nature about him, transformed the universe into a vast reflection of this man's sensibility at once pathetic and ludicrous.[28]

When applied to Ruskin's early theory of art, Ladd's interpretation shows that the Idea of Truth in *Modern Painters I* and the aesthetic of Beauty in *Modern Painters II* are Ruskin's anthropomorphic projections of his own experience and belief into art. The Idea of Truth in landscape painting concerns both accurate representation of nature and also expressive "statements . . . of emotions, impressions, and thoughts" (III, 104). These experiences, according to Ladd's perspective, are simply Ruskin's. He anthropormophically embodies these sentiments and moral thoughts into the objective representational work itself. Or, in *Modern Painters II,* Typical Beauty in art concerns the appearances of "a stone, flower, beast, or . . . man" that symbolize "the Divine attributes" (IV, 64). According to Ladd's perspective, here Ruskin anthropomorphically projects his subjective religious belief, concerning "Divine attributes" of nature, into the objective art work itself—portraying stones, plants, animals, or man.

Solomon Fishman finds a similar inconsistency in Ruskin's early aesthetic theory. Fishman's *The Interpretation of Art: Essays on the Art Criticism of John Ruskin, Walter Pater, Clive Bell, Roger Fry, and Herbert Read* (1963) concerns the subjective and the objective aspects of the Idea of Truth in *Modern Painters I.* Ruskin maintains that "truth has reference to statements both of the qualities of material things, and of emotions, impressions, and thought" (III, 104). Fishman points out the inconsistency between the representational and the expressive aspects of Truth. In Ruskin's theory of art, Fishman asserts, imitation (i.e. representation) and expression are unresolved.[29] By this statement, Fishman means that the objective aspect of Truth, accurate representation of "the qualities of material things" by landscape painting, conflicts with its subjective aspect—the expression of the painter's "emotions, impressions, and thoughts."

Regardless of this conflict between representation and expression, both aspects of Truth in landscape art are naturalistic, Fishman explains. This interpretation applies primarily to Ruskin's aesthetic of the painter's two major goals with regard to Truth in landscape painting: "The first, to induce in the spectator's mind the faithful conception of any natural objects whatsoever; the second, . . . to inform him of the thoughts and feelings with which

these were regarded by the artist himself" (III, 133). Representation of nature and expression of the painter, Fishman argues, form a naturalistic theory of artistic creation. Imitation of nature, or representation, is a natural phenomenon. And since the imaginative quality of expression cannot be taught, it is also naturalistic. In their respective senses, both representation and expression compose a "naturalist creed," characteristic of "a highly personal religion."[30] By inducing "in the spectator's mind the faithful conception of any natural objects whatsoever" the painter certainly does create the landscape painting naturalistically. And also, by informing the spectator "of the thoughts and feelings with which these were regarded by the artist himself," he expresses himself naturalistically through the landscape work, because these feelings and thoughts are not results of education but instead are direct, instinctive responses to visual perceptions of the natural world. Generally, then, in spite of the logical conflict between the artist's objective representation of nature and his subjective expression of feelings and thoughts, both aspects of the Idea of Truth in landscape painting have a common naturalism.

Whereas Solomon Fishman points out the inconsistency in Ruskin's aesthetic of Truth in *Modern Painters I, The Aesthetic and Critical Theories of John Ruskin* (1971), by George P. Landow, maintains Ruskin's aesthetic of beauty in *Modern Painters I* is inconsistent and that in *Modern Painters II* is partially so. Landow explains the logical conflict in Ruskin's aesthetic of beauty in volume one by demonstrating that the subjective aspect of beauty is inconsistent with its objective aspect:

> Although Ruskin, in contrast to many English aestheticians of the eighteenth and nineteenth centuries, believes that beauty is an objectively existing thing or quality, he yet speaks of "the emotions of the Beautiful and Sublime" (3.48) If emotion is . . . subjective, and if beauty is an emotion, it is difficult to see how Ruskin believes that beauty can be objective.[31]

Ruskin's central concept of beauty in *Modern Painters I* certainly does define beauty not only as a subjective effect of the landscape work on the observer but also as an objective, material quality of the work itself:

> Any material object [in art] which can give us pleasure in the simple contemplation of its outward qualities without any direct and definite exertion of the intellect, I call . . . beautiful. Why we receive pleasure from some forms and colours, and not from others, is no more to be asked or answered than why we like sugar and dislike wormwood. The utmost subtlety of investigation will only lead us to ultimate instincts . . . of human nature, for which no farther reason can be given than the simple will of the Deity that we should be so created. (III, 109)

The observer's emotional response to the objective material qualities of the landscape work certainly, as Landow maintains, does not have an objective,

rational element, because a representation of nature "can give us pleasure . . . without any direct and definite exertion of the intellect." In the sense that beauty in art depends on aesthetic pleasure, beauty *is* pleasure as a response to art. Since beauty is pleasure, Landow argues, then beauty is subjective. Landow also demonstrates that Ruskin inconsistently considers beauty to be an objective quality. And he does, because the objective work of art, causing pleasure in the observer, is *itself* beautiful. Further, Landow maintains, Ruskin also implies that beauty is an objective quality of the landscape painting because the response of pleasure upon which its beauty depends is common to all men:

> Men react so, says Ruskin, because it is God's will and because all men have a divine element in their nature By appealing to an order that is ultimately divine, Ruskin thus proves to his satisfaction, if not, alas, to ours, that aesthetic emotions are both uniform and essential [i.e. objective].[32]

Interpreting Ruskin's theory of Typical and Vital Beauty in *Modern Painters II,* Landow is concerned with the way in which Ruskin uses religion to uphold the objectivity of beauty. In particular, Landow explains the way in which Ruskin's concepts of symbolization and expression in art uphold the spiritual, or religious, quality of Typical and Vital Beauty; thereby, Landow implies that this aesthetic is consistent:

> In both forms of the beautiful, the material object, that which is directly perceived , . . . is a symbol through which, or on which, appear the signs of spiritual law. Vital Beauty expresses spirit, mind, and the energy of life, all informed, ultimately, by God. Typical Beauty expresses the nature of God. The twin . . . ideas of symbolization and expression grant Ruskin the means of reconciling material and immaterial, for they grant him a way of showing that the beautiful object is beautiful . . . because it is spiritual.[33]

This complex interpretation of Typical and Vital Beauty implies that its spiritual quality, symbolized or expressed by art, is religious and is therefore objective. Landow further implies that since this spiritual quality (the immaterial aspect of the painting) is objective, then its symbolization or expression of this quality reconciles the immaterial with the material—the emotional and conceptual qualities of beauty with the objective painting itself. In particular, constituting the aesthetic of Typical Beauty, the objective appearances of stones, plants, animals, and man in the painting symbolize Ruskin's belief in "the Divine attributes" (IV, 64). Otherwise subjective, this belief is objective because it is religious; therefore, Ruskin's religious belief in "Divine attributes" inherent in the painting is consistent with its objective appearances, symbolizing this belief. Moreover, Vital Beauty in art is the expression, by appearances of plants and animals, of the "felicitous fulfilment of function in living things." And form of human beings in art express "the

joyful and right exertion of perfect life in man" (IV, 64). In effect, the forms of plants and animals express Ruskin's happiness; and human forms express his exuberant sense of physical life. In themselves, these expressions of emotion are purely subjective. But when understood as spiritual, or religious— pervaded by God's being—then Ruskin's happiness and his exuberant vitality become objective and consequently consistent with the objective forms of art expressing these feelings.

In general, by using religion to uphold the objectivity of beliefs and emotions symbolized or expressed by nature and man in art, Ruskin establishes the objectivity of Typical and Vital Beauty. However, religion as such is extrinsic to aesthetic theory. Ruskin employs the spiritual, religion, to uphold what in itself is intrinsically subjective—the observer's belief in "Divine attributes" and his emotions of happiness and joyful vitality. When Ruskin rejected his religious faith (Evangelicalism), Landow maintains, the theory of Typical Beauty, for example, became untenable:

> The central theological principle is gone, and once it had departed the theory of Typical Beauty lost all its force; for whereas one can hold that the symbolization in material things of moral qualities is beautiful, unless one can also hold that such symbolization is universal and intentional [i.e. religious]—a law of nature—beauty becomes a matter of subjective responses. It was thus that the explanation of beauty which most emphasized the objective, universal nature of aesthetic qualities became, once Ruskin lost his faith, an implicitly subjective, personal theory.[34]

And, like Typical Beauty, Vital Beauty, Landow implies, is an inherently subjective theory, because Ruskin needed the extrinsic factor of Aristotle's concept of "happiness of function" in order to maintain the objectivity of this aesthetic after losing his religious faith in 1858.[35]

In general, Landow thus implies that Ruskin's theory of beauty in *Modern Painters I* and *II* is intrinsically subjective, for "one may say of Ruskin's aesthetic theories what he said of the arts—that they are in some sort an expression of deeply felt emotion, the recasting of [his] intensely felt experience."[36]

Whereas Landow is concerned with the Christian aspects in Ruskin's theory of Ideas of Beauty and in his theory of Typical and Vital Beauty, John D. Rosenberg is concerned with the pantheism implicit in the aesthetic *of Modern Painters I* and *II*.

According to Rosenberg's *The Darkening Glass: A Portrait of Ruskin's Genius* (1961), an essential modification of traditional Christian belief characterizes Ruskin's early aesthetic theory:

> Through a kind of supernatural naturalism both Wordsworth and Ruskin ignored the Christian dichotomy separating the perfection of the Creator from the sin-blighted creation and brought a pagan adoration of nature to their worship of God.[37]

And Ruskin's emotion in the face of nature (and art), Rosenberg maintains, is primarily an expression of pre-Christian pantheism.[38]

Since this critical perspective concerns pantheistic aspects of nature and of art as well as *Ruskin's* pantheistic responses to them, Rosenberg's approach cannot resolve the inconsistency in the Idea of Truth (for example), between objective representation of nature in landscape painting and subjective expression of the *artist's* feelings and thoughts by it. Nevertheless, Rosenberg's approach can be used to demonstrate a consistent sequence of though in Ruskin's aesthetic of Beauty in *Modern Painters I* and *II* and thereby to show that their *entire* aesthetic is only partially inconsistent.

When applied, for example, to Ruskin's aesthetic of Beauty in *Modern Painters I*, Rosenberg's pantheistic interpretation can be used to reconcile the objective and the subjective aspects of Beauty in representational art. Ruskin's Idea of Beauty is both a subjective response to the landscape work and an objective quality of it. The painting, Ruskin implies, causes pleasure by illustrating the nature of God:

> Any material object which can give us pleasure in the simple contemplation of its outward qualities . . . , I call in some way, or in some degree, beautiful We may indeed perceive, as far as we are acquainted with His nature [i.e. God's], that we have been so constructed as . . . to derive pleasure from whatever things are illustrative of that nature (III, 109)

This theory can be interpreted pantheistically. The landscape work—causing pleasure by illustrating the nature of God—manifests not the characteristics of an individual divine being but rather life-forces of nature and its laws. In this sense, the manifestation of the Divine through representational art is pantheistic. And the manifestation of divine life and divine law through art is Beauty, because "any material object which can give us pleasure in the simple contemplation of its outward qualities" is beautiful. In this sense, the Beauty of art depends upon the response of pleasure. But here pleasure is not subjective; instead, it is universal in the pantheistic sense. Rosenberg, we have seen, explains that Ruskin's emotional response to nature is a mode of pantheism. Responding to nature represented in art, Ruskin's capacity "to derive pleasure from whatever things are illustrative of that nature" (i.e. God's nature) concerns a response to the divine element of the world and therefore is pantheistic. In this sense, Ruskin's response is universal and consequently objective. Thus, the objective Beauty of the landscape work—illustrating divine life and divine law—can depend on pleasure.

John Ruskin's summary of Typical and Vital Beauty in *Modern Painters II* can also be interpreted pantheistically. The nature of God informs both Typical and Vital Beauty:

> It is either the record of conscience, written in things external, or it is a symbolizing of Divine attributes in matter, or it is the felicity of living things, or the perfect fulfilment of

their duties and functions. In all cases it is something Divine; either the approving voice of God, the glorious symbol of Him, the evidence of His kind presence, or the obedience to His will by Him induced and supported. (IV, 210)

Beauty in art, Ruskin says, "is something Divine." That is, Beauty is a pantheistic manifestation by art of universal laws and forces. Not an individual Creator but pantheistic divine law manifests in art through "a symbolizing of Divine attributes in matter." And the universal divine force of a pantheistic natural world manifests as the expression in "living things" of "the obedience to His will by Him induced and supported"—the expression of "the perfect fulfilment of their duties and functions."

Furthermore, interpreted according to Rosenberg's perspective, Ruskin's moral and emotional responses to nature are pantheistic. Since the "record of conscience," an aspect of Beauty, "is something Divine," therefore conscience, as moral feeling and thought, is also pantheistic. The "record of conscience," an "approving voice of God," is simply Ruskin's pantheistic response to nature portrayed in art, his feelings and his thoughts about good and evil. And, since "the felicity of living things" is the expression of *Ruskin's* happiness and since this felicity is also "the evidence of . . . [God's] kind presence," happiness must then be a pantheistic response to "living things" present in nature and portrayed in art. These manifestations of conscience and happiness, Ruskin's responses to nature and to "living things" represented in art, are universal in the sense of pantheism and consequently are objective.

As such, both conscience and happiness are consistent with other objective manifestations of the art work—its expression of pantheistic divine law and its expression of pantheistic divine force.

In the ways here outlined, Rosenberg's approach to Ruskin's early aesthetic can afford a consistent interpretation of his theory of Beauty in *Modern Painters I* and *II*. Of course, just as Landow uses the extrinsic element of Christian religion to show how Ruskin upholds the objectivity of Typical and Vital Beauty in *Modern Painters II,* so also this application of Rosenberg's approach employs the extrinsic element of pre-Chrisian pantheism in order to indicate the objectivity of Ruskin's aesthetic of Beauty in both volumes.

A Phenomenological Approach

The foregoing review of aesthetic theories and of literary criticism relevant for interpretation of Ruskin's aesthetic theory in *Modern Painters I* and *II* demonstrates the possibility for a new interpretation. None of the aesthetic theories reviewed can afford an interpretation of this theory as an *entirely* consistent body of thought. For example, although Wordsworth's and Coleridge's theories can explain Ruskin's aesthetic (in volume one) about the

landscape painter's expression of feeling and thought through art, Romantic theory, concerned with subjective expression of the artist's experience, cannot account for the landscape painter's first goal, accurate representation of nature, because representation is objective. Or, although G.P. Landow employs the Christian aspects of Ruskin's theory of Typical and Vital Beauty in order to imply an interpretation of it as consistently objective, nevertheless Landow demonstrates Ruskin's inconsistent attributions of objectivity to beauty in volume one and indicates that the theory of Typical and Vital Beauty in volume two became partially subjective when Ruskin rejected his faith. Or, as we have seen, Rosenberg bases an interpretation of Ruskin's early aesthetic on pantheism. Concerned primarily with pantheism in art and with Ruskin's pantheistic responses to it, Rosenberg's approach cannot resolve inconsistencies in Ruskin's aesthetic of the artist in *Modern Painters I* (for example). And, although this approach can implement a demonstration of consistent objectivity in Ruskin's aesthetic of Beauty in both volumes, nevertheless pantheism is also extrinsic to this theory—perhaps more so than its Christian elements—because the religious substratum in *Modern Painters I* and *II* is primarily Evangelical.

Consequently, none of the aesthetic theories relevant to and the criticisms of Ruskin's early aesthetic can afford an interpretation of it *as* consistent by explaining it only according to its intrinsic aspects. These are Ruskin's theories of the art work as such, his theories of its creation, and his theories of its appreciation. The Christian or pantheistic aspects of these theories have secondary importance for them.

Explained fully in "The Origin of the Work of Art," Martin Heidegger's aesthetic can implement a demonstration of consistency in all the intrinsic aspects of Ruskin's aesthetic in *Modern Painters I* and *II*. Like Ruskin's theory, Heidegger's concerns the art work, its creation, and its appreciation.

Opening his essay, Heidegger immediately makes this point clear: "The question concerning the origin of the work of art asks about the source of its nature."[39] Hans Jaeger, in "Heidegger and the Work of Art," outlines Heidegger's first step in his search for this origin:

> Art is both the origin and the goal of a work of art. We have to go through with this circle. But we must make a start somewhere. And we can better start with what is the more concrete of the two, namely the work of art. The work of art is part of art as a whole and must reveal art. Therefore we ask: what is the nature of a work of art? Is it a thing?[40]

Heidegger then inquires into the traditional concepts of the thing, but rejects them as concepts of art, because they preconceive "all immediate experience of beings."[41] Consequently, Heidegger speaks about a thing in a work of art in order to determine its nature; he describes the peasant shoes in a painting by Van Gogh:

From the dark opening of the worn insides of the shoes the toilsome tread of the worker stares forth. In the stiffly rugged heaviness of the shoes there is the accumulated tenacity of her slow trudge through the far-spreading and ever-uniform furrows of the field swept by a raw wind. On the leather lie the dampness and richness of the soil. Under the soles slides the loneliness of the field-path as evening falls. In the shoes vibrate the silent call of the earth, its quiet gift of the ripening grain and its unexplained self-refusal in the fallow desolation of the wintry field. This equipment is pervaded by uncomplaining anxiety as to the certainty of bread, the wordless joy of having once more withstood want, the trembling before the impending childbed and shivering at the surrounding menace of death. This equipment belongs to the *earth,* and is protected in the *world* of the peasant woman. From out of this protected belonging the equipment itself rises to its resting-within-itself.[42]

By way of knowing what the shoes in Van Gogh's painting are, Jaeger says, "we have . . . learned something of importance about the work of art. Van Gogh's painting has revealed to us what the peasant shoes really and truly *are.* Thus the work of art reveals the true being of things, it reveals truth."[43]

Then, in order to determine the nature of "truth" in art, Heidegger interprets another work of art, a Greek temple:

It is the temple-work that first fits together and at the same time gathers around itself the unity of those paths and relations in which birth and death, disaster and blessing, victory and disgrace, endurance and decline acquire the shape of destiny for human being. The all-governing expanse of this open relational context is the world of this historical people. . . . The luster and gleam of the stone, though itself apparently glowing only by the grace of the sun, yet first brings to light the light of day, the breadth of the sky, the darkness of the night. . . . The steadfastness of the work contrasts with the surge of the surf, and its own repose brings out the raging of the sea. Tree and grass, eagle and bull, snake and cricket first enter into their distinctive shapes and thus come to appear as what they are. The Greeks early called this emerging and rising in itself and in all things *phusis.* . . . We call this ground the earth. . . .

The temple-work, standing there, opens up a world and at the same time sets this world back again on earth, which itself only thus emerges as native ground.[44]

In effect, the temple-work epitomizes the "truth" of the art work, its essential nature, comprising "earth" and "world." The "earth" is the visible form of the work. And the "world" is the significance that form has for a historical people. According to Jaeger, then, Heidegger's "description of the temple tried to bring out this interrelation of the world and the earth. In erecting a world the work of art uses the earth, i.e., earthly material, rock, color, tone, words, when we think of the whole realm of art."[45]

Continuing his search for the origin of the work of art, Heidegger shows that the artist establishes its "truth" and that the observer experiences this "truth." In "Heidegger's Theory of Art," William H. Bossart explains the way in which the art work is related to its creator and to its observer:

Thus, the letting-be of the work requires an audience which conserves the world which is established by the work. Just as the work cannot be without those who create, it cannot

come forth in its Being without its proper audience. And it is the conservation of works of art through the conservation of the traditions they establish which unifies individuals into a specific historical people. Art, then, considered as the origin of a work of art is, according to Heidegger, "the creative conservation of truth in a work of art."[46]

This statement means that the artist's "creation" of the "truth" of the work of art and the observer's apprehension of this "truth" constitute art, which is the origin of the work itself. Art is the origin not only of the work but also of the creator and the preserver themselves, Heidegger maintains:

> The origin of the work of art—that is, the origin of both the creators and the preservers, which is to say of a people's historical existence, is art. This is so because art is by nature an origin: a distinctive way in which truth comes into being, that is, becomes historical.[47]

Essentially, then, since art is the origin of the work, of the creator, and of the preserver and since art is the coming-into-being of "truth," then "truth" itself, the essential nature of the work, is the primary origin of the art work itself, of its "creation" by the artist, and of its conservation by the observer. Comprising an "earth" and a "world," "truth" is the primary origin of the work, of "creation," and of "preservation"; because the creator establishes "truth" in the work, the nature of the work itself is "truth," and the observer apprehends the "truth" of the work of art.

Martin Heidegger's essay "The Origin of the Work of Art" is an application of phenomenology to aesthetic theory. Phenomenology itself, Herbert Spiegelberg maintains in *The Phenomenological Movement,* is basically a mode of knowledge taking its starting-point directly from human experience:

> The chief meaning of phenomenology . . . is not that of a revolt but of a fertilizing and reconstructive effort. The watchword "To the things themselves" has primarily a positive objective, bids us to turn toward phenomena which had been blocked from sight by the theoretical patterns in front of them. But what does this positive turn imply? That question will have to be answered by a more detailed discussion of the positive steps of the phenomenological method, which we shall take up in the following order:
> 1. investigating particular phenomena;
> 2. investigating general essences;
> 3. apprehending the essential relationships among essences;
> 4. watching modes of appearing;
> 5. watching the constitution of phenomena in consciousness;
> 6. suspending belief in the existence of phenomena;
> 7. interpreting the meaning of phenomena.
> The first three steps have been accepted, at least implicitly, and practiced by all those who have aligned themselves with the Phenomenological Movement; the later ones only by a smaller group.[48]

Of course, to enter into a detailed explanation of all these methods of phenomenology would exceed the scope of the present study. Only the first method and the last are relevant for the present discussion.

The basic guideline of phenomenology, "To the things themselves," means that the phenomenologist makes direct experience of phenomena his starting point for knowledge, instead of approaching them with preconceived theory about them. Bringing this kind of theoretical contruct to phenomena obstructs them *as* themselves.

The theoretical preconception implicit in the aesthetic theories and in the literary criticism reviewed in this chapter is the distinction between the subjective and the objective. In effect, the reason why the aesthetic theories and the criticisms relevant to Ruskin's early theory cannot afford a complete interpretation of it as a consistent body of thought is simply that these approaches assume the subject-object distinction. Applied to interpretation of the aesthetic of the painter in volume one, Wordsworth's aesthetic (for example) can be used to show that the landscape painter expresses his subjective responses to nature, his thoughts and feelings about it, through the landscape work. But, maintaining that the art work also portrays the artist's modified (and hence subjective) perceptions of nature, Wordsworth's theory cannot afford an explanation of Ruskin's theory about the painter's objective representation of nature. Or, without the universality of the Christian religion to uphold the objectivity of Typical and Vital Beauty in volume two, Landow maintains, this theory becomes only an expression of Ruskin's subjective responses to art—although he himself asserts that beauty is an objective quality in it. In general, the artist's or Ruskin's aesthetic experience is subjective. But the art work is objective. Thus, embodying his own or the painter's experience into the painting, Ruskin's early aesthetic as a whole must remain inconsistent as long as the subject-object dichotomy is assumed as the basis for interpretation. However, phenomenology can afford a new approach to Ruskin's early theory by eliminating all theoretical preconceptions for interpretation. Particularly, phenomenology can eliminate the subject-object preconception altogether and go "To the things themselves"—the intrinsic elements of the work, the painter, and the observer that characterize Ruskin's aesthetic in *Modern Painters I* and *II*.

The particular manner in which the phenomenologist eliminates the subject-object distinction involves the first method of phenomenology—the investigation of "particular phenomena."[49] The phenomenology of Edmund Husserl accomplishes this movement away from the preconception of subject and object and toward the phenomena themselves. Without preconceiving the subject-object dichotomy, Husserl simply investigates phenomena themselves

as they are directly present for human consciousness. Herbert Spiegelberg, in *The Phenomenological Movement,* explains this manner of investigating phenomena.

This investigation is based on what Husserl calls "the intentionality of consciousness," a concept central to his *Logical Investigations.* According to this work, intentional consciousness is consciousness that is directed toward something, a visual object for example. Husserl calls such acts of consciousness "intentions," and their referents he calls "intentional objects." The direction of consciousness toward an object is equivalent to the human being's "'consciousness *of,*' 'perception *of,*' 'joy *at*'" something, and so on. Thus, intentional consciousness refers to objects in various ways, "as perception, thought, [or] doubt (which Husserl called the 'qualities' of the intention, as opposed to its 'matter.')" And thus, the character of the intention corresponds to that of its object. That is, objects are perceived visually, thoughts are apprehended mentally, and emotions are felt. Furthermore, different acts of intentional consciousness integrate their respective intentional objects.[50] That is, consciousness can be directed toward a single intentional object in different ways. The phenomenologist can have a perception of it, a feeling or a thought about it, and so on. These several intentional objects can integrate into a single one. For instance, what he perceives in a painting, what he feels about it, and what thoughts he refers to it all combine into one object of consciousness—the meaningful work itself. Finally, having apprehended an object intentionally, the phenomenologist then simply describes it. He relates what he is aware of with regard to a given intentional object, whether feelings and thoughts about it, or perceptions of it.

Martin Heidegger's *Being and Time* (1927) is based on this theory of intentionality. Husserl's theory concerns the first method of phenomenology—investigation of "particular phenomena" with intentional consciousness.[51] Heidegger's phenomenology in *Being and Time* concerns this method of phenomenology and the last one—"interpreting the meaning of phenomena."[52] The phenomenology of Husserl is descriptive; it describes the intentional objects toward which consciousness is directed. The phenomenology of Heidegger in *Being and Time* is hermeneutic.[53] Heidegger interprets the concealed, implicit meanings of the phenomena intended by consciousness. Thus, *Being and Time* combines the first and the last methods of phenomenology—the description of intentional phenomena and the interpretation of their implicit significance. Herbert Spiegelberg characterizes the hermeneutic phenomenology of *Being and Time:*

Hermeneutic phenomenology may thus be defined as a method of bringing out the normally hidden purposes of such goal-determined things-in-being as human beings. It presupposes, of course, that these beings possess such a purposeful structure; but there seems to be no reason why this presupposition should not be verifiable and also actually

verified. Hermeneutics thus uses methods which go beyond mere description of what is manifest [i.e. for consciousness] and tries to uncover hidden meanings by anticipatory devices.[54]

In *Being and Time,* the central concept of *Dasein* is the equivalent in hermeneutic phenomenology to Husserl's descriptive concept of intentional consciousness.[55] *Dasein* means "'there' *(da),* 'with it.'"[55] Consequently, *Dasein* translates as "Being-with" something. In general, the concept of *Dasein* expands Husserl's descriptive phenomenology with hermeneutic methods. For example, Being-with an entity is being conscious of it as an interpreted intentional object, the implicit structure or meaning of which is apprehended. When seeing an entity, then the phenomenologist understands the implicit structure of its visual appearances. Or, when thinking about the entity, he comprehends the implicit meanings of thoughts about the object itself. In the perspective of phenomenology, then, Husserl's descriptive conception of intentional consciousness becomes Heidegger's hermeneutic concept of Being-with the implicit structure and significance of entries perceived, felt, thought about, and so on.

In "The Origin of the Work of Art," Martin Heidegger interprets the intentional correlates of *Dasein* in terms of fundamental requirements of aesthetic theory—the nature of artistic creation, of the work of art itself, and of aesthetic appreciation. Each of these aspects of aesthetic theory has two major themes. The first is "truth." And the second is "beauty."

William J. Richardson's *Heidegger: Through Phenomenology to Thought* (1967) summarizes Heideger's three-part theory from the perspective of "truth":

> At this point, the process of truth that takes place in the art-work may be conceived as a confluence of three different movements: truth as the contention of World and earth establishes itself in the work; the artistic creator stabilizes this contention in a form; contentious truth, thus stabilized, must be allowed to come-to-pass by the conservers of art. The masterpiece emerges as itself when these three movements fuse into a dynamic unity.[56]

In contrast to this phenomenological aesthetic, Husserl's phenomenology simply describes what consciousness is directed toward. For example, the artist can be aware of embodying his feelings and thoughts in the perceptual art work. The observer becomes aware of these intentional objects—the perceptual work and its embodied feelings and thoughts. The art work itself exists insofar as the artist or the observer directs his consciousness toward it in these ways. Heidegger's hermeneutic aesthetic interprets these various intentional acts and their objects. "Truth" means that consciousness is directed toward the basic contrast in the intentional art work between its "earth" (or perceptual appearance) and its "world" (or emotive and con-

ceptual meaning). When the artist creates the work, he sees that he establishes its forms and knows that he embodies his feelings and thoughts in it. Similarly, the observer of the work becomes aware of this contrast of "truth."

Furthermore, the manifestation of the "truth," or essential nature, of the art work through its form is "beauty." The creator can be aware of expressing this essence in form. And the preserver can apprehend this expression of "beauty."

Sir Joshua Reynolds, we have seen, was concerned with landscape painting as an imitation of ideal or generalized aspects of nature; this aesthetic implicitly concerns a theory of the work of art as such. Heidegger, however, explicitly formulates a theory of the art work itself. The art work is the manifestation of "truth" for intentional consciousness.

And, as we have seen, Heidegger introduces the concept of "truth" by way of a consideration of Van Gogh's *Les Souliers*. An object of intentional consciousness, this painting reveals the shoes of the peasant woman as they actually are. This manifestation is the "truth" of the painting. "Truth" is Heidegger's Being-with the peasant shoes in the work as themselves.[57] Having employed the commentary on *Les Souliers* in order to introduce the "truth" of the work of art, Heidegger then defines "truth" explicitly:

> The art work opens up in its own way the Being of beings. The opening up, i.e., this deconcealing, i.e., the truth of beings, happens in the work. In the art work, the truth of what is has set itself to work. Art is truth setting itself to work.[58]

And the "truth" of the work of art is the contrast between an "earth" and a "world":

> The nature of truth is, in itself, the primal conflict in which that open center is won within which what is, stands, and from which it sets itself back into itself.
> This Open happens in the midst of beings. It exhibits an essential feature which we have already mentioned. To the Open there belong a world and the earth. But the world is not simply the Open that corresponds to clearing, and the earth is not simply the Closed that corresponds to concealment. Rather, the world is the clearing of the paths of the essential guiding directions with which all decision complies. Every decision, however, bases itself on something not mastered, something concealed, confusing; else it would never be a decision. The earth is not simply the Closed but rather that which rises up as self-closing. World and earth are always intrinsically and essentially in conflict, belligerent by nature. Only as such do they enter into the conflict of clearing and concealing.[59]

When the art work manifests "in its own way the Being of beings," consciousness is directed toward its essential nature—its "Being," or "truth." "Truth" is Being-with the "conflict," or contrast, between the "earth" and the "world" of the art. "Earth" is the consciousness of the particular appearances

and forms of the art work. For Heidegger's intentional consciousness, these visual qualities have "something not mastered, something concealed, confusing" and are "self-closing." In other words, "earth" as "closed" means that Heidegger knows that the visual appearances of the work are not meanings themselves. These forms are simply what he sees in the work. But they do express "the clearing of the paths of the essential guiding directions with which all decision complies." These directions are the meanings constituting the "world" of the art work. The appearances of art express meanings, whether as emotions or as thoughts. And these meanings are "open," manifest, evident for intentional consciousness. Thus, the "world" is the meaning that Heidegger understands when he sees the work of art. "Truth" itself, then, is simply Heidegger's apprehension of the basic contrast between the perceptual "earth" and the meaningful "world" of the work of art—for instance, a painting.[60]

Similarly, as a representative instance of the first intrinsic element of Ruskin's early aesthetic, the Idea of Truth in landscape painting, the central element of the aesthetic in *Modern Painters I,* comprises both the visual aspects of the painting and also their meanings:

> The word Truth, as applied to art, signifies the faithful statement, either to the mind or senses, of any fact of nature . . . truth has reference to statements both of the qualities of material things, and of emotions, impressions, and thoughts. (III, 104)

According to the Idea of Truth, the landscape painting both represents nature accurately and also embodies the "emotions, impressions, and thoughts" of the artist. The inconsistency in this theory is clearly evident. Representation of nature by landscape art is objective. The artist's feelings and his thoughts as well as his impressions are subjective. Therefore they cannot be embodied in the objective landscape work itself.

A consistent interpretation of the Idea of Truth presupposes elimination of its subject-object distinction. Husserl's theory of intentionality describes not subjects nor objects but instead whatever consciousness is directed toward, be it perceived entities, thoughts, or feelings. The first element of Truth, then, concerns Ruskin's visual perception of the landscape painting as an intentional object—"the faithful statement, either to the mind or senses, of any fact of nature." Constituting the second element of the Idea of Truth, "statements . . . of [the artist's] emotions, impressions, and thoughts" are also intentional objects of Ruskin's consciousness; there are the artist's experiences that Ruskin apprehends when he looks at the landscape work. These "emotions, impressions, and thoughts" can be embodied in the painting, because it is an intentional object—the correlate of Ruskin's visual perception.

A hermeneutic theory, Martin Heidegger's concept of "truth" can afford an interpretation of this phenomenological description of the Idea of Truth. The visual element of Truth is the "earth" of landscape art, its appearances and forms which consciousness perceives. Ruskin sees "the faithful statement... of any fact of nature." The element of emotional and conceptual experience in the Idea of Truth is the "world" of the landscape work. Whether emotion or thought, this "world" of the work is the meaning of its representational "earth." When Ruskin sees a faithful representation of the natural world, then he knows about the artist's experience. That is, Ruskin apprehends an expression, or statement, of the artist's "emotions, impressions, and thoughts." With respect to the Idea of Truth, phenomenological "truth" is simply Ruskin's act of Being-with the contrast between the perceptual aspect of the landscape painting and its significance—between "earth" and "world." Specifically, Ruskin apprehends "statements *both* of the [visual] qualities of material things, and of [the painter's] emotions, impressions, and thoughts [italics mine]."[61]

According to Heidegger's aesthetic theory, such a contrast between "earth" and "world," between the perceptual work and its meaning, is the "conflict" of the work of art:

> But as a world opens itself the earth comes to rise up. It stands forth as that which bears all, as that which is sheltered in its own law and always wrapped up in itself. World demands its decisiveness and its measure and lets beings attain to the Open of their paths. Earth, bearing and jutting, strives to keep itself closed and to entrust everything to its law.[62]

S.L. Bartky, in "Heidegger's Philosophy of Art," explains the "conflict" of the art work accurately:

> The relationship between world and earth is not dialectical, it should be noted, in that neither element arises out of the other nor are the two drawn into some higher synthesis. Each element can be seen for what it is precisely in its commerce with the other. In its attempt to assert itself each element must use the other as instrument; in order to be at all each element is intimately set against an other which embodies a principle to which it is diametrically opposed. This is the meaning of "strife." Thus the world, the principle of disclosure, can only *be* insofar as it is borne by the medium, the self-concealing earth; but the whole notion of a self-concealing element, in turn, would make no sense were there no "world," no disclosure, within which a concealment might take place and be recognized as such.[63]

In other words, the "strife," or "conflict," of the work means that when Heidegger understands its meanings (its "world"), then he knows that it requires a referent, the visual appearance of the art work (its "earth"). Conversely, when he sees the appearances of the work, he knows that they require an expression—a meaning (a "world"). The "conflict" is thus

Heidegger's Being-with artistic form needing an expression in meaning and (conversely) a meaning needing a referent in form. With respect to the Idea of Truth, the "earth" of the landscape painting, "the faithful statement, either to the mind or senses, of any fact of nature," establishes a perceptual contrast, or "conflict," with the meaning, the "world," of the work—its expressive statement of the artist's feelings and thoughts. Ruskin's perception of representation remains merely visual until he becomes aware of a contrast in meaning—"statements . . . of [the artist's] emotions, impressions, and thoughts"—because "there is . . . a truth . . . of thought as well as of matter . . . " (III, 104).

Finally, according to Martin Heidegger's theory of art, the "conflict," when unified, becomes the "rift" of the work of art:

> The conflict is not a rift *(Riss)* as a mere cleft is ripped open; rather, it is the intimacy with which the opponents belong to each other. This rift carries the opponents into the source of their unity by virtue of their common ground. It is a basic design, an outline sketch, that draws that basic features of the rise of the lighting of beings. This rift does not let the opponents break apart; it brings the opposition of measure and boundary into their common outline.[64]

Lambert van de Water's "The Work of Art, Man, and Being: A Heideggerian Theme" explains the "rift" of the art work. He refers to the "rift" as a repose:

> The opening up of a "world" and the bringing to the fore of "the earth" are dependent on each other in the unity of the work of art. Their solidarity constitutes the autonomy and the essential stability or repose of the work of art. But these two fundamental traits are an event, a movement, something which seems to be opposed to repose. This is the case if we conceive this repose as excluding all movement. But repose may also be understood as the equilibrium of opposed movements, as a relation of tensions. The proper nature of the essential repose of the work of art may be understood from the proper nature of the double event in this work: "world" and "earth."[65]

The "rift" of the work of art is the repose or unity of its "earth" and "world"— the complementary relations between visual form and meaning, an equilibrium of opposites. These opposing factors mutually complement one another and are essentially necessary for each other.[66] Thus, the "rift" of the art work is Heidegger's consciousness of, or Being-with, the complementary unity of visual form and understood meaning. Each requires the other for completeness. The Idea of Truth, for example, includes a "rift" as Ruskin's awareness of the complementary unity of representation and expression in the landscape painting. He sees visual representations of nature in the landscape work. And he knows that these visual aspects are unified with their expressed significance, the complement of the artist's feelings and thoughts—because both representation and expression are *"statements"* of the landscape work,

specifically because "truth has reference to *statements both* of the qualities of material things, and of emotions, impressions, and thoughts [italics mine]" (III, 104).

In the ways outlined, then, Martin Heidegger's fourfold concept of "truth"—including an "earth," a "world," their "conflict," and their "rift"— can afford an interpretation of Ruskin's Idea of Truth.

Heidegger's theory of the work of art includes not only an aesthetic of its "truth" but also a concept of its "beauty." Unlike certain aesthetic theories already reviewed, this theory of "beauty" is an explicit aesthetic of the art work. On one hand, according to the aesthetic of Plotinus (for instance) the actual forms of art, which imitate the natural world, manifest its Ideal Forms, or archetypes. The connection of actual form with Ideal Form is beauty. This aesthetic implies an aesthetic of the art work itself with respect to beauty. On the other hand, "The Origin of the Work of Art" explicitly presents a theory about the work of art with respect to "beauty." And this theory takes its starting point from "truth," the essential nature of the work of art. According to Heidegger, the "truth" of the art work is its essential nature. "Beauty" is simply the manifestation of the essential nature of the work through its visual form:

> Truth is the unconcealedness of that which is as something that is. Truth is the truth of Being. Beauty does not occur alongside and apart from this truth. When truth sets itself into the work, it appears. Appearance—as this being of truth in the work and as work—is beauty. Thus the beautiful belongs to the advent of truth, truth's taking of its place. It does not exist merely relative to pleasure and purely as its object. The beautiful does lie in form, but only because the *forma* once took its light from Being as the isness of what is.[67]

In general, the manifestation of the "truth," or "Being," of the art work through its form is "beauty." In particular, when consciousness is directed toward the forms of the work of art and toward an expression of these forms, toward the "Being," or essential nature of the work, then consciousness is aware of "beauty." When Heidegger sees the forms of a painting, for instance, then he becomes aware of its essential nature. This apprehension, both visual and cognitive, is "beauty." In other words, "beauty" is Heidegger's Being-with the manifestation of the essence of the painting through its form, "because the *forma* once took its light from Being as the isness of what is."

In *Modern Painters II,* the theory of Beauty is central to Ruskin's religious aesthetic of the art work. In general, Typical Beauty involves the expression of the painter's religious belief in divine characteristics of nature, animals, and man. And Vital Beauty, through similar appearances in art, expresses the artist's happiness and his exuberant sense of life. Beauty, Ruskin says, has two fundamental aspects:

First, that external quality of bodies already so often spoken of, and which, whether it occur in a stone, flower, beast or in man, is absolutely identical, which . . . may shown to be in some sort typical of the Divine attributes, and which therefore I shall . . . call Typical Beauty: and, secondarily, the appearance of felicitous fulfilment of function in living things, more especially of the joyful and right exertion of perfect life in man; and this kind of beauty I shall call Vital Beauty. (IV, 64)

George P. Landow, we have seen, in *The Aesthetic and Critical Theories of John Ruskin,* implicitly interprets Typical and Vital Beauty as objective, because the symbolization, by the work, not of the painter's but instead of *Ruskin's* belief and of his happiness, is religious, in the traditional sense, and therefore is universal. Although acceptable, Landow's interpretation relies on religion, an extrinsic element of Ruskin's theory of beauty, in order to demonstrate consistency in this theory. When interpreted with repect to its intrinsic aspects, however, Ruskin's theory of Typical and Vital Beauty inconsistently combines subjective and objective factors. Portrayed in the work of art, the objective appearances of stones, flowers, beasts, or man symbolize the *artist's* subjective religious belief in "the Divine attributes" of natural creation. And the objective forms of "living things" and of man express the artist's subjective emotions—his happiness and his joyful vitality.

The inconsistency in the aesthetic of Typical Beauty can be resolved with Husserl's descriptive phenomenology of intentional consciousness. With regard to Typical Beauty, Ruskin's consciousness is directed toward the art work not as an objective fact but as an objective corrrelate for sight, because he sees forms of nature, animals, or man. Again, their symbolization of the painter's belief in "the Divine attributes" is not subjective but intentional. The artist's religious belief is the correlate for Ruskin's experience *of* the art work. When he looks at the appearances of nature and of man in art, then he understands their symbolization of the painter's religious belief in "Divine attributes." Heidegger's hermeneutic theory of "beauty" affords an interpretation of this phenomenological description of Typical Beauty in art. With regard to Typical Beauty, phenomenological "beauty" is Ruskin's consciousness of, or his Being-with, the visual forms of the painting insofar as they express its divine "Being," and its divine essence, embodied in the work by the artist himself. Apprehending Typical Beauty, Ruskin initially sees "that external quality" present "in a stone, flower, beast, or . . . man." He then knows that these forms of the painting symbolize the artist's religious belief concerning the existence of divine characteristics in nature or in man. Ruskin recognizes these "Divine attributes," embodied in the painting and manifested by its forms, to be aspects of the divine "Being," the essence, of the work.

In a manner similar to that outlined for Typical Beauty, Heidegger's aesthetic theory can resolve the inconsistency between subject and object in Ruskin's theory of Vital Beauty and can also implement an interpretation of this theory.

Having as its first fundamental aspect a theory of the work of art as such, Martin Heidegger's aesthetic in "The Origin of the Work of Art" has as its second basic aspect a theory of the "creation" of the art work. And he derives his theory of "creation" from his theory of "truth." As we have seen, "truth" in art is the contrast between the visual aspects of the work and their meanings—between, respectively, "earth" and "world." When creating the art work, the artist establishes its "earth," its "world," and their "conflict." "Creation" thus establishes the "truth" of the art work:

> The establishing of truth in the work is the bringing forth of a being such as never was before and will never come to be again. The bringing forth places this being in the Open in such a way that what is to be brought forth first clears the openness of the Open into which it comes forth. Where this bringing forth expressly brings the openness of beings, or truth, that which is brought forth is a work. Creation is such a bringing forth. As such a bringing, it is rather a receiving and an incorporating of a relation to unconcealedness. What, accordingly, does the createdness consist in? It may be elucidated by two essential determinations.
>
> Truth establishes itself in the work. Truth is present only as the conflict between lighting and concealing in the opposition of world and earth. Truth wills to be established in the work as this conflict of world and earth.[68]

When Coleridge speaks of the capacity of imagination to reconcile opposites into a new unity in the poem or the art work, he implies a theory of the artist as creator of the work. Heidegger sets forth a theory of the artist explicitly, because, when the creative artist brings "truth" into the "open," then "that which is brought forth is a work." Fundamentally, Heidegger's aesthetic concerning the "creation" of art explains the activities that the artist's consciousness is directed toward when he creates the work. In general, "creation" is the artist's Being-with the art work by establishing its "truth—comprising an "earth," a "world," and the "conflict" (or contrast) between them. Creating the "earth" of the art work, the artist is visually aware of establishing its form and appearance. Thus, he establishes their "concealment," because he knows that the visual qualities of the work are not, *in* themselves, meanings. But he also establishes this formal appearance as the expression of meaning—whether emotion or thought. And, belonging to the work of art, this meaning is its "world," which is evident or present in "unconcealment" for his consciousness. Since the perceptual "earth" thus contrasts with the emotive or conceptual "world," then the artist knows that he establishes the "conflict" of "truth" in the work of art itself.[69] And since the formal manifestation of "truth," the essence of the work, is "beauty"—then the artist's consciousness of embodying the essential nature of the art work in its form is his "creation" of "beauty."

Representative of the second intrinsic aspect of his early aesthetic, Ruskin's theory of the landscape painter in *Modern Painters I* corresponds to

Heidegger's aesthetic concerning the "creation" of "truth" in art. Since the Idea of Truth includes both "the faithful statement . . . of any fact of nature" and also "statements . . . of [the painter's] emotions, impressions, and thoughts" (III, 104) and since the landscape artist should attempt both accurate representation of nature and also expression of his emotions and thoughts about it (III, 133) therefore the aim of the painter is to establish an Idea of Truth in the landscape painting. When understood according to the perspective of the subject-object distinction, this theory of the landscape painter is contradictory, because his representation of nature is objective but his embodiment of emotions and thoughts about nature is subjective. This contradiction is implicit in Ruskin's theory of the painter's two goals: "The first, to induce in the spectator's mind the faithful conception of any natural objects whatsoever; the second, . . . to inform him of the thoughts and feelings with which these were regarded by the artist himself" (III, 133).

When described with Husserl's concept of intentionality, however, this theory is logically consistent. When creating the landscape painting, the painter is simply aware of representing nature accurately and of expressing his emotions and thoughts about it. Heidegger's aesthetic of "creation" can implement interpretation of this way of being-aware-of art creatively. The "creation" of the "earth" of the landscape painting is the painter's awareness of accurately representing nature in order to "induce in the spectator's mind the faithful conception of any natural objects whatsoever." Creating the "world" of the painting, the painter embodies its meaning in order to inform the spectator "of the thoughts and feelings with which these were regarded by the artist himself." Consequently, the "creation" of the basic "conflict" in "truth" between "earth" and "world" is the lanscape painter's Being-with the landscape work by thus establishing a contrast between its perceptual aspect and its meaningful one, between the two aspects of the Idea of Truth—as "the faithful statement . . . of any fact of nature" and as the expression of his "emotions, impressions, and thoughts" (III, 104).

In general, just as Ruskin's theory concerning the goals of the landscape painter includes the spectator of the landscape painting, similarly Heidegger's aesthetic of "creation" leads into his theory of the "preservation" of art, the appreciation of it by the observer. The observer simply apprehends what the artist has created—the "truth" or the "beauty" of the art work. In order to do so, the observer must suspend his usual ways of experiencing art:

> To submit to this displacement means: to transform our accustomed ties to world and to earth and henceforth to restrain all usual doing and prizing, knowing and looking, in order to stay within the truth that is happening in the work. Only the restraint of this staying lets what is created be the work that it is. This letting the work be a work we call the preserving of the work. It is only for such preserving that the work yields itself in its createdness as actual, i.e., now: present in the manner of the work.[70]

The observer must suspend or withhold his usual or habitual ways of "knowing and looking, in order to stay within the truth that is happening in the work" and in order to direct his attention toward the work of art *as* itself. According to Heidegger, "this letting the work be a work we call the preserving of the work."

Fundamentally, the "preservation" of the work is simply the observer's Being-with what the artist has established in the work through "creation." First, "creation" establishes the "truth" of art—its contrast between an "earth" and a "world." Through "preservation," the observer simply becomes aware of the "truth" of the art work. He sees an "earth" as the forms and appearances of the work of art. He understands the emotions and thoughts that are the meaning of these forms and that constitue their "world." And thereby he apprehends "truth"—the contrast between his perceptions of art and their significance.[71] Second, since "truth" is the essential nature of the art work, since "beauty" is the manifestation of the essential nature of the work through its form, and since the "creation" of art establishes its "beauty" as well as its "truth," therefore "preservation" is also the observer's Being-with the "beauty" of the work of art. He sees the form of the work and thereby knows that this form manifests the essential nature of the work, its "Being."

Thus, Heidegger's theory of "preservation" makes explicit what Edmund Burke's aesthetic (for example) implies—a theory concerning appreciation of art. Burke implies such a theory by explaining that the visual aspects of art evoke emotions of beauty. Heidegger explicitly presents a theory of appreciation that concerns the "preservation" of art as the observer's apprehension of the "truth" or the "beauty" of works of art.

A representative instance of the third intrinsic element of his aesthetic in *Modern Painters I* and *II*, Ruskin's religious aesthetic of the Theoretic Faculty in volume two is remarkably similar to Heidegger's aesthetic concerning the "preservation" of "beauty." The aesthetic of the Theoretic Faculty involves the suspension of Aesthesis (mere sensory perception of art) in order to apprehend its Beauty:

> Now the mere animal consciousness of the pleasantness [of sense perceptions] I call Aesthesis; but the exulting, reverent, and grateful perception of it I call Theoria. For this, and this only, is the full comprehension and contemplation of the Beautiful as a gift of God (IV, 47)

The observer's Theoretic Faculty performs two basic functions. It perceives the external forms of art visually, and it apprehends their expression of divine Beauty. The first function is objective; but the second is subjective, because the observer (in effect) projects his own religious belief about Beauty into the painting. But understood in the perspective of Husserl's theory of intentionality, the aesthetic of the Theoretic Faculty is consistent. The Theoretic Faculty

is Ruskin's intentional consciousness. It is directed toward an intentional object, the art work. He perceives its appearances and apprehends their expression of the *artist's* religious belief in divine Beauty. Heidegger interprets such an intentional manner of observing art. In part, Heidegger's theory of "preservation" concerns the observer's withholding ordinary apprehensions of art in order to grasp its "beauty"—the manifestation of its essence through its form. "Preservation" is, then, Ruskin's Being-with the "beauty" of painting by willing first to suspend Aesthesis (i.e. habitual, merely sensory perception of the work) and then to apprehend its visual forms as expressions of the divine "Being" of the work. On one hand, Ruskin suspends "mere animal consciousness of the pleasantness" of visual art. On the other, Theoria is "the exulting, reverent, and grateful perception of it." Through these theoretic apprehensions, Ruskin knows that the forms of the work express the artist's belief in the divinity of nature. And since this apprehension "is the full comprehension and contemplation of the Beautiful as a gift of God . . . ," then Ruskin is also aware that these natural forms portrayed in art manifest its essential nature, its divine "Being."

Heidegger's aesthetic of the "preservation" of "truth" and of "beauty" rejects usual ways of apprehending art and adopts unusual ones, because "truth," the essential nature of the work, is unusual and because "beauty," the formal manifestation of this essence, is also unusual. Since "truth" and "beauty" can be created in art and since the work of art itself can be both beautiful and true, therefore the "creation" of art and the work itself as well as "preservation" of it should not be commonplace but unusual. This distinction implies the one that Heidegger makes in *Being and Time* between inauthenticity and authenticity. According to Heidegger, the *other* person (i.e. any person) chooses inauthentic possibilities of existence; hence, these belong only indirectly to *Dasein* (i.e. Heidegger). But possibilities that are chosen by *Dasein*— that are his own, belonging directly to him—are authentic.[72] In *A Commentary on Heidegger's "Being and Time"* (1970), Michael Gelven explains this concept:

> Authenticity, then, never implies hermit-like loneliness or stoic detachment from world events. It does suggest a clear awareness of the self as a self, and a realization that one alone is responsible for the way one exists, and it avoids the slavery of the they-self.[73]

In other words, when any person can be conscious of possible modes of existence, then these must be usual, or inauthentic. When only *Dasein* (i.e. Heidegger) can be aware of possibilities of existence, then these must be unusual, or authentic.

These concepts of unauthenticity and of authenticity are implicit in the aesthetic of "The Origin of the Work of Art." With regard to appreciation of art, for instance, in order for the "preservation" of the art work to occur, we

must alter "our accustomed ties to world and earth" and suspend "all usual doing and prizing, knowing and looking, in order to stay within the truth that is happening in the work."[74] In different words, in order to apprehend the "truth" of an art work, the observer must suspend his usual, or inauthentic, ways of looking at and knowing about art. Thus, according to Heidegger, withholding the inauthentic or usual modes of appreciation permits authentic "preservation" of the "truth" of the work, its essential nature. And since the manifestation of the essential nature of the work through its form is "beauty," then suspension of these inauthentic modes also permits the observer's consciousness of authentic "beauty" in the art work.

With regard to the apprehension of Beauty in art, Ruskin's aesthetic of the Theoretic Faculty implies a similar restriction: "The mere animal consciousness of the pleasantness [of art's visual form] I call Aesthesis; but the exulting, reverent, and grateful perception of it I call Theoria. For this ... is the full comprehension and contemplation of the Beautiful as a gift of God ..." (IV, 47). Ruskin here withholds a merely usual way of directing his consciousness toward art, a way possible for anyone. He withholds any person's Being-with art inauthentically, merely according to Aesthesis, according to "the mere animal consciousness of the pleasantness" of visual perceptions of the painting. This restriction permits apprehension of phenomenological "beauty." Since Ruskin has suspended Aesthetics, then his "exulting, reverent, and grateful" apprehension of the painting becomes his authentic Being-with an unusual manifestation of divine "beauty" through its perceived natural forms. Ruskin's "exulting, reverent, and grateful perception of" these forms in art belongs only to him, because this combination of joy, reverence, and gratitude with visual perception is unusual. And since the manifestation of God's "Being" through the visual forms of the work is unusual, then only Ruskin can apprehend this expression of "beauty," "the Beautiful as a gift of God" (IV, 47). Thus, the concept of "preservation" shows the manner in which the aesthetic of the Theoretic Faculty rejects an inauthentic and adopts an authentic mode of apprehending divine "beauty" in art.

In general, Heidegger's concepts of inauthenticity and authenticity apply not only to the "preservation" of art but also to the "creation" of "truth" and "beauty" in art as well as to the "truth" and the "beauty" of the work of art itself.

These concepts of authenticity and inauthenticity constitute one important implicit element of the aesthetic in Heidegger's "The Origin of the Work of Art." The second major implicit element of this theory of art concerns temporality. Temporality is implicit primarily in Heidegger's concept of "world." Since "truth" in the art work includes its meaning, since the artist's "creation" of the work establishes its meaning, and since the observer's

"preservation" of the work apprehends its meaning—then all three aesthetics, in different ways, include the "world" of the art work. "World" is aesthetic meaning, whether present in the art work as such, created for it, or preserved through it. And this "world" is temporal, or historical:

> Whenever art happens—that is, whenever there is a beginning—a thrust enters history, history either begins or starts over again. History means here not a sequence in time of events of whatever sort, however important. History is the transporting of a people into its appointed task as entrance into that people's endowment. [75]

The "transporting of a people into its appointed task as entrance into that people's endowment" is the temporal meaning of art, its historical significance for consciousness, *Dasein.* In "The Being of the Work of Art in Heidegger," George Stack maintains that "just as *Dasein* is universally conditioned by the modi of temporality so, too, is the art work a temporal happening, an 'event' which establishes a world and which reveals 'the essential decisions of a historical people.' "[76] Furthermore, the temporality of *Dasein* can specify that of the "world" in the work. In *Being and Time,* Heidegger summarizes the temporality of *Dasein:*

> Understanding is grounded primarily in the future (whether in anticipation or in awaiting). States-of-mind temporalize themselves primarily in having been (whether in repetition or in having forgotten). Falling has its temporal roots primarily in the Present (whether in making-present or in moment of vision). . . . *in every exstacis, temporality temporalizes itself as a whole; and this means that in the ecstatical unity with which temporality has fully temporalized itself currently, is grounded the totality of the structural whole of existence, facticity, and falling—that is, the unity of the care-structure.* [77]

In "falling," consciousness is directed toward present possibilities of existence. In "state-of-mind," the self is aware of past possibilities of existence. And "understanding" is the self's Being-with future possiblities of existence. Although each mode of *Dasein* emphasizes one particular time, yet each also includes the other two temporal possibilities. For instance, "understanding," the most important temporal mode, is an awareness primarily of future and secondarily of present or past possibilities of existence.

In general, there are six modes of "understanding," two for each time zone. "Forgetting" is *Dasein's* projection (or awareness) of any person's inauthentic past possibilities of existence; but "repitition"is *Dasein's* consciousness of his own authentic possibilities that existed in the past. "Making-present" is the self's apprehension of inauthentic present possibilities— activities, actions, and situations that are merely usual—but "moment of vision" is *Dasein's* awareness of his free action using the present moment and the present situation specifically, in an unusual, an authentic, manner. The primary temporal ecstacis of "understanding" is the future. Since it is *Dasein's*

projection toward, or consciousness of, future possibilities concerning ordinary events and usual circumstances, "waiting" is inauthentic. On the other hand, "anticipation" is authentic, because the self is capable of and aware of his own possible "ways to be" in the future.[78]

Since the "world" of the art work is its meaning apprehended intentionally by the human being *(Dasein)*, since this "world" is temporal, and since *Dasein* can apprehend temporal possibilities, therefore the "world" of the art work can be interpreted according to *Dasein's* temporal modes of "understanding." For example, the "world" of the work of art can be the self's Being-with its meaning concerning future possibilities of existence. As "waiting," the inauthentic meaning of the art work can be any person's apprehension of ordinary events and situations possible in the future. Or, as "anticipation," the authentic "world" of the art work can be the human being's *own* awareness of unusual possibilities of existence in the future.

Ruskin's art criticism of Tintoretto's *The Last Judgment*, in *Modern Painters II*, has an interesting example of future possibilities of existence for human souls after the final judgment:

> . . . the Firmament is all full of them, a very dust of human souls, that drifts, and floats, and falls . . . ; the bright clouds are darkened with them as with thick snow . . . , now soaring up slowly, and higher and higher still, . . . borne up, wingless, by their inward faith and by the angel powers invisible, now hurled in countless drifts of horror before the breadth of their condemnation. (IV, 277)

Ruskin interprets *The Last Judgment* as an expression of Tintoretto's Penetrative Imagination, capable of apprehending the essences of things and of beings (IV, 278). Tintoretto, Ruskin implies, imagined the inner states of souls experiencing salvation or facing damnation. However, this imagination of the states of souls is subjective and therefore cannot be embodied in the visible art work itself, because it is objective. That is, the painting itself is an objective representation of souls "borne up, wingless, by their inward faith and by the angel powers invisible" or of other souls "now hurled in countless drifts of horror before the breadth of their condemnation."

But, imagined by Tintoretto and incorporated into *The Last Judgment,* the inner states of these souls can be described as the intentional objects, the thoughts and the feelings, that Ruskin is aware of when he sees souls "borne up . . . by their inward faith . . . , now hurled in countless drifts of horror before the breadth of their condemnation." Described thus with Husserl's intentional distinctions, these visual appearances of *The Last Judgment,* when interpreted with Heidegger's aesthetic, become the "earth" of the art work. And this "earth" expresses a "world"—a meaning concerning the inner states of souls, states attributed to them by the artist's Penetrative Imagination. This meaning is an "anticipation" of future possibilities of existence. And this

"anticipation" is Ruskin's Being-with the feelings and thoughts of human souls subjected to the final judgment. Seeing the saved, "borne up, wingless, by their inward faith," Ruskin knows that they hope for infinite joy and complete goodness in the future. But seeing the damned, "now hurled in countless drifts of horror before the breadth of their condemnation," Ruskin knows that these souls expect only infinite suffering from their evil—forever.

Conclusions

In conclusion, a phenomenological approach can both resolve the subject-object inconsistency in Ruskin's aesthetic in *Modern Painters I* and *II* and also can interpret its intrinsic aspects—its theory of painting, the artist who creates it, and the spectator who appreciates it. Derived from Husserl's *Logical Investigations,* the first step for understanding Ruskin's aesthetic in these two works is eliminating its inconsistency between subject and object by describing the intentional aesthetic objects that his consciousness is directed toward. The second method, derived from Heidegger's "The Origin of the Work of Art," can afford interpretation of these descriptions of Ruskin's aesthetic. Heidegger's aesthetic of the"truth" and of the "beauty" of the work of art can implement interpretation of Ruskin's theory of the art work. Heidegger's theory of "creation" can afford interpretation of Ruskin's aesthetic of the painter. And Heidegger's aesthetic of "preservation" is appropriate for explanation of Ruskin's theory of the spectator of painting.

Throughout interpretation of the aesthetic of *Modern Painters I* and *II,* I will refer to the elements of phenomenology here outlined—Edmund Husserl's descriptive theory of intentionality and Martin Heidegger's hermeneutic theory of the art work, its "creation," and its "preservation." Throughout, I will mention further details from "The Origin of the Work of Art" in order to supplement these three fundamental aspects of Heidegger's aesthetic theory. And throughout, I will relate aspects of Ruskin's early theory to aspects of traditional aesthetics when such a connection will contribute to an understanding of Ruskin's thought or lead into phenomenological interpretation of it.[79]

John Ruskin initially founds his theory of landscape painting in *Modern Painters I* on the aesthetic Idea. Among several different Ideas, the Idea of Truth is fundamental to the painting itself. The landscape painter creates the Idea of Truth in the work. And the spectator apprehends this Idea in it. Then Ruskin specifies different ways in which the painter should accurately represent nature. And finally Ruskin shows how the landscape art of J.M.W. Turner exemplifies the Idea of Truth, both as accurate representation of nature and also as expression of his feelings and his thoughts.

The Aesthetic Theory of *Modern Painters I*

In the first volume of *Modern Painters,* Ruskin's aesthetic theory concerns what he refers to as "Ideas" of landscape painting:

> I think that all the sources of pleasure, or of any other good, to be derived from works of art, may be referred to five distinct heads.
> I. Ideas of Power.—The perception or conception of the mental or bodily powers by which the work has been produced.
> II. Ideas of Imitation.—The perception that the thing produced resembles something else.
> III. Ideas of Truth.—The perception of faithfulness in a statement of facts by the thing produced.
> IV. Ideas of Beauty.—The perception of beauty, either in the thing produced, or in what it suggests or resembles.
> V. Ideas of Relation.—The perception of intellectual relations in the thing produced, or in what it suggests or resembles. (III, 93)

Each of these aesthetic Ideas concerns particular aspects of Ruskin's apprehension of landscape art. The Idea of Truth, for instance, concerns his "perception of faithfulness in a statement of facts by the thing produced." Or, the Idea of Relation concerns his "perception of intellectual relations in the thing produced, or in what it suggests or resembles." The Idea itself, then, regardless of its particular subject in the landscape painting, concerns both visual apprehension of its form and mental apprehension of its significance.

Ruskin introduces his aesthetic of the landscape Idea with analogies between the botanist and the painter and between the versifier and the painter.

The Idea in Landscape Painting

By means of an analogy between the landscape painter and the botanist, Ruskin implies an aesthetic concerning form and meaning in the landscape painting itself:

> This is the difference between the mere botanist's knowledge of plants, and the great poet's
> or painter's knowledge of them. The one notes their distinctions for the sake of swelling his
> herbarium, the other, that he may render them vehicles of expression and emotion. (III, 36)

For the painter, representation of nature is the means whereby he expresses his feelings and thoughts about it. Here, Ruskin implies that the landscape painting itself, as a representation of nature, is the medium—the vehicle—which expresses the artist's experience.

When understood in the perspective of subject and object, however, this concept of landscape painting is inconsistent, because the painter's subjective emotions and thoughts cannot be embodied in or expressed by objective representation itself. But when interpreted phenomenologically, this theory is consistent. Interpreted according to Edumund Husserl's perspective of intentionality, this aesthetic describes how Ruskin is aware of the landscape work. Husserl, in his *Logical Investigations,* shows that intentional objects are neither subjective nor objective, but instead are phenomenal; they are whatever consciousness is directed toward. Since human consciousness can be aware of emotions and thoughts as well as visual objects, then all these phenomena are intentional. A representation of the natural world, the landscape painting is, in this phenomenological perspective, a visual object of Ruskin's consciousness. The intentional correlates for his mental experience of the painting are the artist's feelings and thoughts. As an intentional object of visual perception, the landscape painting itself can embody these feelings and thoughts, because they are intentional objects of Ruskin's mind. In this sense, he is conscious of the representational work as a vehicle "of [the painter's] expression and emotion."

Ruskin implicitly expands this concept of the landscape painting by developing another analogy, now between the versifier and the painter:

> Painting, or art generally, as such, with all its technicalities, difficulties, and particular
> ends, is nothing but a noble and expressive language, invaluable as the vehicle of thought,
> but by itself nothing. He who has learned what is commonly considered the whole art of
> painting, that is, the art of representing any natural object faithfully, has as yet only learned
> the language by which his thoughts are to be expressed. . . .
> Speaking with strict propriety, therefore, we should call a man a great painter only as he
> excelled in precision and force in the language of lines, and a great versifier, as he excelled in
> precision and force in the language of words. A great poet would then be a term strictly, and
> in precisely the same sense, applicable to both, if warranted by the character of the images
> or thoughts which each in their respective languages conveyed. (III, 87-88)

This analogy comparing the "great painter" and the "great versifier" with each other and identifying both with the "great poet" implies that landscape painting and verse are both instances of poetry—understood in a general sense as the expression of meaning by a formal medium, which Ruskin calls

"language." This concept is his version of the eighteenth century aesthetic of *ut pictura poesis*. According to this theory, poetry, in resembling painting, has its primary aim in presenting thoughts or concepts through visual appearances of things.[1] That is, verse describes nature, painting represents it, and both thereby express thought. For Ruskin also, the language of versification and that of painting depict visual phenomena, (respectively) either descriptively or representationally. And each language thereby expresses "the images or thoughts" of the artist, whether versifier or painter.

Martin Heidegger's "The Origin of the Work of Art" sets forth a similar analogy between verse and painting. "Poetry," he says, comprises architecture, verse, music, sculpture, and painting. He continues:

> Projective saying is poetry: the saying of world and earth, the saying of the arena of their conflict and thus of the place of all nearness and remoteness of the gods. Poetry is the saying of the unconcealedness of what is. Actual language at any given moment is the happening of this saying . . . [2]

This concept of "poetry," comprising both verse and painting, means that consciousness is directed toward either art form in certain ways. "Poetry" is Heidegger's Being-with the "saying"—the "speech," or "language"—belonging to either mode of art. In verse, the "language" of words can describe visual perception of natural objects (for example). In painting, the "language" of form can represent visual appearances. "Language" constitutes the "earth" (or form) of the art work. Each mode of "language," of "speech," also expresses meaning, thought and emotion—constituting the "world" of the poem or of the painting. When Heidegger reads the verse or sees the painting, he thus apprehends the emotions and the thoughts constituting the meaning of the work. In these senses, then, "poetry," comprising verse and painting, is the "saying of world and earth."

Ruskin, we have seen, implies that poetry in general comprises both verse and landscape painting, because both employ language, either as words or as representational form, in order to express the thought of the artist, whether versifier or painter. Phenomenologically, "poetry" is Ruskin's consciousness of, his Being-with, the "language" of verse or landscape painting. When he becomes aware of "precision and force in the language of words" and when he sees "precision and force in the language of lines," then he apprehends forms of nature, either described by the poet or represented by the painter. These forms constitute the "earth" of the verse or of the painting. And this "earth" expresses a meaning, a "world." Apprehending the "world" either of a poem or of a painting, Ruskin understands the meanings expressed by (respectively) "the language of words" or "the language of lines." These meanings are the versifier's or the painter's "images or thoughts" about nature. Finally, Ruskin's apprehensions of the appearances of nature and their expression of

thought is phenomenological "poetry," because "a great poet would then be a term strictly, and in precisely the same sense, applicable to both [i.e. the versifier and the painter], if warranted by the character of the images or thoughts which each in their respective languages conveyed."

Ruskin applies the concept of landscape painting as a formal language to practical criticism of Sir Edwin Landseer's *The Old Shepherd's Chief-Mourner:*

> Take, for instance, one of the most perfect poems or pictures (I use the words as synonymous) which modern times have seen—the "Old Shepherd's Chief-Mourner." Here the exquisite execution of the glosssy and crisp hair of the dog, the bright sharp touching of the green bough beside it, the clear painting of the wood of the coffin and the folds of the blanket, are language—language clear and expressive in the highest degree. But the close pressure of the dog's breast against the wood, the convulsive clinging of the paws, which has dragged the blanket off the trestle, the total powerlessness of the head laid, close and motionless, upon its folds, the fixed and tearful fall of the eye in its utter hopelessness, the rigidity of repose which marks that there has been no motion nor change in the trance of agony since the last blow was struck on the coffin-lid, the quietness and gloom of the chamber, the spectacles marking the place where the Bible was last closed, indicating how lonely has been the life, how unwatched the departure, of him who is now laid solitary in his sleep—these are all thoughts—thoughts by which the picture . . . ranks as a work of high art, and stamps its author, not as the neat imitator of the texture of a skin, or the fold of a drapery, but as the Man of Mind. (III, 88-89)

This description shows that the painting *The Old Shepherd's Chief-Mourner* is representational language, because the forms of the dog, of the coffin, and so on "are language . . . clear and expressive in the highest degree." And the meanings expressed by this language are "thoughts—thoughts by which the picture . . . ranks as a work of high art "

Phenomenologically, this painting—a poem—includes an "earth" as representational form and a "world" as its meaning. The "earth" is Ruskin's Being-with the painting according to perception of "speech," or (formal) "language"—"the exquisite execution" of the dog's hair, "the bright, sharp touching of the green bough," and "the clear painting" of the coffin and blanket. And the visual appearances of the dog, the coffin, and the chamber have meaning for Ruskin's consciousness. His apprehension of this meaning is his Being-with the thoughts expressed by the formal "language" of the painting. For instance, he knows about the agonized suffering of the dog, because he sees "the convulsive clinging of the paws," "the total powerlessness of the head laid" down, and "the rigidity of repose which marks that there has been no motion nor change in the trance of agony since the last blow was struck on the coffin-lid." Or, when Ruskin sees "the spectacles marking the place where the Bible was last closed," he then knows that this formal "language," or "speech," expresses the loneliness experienced by the shepherd. Particularly, seeing the spectacles, Ruskin knows that they indicate "how

lonely has been the life, how unwatched the departure, of him who is now laid solitary in his sleep. . . . " As the emotive meaning of the painting, the sorrow of the shepherd's dog and the loneliness of the shepherd's past life constitute the "world" expressed by the forms of the painting. And this "world" concerns Landseer's view of his subject, the death of the shepherd. Ruskin simply directs his awareness toward what Landseer has already embodied in the work, its meanings concerning the suffering of the shepherd's dog and the past loneliness of its master—because "these are all thoughts—thoughts by which the picture ranks as a work of high art, and stamps its author, not as the neat imitator of the texture of a skin, or the fold of a drapery, but as the Man of Mind."

In general, Ruskin's discussion of formal language as the basis for landscape art and his applied criticism of Sir Edwin Landseer's *The Old Shepherd's Chief Mourner* as formal language lead directly to the seminal concept of *Modern Painters I,* the aesthetic Idea. Landscape art is a language in the sense that its forms representing nature express the artist's thoughts about it. Correspondingly, the Idea comprises Ruskin's visual perception of the painting as well as his apprehension of the painter's thought, expressed by its form.

Here, Ruskin views painting from the perspective of the aesthetic Idea. Specifically, the language of landscape art conveys meaning and thereby addresses not only the senses but also the intellect. According to John Locke's definition in *An Essay Concerning Human Understanding* (1690), Ruskin says, the "idea" includes "sensual impressions themselves as far as they are 'things which the mind occupies itself about in thinking;' that is, not as they are felt by the eye only, but as they are received by the mind through the eye" (III, 91-92). According to Locke, Henry Ladd explains, "ideas" are not real external qualities, but instead are perceptions of the mind. Ruskin calls perceptions "ideas," but does not distinguish these according to their external quality or inward reality.[3] Thus, the Idea of landscape art is neither objective nor subjective, but, understood in Husserl's perspective, is intentional. The Idea is the visual form and the concomitant thought toward which Ruskin directs his consciousness. And as perceived form and understood meaning, the Idea is the basis, the source, or origin. In "The Being of the Work of Art in Heidegger," George Stack explains the relationship of form and meaning in the work to its "Being":

> In the unity formed through the opposition between earth and world, between the resistant material out of which the work is made and the intelligible realm which provides the art work with its . . . meanings, there is an unconcealment of the being of the object.[4]

Thus, when Heidegger says that "poetry is the saying of the unconcealedness of what is,"[5] he means that the formal "language" of the art work "unconceals," or manifests, its "Being," its essential nature. The work manifests its "Being" to intentional consciousness by presenting a unity of form and expression, of appearance and meaning of "earth" and "world."

Interpreted phenomenologically, the Idea of landscape painting is Ruskin's awareness of the essential nature of the work, its "Being"—the unity of its appearances ("earth") and their meanings ("world"). When he sees the representational form of the painting, he then becomes aware of the expression belonging to this "language" of lines and colors. His mind apprehends the artist's thought concerning aspects of nature represented in the work. As the unity of visual form and expressed thought, the Idea of landscape art is, then, Ruskin's Being-with the essential nature of the landscape painting, its "Being." And as the essence of the landscape work, the Idea is its source, its origin.

According to Heidegger in "The Origin of the Work of Art," "Being"— the essence of the art work—is its origin and also the origin of its "creation" and of its "preservation." The origin of "creation" is the artist's awareness of establishing the "Being" of the work. And the origin of "preservation" is the observer's apprehension of the "Being" in the work, its essence comprising "earth" as form and "world" as meaning. Ruskin's aesthetic of the landscape Idea has a similar orientation toward the painter and the spectator of the landscape work. Since "he is the greatest artist who has embodied, in the sum of his works, the greatest number of the greatest ideas . . . " (III, 92), the landscape painter, creating the landscape painting, establishes an aesthetic Idea in it. He sees that he establishes its representational form. He knows that he embodies his thoughts about nature into the work. And he thereby becomes aware of establishing an aesthetic Idea in it, its essential nature, or "Being"—the unity of a formal "earth" with a meaningful "world." When preserving the Idea, the essential "Being," of the work, the observer becomes aware of visual form both representing nature and expressing the painter's thoughts about it. Consequently, Ruskin maintains that the greatest painting "conveys to the mind of the spectator the greatest number of the greatest ideas . . ."(III, 92). In general, then, the Idea of landscape art, its "Being" or essence—a unity of representational form and expressed meaning—is the origin not only of the work but also of the painter's "creation" and the observer's "Preservation" of it, because the former establishes the Idea in the work and the latter apprehends this Idea in it.

Thus, the Idea is the starting point for Ruskin's aesthetic in *Modern Painters I;* because the painter establishes the Idea in the work, the Idea is the basis of the painting itself, and the spectator apprehends the Idea in the landscape

painting. Among the different types of Ideas in landscape art, Ideas of Power have the least importance for Ruskin's aesthetic, because they concern skill in representation—a subject which he fully covers under the Truths of Tone, Colour, Space, and Chiaroscuro. And among the remaining important Ideas, he rejects Ideas of Imitation and adopts those of Relation, Beauty, and Truth as valid criteria for the landscape painting.

The Inauthentic and the Authentic in Landscape Art

Ruskin's concept of Imitation contains interesting implications about what the landscape painting should not be:

> Whenever anything looks like what it is not, the resemblance being so great as *nearly* to deceive, we feel a kind of pleasurable surprise, an agreeable excitement of mind, exactly the same in its nature as that which we receive from juggling. Whenever we perceive this in something produced by art, that is to say, whenever the work is seen to resemble something which we know it is not, we receive what I call an idea of imitation. (III, 100)

Referring to Ruskin's view of imitation as deceptive resemblance in landscape painting, Solomon Fishman says that Ruskin objects to imitation as an illusion of painting, as "a mechanical trick."[6] The "mechanical trick" that Ruskin objects to is simply that a landscape work can seem to *be* what it depicts. For instance, the work might portray a flowing stream and surrounding countryside. When the observer looks at the painting, he is nearly deceived. He almost believes that he is looking at an actual scene and not at a representation of nature. Consequently, he is surprised.

Heidegger, in "The Origin of the Work of Art," also objects to art as imitation. When art is imitative, then "untruth," always latent in "truth," predominates over it. He explains the aspects of "untruth" that can eclipse "truth," the essential nature of the work of art:

> Truth occurs precisely as itself in that the concealing denial, as refusal, provides its constant source to all clearing, and yet, as dissembling, it metes out to all clearing the indefeasible severity of error. Concealing denial is intended to denote that opposition in the nature of truth which subsists between clearing, or lighting, and concealing.[7]

"Concealment as refusal" concerns awareness of particular being only as fact. "Concealment is dissembling" when the work visually appears as something other than it actually is.[8] To be aware of the art work in these two ways is Being-with it merely by perceiving it visually and by realizing that it appears to be something other than itself. And, of course, this way of apprehending art is ordinary, or inauthentic—because anyone can merely look at the art work and then mistake it for something else.

Ruskin rejects this kind of commonplace, inauthentic apprehension of the landscape painting, which has a "refusal" of meaning as well as a "dissembling" in form. First, the Idea of Imitation includes a "refusal" of an aesthetic meaning belonging to the work itself. Anyone can be aware of a landscape painting that simply exhibits aspects of nature that, *in themselves,* are devoid of meaning. He visually apprehends the form of the work merely as physical fact. And, second, "whenever anything looks like what it is not, the resemblance being so great as *nearly* to deceive," then "dissembling" occurs. The observer realizes that the visual form, the "earth," of the landscape work almost appears to be something other than it actually is. The work tricks his eye by nearly appearing to *be* a natural scene.

This visual mode of Being-with ordinary, deceptive appearances in the landscape painting causes surprise in the observer. And this habitual response, possible for anyone, constitutes the phenomenological "world" of the imitative painting, its emotive significance for the observer. In particular, in order to perceive an Idea of Imitation, the visual resemblance between the landscape painting and its referent in nature must be so perfect as to amount to a deception. And there must be some means of proving at the same moment that it is a deception. Then, the observer is surprised at this deception (III, 100). As an ordinary emotive significance, the inauthentic "world" of the imitative landscape painting is, then, any person's Being-with the work by responding with surprise to it as a mere copy of nature. He feels "a kind of pleasurable surprise, an agreeable excitement of mind, exactly the same in its nature as that which we receive from juggling." And, of course, apprehending an Idea of Imitation in landscape painting is inauthentic, because the surprise from watching *juggling* has nothing to do with seeing and understanding the landscape work *as* itself. Anyone can associate this kind of irrelevant response with his visual perceptions of an imitative landscape painting.

The Idea of Relation, however, is authentic, because it concerns unusual aspects of the landscape painting that only Ruskin, not anyone, can be aware of.

According to Ruskin, Ideas of Relation are "the noblest subjects of art" and are "the most extensive as the most important source of pleasure" from art. He continues: "By the term 'ideas of relation,' then, I mean in future to express all those sources of pleasure, which involve and require, at the instant of their perception, active exertion of the intellectual powers" (III, 114-15). Conveyed by the landscape painting, Ideas of Relation include "everything productive of expression, sentiment, and character, whether in figures or landscapes" and everything related to the conceived subject and its parts in their relation and congruity—in so far as these parts "give each other expression and meaning" (III, 112).

Ideas of Relation in landscape painting, then, concern its representational appearances for Ruskin's sight and (primarily) their conceptual meanings for his mind. Martin Heidegger calls such distinctions between the visual forms of the art work and their understood meanings (respectively) "earth" and "world," both of which are authentic if unusual. With regard to the Idea of Relation, then, an authentic "earth" is Ruskin's Being-with unusual represented forms of nature in the landscape painting. And an authentic "world" is his Being-with unusual conceptual meanings belonging to these forms. Thus, Ideas of Relation concern what Ruskin sees in and understands about the landscape work.

Ruskin gives several instances of Ideas of Relation, "which are the subjects of distinct intellectual perception and action, and which are therefore worthy of the name of thoughts" (III, 112). In each example, he shows how perception of an unusual artistic form (an authentic "earth") leads to his consciousness of an unusual meaning (an authentic "world"). As unusual, these Ideas of Relation are authentic modes of Ruskin's Being-with the "world," the emotive or cognitive meaning, suggested by the form of the painting, its "earth." Ruskin mentions "the choice, for instance, of a particular lurid or appalling light to illustrate an incident in itself terrible" (III, 112). Here, the "earth" of the painting is "a particular lurid or appalling light," unusual because it stuns the eye. Seeing this light, Ruskin becomes aware of a meaning, a subject for thought, an incident unusual because "in itself terrible." Or, he speaks about the use, in art, "of a particular tone of pure colour to prepare the mind for the expression of refined and delicate feeling" (III, 112). Here, the emotive significance, the "world," of the painting is the emotion that Ruskin apprehends when he sees "a particular," and thus unusual, "tone of pure colour" in the work. He apprehends its expression of the painter's "refined and delicate feeling," which also is unusual because it is cultivated. Finally, Ruskin mentions

> . . . the invention of such incidents and thoughts as can be expressed in words as well as on canvas, and are totally independent of any means of art but such as may serve for the bare suggestion of them. The principal object in the foreground of Turner's "Building of Carthage" is a group of children sailing toy boats. The exquisite choice of this incident, as expressive of the ruling passion which was to be the source of future greatness, in preference to the tumult of busy stonemasons or arming soldiers, is quite as appreciable when it is told as when it is seen,—it has nothing to do with the technicalities of painting; a scratch of the pen would have conveyed the idea and spoken to the intellect as much as the elaborate realizations of colour. (III, 112-13)

Here, Ruskin minimizes the importance of the perceptual aspect of Turner's *Building of Carthage* (its "earth") and emphasizes the importance of the emotion that this visual form expresses—a "world." When Ruskin sees "a group of children sailing toy boats," he implies that this representation is

unusual, and authentic, because Turner has made an "exquisite choice of . . . incident." Seeing these "children sailing . . . boats," Ruskin then knows that this represented scene, an authentic "earth," expresses an emotive meaning, a "world." Specifically, he knows that the scene is "expressive of the ruling passion which was to be the source of future greatness." As a recognition of "the source of future greatness," this passion is unusual and consequently is authentic. And, generally, since all these Ideas of Relation are authentic, then their apprehension is possible not for anyone but only for the writer Ruskin.

Thus, in contrast to Ideas of Imitation, Ideas of Relation are not ordinary, but instead are extra-ordinary, or authentic. In similar ways, the Idea of Beauty and the Idea of Truth are authentic; however, given Ruskin's detailed examples implying authenticity in Ideas of Relation, further demonstration of authenticity in Beauty and in Truth seems unnecessary.

The Idea of Beauty in Landscape Painting

Ruskin's discussion of Beauty in landscape painting constitutes an important part of *Modern Painters I.*

According to the Idea of Beauty, a beautiful natural object or one represented in landscape painting produces pleasure in the observer not from any intellectual reflection but simply and directly through visual contemplation of that object's external aspects. Furthermore, he instinctively receives pleasure from natural objects illustrating the fundamental character of the Deity (III, 109); consequently, these objects—whether present in nature or represented by the landscape painting—are beautiful.

Several criticisms of Ruskin's aesthetic of Beauty in landscape painting raise problems about this theory that lead into phenomenological interpretation of it.

According to Henry Ladd's *The Victorian Morality of Art,* for example, Ruskin's "idea of beauty" means that a beautiful object creates pleasure, manifested morally, in proportion to the degree of beauty itself, which is not manifested intellectually and which does not have a knowing aspect.[9] Furthermore, Ladd says, Ruskin's concept of beauty depends on particular emotions. But God can be beauty and at the same time cause it.[10] Thus, beauty resides in the art object, and God as beauty manifests Himself in it. However, since beauty as a manifestation of God *causes* pleasure but since beauty *depends* on pleasure, then, as Ladd implies, Ruskin's theory is logically circular.

George P. Landow, the most important critic of Ruskin's aesthetic in *Modern Painters I,* demonstrates a similar contradiction in the Idea of Beauty. Referring to this aesthetic, Landow maintains that "one may say of Ruskin's aesthetic theories what he said of the arts—that they are in some sort

an expression of deeply felt emotion, the recasting of intensely felt experience."[11] That is, Ruskin feels pleasure at visual qualities of nature represented in landscape art and then recasts this emotional response into a theory of Ideas of Beauty. Landow then demonstrates the inconsistency in this theory:

> Ruskin believes beauty, then, to be a disinterested pleasure which has an objective reality and which is perceived by the nonintellectual part of the mind. Although Ruskin, in contrast to many English aestheticians of the eighteenth and nineteenth centuries, believes that beauty is an objectively existing thing or quality, he yet speaks of "the emotions of the Beautiful and Sublime" (3.48). Emotion is subjective, and it is difficult to see how it could be thought to be objectively verifiable, since emotions, which are the product of the nonintellectual, the "moral" part of the mind, cannot, as can conceptual thought, be reasoned over or even compared with each other. If emotion is thus subjective, and if beauty is an emotion, it is difficult to see how Ruskin believes that beauty can be objective. He attempts to solve the problem of feeling in beauty by reasoning that all men perceive, or should perceive, certain qualities with the same emotion much in the same manner that all men find sugar sweet and wormwood bitter. Men react so, says Ruskin, because it is God's will and because all men have a divine element in their nature By appealing to an order that is ultimately divine, Ruskin proves his satisfaction, if not, alas, to ours, that aesthetic emotions are both uniform and essential.[12]

Thus, beauty, Landow argues, cannot be both "an objectively existing thing or quality" as well as a subjective emotion (i.e. pleasure), even though Ruskin argues that aesthetic emotions are uniform (i.e. objective) because the will of God determined that all men respond to nature in art with the same instinctive pleasure. Explaining this response, Ruskin says: "The utmost subtlety of investigation will only lead us to ultimate instincts and principles of human nature, for which no farther reason can be given than the simple will of the Deity that we should be so created" (III, 109). Nevertheless, as Landow maintains, Ruskin's view of aesthetic response as a uniform (i.e. objective) function originally created by God does not alter the fact that pleasure itself is a subjective response to the material aspects of nature represented in art. In this sense, Ruskin's argument concerning the objectivity of beauty in landscape painting is untenable.

Another critic, Francis Townsend, explains a circularity in the aspect of Ruskin's theory concerned with the elevating effect of beauty on the observer. This elevating effect of beauty in nature and in art is an instance of what Townsend calls the "landscape feeling":

> I need hardly point out that some cement is needed to hold this theory together. Let me recapitulate the theory briefly. God has created a universe in which nearly every single part is a source of ideas of beauty. These beautiful things are types of the divine attributes. God has so created man that he is attracted instinctively to beautiful things, i.e., to those aspects of the universe which are types of the divine attributes. Therefore, God has so made man that if he will only look with attention and humility at the world around him [and at art], he will be led inevitably to faith in God. His whole nature will be purified and ennobled by this preview of the Beatific Vision.[13]

But, Townsend argues, a circle of reasoning is related to the "landscape feeling"; that is, if men are not already virtuous, can art make them so?[14]

Certainly, the aspects of art representing external nature and illustrating the attributes, the characteristics, of the Deity do purify and enoble Ruskin the observer, because "ideas of beauty are among the noblest which can be presented to the human mind, invariably exalting and purifying it according to their degree . . ." (III, 111). However, since God originally created man "to derive pleasure from whatever things are illustrative of . . . [His] nature" (III, 109), therefore virtue, the aesthetic sensibility for such pleasure, is already innate in Ruskin before he apprehends beauty in art. The manifestation of God through the natural appearances of landscape art simply exalts and purifies what is already innate in him—the virtue or capacity for responding to divine beauty by feeling pleasure. In this sense, as the "landscape feeling" shows, Ruskin's concept of beauty in landscape art is circular.

The inconsistencies pointed out by Ladd, Landow, and Townsend in Ruskin's theory of beauty in *Modern Painters I* can be resolved by describing Beauty not according to the subject-object dichotomy but instead acording to Husserl's perspective of intentional consciousness and intentional object. According to Husserl, intentional consciousness can be directed toward different kinds of intentional objects, whether they be perceived entities, feelings, or thoughts.

Henry Ladd, we have seen, implies that Ruskin's aesthetic of beauty is inconsistent—because, although the manifestation of God in art is beauty, God yet causes the observer's pleasure, upon which beauty depends. Phenomenologically, however, Ruskin can be aware of Beauty as his response of pleasure to apprehension of the expression, by the representational work not of his own but of the painter's belief that God manifests through nature. Although Landow argues that beauty cannot be both an objective quality of visual art and also a subjective emotion, nevertheless Beauty can have both visual and emotional aspects *if* they are understood as intentional objects of Ruskin's consciousness. That is, he can apprehend Beauty in two ways. He can perceive a representation of landscape that expresses the nature of God, and he can thereby become aware of his emotional response to this perception, because, as Ruskin asserts, "we have been so constructed as . . . to derive pleasure from whatever things are illustrative of that nature . . ." (III, 109). And, although Townsend argues that Ruskin's "landscape feeling" about beauty is circular, that landscape painting exalts what is already inherent in the observer, his capacity for aesthetic response; yet, phenomenologically, Ruskin can be conscious of his divinely created capacity to receive pleasure from representation manifesting the painter's belief in the nature of God. And Ruskin also can be aware that this apprehension of divine Beauty in the work exalts and purifies—i.e. enhances—his capacity for such pleasure, his aesthetic sensibility.

Aspects of Heidegger's aesthetic in "The Origin of the Work of Art" can afford interpretation of these phenomenological descriptions of the Idea of Beauty in landscape painting. Visual form representing nature becomes an "earth." The emotional response of pleasure to this form is its emotive meaning for Ruskin, its "world." In particular, Ruskin begins his consideration of Beauty with an explanation of its visual and emotional aspects: "Any material object which can give us pleasure in the simple contemplation of its outward qualities without any direct and definite exertion of the intellect, I call in some way, or in some degree, beautiful" (III, 109). Phenomenologically, then, the Idea of Beauty is simply Ruskin's Being-with landscape art by seeing it and by responding emotionally to it. When Ruskin perceives the "earth" of the representational art work, he engages "in the simple contemplation of its outward qualities without any direct and definite exertion of the intellect." As the emotive significance of this visual perception, the "world" of the work is Ruskin's emotional response to its represented natural scene, because (he says) "any material object which can give us pleasure in the simple contemplation of its outward qualities . . . , I call in some way, or in some degree, beautiful."

Beauty, Ruskin continues, concerns not only his emotional response to visual perception of art but also its expression of the nature of God:

> Why we receive pleasure from some forms and colours, and not from others, is no more to be asked or answered than why we like sugar and dislike wormwood. The utmost subtlety of investigation will only lead us to ultimate instincts and principles of human nature, for which no farther reason can be given than the simple will of the Deity that we should be so created. We may indeed perceive, as far as we are acquainted with His nature [i.e. the Deity's], that we have been so constructed as, when in a healthy and cultivated state of mind, to derive pleasure from whatever things are illustrative of that nature; but we do not receive pleasure from them *because* they are illustrative of it, nor from any perception that they are illustrative of it, but instinctively and necessarily, as we derive sensual pleasure from the scent of a rose. (III, 109)

The Creator predisposed man to experience pleasure by apprehending Beauty—His manifestation through nature portrayed in art. Here, Ruskin implies that the painter expresses his own belief about the manifestation of God in nature by embodying this conviction in the landscape work. Thus, by seeing the work's representational forms, Ruskin apprehends its expression of the painter's belief in the Deity and thereby instinctively feels pleasure.

This expression of divine being by natural form in art is an instance of phenomenological "beauty," as Heidegger explains it in "the Origin of the Work of Art." When seeing the form of the art work and thereby apprehending its essential nature, or "Being," Heidegger then apprehends its "beauty." In other words, "beauty" is his Being-with artistic form expressing the essence of the work. In Ruskin's theory of beauty, this essence is divine.

Phenomenological "beauty" is Ruskin's consciousness of a manifestation of God through landscape art. The painter believes that God reflects Himself through nature and therefore embodies in the landscape painting what he considers to be a manifestation of the Divine. Ruskin directs his attention toward the work. First, he sees represented forms of nature and then knows that these forms express the basic character of the work, its *divine* "Being," because "we have been so constructed as, when in a healthy and cultivated state of mind, to derive pleasure from whatever things are illustrative of . . . [God's] nature. . . ." In general, then, "beauty" is Ruskin's Being-with the divine essence of nature adumbrated through the representational form of the landscape painting.

Finally, the aesthetic of Beauty concerns Ruskin's apprehension that these aspects of the painting elevate his sensibility:

> Ideas of beauty are among the noblest which can be presented to the human mind, invariably exalting and purifying it according to their degree; and it would appear that we are intended by the Deity to be constantly under their influence, because there is not one single object in nature which is not capable of conveying them, and which, to the rightly perceiving mind, does not present an incalculably greater number of beautiful than of deformed parts (III, 111)

In summary, then, Ruskin's phenomenological aesthetic of Beauty in *Modern Painters I* has several facets. First, he visually contemplates the "outward qualities" of the work "without any direct and definite exertion of the intellect." Here, he sees the "earth," the form, of the landscape work. Contemplated visually, this representational form "can give us pleasure." Pleasure is the "world," the emotive meaning, which natural form in art has for Ruskin's consciousness. Viewing nature represented in art, he then becomes aware of phenomenological "beauty." "Beauty" is his Being-with the manifestation, through form, of the essence, or "Being," of the work. That is, having the capacity "to derive pleasure from whatever things are illustrative of . . . [God's] nature," Ruskin sees a representation of nature and thereby knows that this form expresses the painter's view of essential attributes belonging to God's "Being." Visual, emotional, and religious—all of these apprehensions of landscape art constitute an Idea of Beauty. Finally, Ruskin is aware that such apprehension of Beauty enhances his sensibility for landscape art, his capacity to receive pleasure from it, because, he maintains, "ideas of beauty are among the noblest which can be presented to the human mind, invariably exalting and purifying it according to their degree. . . ."

Taking precedence over the Idea of Beauty, the central concept of *Modern Painters I* is the Idea of Truth.

The Idea of Truth in Landscape Painting

Initially, Ruskin states that "the word Truth, as applied to art, signifies the faithful statement, either to the mind or senses, of any fact of nature" (III, 104). Continuing, he compares the Idea of Truth to Imitation:

> First,—Imitation can only be of something material, but truth has reference to statements both of the qualities of material things, and of emotions, impressions, and thoughts. There is a moral as well as material truth,—a truth of impression as well as of form,—of thought as well as of matter; and the truth of impression and thought is a thousand times the more important of the two. Hence, truth is a term of universal application, but imitation is limited to that narrow field of art which takes cognizance only of material things. (III, 104)

Thus, Truth has two basic aspects. First, the landscape painting is an accurate representation of natural fact, specifically, of visual aspects and qualities belonging to material objects. Second, the painting expresses the painter's impressions, emotions, and thoughts. The material aspect of Truth is formal. The immaterial aspect is moral, emotional, or conceptual. And the material aspect of Truth is secondary in importance to its immaterial aspect, its expression of the artist's moral views, impressions, emotions, and thoughts.

Ruskin's theory of Truth has two basic relations to the tradition of aesthetic theory. On one hand, Truth is related to the Neo-classical aesthetic of art as imitation. According to M. H. Abrams in *The Mirror and the Lamp,* "'imitation' is a relational term, signifying two items and some correspondence between them." The concept of imitation was prominent in aesthetic theory from the time of Aristotle "all the way through the eighteenth century."[15] Although Ruskin abjures imitation in the sense of duplicating nature in art, nevertheless representational Truth is imitative in the Neo-classical sense, because "the faithful statement . . . [by art] of any fact of nature" concerns accurate correspondence between the landscape work and the natural scene it represents. This relation between the painting and nature shows that representational Truth is objective. On the other hand, Truth is related to the Romantic tradition of art as expression, a tradition prominent in English theory during the first four decades of the nineteenth century.[16] According to this view, Abrams explains, ". . . a work of art is essentially the internal made external, resulting from a creative process operating under the impulse of feeling, and embodying the combined product of the poet's [modified] perceptions, thoughts, and feelings."[17] Similarly, according to the Idea of Truth, the work of landscape art expresses the painter's "emotions, impressions, and thoughts." Concerning expression of the artist, this Romantic element of Truth in landscape art is subjective. Thus, the Neo-classical aspect of Truth is objective, but the Romantic aspect is subjective. In this sense, the Idea of Truth is inconsistent. The landscape work cannot

comprise both representational and expressive elements if these are understood in the perspective of subject and object. However, by removing this dichotomy, Husserl's theory of intentional consciousness and intentional object can afford a consistent phenomenological description of Truth.

According to Husserl's *Logical Investigations,* intentional consciousness has a direction toward something. Whether a visual entity, an emotion, or a thought, an object of consciousness is neither subjective nor objective, but instead is intentional. Furthermore, several intentional objects can form a single one. For instance, as intentional, a painting has visual qualities; it may also embody meanings—emotions and thoughts apprehended by consciousness. These intentional objects—visual phenomena, emotions, and thoughts—combine into the meaningful work, a single intentional object apprehended by the observer. With respect to the Idea of Truth, since the landscape work is first a "statement, either to the mind or senses, of any fact of nature," therefore the work's representational aspect is an intentional object of sight for Ruskin's consciousness. Second, Truth includes "statements . . . of [the painter's] emotions, impressions, and thoughts." Here, Ruskin is aware of meaningful intentional objects. He apprehends *what* representation expresses—the painter's thoughts, feelings, and impressions. Thus, the landscape work itself is an intentional unity comprising Ruskin's visual awareness of a representation of nature and his mental apprehension of an expression of the painter's "emotions, impressions, and thoughts."

The first element of the Idea of Truth, "the faithful statement either to the mind or senses, of any fact of nature" is not an imitation, or copy, of nature but rather a visual correspondence to it. Ruskin makes this point clear when explaining that Truth is limited to representation of one aspect of any natural object:

> . . . an idea of truth exists in the statement of *one* attribute of anything, but an idea of imitation requires the resemblance of as many attributes as we are usually cognizant of in its real presence. A pencil outline of the bough of a tree on white paper is a statement of a certain number of facts of form. It does not yet amount to the imitation of anything, The idea of that form is not given in nature by lines at all, still less by black lines with a white space between them. But those lines convey to the mind a distinct impression of a certain number of facts, which it recognizes as agreeable with its previous impressions of the bough of a tree; and it receives, therefore, an idea of truth. If, instead of two lines, we give a dark form with the brush, we convey information of a certain relation of shade between the bough and sky, recognizable for another idea of truth: but we have still no imitation, for the white paper is not the least like air, nor the black shadow like wood. (III, 105)

George P. Landow, in an article called "J. D. Harding and John Ruskin on Nature's Infinite Variety," makes an interesting statement about this aspect of representational Truth. According to Ruskin, Landow argues, "art, then, does not imitate objects or phenomena; it states facts about them. Art can

make such statements precisely because art—whether painting, drawing, or sculpture—is a language developed to convey visual fact." Furthermore, Landow maintains, the "ability of art to create systems of proportionate relationships parallel to those of nature allows the artist to make [such] statements of visual fact."[18] Thus, Ruskin's statement limiting representation to one aspect of the natural object indicates that the landscape painting is not an imitative reproduction of nature but rather a visual correspondence to, an approximation of, it.

This aspect of representational Truth can be interpreted phenomenologically as Ruskin's consciousness of visual qualities of landscape art that do not imitate the natural world but instead correspond with it. Understood in the perspective of Heidegger's phenomenological aesthetic in "The Origin of the Work of Art," this correspondence constitutes the "earth," the visually perceived form, of the landscape work.

According to Ruskin, "an idea of imitation requires the resemblance of as many attributes as we are usually cognizant of in . . . [the] real presence" of the natural object. The landscape painting should, however, not imitate but correspond to nature. With regard to representation, Ruskin is visually aware of "the statement of *one* attribute of anything." Then he discusses a hypothetical instance of such representation in art. Thus, he discusses not an actual but rather a possible visual aspect of landscape painting. He discusses the "earth" of landscape painting as a *possible* mode of Being-with its form visually. In particular, with regard to representation, Ruskin could be visually aware of a single fact that does not imitate but corresponds to nature, because, he argues, "if . . . we give a dark form with the brush, we convey information of a certain relation of shade between the bough and sky, recognizable for . . . [an] idea of truth" His eye would assure him that this instance of Truth is not an imitation, but rather is a representation, a visual adaptation of form to the natural scene, because "the white paper is not the least like air, nor the black shadow like wood." In this sense of corresponding to but not imitating nature, the "earth" of landscape painting would be Ruskin's visual perception of "the faithful statement, either to the mind or sense, of any fact of nature" (III, 104).

Having secondary importance for the Idea of Truth, representation expresses its primary element, the experience of the landscape painter:

> Imitation can only be of something material, but truth has reference to statements both of the qualities of material things, and of emotions, impressions, and thoughts. There is a moral as well as material truth,—a truth of impression as well as of form,—of thought as well as of matter; and the truth of impression and thought is a thousand times the more important of the two. (III, 104)

The landscape work both represents nature and also expresses its significance for the painter. According to J. H. Buckley's *The Victorian Temper: A Study in Literary Culture* (1951), Ruskin valued the content of art over its form. The material qualities of art should embody "moral and intellectual" value. Based securely on physical fact and on actual "human experience," the art object must interpret the phenomena of nature. In this way, Buckley explains, Ruskin avoided the goal of art as an imitation of nature.[19] Understood in this perspective, Ruskin's theory avoids a view of landscape art as a material copy of something in nature by stipulating that the work interprets nature. That is, representation in the work expresses meaning. And this meaning is the artist's experience—his impressions, feelings, and thoughts about nature.

In the phenomenological perspective, just as Ruskin can become visually conscious of the work as a representation of nature, so also can he become mentally aware of it as an expression of meaning, concerning the painter's feelings and thoughts. Martin Heidegger interprets the meaning that consciousness can be aware of in art. According to "The Origin of the Work of Art," the meaning of the art work, expressed by its appearance (its "earth"), is its "world," whether as emotion or as thought. The "world' of the art work is Heidegger's Being-with its emotive or conceptual significance. The "earth" is "closed." That is, he is not aware of artistic form *as* meaning; he simply sees this form. However, the "world" is "open." When he sees the form of the work, then he knows that its meaning is "open," or evident, for his consciousness. With regard to the first element of Truth, then, "earth" as representation of nature is "closed," because Ruskin is not aware of natural forms in landscape art *as* meanings. He simply sees these forms, which correspond to nature. But he also becomes conscious of the meaning expressed by this representation. This meaning, "open" or evident for his consciousness, is the "world" of the landscape painting. And this "world" is his Being-with the expression, by representational form, of the painter's experience. Seeing "the qualities of material things" in the landscape work, Ruskin apprehends their aesthetic significicnace as it is constituted by the painter's "emotions, impressions, and thoughts" about the scene represented.

Thus, the Idea of Truth includes both Ruskin's visual perception of representation and his mental apprehension of aesthetic meaning. In that representation and expression are, respectively, visual and mental, they contrast. Heidegger, in "The Origin of the Work of Art," calls this kind of contrast the "conflict" of the art work. The "conflict" is his Being-with the opposition between "earth" and "world." He sees the form of the work and knows that without a meaning this form would be merely sensory. Conversely, when he understands this meaning, he knows that it must have a referent, the form of the art work. In this sense, he is aware of the contrast, or "conflict," between visual form and understood meaning. In Ruskin's Idea of Truth, the

"earth" of the landscape work contrasts with its "world." When he sees an aspect of nature represented in the landscape painting, then he also becomes aware of a corresponding aesthetic meaning. For instance, he apprehends "a moral as well as material truth,—a truth of impression as well as form,—of thought as well as of matter." He implies that the representational form of the painting, its "earth," needs to have such meaning, a "world" constituted by the painter's moral views, impressions, and thoughts about nature. Otherwise, the form of the work would be merely sensory, purely imitative; therefore, Ruskin maintains that "Imitation can only be of something material" Furthermore, Ruskin knows that the meaning of the landscape painting, although more important than its representation of nature, nevertheless needs this referent in form. Specifically, although "the truth of impression and thought is a thousand times . . . more important" than Truth of representation, yet Ruskin's apprehension of meaning in the landscape work—its expression of the painter's "emotions, impressions, and thoughts" about nature—must refer to form representing it. Otherwise, this meaning, the painter's experience, would be irrelevant. In these ways, then, the "conflict" in the Idea of Truth is Ruskin's Being-with the landscape painting by apprehending the complementary contrast between representation of nature and expression of meaning, between "earth" and "world," and between "the qualities of material things," and the painter's emotions, impressions, and thoughts."

This complementary relation between representation and expression establishes not only the "conflict" but also the "rift," or unity, of the Idea of Truth. Heidegger conceives the "rift" of the art work as his consciousness of, or Being-with, its complementary unity of "earth" and "world." When he sees the form of the work, he knows that this form requires a meaning in order to be complete. And when he understands this meaning, he knows that it would be incomplete without a referent in form. Both visual form and understood meaning in art thus become a unity, or "rift," for his intentional consciousness. A similar unity characterizes the Idea of Truth, a "statement" of two basic kinds to Ruskin's consciousness. First, landscape art is a visual "statement, either to the mind or senses, of any fact of nature." Second, the painting is an expressive statement, to Ruskin's mind, of the painter's "emotions, impressions and thoughts" about nature. "Earth" as representational form and "world" as meaning about the painter's experience would rest incomplete, Ruskin knows, without their mutual reference to one another. For example, having reference to the Idea of Truth, the "rift," or unity, of the landscape painting is Ruskin's Being-with its "*statements both* of the qualities of material things [in nature], and of [the artist's] emotions, impressions, and thoughts" about these natural aspects. (Italics mine.)

In general, then, the idea of Truth comprises four basic phenomenological elements, all evident to Ruskin's intentional consciousness: an "earth" as

representation correspondent to aspects of nature, a "world" as the expressed meaning of this visual form, a "conflict" as the complementary contrast between representational form and its expression of meaning, constituted by the painter's feelings and thoughts about these natural aspects, and a "rift" as the complementary unity of this form and this meaning. According to "The Origin of the Work of Art," the "truth" of the art work is the self's Being-with its essential nature, comprising an "earth," a "world," their "conflict," and their "rift," or unity. Thus, the Idea of Truth is Ruskin's Being-with, his consciousness of, the phenomenological "truth," the essential nature, of the work of art.

Ruskin views the Idea of Truth not only according to its elements but also according to its temporal, or historical, significance. In the "Recapitulation" to "General Principles Respecting Ideas of Truth," Ruskin discusses Truth from a temporal perspective:

> It ought farther to be observed respecting truths in general, that those are always most valuable which are most historical; that is, which tell us most about the past and future states of the object to which they belong. In a tree, for instance, it is more important to give the appearance of energy and elasticity in the limbs which is indicative of growth and life, than any particular character of leaf, or texture of bough. It is more important that we should feel that the uppermost sprays are creeping higher and higher into the sky, and be impressed with the current of life and motion which is animating every fibre, than that we should know the exact pitch of relief with which those fibres are thrown out against the sky. For the first truths tell us tales about the tree, about what it has been, and will be, while the last are characteristic of it only in its present state, and are in no way talkative about themselves. Talkative facts are always more interesting and more important than silent ones. (III, 163)

This discussion of historical Truth concerns the Idea of Truth in landscape painting. Representation of a tree expressing (the artist's) thoughts about its present state should have secondary importance to formal expression of his thoughts about its past and future states. Thus, explaining what landscape art should represent and express with regard to historical Truth, Ruskin is concerned with possible ways of apprehending painting rather than with actual ones.

Understood according to Heidegger's aesthetic theory, this representation, constituting the "earth" (or form) of the painting, would express a "world" (a meaning), the painter's historical thoughts. Historical Truth in landscape painting would be, then, Ruskin's consciousness of, or Being-with, an "earth" and a "world" (respectively); his Being-with the visual form representing the tree and the expressed meaning concerning the painter's historical thoughts about it. An intentional object of Ruskin's consciousness, this historical meaning would have three temporal modes: the past, the

present, and the future. In *Being and Time,* Martin Heidegger explains such temporal modes *as* objects of consciousness, as (respectively) "repetition" of the past, "making present," and "anticipation" of the future.

In particular, one aspect of the landscape work would concern Ruskin's Being-with silent facts in the present. He could be aware of "any particular character of lear, or texture of bough." Or, he could see "the exact pitch of relief with which those fibres [i.e. sprays] are thrown out against the sky." These visual impressions would, however, express only an ordinary meaning, or "world," to Ruskin. This "world" would be a "making present," an expression of the painter's view of a merely usual present situation. Thus, having seen such silent facts, Ruskin would realize that they "are characteristic of . . . [the tree] only in its present state, and are in no way talkative about themselves."

But, Ruskin says, "talkative facts are always more interesting and more important than silent ones." Such "talkative facts," he asserts, "are most historical"; they "tell us most about the past and future states of the object to which they belong." For instance, by seeing "the appearance of energy and elasticity in the limbs" of a tree represented in a landscape work, by seeing this dynamic aspect of its "earth," or form, Ruskin would then apprehend a historical meaning, a "world," as a "repetition" of past possibilities of existence. He would understand the painter's thought concerning the past state of the tree, because its dynamic form "is indicative of [past] growth and life." Or, Ruskin could perceive "that the uppermost sprays are creeping higher and higher into the sky, and be impressed with the current of life and motion which is animating every fibre." By seing these forms and lines of the tree that constitute the "earth" of the painting, Ruskin would then apprehend their temporal meaning, a "world." An "anticipation" of future possibilities of existence, this meaning of historical Truth concerning the represented tree would be Ruskin's Being-with the painter's view of its future condition, what it "will be." That is, Ruskin would be aware of what the sprays will become through their slow movement "higher and higher" and through their "current of life and motion."

Thus, the "talkative facts" of a tree represented in landscape painting would tell Ruskin "tales about the tree, about what it has been, and will be." And thus, with a discussion of historical Truth, Ruskin completes his aesthetic concerning Ideas of Truth in *Modern Painters I.* On the basis of the Idea of Truth, he then formulates an aesthetic of the painter and of the observer.

The Painter and the Spectator of Landscape Art

In general, the painter establishes the Idea of Truth in the landscape work and the spectator apprehends Truth in it.

According to Ruskin, the two primary goals of the landscape painter are to give the spectator an accurate visual conception of objects in nature and a mental conception of the artist's feelings and thoughts, according to which he regarded these objects (III, 133). In other words, the painter of the landscape work both represents the natural world and expresses his feelings and thoughts about it. According to Solomon Fishman in *The Interpretation of Art,* this aesthetic of the landscape painter is naturalistic. Since representation corresponds to aspects of nature, then representation is naturalistic. And since the painter's imaginative capacity for expression of feeling and thought cannot be explained or taught to him (i.e. since this capacity is innate or instinctive in him), expression in landscape painting is consequently also naturalistic.[20]

Furthermore, the creative activities of the painter are phenomenological. His consciousness is directed toward certain creative activities. That is, he is aware of them when creating the work. These activities are intentional correlates for his consciousness. When creating the landscape painting, he becomes aware of representing forms of nature accurately and of embodying his feelings and thoughts about it into these forms. Based on Husserl's phenomenology, this description of the artist's activity, when interpreted with Heidegger's aesthetic, becomes the "creation" of the "truth" of the art work, its essential nature which comprises an "earth," a "world," and their "conflict." According to "The Origin of the Work of Art," the artist, when creating the work, becomes aware of certain artistic activities, particularly, of establishing the work's form (or "earth"), its meaning (or "world"), and the contrast (or "conflict") between visual form and expressed meaning. These aspects of artistic "creation" constitute the artist's Being-with the work of art by establishing its essential nature, or "truth." And these creative operations are basically what Ruskin's landscape painter is aware of when he produces the landscape work.

Ruskin explains the two primary goals of the landscape painter in detail:

> It cannot but be evident from the above division of the ideas conveyable by art, that the landscape painter must always have two great and distinct ends: the first, to induce in the spectator's mind the faithful conception of any natural objects whatsoever; the second, to guide the spectator's mind to those objects most worthy of its contemplation, and to inform him of the thoughts and feelings with which these were regarded by the artist himself. (III, 133)

Since the two goals of the painter include faithful representation of nature for the spectator as well as expression of feelings and thoughts to him, therefore the artist establishes the Idea of Truth in the landscape work, its "statements both of the qualities of material things, and of [the painter's] emotions, impressions, and thoughts" about them (III, 104).

When creating the landscape work, the painter establishes its phenomenological "truth," its essential nature. First, he creates the "earth" of the landscape painting, its form. He sees that he creates an accurate visual correspondence to nature, in order "to induce in the spectator's mind the faithful conception of any natural objects whatsoever." Furthermore, the painter expresses his "thoughts and feelings" through this representational form; these experiences constitute its meaning, or "world." The painter, then, knows that, when creating the visual form of the work, he embodies his experiences of nature into this representation, in order "to guide the spectator's mind to those [natural] objects most worthy of its contemplation, and to inform him of the thoughts and feelings with which these were regarded by the artist himself." Since "the landscape painter must always have [these] two great and distinct ends . . . ," consequently, when creating the landscape painting, he is aware of establishing its contrast, or "conflict," between form and meaning, between visual correspondences to nature and their expression of his feelings and thoughts about it. In these different ways, then, the "creation" of phenomenological "truth" in the landscape painting is his Being-with the work by creating its essential nature—its contrast between visual representation and expressed meaning. In other words, he is aware of establishing an Idea of Truth in the phenomenological—its "faithful statement, either to the mind or senses, of any fact of nature" and its expression of his "emotions, impressions, and thoughts" about nature (III, 104).

By elaborating the second goal of the painter (i.e. the expression of emotion and thought) and by emphasizing the observer's experience of art instead of the painter's creation of it, Ruskin arrives at his theory of aesthetic appreciation:

> But in attaining the second end, the artist not only *places* the spectator, but *talks* to him; makes him a sharer in his own strong feelings and quick thoughts; hurries him away in his own enthusiasm; guides him to all that is beautiful; snatches him from all that is base; and leaves him more than delighted,—ennobled and instructed, under the sense of having not only beheld a new scene, but of having held communion with a new mind, and having been endowed for a time with the keen perception and the impetuous emotions of a nobler and more penetrating intelligence. (III, 133-34)

This theory is essentially an instance of the Victorian "moral aesthetic," which Jerome H. Buckley explains in *The Victorian Temper*. According to Buckley, the spectator's mind must be noble and aware of "the vital reality" beneath the appearance of the art work. In this way, his mind achieves "empathic identification and . . . moral self-effacement."[21] In Ruskin's theory, the spectator's awareness of a "vital reality" underlying the appearances of nature represented in the painting is his apprehension that they express the artist's enthusiasms, feelings, and thoughts. By apprehending these expressions of the

painter, the spectator morally effaces himself and empathically identifies with the painter. Thus, after looking at the painting, the spectator, Ruskin says, is "under the sense of having not only beheld a new scene, but of having held communion with a new mind."

When interpreted phenomenologically with the aesthetic in "The Origin of the Work of Art," the spectator's apprehension of the landscape painting becomes his "preservation" of its essential nature, comprising the contrast, or "conflict," between an "earth" and a "world." "Preservation," Heidegger explains, is the observer's Being-with the "truth" of the work of art. He sees the formal appearance of the work, its "earth." He apprehends the expression of meaning by this form, the artist's emotions and thoughts. And, seeing form and understanding its significance, as a "world,"—the spectator thereby apprehends the "conflict"—or contrast—between "earth" and "world." Since the former is visual but the latter is cognitive, the spectator knows that they contrast. In Ruskin's aesthetic of the spectator, the "preservation" of "truth" in the landscape painting is his consciousness of the Idea of Truth, incorporated in the work by the painter. By *placing* the spectator, the artist establishes the "earth," the form, of the painting for him. The spectator perceives an accurate correspondence to nature. By *talking* to the spectator, the artist expresses the meaning, the "world," of the work to him, through its representational form. Thus, when looking at the landscape painting, he apprehends the painter's "own strong feelings and quick thoughts." Thereby, the spectator becomes aware of the "conflict" of the painting—its contrast between visual representation of nature and expression of the artist's feeling and thought. Specifically, the spectator is conscious of this contrast between form and meaning, because he is "under the sense of having not only beheld a new scene, but of having held communion with a new mind, and having been endowed for a time with the keen perception and impetuous emotions of a nobler and more penetrating intelligence." In effect, the spectator's "preservation" of "truth" in landscape art is his Being-with its essential nature—an Idea of Truth. He sees a "faithful statement . . . of any fact of nature" and understands the meaning of this representational form, its statement of the painter's thought and feeling about nature. Thus, the spectator apprehends the contrast of Truth in the landscape painting between "statements both of the [visual] qualities of material things, and of [the landscape painter's] emotions, impressions, and thoughts" (III, 104).

Based on the Idea of Truth, the theories of the landscape painter and of the spectator essentially complete the theoretical part of John Ruskin's aesthetic in *Modern Painters I*. Throughout the remainder of this work, he first elaborates the theory of Truth by specifying different ways in which the landscape painter can represent nature and second applies this theory by demonstrating different ways in which several of Turner's important landscape paintings exemplify Truth.

4

Representational Truth and
the Truth of Turner's Art

The Representational Truths of Landscape Painting

In *Essays in the Philosophy of Art* (1964), R.G. Collingwood explains the reason for the emphasis in *Modern Painters I* on accurate representation of nature. Collingwood maintains that Ruskin's emphasis on representation assumes the already existent fact of the artist's feeling. Although the ordinary person can be taught to draw, he cannot be taught to feel. Thus, by emphasizing representation, Ruskin attempts to complete the education of the painter.[1]

Thus, since representational Truth in landscape painting is "the faithful statement, either to the mind or senses, of any fact of nature," (III, 104) the landscape painter should learn to establish such a correspondence between the forms of the work and the natural scene. The representational Truths of Tone, of Colour, of Chiaroscuro, and of Space elaborate and specify ways in which the painter should accomplish this task. Among these visual Truths of landscape art, those of Colour, Space, and Chiaroscuro have secondary importance for Ruskin's aesthetic of the painter in *Modern Painters I*. Yet they deserve brief mention in passing.

In nature, Ruskin argues, the precise colors of objects are usually not clearly evident and determinate; their forms are revealed instead "by light and shade." More specifically, the forms of natural and represented objects are founded not on their color, which does not concern their "nature and essence," but rather on their form—a unity of outline and Chiaroscuro, a "unity of outline with light and shade." For the painter, then, "truth of colour" is secondary in importance to "truth of form" (III, 158-62). And since Tone (shading with respect to distance), Chiaroscuro (pattern of light and shade), and Space do concern the fundamental forms of natural objects, therefore these Truths take precedence over that of Colour for the painter representing nature.

In the chapter on Truth of Chiaroscuro, Ruskin elaborates an aesthetic of chiaroscuro in landscape painting. When the sun is shining, he says, the most evident aspects of the natural landscape are, with the exception of the strongest lights, the shadows. Chiefly through them, the forms of landscape can be understood. For instance, hovering between light and shade, the intermediate "shadows of the ridges" define "the roughness of the bark of a tree." Consequently, in order to define strong light in landscape painting, shadow (even if not completely dark) must be flat and even, must "conceal the details of the objects it crosses," and must have sharply defined edges. By following these guidelines, the painter can give the light in his painting the character of sunlight (III, 304-305).

In two chapters on Truth of Space, Ruskin sets forth views of representation that depend on the limits of visual perception. Because of limitations in the eye's focus, he argues, "it is totally impossible to see distinctly, at the same moment, two objects, one of which is much farther off than another." In an actual landscape, if the far distance and "the middle distance" are clearly seen, then the foreground will be indistinct; and consequently, "if in a painting our foreground is anything, our distance must be nothing" Thus, when depicting objects at different distances, the landscape painter must represent them as distinct or indistinct in correspondence with visual perception of actual nature (III, 320-21). Finally, Ruskin maintains, in actual visual perception of natural objects at varying distances, regardless of how close, there is always something that cannot be seen, and, regardless of how far, there is always something visible: "And hence in art, every space or touch in which we can see everything, or in which we can see nothing, is false" (III, 329).

In general, the representational Truths of Colour, of Chiaroscuro, and of Space establish standards for the landscape painter to follow in order to create visual forms accurately corresponding to the appearances of nature. Ruskin's aesthetic concerning Truth of Tone also establishes such standards.

The most important representational Truth, Truth of Tone combines the Truths of Chiaroscuro and of Space by elaborating the painter's representation of light and shade with respect to distance. Truth of Tone, Ruskin explains, is

> . . . first, the exact relief and relation of objects against and to each other in substance and darkness, as they are nearer or more distant, and the perfect relation of the shades of all of them to the chief light of the picture, whether that be sky, water, or anything else; secondly, the exact relation of the colours of the shadows to the colours of the lights, so that they may be at once felt to be merely different degrees of the same light (III, 259-60)

That is, when representing a natural scene, the artist must first graduate the shading of objects with respect to their proximity or distance in the actual scene and with respect to the major light of the painting itself. Second, he should establish

> . . . the accurate relation among the illuminated parts themselves, with respect to the degree in which they are influenced by the colour of the light itself, whether warm or cold; so that the whole of the picture . . . may be felt to be in one climate, under one kind of light, and in one kind of atmosphere; this being chiefly dependent on that peculiar and inexplicable quality of each colour laid on, which makes the eye feel both what is the actual colour of the object represented, and that it is raised to its apparent pitch by illumination. (III, 259-60)

This aspect of Tone concerns the painter's harmonization of the different lights of represented natural objects with each other and with the primary light of the picture, "so that the whole of the picture . . . may be felt to be . . . under one kind of light" When reflecting the predominant light of the natural scene, "a very bright brown, for instance, out of sunshine" will have a better quality of tone than "a very dead or cold brown in sunshine," a color not reflecting the predominant light (III, 260). In general, then, Ruskin's two concepts of Tone are detailed instructions to the landscape painter about establishing the first aspect of the Idea of Truth in his painting—its "faithful statement . . . of any fact of nature" (III, 104).

Described with Edmund Husserl's concept of intentional consciousness, which can be directed toward visual phenomena, Ruskin's aesthetic of Tone concerns what the landscape painter should visually perceive when representing nature. With regard to the first aspect of Tone, he should be visually aware of shading objects in proportion to their nearness or distance in nature itself and of harmonizing these shades with the major light of the painting. Or, when concerned with the second aspect of Tone, he should relate the colors of shaded objects to the colors of lighted ones; consequently, he will see these colors as different gradations of one light. When interpreted according to Martin Heidegger's aesthetic, this phenomenological description of Ruskin's advice to the painter about Tone concerns his "creation" of the "Gestalt" in the work of art.

In "The Origin of the Work of Art," Heidegger explains the "Gestalt" of the art work, its unified form:

> The strife that is brought into the rift and thus set back into the earth and thus fixed in place is *figure, shape, Gestalt*. Createdness of the work means: truth's being fixed in place in the figure. Figure is the structure in whose shape the rift composes and submits itself. This composed rift is the fitting or joining of the shining of truth. What is here called figure, *Gestalt*, is always to be thought of in terms of the particular placing *(Stellen)* and framing or framework *(Ge-stell)* as which the work occurs when it sets itself up and sets itself forth.[2]

S.L. Bartky, in an article called "Heidegger's Philosophy of Art," explains the "Gestalt" of the art work and the role of the artist in establishing this "Gestalt":

> Artistic form *(Gestalt)* is the establishment, the fixing in a medium, of the basic strife between the self-closing medium and the disclosure which the medium bears and supports. All works of art may partake of a single essence for Heidegger, but what distinguishes one work from another is the particular framing or ordering of its material, i.e., the form. The earth, though self-concealing, is not monotonous for its concealment, is neither unvaried nor inflexible. It can take a "variety of simple modes and forms" and it is part of the function of the artist to exploit these possibilities.[3]

Thus, the variety of modes which the "earth," or form, of the art work can assume for the artist's visual consciousness constitute the "Gestalt." In this sense, the artist's "creation" of the "Gestalt" of the work of art is his Being-with it by creating its varied but unified visual form.

The two aspects of Tone in landscape painting concern such form representing aspects of the natural world. When the landscape artist creates, he should establish its "Gestalt" as Tone—a coherent formal pattern of shadow, of light, and of color. Concerned with the first aspect of Tone, his "creation" of the landscape painting should be his awareness of establishing "the exact relief and relation of objects against and to each other in substance and darkness, as they are nearer or more distant." He should be visually aware of graduating the shade of represented objects in proportion to their place in the actual scene and of relating these shadows "to the chief light of the picture." When concerned with the second aspect of Tone, he should harmonize "the colours of the shadows to the colours of the lights," in order that he may see these colors as "merely different degrees of the same light." And he should interrelate the colors of represented natural objects and should harmonize these colors with the basic light of the painting—"so that the whole of the picture . . . may be felt [by his eye] to be in one climate, under one kind of light, and in one kind of atmosphere." As standards for the landscape painter, then, his "creation" of Truth of Tone is his Being-with the landscape work by painting its "Gestalt"—its varied but coherent pattern of light, shade, and color in represented natural phenomena—by graduating shadow and light according to distance and to the primary light, by balancing shaded colors and lighted colors according to the basic light, and by harmonizing the lighted colors with the predominating light. Thus, the painter, when representing a natural scene, should visually perceive that these aspects of form fuse into a unity, because each aspect of Tone is governed by the primary light of the picture. And, for his eye, this governing light should correspond to the primary light of the original scene, upon which the painting is based:

A very bright brown, for instance, out of sunshine, may be precisely of the same shade of colour as a very dead or cold brown in sunshine, but it will be totally different in *quality;* and that quality by which the illuminated dead colour would be felt in nature different from the unilluminated bright one, is what artists are perpetually aiming at, and connoisseurs talking nonsense about, under the name of "tone." (III, 259-60)

With respect to Truth of Tone, then, Ruskin instructs the landscape painter on ways of correctly representing patterns of light and shade in the natural world and creating, in this sense, an aspect of representational Truth in landscape painting. Ruskin not only instructs the painter in representation of Tone but also explains its presence in J.M.W. Turner's landscape painting.

In "J.D. Hardin and John Ruskin on Nature's Infinite Variety," George P. Landow explains that, in Ruskin's early aesthetic, representation—including Truth of Tone—means not duplication of but instead correspondence to nature:

In the first and fourth volumes of *Modern Painters* Ruskin explains that the painting relates structures of relationships—between colors, between tones, and between forms—which have the same proportions, though not the same scale or intensity, as the visual structures of the natural world.[4]

With respect to Truth of Tone, Turner's art does exhibit this kind of proportionate correspondence to nature, because, Ruskin maintains, Turner

. . . boldly takes pure white (and justly, for it is the sign of the most intense sunbeams) for his highest light, and lampblack for his deepest shade; and between these he makes every degree of shade indicative of a separate degree of distance, giving each step of approach, not the exact difference in pitch which it would have in nature, but a difference bearing the same proportion to that which his sum of possible shade bears to the sum of nature's shade; so that an object half-way between his horizon and his foreground, will be exactly in half tint of force, and every minute division of intermediate space will have just its proportionate share of the lesser sum, and no more. Hence where the old masters expressed one distance, he expressed a hundred, and where they said furlongs, he says leagues. (III, 262-63)

Here, Ruskin is concerned with the first aspect of Tone: "the exact relief and relation of objects against and to each other in substance and darkness, as they are nearer or more distant" (III, 259). He then demonstrates the correspondence in Tone between Turner's *Mercury and Argus* and nature itself:

Compare with these [paintings by other artists], Turner's treatment of his materials in the Mercury and Argus. He has here his light actually coming from the distance, the sun being nearly in the centre of the picture, and a violent relief of objects against it would be far more justifiable than in Poussin's case. But his dark relief is used in its full force only with the nearest *leaves* of the nearest group of foliage overhanging the foreground from the left; and between these and the more distant members of the same group, though only three or four

yards separate, distinct aërial perspective and intervening mist and light are shown; while the large tree in the centre, though very dark, as being very near, compared with all the distance, is much diminished in intensity of shade from this nearest group of leaves, and is faint compared with all the foreground. It is true that this tree has not, in consequence, the actual pitch of shade against the sky which it would have in nature; but it has precisely as much as it possibly can have, to leave it the same proportionate relation to the objects near at hand. And it cannot but be evident to the thoughtful reader, that whatever trickery or deception may be the result of a contrary mode of treatment, this is the only scientific or essentially truthful system, and that what it loses in tone it gains in aërial perspective. (III, 264-65)

In this passage on Turner's *Mercury and Argus,* Ruskin thus describes its Truth of Tone, its visual correspondence to differences of shade in nature that are proportionate to distances of objects from the eye. Here, Ruskin describes his visual consiousness of the "Gestalt" of *Mercury and Argus*—its "earth" as varied but interrelated patterns of light and shade.

In particular, the phenomenological "Gestalt" of *Mercury and Argus* is Ruskin's Being-with its Truth of Tone as "the exact relief and relation of objects against and to each other in substance and darkness, as they are nearer or more distant" (III, 259). For each instance of Tone in Turner's painting, Ruskin is visually aware that patterns of light and shade correspond with but do not duplicate nature's light and shade. He sees, in particular, the "light actually coming from the distance, the sun being nearly in the centre of the picture." He sees that "dark relief is used in its full force only with the nearest *leaves* of the nearest group of foliage overhanging the foreground from the left." He sees that

. . . between these and the more distant members of the same group, though only three or four yards separate, distinct aërial perspective and intervening mist and light are shown; while the large tree in the centre, though very dark, as being very near, compared with all the distance, is much diminished in intensity of shade from this nearest group of leaves, and is faint compared with all the foreground.

And Ruskin perceives that the Truth of Tone belonging to this relationship between the darker leaves in the foreground and the lighter tree farther back is not a duplication—an imitation—of nature. This Tone of *Mercury and Argus* does not imitate nature, but simply presents Ruskin's eye with a correspondence to nature, because "this tree has not, in consequence, the actual pitch of shade against the sky which it would have in nature; but it has precisely as much as it possibly can have, to leave it the same proportionate relation to the objects [i.e. the leaves] near at hand." Establishing a coherent, unified relationship between the darkened leaves in the immediate foreground and the lighter tree a few yards distant, all these tones constitute the visual form, the "Gestalt," of *Mercury and Argus.*

In general, then, the representational Truths of landscape painting—those of Colour, of Chiaroscuro, of Space, and especially of Tone—specify the first goal of the landscape painter, "to induce in the spectator's mind the faithful conception of any natural objects whatsoever" (III, 133). And, of course, this goal concerns the first element of the Idea of Truth, "the faithful statement, either to the mind or senses, of any fact of nature" (III, 104).

In *Modern Painters I,* usually relying on his concept of representational Truth as a criterion, Ruskin presents criticisms of numerous landscape paintings, some antedating and others contemporary with Turner's works. In *A History of Modern Criticism: 1750-1950,* René Wellek explains the general focus of this criticism:

> The polemics [of Ruskin's aesthetic] . . . is comprehensible if we understand Ruskin's central idea: art is an analogue of nature, is as alive, "organic," as nature, and must reflect the truth of nature—a truth Ruskin feels to be violated both by the deadness (or what he feels as deadness) of Dutch art and the "classicism" of the French and Italian 17th- and 18th-century landscape painters.[5]

Among the painters whose works Ruskin criticizes are Claude (1600-1682) and G. Poussin (1615-1675). Since these criticisms are both short and general, they merit only brief consideration in this chapter; therefore, I shall discuss only one representative example.

Ruskin depreciates Gaspard Poussin's *The Sacrifice of Isaac.* In this work, Ruskin explains, the scene is set at noon with a clear sky. At the upper part of the scene, the sky has "a pitch of darkness which . . . is as purely impossible as colour can be." Furthermore, Ruskin argues, the "yellow horizon" of this painting is a visual absurdity. Such a horizin, he argues, could not exist in nature (III, 348-49).

Thus, Ruskin depreciates Poussin's *The Sacrifice of Isaac* because visual perception of its phenomenological form (or "earth") indicates that it is a distortion of nature. In particular, looking at the painting, Ruskin does not see, for instance, a sky that would corresond to nature—a sky "pale and grey with heat, full of sunshine, and unfathomable in depth . . ." (III, 349). Instead, he perceives a dark blue color not having any similarity to an actual sky at noon. He sees only "a pitch of darkness which, except on Mont Blanc or Chimborazo, is as purely impossible a colour can be" (III, 349). And, although "the horizon at noon may be yellow when the whole sky is covered with dark clouds, and only *one* open streak of light left in the distance from which the whole light proceeds . . . ," nevertheless, in the painting, Ruskin perceives merely color as such, because, he argues, "with a clear open sky, and opposite the sun, at noon, such a yellow horizon as this is physically impossible" (III, 349). Since the dark blue of the sky and the yellow of the horizon have no

visual correspondence to anything in nature, then Poussin's *The Sacrifice of Isaac,* Ruskin implies, does not demonstrate the representational aspect of the Idea of Truth, "the faithful statement, either to the mind or senses, of any fact of nature" (III, 104).

By evaluating *The Sacrifice of Isaac,* Ruskin introduces his consideration of Truth in the landscape paintings of J.M.W. Turner:

> . . . but as it is, we have in this sky (and it is a fine picture, one of the best of Gaspar's that I know) a notable example of the truth of the old masters, two impossible colours impossibly united! Find such a colour in Turner's noon-day zenith as the blue at the top, or such a colour at a noon-day horizon as the yellow at the bottom, or such a connection of any colours whatsoever as that in the centre, and then you may talk about his being false to nature if you will. (III, 349)

The Idea of Truth in Turner's Art

Throughout the remainder of *Modern Painters I,* Ruskin applies the Idea of Truth, concerning representation of nature and expression of the painter's feelings and thoughts, to interpretation of several major landscape works by J.M.W. Turner (1775-1851). With this application of Truth, Ruskin fulfills the major purpose of *Modern Painters I*—a defense of Turner's landscape painting. In the "Preface to the Second Edition," Ruskin explains this purpose:

> For many a year we have heard nothing with respect to the works of Turner but accusations of their want of *truth.* To every observation on their power, sublimity, or beauty, there has been but one reply: They are not like nature. I therefore took my opponents on their own ground, and demonstrated, by thorough investigation of actual facts, that Turner *is* like nature, and paints more of nature than any man who ever lived. (III, 51-52).

In general, Ruskin defends Turner's landscape paintings in four final sections of *Modern Painters I* that are concerned, respectively, with Truth of Skies, Truth of Earth, Truth of Water, and Truth of Vegetation.

Although Truth of Vegetation is the least important of these natural Truths in Turner's work, nevertheless Ruskin's comments on Turner's representation of trees deserve brief mention. First, Ruskin describes a visual aspect of trees:

> The last and most important truth to be observed respecting trees is, that their boughs always, in finely grown individuals, bear among themselves such a ratio of length as to describe with their extremities a symmetrical curve, constant for each species; and within this curve all the irregularities, segments, and divisions of the tree are included, each bough reaching the limit with its extremity, but not passing it. (III, 594-95)

According to Ruskin, "the shape of a dome as in the oak, or, in tall trees," is an example of this "symmetrical curve" (III, 594-95). Then he applies this principle of curvature to a general evaluation of such representation in Turner's landscape painting:

> But I need scarcely tell anyone in the slightest degree acquainted with the works of Turner, how rigidly and constantly he adheres to this principle of nature; taking in his highest compositions the perfect ideal form, every spray being graceful and varied in itself, but inevitably terminating at the assigned limit, and filling up the curve without break or gap; in his lower works, taking less perfect form but invariably hinting the constant tendency in all; and thus, in spite of his abundant complexity, he arranges his trees under simpler and grander forms than any other artist, even among the moderns. (III, 596)

In general, the trees represented in Turner's landscape paintings have the domed shape, an "ideal form," that is characteristic for each species in the natural world.

With the exception of the section in *Modern Painters I* on Truth of Vegetation, the sections on Truth of Skies, on Truth of Earth, and on Truth of Water constitute the substance of Ruskin's defense of Turner's landscape painting.

Truth of Clouds in *Land's End*

The first important natural Truth that Ruskin discovers in Turner's landscape painting is Truth of Skies. Ruskin organizes his aesthetic concerning Truth of Skies in the following manner: "I shall therefore consider the sky as divided into three regions: the upper region, or region of the cirrus; the central region, or region of the stratus; the lower region, or the region of the rain-cloud" (III, 359).

Describing the "rain-cloud," Ruskin remarks:

> But the nearness of the rain-cloud rendering it impossible for a number of phenomena to be at once visible, makes its hue of grey monotonous, and (by losing the blue of distance) warm and brown compared with that of the upper clouds
>
> With these striking differences in colour, it presents no fewer nor less important in form, chiefly from losing almost all definiteness of character and outline. (III, 394)

The visual appearances of clouds in J.M.W. Turner's *Long Ships Lighthouse, Land's End* correspond to these phenomena "of the raincloud," especially to its broad expanse of grey color and to its indefinite outline. This painting, Ruskin says, depicts "clouds without rain, at twilight, enveloping the cliffs of the coast" (III, 403-404). He continues:

We have thus the painting, not of a mere transparent veil, but of a solid body of cloud, every inch of whose increasing distance is marked and felt. But the great wonder of the picture is the intensity of gloom which is attained in pure warm grey, without either blackness or blueness. It is a gloom dependent rather on the enormous space and depth indicated, than on actual pitch of colour; distant by real drawing, without a grain of blue; dark by real substance, without a stroke of blackness: and with all this, it is not formless, but full in indications of character, wild, irregular, shattered, and indefinite; full of the energy of storm, fiery in haste, and yet flinging back out of its motion the fitful swirls of bounding drift, or tortured vapour tossed up like men's hands, as in defiance of the tempest, jets of resulting whirlwind, hurled back from the rocks into the face of the coming darkness, which, beyond all other characters, mark the raised passion of the elements. (III, 404)

Having "reference to statements both of the qualities of material things, and of [the painter's] emotion, impressions, and thoughts" about these natural phenomena (III, 104), an Idea of Truth is implicit in this account of *Land's End*. The work corresponds to nature visually. The "pure warm grey" of the clouds in the painting correspond to the "grey monotonous" hue of the rain-cloud in nature. And the forms of cloud, air, and spray in *Land's End*, all marking "the raised passion of the elements," embody the emotions that *Turner* felt about these natural facts.

Explaining the phenomenological "truth," the essential nature of the work of art, Heidegger presents a description similar to Ruskin's of the sky in *Land's End*. Heidegger describes the atmospheric phenomena above a Greek temple:

Standing there, the building holds its ground against the storm raging above it and so first makes the storm itself manifest in its violence. The luster and gleam of the stone, though itself apparently glowing only by the grace of the sun, yet first brings to light the light of the day, the breadth of the sky, the darkness of the night. The temple's firm towering makes visible the invisible space of air.[6]

Since these atmospheric phenomena constitute part of the environment of the Greek temple, they cannot, of course, be visual aspects of the temple-work itself. Metaphorically, however, Heidegger means that the art work as such, epitomized by the Greek temple, indicates the appearances of the sky purely as themselves. In a painting, for example, the formal aspects of sky, air, light, and darkness appear only as themselves to the observer's visual consciousness. In this sense, the work "first brings to light the light of the day, the breadth of the sky, the darkness of the night." These formal aspects of the painting constitute its "earth" for visual consciousness.

Having forms corresponding to those of actual rain-clouds, the "earth" of Turner's *Land's End* is Ruskin's visual consciousness of the first element of Truth, "the faithful statement, either to the mind or senses, of any fact of nature" (III, 104). Throughout his commentary, Ruskin indicates the intensity of his visual perceptions of this painting, thereby implying that its represented

phenomena appear only *as* themselves for sight. For example, he sees "a solid body of cloud, *every inch* of whose increasing distance is marked and felt" by his eye. (Italics mine.) Or, he visually perceives the essential hue of this cloud—a color corresponding to the "grey monotonous" of the actual rain-cloud in nature (III, 394). Looking at the cloud in *Land's End,* Ruskin sees that the hue of this cloud appears as itself, because this color is intense. That is, he sees "the intensity of gloom which is attained in pure warm grey, without either blackness or blueness." And he perceives that this intense color "is a gloom dependent rather on the enormous space and depth indicated, than on actual pitch of colour; distant by real drawing, without a grain of blue; dark by real substance, without a stroke of blackness"

These intense colors of the rain-cloud in Turner's *Land's End* constitute its "earth," its visual appearance. This appearance has not only color but also form. And this form embodies Turner's emotions about such aspects of the rain-cloud as he has portrayed. Therefore, Ruskin says, the gloom of the cloud in *Land's End* "is not formless, but full of indications of character, wild, irregular, shattered, and indefinite." The embodiment of these turbulent emotions in the cloudforms of the painting exemplifies part of the second aspect of Truth, "statements . . . of [the painter's] emotions" by the landscape painting (III, 104).

Heidegger's description of the storm over the Greek temple indicates a similar expression of emotion: "The building holds its ground against the storm raging above it and so first makes the storm itself manifest in its violence."[7] The forms of the sky around the temple imply what appearances of the sky in an art work—a painting, for instance—can express. Through its appearances of the sky, the painting can express the artist's heightened emotion—his rage, for example—to the observer's intentional consciousness. In this sense, he apprehends a "world" as emotive meaning. By way of the Greek temple Heidegger thus shows that the "truth," the essential nature, of the work of art is the act of being-aware-of, of Being-with, an "earth" and a "world," in this case the forms of the sky and their emotive significance. Similarly, the phenomenological "truth" implicit in *Land's End* is an Idea of Truth, Ruskin's Being-with the visual forms of a rain-cloud that embody an emotive significance, a "world"—Turner's heightened passions about clouds and storm.

Looking at the rain-cloud in *Land's End* and seeing "the intensity of gloom which is attained in pure warm grey," Ruskin knows that this gloom "is not formless, but full of indications of [*Turner's*] character, wild, irregular, shattered, and indefinite." Ruskin also apprehends that the cloud-gloom is

. . . full of the energy of storm, fiery in haste, and yet flinging back out of its motion the fitful swirls of bounding drift, of tortured vapour tossed up like men's hands, as in defiance of the

tempest, the jets of resulting whirlwind, hurled back from the rocks into the face of the coming darkness, which . . . mark the raised passion of the elements. (III, 404)

These visual aspects of *Land's End* embody Turner's emotions—and constitute the painting's significance, or "world." Ruskin sees the gloom of the storm and then becomes aware of Turner's energy and his fiery character. When seeing "the fitful swirls of bounding drift," he feels Turner's restless defiance of nature. Or, when Ruskin sees "the jets of resulting whirlwind," he knows that they, "beyond all other characters, mark the raised passion of the elements." In effect, Ruskin knows that these whirlwinds embody *Turner's* "raised passion," his turbulent emotion felt in response to storm and violent wind on the sea.

From the discussion of Truth of Clouds in *Land's End*, Ruskin moves to a consideration of Truth of Earth in Turner's art.

Truth of Earth in *The Upper Fall of the Tees*

According to Ruskin, the basis of all other Truths in landscape painting is Truth of Earth, which is "the faithful representation of the facts and forms of the bare ground" apart from vegetation or any other natural modification. In nature, the organization of the earth constitutes the structure of the landscape. The same structural organization should inform the landscape painting (III, 425). In general, Truth of Earth concerns accurate representation of mountains. Ruskin divides his consideration of mountains into three parts: "Hence our task will arrange itself into three divisions: the investigation of the central mountains, of the inferior mountains, and of the foreground" (III, 430).

Ruskin applies the aesthetic concerning Truth of Earth to commentary of J.M.W. Turner's *The Upper Fall of the Tees, Yorkshire*. This work, Ruskin explains, is an instance of Turner's "rock-drawing." In a rock face directing "two streams," there are "horizontal lines which indicate the real direction of the strata, and the same lines are given in ascending perspective all along the precipice on the right." Debris in the channel indicates "the force of the water." And results of the long friction of the waterfall on the rock are evident (III, 486-87). Depicting this erosion, the drawing suggests many natural events that occurred and that will occur between rock and water:

In fact, the great quality about Turner's drawings which more especially proves their transcendent truth is, the capability they afford us of reasoning on past and future phenomena, just as if we had the actual rocks before us (III, 487)

This account of *The Upper Fall of the Tees* implies an Idea of Truth, including faithful representation of nature and clear expression of the artist's feelings or

thoughts about it. In this painting, the portrayal of the rock face, its strata, and its eroded forms all constitute a visual aspect of Truth of Earth, "the faithful representation of the facts and forms of the bare ground" (III, 425). The expression, by these eroded rocks, of Turner's thoughts about their future and primarily about their past states, constitutes part of the expressive element of Truth, which includes "statements . . . of [the artist's] emotions, impressions, and thoughts" about nature (III, 104).

The first element of Truth of Earth in *The Upper Fall of the Tees* concerns rocks, strata, and evidences of erosion—all parts of the waterfall that Ruskin sees. In "The Origin of the Work of Art," Heigegger's description of the rocks surrounding the Greek temple is a parallel to this aspect of Truth of Earth. Heidegger says that, "standing there, the building rests on the rocky ground. This resting of the work draws up out of the rock the mystery of that rock's clumsy yet spontaneous support."[8] Thus, according to Hans Jaeger in "Heidegger and the Work of Art," the art work "brings out the true nature of the material."[9] Although the rock surrounding the temple is not part of it as an art work, nevertheless Heidegger's statement means that an art work as such causes elements of its "earth"—forms of rock in a painting, for instance—to appear purely as themselves for visual consciousness. Like the rocks around the Greek temple, the rocks in Turner's *The Upper Fall of the Tees* constitute its "earth," its Truth of Earth as accurate "representation of the facts and forms of the bare ground" (III, 425). The art work, *The Upper Fall of the Tees,* causes these rock forms to appear to Ruskin's sight only *as* themselves. He sees, for example, "in the great face of rock which divides the two streams, horizontal lines which indicate the *real* direction of the strata." (Italics mine.)

Furthermore, such visual phenomena of the represented waterfall have a temporal significance for Ruskin's consciousness. He apprehends an aspect of expressive Truth in the painting and its statement of Turner's thoughts about past states of the fall. This aspect of Truth is an example of historical Truth, which Ruskin has explained in the section of *Modern Painters I* called "General Principles Respecting Ideas of Truth":

> It ought farther to be observed respecting truths in general, that those are always most valuable which are most historical; that is, which tell us most about the past and future states of the object to which they belong. . . . Talkative facts are always more interesting and more important than silent ones the lines in a crag which mark its stratification, and how it has been washed and rounded by water, or twisted and drawn out in fire, and more important, because they tell us more than the stains of the lichens which change year by year, and the accidental fissures of frost or decomposition; not but that both of these are historical, but historical in a less distinct manner, and for shorter periods. (III, 163)

Interpreted according to this temporal perspective, the past effects of flowing water on rocks are historical Truths, "talkative facts" that Ruskin becomes aware of when he sees eroded rocks represented in *The Upper Fall of*

the Tees. And these historical Truths are Turner's thoughts, expressed by the rock forms in the painting (its "earth") and constituting its meaning (or "world"). Since this meaning is temporal, or historical, when Ruskin is conscious of it it becomes a phenomenological mode of "understanding"—a "repetition" of past existence. According to Heidegger in *Being and Time,* "repetition" is the self's awareness of past possibilities of existence.

With respect to *The Upper Fall of the Tees,* the "repetition" of the past is Ruskin's Being-with the "earth" of the painting insofar as its represented geological forms express Turner's thoughts about past states of the fall itself. That is, when Ruskin sees forms of rocks in the painting, then he becomes aware of their past significance:

> With this drawing before him, a geologist [i.e. Ruskin] could give a lecture upon the whole system of aqueous erosion, and speculate as safely upon the past and future states of this very spot, as if he were standing and getting wet with the spray. He would tell you at once, that the waterfall was in a state of rapid recession; that it had once formed a wide cataract just at the place where the figure is sitting on the heap of débris; and that when it was there, part of it came down by the channel on the left, its bed being still marked by the delicately chiselled lines of fissure He would tell you that the fall was then much lower than it is now, and that being lower, it had less force, and cut itself a narrower bed; and that the spot where it reached the higher precipice is marked by the expansion of the wide basin which its increased violence has excavated, and by the gradually increasing concavity of the rocks below, which we see have been hollowed into a complete vault by the elastic bound of the water. (III, 488)

Looking at the rocks, strata, fissures, and hollows represented in *The Upper Fall of the Tees* Ruskin becomes aware of a "repetition" of past possibilities of existence. He apprehends Turner's thoughts about past states of the waterfall. As "if he were standing and getting wet with the spray," Ruskin sees, for example, "the channel on the left, its bed being still marked by the delicately chisselled line of fissure." These historical facts tell him what Turner thought about a past state of the waterfall—"that the waterfall was in a state of rapid recession; that it had once formed a wide cataract just at the place where the figure is sitting on the heap of débris." Another historical Truth as a "repetition" of past existence is Ruskin's Being-with Turner's thoughts concerning past levels of the fall. Ruskin becomes aware of these thoughts, meanings of the art work, by seeing the results of the water flowing at different levels. In particular, apprehending Turner's thought "that the fall was then much lower than it is now," Ruskin sees

> . . . that the spot where it reached the higher precipice is marked by the expansion of the wide basin which its increased violence has excavated, and the gradually increasing concavity of the rocks below, which we see have been hollowed into a complete vault by the elastic bound of the water.

In the ways outlined, then, Ruskin's commentary on *The Upper Fall of the Tees* concerns historical Truths, "talkative facts" informing him of Turner's thoughts about past states of the waterfall.

Truth of Water and *The Slave Ship*

In *Modern Painters I,* Ruskin's most extensive description of nature and his fullest criticisms of paintings by Turner occur in the climactic section of this volume, "Of Truth of Water."

Describing his visual and mental impressions of actual waves on the sea Ruskin says that, viewed from a short distance beyond the shore, the backs of breakers advancing towards the beach exhibit long, varied, and curved lines "expressive both of velocity and power." Each breaking wave

> . . . appears to the mind a separate individual, whose part being performed, it perishes, and is succeeded by another; and there is nothing in this to impress us with the idea of restlessness, any more than in any successive and continuous functions of life and death. But it is when we perceive that it is no succession of wave, but the same water, constantly rising, and crashing, and recoiling, and rolling in again in new forms and with fresh fury, that we perceive the perturbed spirit, and feel the intensity of its unwearied rage. (III, 563)

Interpreted according to Edmund Husserl's phenomenological perspective, this account of sea-waves describes what Ruskin is aware of when looking at them. According to Husserl's *Logical Investigations,* acts of consciousness that are directed toward something are called intentions. And the ways that consciousness is directed toward its correlates are called quantities of the intention. Thus, the observer can experience a perception of something, an emotion or a thought about it, and so on. Furthermore, whatever consciousness is directed toward whether it be a perceived entity, a feeling, or a thought, is an intentional object.

In Ruskin's description, then, one intention is perceptual. At a distance from the shore, each "wave around us appears vast [to the eye], every one different from all the rest . . ." (III, 563). Another intention combines perception and thought. Seeing the long, curved, and varied lines of advancing breakers, Ruskin thinks about these lines; they are "expressive both of velocity and power." Or, seeing "waves that successively approach and break," Ruskin knows that "each appears to the mind a separate individual, whose part being performed, it perishes, and is succeeded by another. . . ." Still other intentions are both perceptual and emotional. When Ruskin sees "that it is not succession of wave, but the same water, constantly rising, and crashing, and recoiling, and rolling in again in new forms," he feels its "fresh fury," its "perturbed spirit," and "the intensity of its unwearied rage." Throughout all of these phenomenological descriptions, the correlates of these intentions are

simply the waves that he sees, their power and individuality that he thinks about, and their rage that he is aware of emotionally.

And interpreted according to Martin Heidegger's phenomenological perspective in "The Origin of the Work of Art," Ruskin's account of waves concerns the art implicit in them. The art work, Heidegger explains, interprets what is already inherent in nature:

> True, there lies hidden in nature a rift-design, a measure and a boundary and, tied to it, a capacity for bringing forth—that is, art. But it is equally certain that this art hidden in nature becomes manifest only through the work, because it lies originally in the work.[10]

A correlate of intentional consciousness, the "rift-design" immanent in nature is the contrast between its "measure and . . . boundary" and its "capacity for bringing forth"—respectively, between its appearance for sight and its meaning for the mind. Ruskin's apprehension of sea-waves has a similar contrast. For example, he sees "the same water, constantly rising, and crashing, and recoiling, and rolling in again in new forms and with fresh fury." He then apprehends the motive meaning that this natural phenomenon has for his consciousness. Looking at the wave, he perceives its "perturbed spirit" and feels "the intensity of its unwearied rage" (III, 563). In the sense of having this phenomenological contrast between perceived form and understood significance, Ruskin's account of sea-waves concerns the art hidden—or immanent—in the natural world.

According to Heidegger, the "art hidden in nature becomes manifest only through the work."[11] That is, the contrast inherent in nature between form and meaning becomes manifest in the work of art. J.M.W. Turner's *The Slave Ship* manifests such a contrast between form and meaning to Ruskin's consciousness. On one hand, he perceives a representation of waves, the sea, the sky, and a ship from which slaves were cast overboard. On the other, by viewing this representation, he apprehends its meaning, and Turner's impression of the scene:

> But, I think, the noblest sea that Turner has ever painted, and, if so, the noblest certainly ever painted by man, is that of the Slave Ship, the chief Academy picture of the Exhibition of 1840. It is a sunset on the Atlantic, after prolonged storm; but the storm is partially lulled, and the torn and streaming rain-clouds are moving in scarlet lines to lose themselves in the hollow of the night. The whole surface of the sea included in the picture is divided into two ridges of enormous swell, not high, nor local, but a low broad heaving of the whole ocean, like the lifting of its bosom by deepdrawn breath after the torture of the storm. Between these two ridges the fire of the sunset falls along the trough of the sea, dyeing it with an awful but glorious light, the intense and lurid splendour which burns like gold, and bathes like blood. Along this fiery path and valley, the tossing waves by which the swell of the sea is restlessly divided, lift themselves in dark, indefinite, fantastic forms, each casting a faint and ghastly shadow behind it along the illuminated foam. They do not rise everywhere, but three or four together in wild groups, fitfully and furiously, as the under strength of the swell

compels or permits them; leaving between them treacherous spaces of level and whirling water, now lighted with green and lamp-like fire, now flashing back the gold of the declining sun, now fearfully dyed from above with the undistinguishable images of the burning clouds, which fall upon them in flakes of crimson and scarlet, and give to the reckless waves the added motion of their own fiery flying. Purple and blue, the lurid shadows of the hollow breakers are cast upon the mist of night, which gathers cold and low, advancing like the shadow of death upon the guilty ship as it labours amidst the lightning of the sea, its thin masts written upon the sky in lines of blood, girded with condemnation in that fearful hue which signs the sky with horror, and mixes its flaming flood with the sunlight, and, cast far along the desolate heave of the sepulchral waves, incarnadines the multitudinous sea.

I believe, if I were reduced to rest Turner's immortality upon any single work, I should choose this. . . . its drawing [is] as accurate as fearless; the ship buoyant, bending, and full of motion; its tones as true as they are wonderful; and the whole picture dedicated to the most sublime of subject and impressions . . . the power, majesty, and earthfulness of the open, deep, illimitable sea. (III, 571-73)

This commentary indicates the *The Slave Ship* embodies an Idea of Truth, having "reference to statements both of the qualities of material things, and of [the painter's] emotions, impressions, and thoughts" (III, 104). Referring to the representational aspect of Truth in this painting, Ruskin asserts: "Its drawing [is] as accurate as fearless; the ship [is] buoyant, bending, and full of motion; its tones [are] as true as they are wonderful. . . ." And the expressive element of Truth in the painting concerns Turner's thoughts and feelings about the scene depicting the death of slaves; that is, "the whole picture [is] dedicated to the most sublime of subjects and impressions . . . the power, majesty, and deathfulness of the open, deep, illimitable sea." Here, Ruskin is visually conscious of accurate drawing and is mentally aware of its expression—Turner's thoughts and feelings about the scene itself.

Understood not descriptively but hermeneutically, the representational aspect of Truth in *The Slave Ship* is its phenomenological "earth," visual form. Commenting on the sea near the Greek temple, Heidegger asserts: "The steadfastness of the work contrasts with the surge of the surf, and its own repose brings out the raging of the sea."[12] Although the temple-work itself does not portray the sea, yet Heidegger implies that the art work (such as a painting) can manifest visual appearances of the sea, *as* themselves, to consciousness. These constitute the "earth" of the work of art. And Ruskin's perceptual awareness of *The Slave Ship* is his Being-with the "earth" of the painting, its representational form. For example, he sees that "it is a sunset on the Atlantic, after prolonged storm . . . ," that "the torn and streaming rain-clouds are moving in scarlet lines to lose themselves in the hollow of the night," and that "the sunset falls along the trough of the sea, dyeing it with an awful but glorious light. . . ." Or, he perceives "the lurid shadows of the hollow breakers" on night mist, "the guilty ship as it labours amidst the lightning of the sea," and "that fearful hue which signs the sky with horror, and mixes its flaming flood with the sunlight, and, cast far along the desolate heave of the sepulchral waves, incarnadines the multitudinous sea."

And the expressive aspect of the Idea of Truth in *The Slave Ship* is its "world," or meaning, constituted by Turner's emotions and thoughts and apprehended by Ruskin. Concerning the "world" of the Greek temple as an art work, Heidegger remarks:

> It is the temple-work that first fits together and at the same time gathers around itself the unity of those paths and relations in which birth and death, disaster and blessing, victory and disgrace, endurance and decline acquire the shape of destiny for human being. The all-governing expanse of this open relational context is the world of this historical people.[13]

Expressed by form (an "earth") and apprehended by Heidegger's consciousness, the "world" of the temple-work, or of any art work, can be its emotive or conceptual significance concerning the destiny of human beings. Correspondently, looking at representational forms of *The Slave Ship*, Ruskin becomes aware of its "world." For example, he apprehends Turner's feelings and thoughts about the disaster and death of the slaves. Specifically, Ruskin feels Turner's unrest, fury, indignation, and horror at the murder, emotions and thoughts expressed by (for example) "the tossing waves" that rise "three or four together in wild groups, fitfully and furiously" and by "that fearful hue which signs the sky with horror."

Constituting the "world" of *The Slave Ship*, Ruskin's apprehension of Turner's feeling and thoughts about the slaves and about their murderers also constitutes an important instance of historical Truth in *Modern Painters I*. With respect to historical Truth, Ruskin asserts: "It ought farther to be observed respecting truths in general, that those are always most valuable which are most historical; that is, which tell us most about the past and future states of the object to which they belong" (III, 163). Constituting the temporal meaning, the "world," of the landscape painting, such historical truths are what Heidegger, in *Being and Time*, calls "repetition," "moment of vision," and "anticipation"—all temporal modes of "understanding." Historical Truth is concerned primarily with the first and the last modes—"repetition" as the self's consciousness of possibilities of existence that occurred in the past and "anticipation" as his Being-with possibilities of existence that will occur in the future.

These historical Truths are implicit in the latter part of Ruskin's commentary on *The Slave Ship*:

> Purple and blue, the lurid shadows of the hollow breakers are cast upon the mist of night, which gathers cold and low, advancing like the shadow of death upon the guilty ship as it labours amidst the lightening of the sea, its thin masts written upon the sky in lines of blood, girded with condemnation in that fearful hue which signs the sky with horror, and mixes its flaming flood with the sunlight, and, cast far along the desolate heave of the sepulchral waves, incarnadines the multitudinous sea.

Past historical Truths are evident at the beginning of this statement and future ones at the end. As historical Truth, a "repetition" of past modes of existence is Ruskin's consciousness of, his Being-with Turner's thoughts about past events that occurred on the sea. When seeing "the mist of night, which gathers cold and low, advancing . . . upon the guilty ship as it labours amidst the lighting of the sea, its thin masts written upon the sky in lines of blood," Ruskin understands Turner's certainty about a past deed, the murder of the slaves, and about the guilt of those on the ship who cast them overboard.

Furthermore, by seeing the red sea and the red sky of *The Slave Ship,* Ruskin becomes aware of Turner's view about the future of the murderers. In this sense of historical Truth, "anticipation" is Ruskin's Being-with the murderers' future possibilities of existence. Apprehending Turner's thought about their future, Ruskin knows that since the Divine, in wrath, has condemned them, in the future, as the result of this judgment, they will probably degenerate as human beings and will possibly meet violent deaths. Ruskin surmises this fate because he interprets his visual perception of the ship's masts, "girded with *condemnation* in that fearful hue which signs the sky with horror, and mixes its flaming flood with the skylight, and, cast far along the desolate heave of the sepulchral waves, incarnadines the multitudinous sea." (Italics mine.)

Ruskin's historical analysis of J.M.W. Turner's *The Slave Ship,* according to the Idea of Truth, completes the section of Truth of Water in *Modern Painters I.*

Conclusions—the Phenomenological Aesthetic of *Modern Painters I*

In conclusion, when interpreted with Martin Heidegger's aesthetic in "The Origin of the Work of Art," Ruskin's aesthetic theory in *Modern Painters I* is an ingenious development of Locke's concept of the "idea." The "idea" itself, applied to landscape painting, comprises Ruskin's perception of the work and his understanding of the meaning embodied in it by the painter. And Ruskin's awareness of the contrast between precept and meaning is the phenomenological origin of the landscape painting. By expanding the Idea of landscape art into his visual awareness of "the faithful statement, either to the mind or senses, of any fact of nature" and his mental awareness of the expression, or statement, of the painter's "emotions, impressions, and thoughts" about nature (III, 104)—Ruskin thereby arrives at the Idea of Truth. As phenomenological "truth," the essential nature of the landscape painting is Ruskin's Beingwith a visual "earth" (representational form) corresponding to nature and expressing a meaningful "world," the artist's feelings and thoughts about nature. Consequently, the "creation" of the landscape painting by the artist is his awareness of establishing an Idea of Truth in it. In this sense, the landscape

painter's "creation" of phenomenological "truth" in the painting determines the spectator's "preservation" of it—by inducing "in the spectator's mind the faithful conception of any natural objects whatsoever" and by informing "him of the thoughts and feelings with which these were regarded by the artist himself" (III, 133).

Throughout the remainder of *Modern Painters I,* Ruskin expands the Idea of Truth in two basic ways. First, he elaborates the representational element of Truth into the Truth of Tone, Colour, Chiaroscuro, and Space, each indicating particular ways in which the painter should represent nature. When he creates Tone, for example, his eye must tell him that he is depicting "the exact relief and relation of objects against and to each other in substance and darkness, as they are nearer or more distant" (III, 259-60). Finally, with respect to the Truths of Skies, Earth, and Water, Ruskin applies the Idea of Truth to interpretation of certain major landscape paintings by Turner. In the commentary on *The Slave Ship,* Ruskin even implicitly extends the meaning of Truth temporally. The "earth" of the painting, its representational form, is Ruskin's visual perception of the ship, the red ocean, and the red sky, all colored by diminishing sunlight. And the "world" of the painting, its meaning, is historical. When Ruskin sees "the guilty ship as it labours amidst the lightning of the sea" (III, 572), he apprehends an expression of Turner's thought about the past, that is, about the guilt of those on the ship who murdered the slaves. Or, when Ruskin sees the ship's masts "girded with condemnation in that fearful hue which signs the sky with horror" (III, 572), he then understands an expression of Turner's thought about the future; that is, God's condemnation of the murderers could cause their eventual decline and death.

Just as Ruskin expands the landscape Idea into the Idea of Truth in order to develop the aesthetic of *Modern Painters I,* so also he expands the Idea of Beauty in order to develop the religious aesthetic of *Modern Painters II.*

The Aesthetic of Beauty
in *Modern Painters II*

When the first volume of *Modern Painters* was published in May of 1843, Ruskin was already working on *Modern Painters II*. But (according to Van Akin Burd) during the following year, Ruskin's work, based on a "plan to work out Turner's theory of beauty," did not progress satisfactorily; and "the slow progress on the book seems to have been due to Ruskin's gradual realization that his plans lacked a satisfactory psychology of the imagination."[1] In 1844, he read *De la Poésie Chrétienne* (1836)[2] by A. F. Rio, which identified religious art with great art and thereby (eventually) created widespread sympathy for Pre-Raphaelite painters;[3] and for Rio, Fra Angelico was the greatest painter before Raphael.[4] Then (according to George P. Landow), in 1845, Ruskin "set out, armed with new knowledge and new enthusiasms, to examine the art of Italy more closely than he had ever done before."[5] And during this journey, Burd explains, Ruskin "came to understand the powers of the artist's imagination in the perception of beauty."[6]

Tracing the growth of this understanding by analyzing Ruskin's letters written "to his parents while he was abroad in 1845," Burd maintains that "the shift during the summer of Ruskin's preferences from Fra Angelico to Tintoretto signified, I think, his gradual discovery of the imagination as a faculty marked by discipline as well as spontaneity."[7] Elaborating this comment, Burd continues:

> The full capacities of the imagination burst upon Ruskin at Venice when he came upon the pictures of the then little-known Tintoretto. Everything which Ruskin had learned through Turner and the experiences of this summer he now saw synthesized in this Venetian painter. He saw first the great penetrative vigor of the Venetian's imagination. The figure of the young girl in Tintoretto's "Presentation of the Young Madonna," her head crowned in soft light, was "made so naturally and so perfectly the centre of all, and its child simplicity and purity so preserved" that Ruskin declared he knew of no other representation of this subject "in which so much reality and sweetness of impression is obtained." Posessed of infinite

vitality, Tintoretto's imagination had the capacity to animate whatever it touched. "The Last Judgment" was not an effort to portray any single emotion but was instead "the great *sensation* of re-awakened life."[8]

Thus, Burd concludes, "from his Italian tour Ruskin had gained the needed insight and impulse to continue his work on *Modern Painters.*"[9] In general, he gained an increased capacity for aesthetic appreciation, a knowledge of fifteenth and sixteenth century Italian religious art, and deepened understanding of the function of artistic imagination—especially of Tintoretto's capacity for penetrative as well as reasoned insight and expression.[10]

Correspondingly, the religious aesthetic of *Modern Painters II* has three basic aspects: a theory of artistic creation, a theory of the art work itself, and a theory of aesthetic appreciation. Ruskin begins with his theory of appreciation, the aesthetic of the Theoretic Faculty. He follows with an aesthetic of Beauty, pertaining to the art work itself. And he concludes with an aesthetic of Imagination, a theory explaining the creation of the work. Each of these three theories is concerned, in different ways, with Beauty.

Whereas the aesthetic of *Modern Painters I* concerns Truth, founded on accurate representation of the natural world, the aesthetic of *Modern Painters II,* Ruskin maintains, concerns Beauty, particularly as the result of Imagination:

> All entirely bad works of art may be divided into those which, professing to be imaginative, bear no stamp of imagination, and are therefore false; and those which, professing to be representative of matter, miss of the representation, and are therefore nugatory.
>
> It is the habit of most observers to regard art as representative of matter, and to look only for the entireness of representation; and it was to this view of art that I limited the arguments of the former sections of the present work, wherein, having to oppose the conclusions of a criticism entirely based upon the realist system, I was compelled to meet that criticism on its own grounds. But the greater parts of works of art, more especially those devoted to the expression of ideas of beauty, are the results of the agency of imagination, their worthiness depending, as above stated, on the healthy condition of the imagination. (IV, 165)

Ideas of Beauty are, then, the results in art of the painter's Imagination. They characterize the art work itself, because it expresses them. And by means of the Theoretic Faculty, the observer apprehends them in the painting (IV, 35).

Furthermore, understood in the perspective of subject and object, these three theories are not mutually consistent with each other. The artist's Imagination establishes his subjective Ideas of Beauty in the art work; they "are the results of the agency of imagination." But Ideas of Beauty are also objective, because they characterize the painting itself; that is, the important elements of art work are "devoted to the expression of ideas of beauty."

Finally, Ideas of Beauty are again subjective, because they are partially constituted by the observer's responses to art; that is, Ruskin maintains that sensory perception of art *and* several responses to it (including joy, love, and thankfulness) constitute "an idea of beauty, and that "no idea can be at all considered as in any way an idea of beauty, until it be made up of those emotions."(IV,48-49). In general, then, the concept of Beauty renders Ruskin's aesthetic inconsistent, because Beauty cannot be subjective for the observer as well as for the painter and objective in the painting itself.

But understood phenomenologically, this threefold aesthetic is consistent. As we have seen in the analysis of the aesthetic theory in *Modern Painters I*, Ruskin bases his reasoning about art on the Idea, deriving it from John Locke's *An Essay Concerning Human Understanding* (1690). Locke, according to Henry Ladd's *The Victorian Morality of Art*, explains the activity of cognition according to faculties inherent in man as a self-conscious being. "Ideas" are not real external qualities, but are perceptions of the mind.[11] Since the Lockean "idea" comprises visual sensation as well as its understood significance, then the Idea of landscape painting becomes Ruskin's visual awareness of its external appearances as well as his mental awareness of its meaning, an expression of the painter's thought and feeling. And since the Idea of Beauty as well as the Idea of Truth derive from Locke's "idea," then the aesthetic of *Modern Painters II*, as well as that of *Modern Painters I* concerns a theory of visual and mental perception. Described phenomenologically with Husserl's theory of intentionality, this aesthetic is consistent. The mind, Husserl explains, can be directed toward visual entities and their meanings; therefore, these percepts and meanings are neither subjection nor objective. Instead, they are the correlates, the intentional objects, of intentional consciousness. They are *what* the mind is aware of. Derived from the Lockean 'idea," comprising both visual perception and its significance for the mind, the Idea of Beauty thus includes visual perception of painting and mental awareness of its meaning.

This intentional perspective can clearly distiguish the three parts of Ruskin's aesthetic in *Modern Painters II* and also can describe them consistently. Specifically, the theory of Imagination concerns what the painter is aware of when he creates the painting. He sees its form take shape under his brush and becomes aware of expressing an Idea of Beauty through this form; in this phenomenological sense, "ideas of beauty" result from "the agency of imagination." The painting itself comprises the visual form that Ruskin sees and its meaning that he apprehends. The painting exists for his consciousness in these modes because art is "devoted to the expression of ideas of beauty" (V, 165). Finally, when appreciating art by means of the Theoretic Faculty the observer sees the form of the work and thereby becomes aware of its emotive significance, its Beauty, because the Theoretic Faculty "is concerned with the moral perception and appreciation of ideas of beauty" (V, 35).

When described phenomenologically, Ruskin's theory of Imagination and his aesthetic of the Theoretic Faculty are interdependent. Through Imagination, the painter becomes aware of creating Beauty in art; and through the Theoretic Faculty, the observer apprehends Beauty in art. Ruskin emphasizes this interdependence:

> The second great faculty is the Imagination, which the mind exercises in a certain mode of regarding or combining the ideas it has received from external nature, and the operations of which become in their turn objects of the theoretic faculty to other minds. (IV, 36)

The phenomenological Ideas of Beauty established in the painting by the artist's Imagination become intentional correlates for the observer's Theoretic Faculty. In "The Origin of the Work of Art," Heidegger interprets this kind of interdependence between the artist and the observer: "Just as a work cannot be without being created but is esentially in need of creators, so what is created cannot itself come into being without those who preserve it' (66). Thus, the work of art depends on "creation" and on "preservation" for its existence. In order for the work to exist, the artist must be aware of creating it, and the observer must be aware of what the artist has created. Similarly, in order for Ideas of Beauty to exist in the painting, the painter's mind first must have been aware of "a certain mode of regarding or combining the ideas it has received from external nature." And Beauty in the art work also exists because the observer apprehends the results of the artist's Imagination, "the operations of which become in their turn objects of the theoretic faculty to other minds."

In general, then, in *Modern Painters II* Ruskin presents a phenomenological aesthetic having three major parts: Concerning the Imagination or the creation of the painting, concerning the Beauty of the art work or its Typical and Vital Beauty, and concerning the Theoretic Faculty or the appreciation of art.

The Aesthetic of the Theoretic Faculty

The religious aesthetic of the Theoretic Faculty concerns the observer's apprehension of painting. By way of contrast, Ruskin outlines a particular mode of apprehending art that should be avoided by the discriminating observer. This mode is purely sensory, and Ruskin calls it "aesthesis":

> Now the term "aesthesis" properly signifies mere sensual perception of the outward qualities and necessary effects of bodies; in which sense only, if we would arrive at any accurate conclusions on this difficult subject, it should always be used. (IV, 42)

Furthermore, to call the Theoretic Faculty "Aesthetic, degrading it to a mere operation of sense," is an error, Ruskin asserts (IV, 35); thus, he rejected a solely visual mode of apprehending art.

Martin Heidegger's hermeneutic of the art work also includes a rejection of purely sensory awareness of art. He calls this mode of apprehension "aisthesis" and rejects the traditional concept of art as the object of sensory perception:

Almost from the time when specialized thinking about art and the artist began, this thought was called aesthetic. Aesthetics takes the work of art as an object, the object of *aisthesis,* of sensuous apprehension in the wide sense. Today we call this apprehension experience. The way in which man experiences art is supposed to give information about its nature. Yet perhaps experience is the element in which art dies. The dying occurs so slowly that it takes a few centuries.[12]

"Aisthesis," then, is purely "sensuous apprehension" of the art work. That is, "aisthesis" is the observer's Being-with the work *only* visually. He has a purely visual experience of it. He simply sees it. And, Heidegger says, this kind of "experience is the element in which art dies" because (he implies) purely sensory experience of art is ordinary and inauthentic. *Anyone* can be aware of a work of art simply by seeing it. Correspondingly, Ruskin rejects what Heidegger calls "aisthesis"— merely visual apprehension of the art work. Aesthesis, Ruskin asserts, is "mere sensual perception of the outward qualities and necessary effects of bodies" portrayed in painting. And this mode of apprehending art, by simply *seeing* it, is ordinary, usual, inauthentic. Any person can be aware of painting according to Aesthesis, "the mere animal consciousness of the pleasantness" of sight (VI, 47).

In contrast to the concept of Aesthesis, the religious concept of the Theoretic Faculty concerns not anyone's but only Ruskin's apprehension of art. In this sense, his experience of painting is unusual. In general, Ruskin's visual *and* moral perception of the painting evokes unusual (i.e. "exulting, reverent, and grateful") responses in him (IV, 35, 46-47).

Thus, in order to apprehend an Idea of Beauty in the painting, Ruskin must suspend Aesthesis, the ordinary, purely sensory consciousness of art. He then is able to experience a visual and moral perception of its form and consequently becomes aware of his unusual responses to it. They constitute the emotive meaning of the work for him. In these ways, Ruskin apprehends Beauty by means of the Theoretic Faculty.

This decision to avoid Aesthesis in order to apprehend Beauty is the kind of phenomenological choice that Martin Heidegger interprets as "willing." In general, "willing" concerns the "preservation" of, a participation in, the work of art by its observer. According to "The Origin of the Work of Art," "willing is the sober resolution of that existential self-transcendence which exposes itself to the openness of beings as it is set into the work."[13] Here, "self-transcendence" concerns the observer's decision not to apprehend the art work in a habitual, ordinary manner (e.g. according to "aisthesis") but to

apprehend it in an unusual way or as unusual in itself. The phrase "openness of beings" signifies that their unusual meaning is "open," evident, for the observer's consciousness. Apprehending this meaning of the art work, its unusual emotive or conceptual significance, the observer is conscious of a "world." And, since the observer is aware of "the openness of beings as it is *set into* the work [italics mine]," he knows that the meaning of the work is expressed *by* its unusual form, an "earth." Apprehended by the observer, the form and the meaning of the art work are authentic, because only *one* observer (i.e. Heidegger)—not anyone—can be aware of art as unusual. In this sense, the observer's apprehension of the art work is his authentic "preservation" of it. This "preservation" is his Being-with an authentic "earth" and an authentic "world" in the work of art. Thus, as "willing," "preservation" is the observer's decision not to apprehend the work in a habitual way but instead to suspend this habit and thereby become aware of unusual form and unusual meaning in the work of art.

Similarly, when apprehending the painting, Ruskin decides not merely to apprehend it according to Aesthesis but to apprehend it visually and mentally according to the operation of the Theoretic Faculty:

> But when, instead of being scattered, interrupted, or chance-distributed, they [i.e. visual forms] are gathered together, and so arranged to enhance each other as by chance they could not be, there is caused by them not only a feeling of strong affection towards the object in which they exist, but a perception of purpose and adaptation of it to our desires; a perception, therefore, of the immediate operation of the Intelligence which so formed us, and so feeds us.
>
> Out of which perception arise Joy, Admiration, and Gratitude.
>
> Now the mere animal consciousness of the pleasantness [i.e. of perceptions] I call Aesthesis; but the exulting, reverent, and grateful perception of it I call Theoria. For this, and this only, is the full comprehension and contemplation of the Beautiful as a gift of God; a gift not necessary to our being, but added to, and elevating it, and twofold: first of the desire, and secondly of the thing desired. (IV, 46-47)

Ruskin's phenomenological apprehension of art according to the Theoretic Faculty involves his authentic "preservation" of it by "willing." On one hand, he decides not to be aware of art in a habitual, inauthentic manner, something anyone can do. He rejects Aesthesis, "the mere animal consciousness" of the visual aspects of art. Anyone, Ruskin implies, can simply stare at the painting. On the other hand, he decides to become aware of the painting with Theoria. Its function is authentic, because Ruskin's visual perception of the work is unusual in combination with his moral contemplation of it. The Theoretic Faculty, Ruskin says, "is concerned with the moral perception and appreciation of ideas of beauty" (IV, 35).

The phenomena that Ruskin apprehends by means of the Theoretic Faculty constitute his authentic "preservation" of the art work. Initially,

Ruskin's "preservation" of the "earth" of the painting is his visual and moral awareness of its authentic form. This apprehension is Ruskin's Being-with its unusual portrayal of nature. The forms of nature that he sees in the painting are not ordinary, "scattered, interrupted, or chance-distributed"; instead, they are unusual and authentic because "they are gathered together, and so arranged to enhance each other as by chance they could not be" Seeing these interrelated forms and contemplating them morally, Ruskin then becomes aware of his emotional responses to them. His apprehension of these responses is his Being-with the "world" of the painting, the emotive meaning that it has for him. And this meaning is unusual. Specifically, he becomes aware of a spontaneous "feeling of strong affection towards the object [the painting] in which they [i.e. coherent forms] exist." He experiences an individual "perception of [the artist's] purpose and [an] adaptation of . . . [the work] to our desires." Fulfilling this purpose by expressing the painter's religious belief in "the immediate operation of . . . [divine] Intelligence," which created nature and man, the painting therefore causes Ruskin to feel deep "Joy, Admiration, and Gratitude" toward the Creator. Constituting the emotive meaning of the painting for Ruskin's consciousness, all these responses are authentic, because they are unusual—that is, because they are "exulting, reverent, and grateful." And since visual and emotional apprehension of the art work constitutes an Idea of Beauty (IV, 48-49), therefore Ruskin's awareness of the work according to these operations of the Theoretic Faculty is an apprehension of Beauty.

Apprehended by Theoria, Beauty in art is, we have seen, divine:

> Now the mere animal consciousness of the pleasantness [of perceptions] I call Aesthesis; but the exulting, reverent, and grateful perception of it I call Theoria. For this, and this only, is the full comprehension and contemplation of the Beautiful as a gift of God; a gift not necessary to our being, but added to, and elevating it, and twofold: first of the desire, and secondly of the thing desired. (IV, 47)

Referring to Ruskin's religious aesthetic of the Theoretic Faculty, Graham Hough, in *The Last Romantics,* says that study of nature's phenomena becomes "theoria or contemplation," providing the principles behind nature's forms. These principles are stated in Evangelical terms. The observer then sees nature's beauty as God's gift.[14] Hough's statement means that Ruskin's contemplation of nature's forms portrayed in the work informs him of the divine principles underlying these forms. In this sense, Ruskin the observer then apprehends nature in art "as a gift of God"—as divine Beauty.

And since this Beauty is divine, then it is unusual and therefore authentic in the phenomenological sense. According to Martin Heidegger's "The Origin of the Work of Art," the observer's "preservation" of the art work can be his awareness of its authentic "beauty." This apprehension is his Being-with the

unusual form of the art work insofar as this form expresses the essential nature of the work, its unusual "Being." The observer sees form and then becomes aware of the essence of the work. And, as we have seen, "preservation" of art includes what Heidegger calls "willing." The observer must withhold ordinary ways of apprehending art in order to become aware of its authentic "beauty," of its essential "Being" expressed by an unusual form.

In order to apprehend divine Beauty in the art work, Ruskin must suspend Aesthesis, mere sensory perception of the work. Anyone can apprehend art in this way; hence, this mode is ordinary, inauthentic. Rejection of this purely visual way of apprehending the art work is the first aspect of Ruskin's "preservation" as "willing." The second is his decision to become aware of the divine "beauty" of the painting. An apprehension by the Theoretic Faculty, this "preservation" of the work, is Ruskin's Being-with its authentic "beauty," his Being-with its unusual "Being" (or essence) expressed by an unusual form. When he sees the unusual form of the painting, constituting by natural forms "gathered together, and so arranged to enhance each other as by chance they could not be" (IV, 47), he combines this visual apprehension with moral contemplation of these interrelated forms, with "exulting, reverent, and grateful perception of" them. This visual and moral apprehension of form enables Ruskin to understand its expression of the painter's belief in "the immediate operation of the Intelligence which so formed us, and so feeds us" (IV, 47). Consequently, by seeing an interrelated form portraying nature, Ruskin then becomes aware of the underlying essence of the painting, its divine "Being." That is, he understands "the immediate operation" of God's creative intelligence, and of His essential nature which is unusual, or authentic, because it is divine. In this sense, Ruskin's authentic "preservation" of "beauty" in the work of art is "the full comprehension and contemplation of the Beautiful as a gift of God."

Furthermore, Ruskin asserts, this gift is "not necessary to our being, but added to, and elevating it, and twofold: first of the desire, and secondly of the thing desired" (IV, 47). Here, he simply apprehends the effect of phenomenological "beauty" in art on his sensibility. He knows that divine Beauty elevates—that is, enhances—his capacity to perceive it in painting. And this effect is authentic, because it concerns a refinement of his own (but not anyone's) sensibility and (in this sense) is unusual.

Having discussed the operations of the Theoretic Faculty, Ruskin then elaborate its object, the Beauty of the painting. Up to this point, he has referred to Beauty only by way of explaining Theoria. Before presenting his religious aesthetic of Typical and Vital Beauty, however, he discusses four false conceptions of beauty in art.

Ruskin's Rejection "Of False Opinions Held Concerning Beauty"

In his chapter "Of False Opinions Held Concerning Beauty," Ruskin rejects "four . . . current opinions respecting Beauty":

> Those erring or inconsistent positions which I would at once dismiss are: the first, that the Beautiful is the True; the second, that the Beautiful is the Useful; the third, that it is dependent on Custom; and the fourth, that it is dependent on the Association of Ideas. (IV, 66)

With respect to the beautiful as truth, Ruskin rejects the proposition that the beautiful concerns whatever appears to be what it actually is. According to Ruskin, the proposition that "the Beautiful is the True" means that an object appearing as itself in art is beautiful but not as itself is ugly. Visual experience, Ruskin asserts, contradicts this concept:

> A stone looks as truly a stone as a rose looks a rose, and yet is not so beautiful: a cloud may look more like a castle than a cloud, and be the more beautiful on that account. The mirage of the desert is fairer than its sands; the false image of the under heaven fairer than the sea. (IV, 66-67)

Ruskin then rejects the proposition that "the Beautiful is the Useful," primarily because this concept confuses appreciation of art with practical utility concerned basically with the needs of man's physical existence. These include hunger, lust, sensation, and the "brutal appetites" in general. Apprehension of beauty as "the Useful," Ruskin maintains, relegates man's ideas and feelings to the satisfaction of mere physical appetites:

> It is to confound admiration with hunger, love with lust, and life with sensation; it is to assert that the human creature has no ideas and no feelings except those ultimately referable to its brutal appetites. It has not a single fact nor appearance of fact to support it, and needs no combating; at least until its advocates have obtained the consent of the majority of mankind, that the most beautiful productions of nature are seeds and roots; and of art, spades and millstones. (IV, 69)

Martin Heidegger's "The Origin of the Work of Art" also rejects the concept of the art work as something useful:

> These three modes of defining thingness conceive of the thing as a bearer of traits, as the unity of a manifold of sensations, as formed matter. In the course of the history of truth about beings, the interpretations mentioned have also entered into combinations, a matter we may now pass over Thus they give rise to a mode of thought by which we think not only about thing, equipment, and work but about all beings in general. This long-familiar mode of thought preconceives all immediate experience of beings. The preconception shackles reflection on the being of any given entity.[15]

Among these three definitions of the art work as a "thing," the last concerns the observer's consciousness of the work "as formed matter," useful for a purpose.[16] This concept of the work is inauthentic, because anyone can apprehend a work merely as useful. This inauthentic apprehension is any person's Being-with the work "as formed matter," a composition of specific materials with a definite shape and a specific use. And, according to Heidegger, "this long-familiar mode of thought preconceives all immediate experience of beings." That is, commonplace apprehension of the art work merely as a useful entity, as an entity understood only in its utilitarian relation to something *else,* precludes apprehension of it only *as* itself.

In general, Ruskin's discussion of the proposition concerning the beautiful as useful rejects apprehension of the artifact merely as a useful and hence usual "thing," constituted by "formed matter." Apprehending the artifact, anyone can see material forms belonging to it and then understand these merely as useful equipment. Since this kind of apprehension is ordinary, and possible for anyone, it is therefore inauthentic. In particular, Ruskin rejects anyone's Being-with the artifact by confusing genuine appreciation of art with practical utility, concerned only with satisfaction of needs belonging to physical existence. This indifferent observation of the art work as a useful artifact confounds "admiration with hunger, love with lust, and life with sensation," asserts "that the human creature has no ideas and no feelings except those ultimately referable to its brutal appetites," and advocates "that the most beautiful productions of nature are seeds and roots; and of art, spades and millstones."

A third false concept of beauty in art, Ruskin maintains, is based on custom. He rejects the view *"that Beauty results from Custom"*: "Somewhat more rational grounds appear for the assertion that the sense of the Beautiful arises from Familiarity with the object, though even this could not long be maintained by a thinking person" (IV, 67). When the object is unfamiliar, Ruskin argues, a repulsion from ugliness is immediately felt, without any stimulation of affection for the object. Therefore, he says, "most minds" prefer "that to which they are accustomed over that they know not" (IV, 68). Furthermore, repeated apprehension of ugliness diminishes aversion against and strengthens affection for it. Although repeated apprehension of beauty diminishes the "sensations of beauty" far less than repeated experience of ugliness does; nevertheless, in either case, customary or familiar apprehension of art impairs aesthetic sensibility:

> Custom has a two-fold operation; the one to deaden the frequency and force of repeated impressions, the other to endear the familiar object to the affections But however far this operation may be carried, its utmost effect is but the deadening and approximating of the sensations of beauty and ugliness. (IV, 68)

Here, Ruskin rejects a merely habitual manner of visually apprehending painting.

His statement, interpreted in the phenomenological perspective of Heidegger's aesthetic, concerns a customary way of looking at the "earth," the form, of the painting. This kind of visual perception is based on habit and is therefore ordinary, or inauthentic. Consequently, anyone can be aware of the painting in this habitual way. The observer's visual apprehension of the work is simply his Being-with it according to the way in which he has become accustomed to look at art. Since he looks at art thus, he fails to see what the form of the work, its "earth," actually looks like. In particular, the indifferent observer argues *"that Beauty results from Custom."* He simply does not see what the work's form actually looks like, because he maintains "that the sense of the Beautiful arises from [visual] Familiarity with the object. . . ."

He adopts this opinion for several reasons. First, he has felt repulsion from ugliness seen in unfamiliar art; consequently, Ruskin explains, "most minds" prefer "that to which they are accustomed over that they know not." Second, the observer's repeated visual apprehensions of ugliness in painting have diminished his aversion for ugliness and have strengthened his desire to see it. And third, sheer repetition of visual perception of paintings has deadened "the frequency and force of repeated impressions," has endeared the familiar objects portrayed in different paintings to his affections, and therefore has deadened and approximated his "sensations of beauty and ugliness." His visual sensibility for painting impaired in these ways, he consequently prefers to apprehend its visual form, its "earth," just as he always has looked at form in art. Custom, then, concerns his ordinary, inauthentic mode of Being-with the work's visual form, not by apprehending it as itself but only by seeing what he wants to see—those ugly or beautiful aspects of form that he has seen *before.*

The fourth erroneous opinion about beauty in painting is the assertion that beauty depends "on the Association of Ideas" (IV, 66). The argument for Association as beauty, Ruskin says, traditionally includes two basic elements: (1) since Association, like beauty, gives pleasure, then "Association is Beauty," and (2) since "the power of Association is stronger than the power of Beauty, therefore the power of Association *is* the power of Beauty" (IV, 70-71). Ruskin then distinguishes two basic kinds of Association, "Rational and Accidental." According to the theory of "Rational Association," the historical connection of "any object" with man's affections or activities elicits his interest. This theory misuses language by

> . . . involving the positions that in uninhabited countries the vegetation has no grace, the rock no dignity, the cloud no colour, and that the snowy summits of the Alps receive no loveliness from the sunset light, because they have not been polluted by the wrath, ravage, and misery of men. (IV, 71)

This theory of Association founds beauty in painting on historical events suggested to the observer by objects and persons portrayed in the work.

Concerned not with extrinsic, historical events suggested by the art work but instead with the observer's own associative responses to it, the theory of Accidental Association consequently has more importance for Ruskin's rejection of false views of beauty than Rational Association does. According to Accidental Association, material objects often summon involuntary feelings, ideas, and recollections—associations according to which the object is "regarded as agreeeable or otherwise." By means of such associations, pleasure or pain is suggested to the observer usually without his conscious knowlege of the cause (IV, 71-72). Specifying an instance of Accidental Association, Ruskin says:

> I believe that the eye cannot rest on a material form, in a moment of depression or exultation, without communicating to that form a spirit and a life,—a life which will make it afterwards in some degree loved or feared,—a charm or a painfulness for which we shall be unable to account even to ourselves, which will not indeed be perceptable, except by its delicate influence on our judgment in cases of complicated beauty. (IV, 72)

Whereas Custom concerns a careless, habitual way of observing the phenomenological form of the art work, Accidental Association concerns its emotive significance for the careless observer. Looking at the painting, he becomes aware of feelings about it that arise from unconscious associations with it. Constituting the phenomenological "world" of the painting, its emotive meaning for the observer's consciousness, these feelings are ordinary and inauthentic, because anyone can become aware of such emotions by a process of unconscious association. A commonplace apprehension of the painting, this inauthentic "world" is any person's Being-with merely ordinary feelings about the work, feelings determined not by it but instead by Accidental Association. In particular, his "eye cannot rest on a material form, in a moment of depression or exultation, without communicating to that form a spirit and a life,—a life which will make it afterwards in some degree loved or feared" Later, this association, now unconscious, causes him to respond to a painting with pleasure or pain, constituting the emotive meaning of the work for him. He simply feels "a charm or a painfulness for which . . . [he] shall be unable to account even to . . . [himself], which will not indeed be perceptible, except by its delicate influence on . . . [his] judgment in cases of complicated beauty." Since anyone can respond to art according to such unconscious association, then the observer's responses—constituting the emotive significance, the "world," of the painting for his consciousness—are ordinary and inauthentic.

Elaborating his explanation of such commonplace responses to art, Ruskin continues:

Let the eye but rest on a rough piece of branch of curious form during a conversation with a friend, rest however unconsciously, and though the conversation be forgotten, though every circumstance connected with it be as utterly lost to the memory as though it had not been, yet the eye will, through the whole life after, take a certain pleasure in such boughs [i.e. portrayed in art] which it had not before, a pleasure so slight, a trace of feeling so delicate, as to leave us utterly unconscious of its peculiar power; but undestroyable by any reasoning, a part, thenceforward, of out constitution, destroyable only by the same arbitrary process of association by which it was created. (IV, 72-73)

Thus, the observer does not understand the actual, inherent meaning of the painting. He feels only a slight pleasure, aroused by his unconscious association with (for example) "a rough piece of branch of curious form," observed "during a conversation with a friend." Therefore, Ruskin says, "though the conversation be forgotten, though every circumstance connected with it be as utterly lost to the memory as though it had not been," nevertheless the observer "will through the whole life after, take a certain pleasure in such boughs" Consequently, when he sees such boughs represented in a painting, he will feel "a pleasure so slight, a trace of feeling so delicate, as to leave . . . [him] utterly unconscious of its peculiar power."

And thus, responding by association to his apprehension of the painting, the observer becomes aware of the "world" of the work, the emotive meaning it has for him—pleasure. But, since anyone can respond to art in this way, this emotive significance is ordinary, inauthentic, and "undestroyable by any reasoning, a part, thenceforward, of . . . [the observer's] constitution, destroyable only by the same *arbitrary* process of association by which it was created." (Italics mine.)

In general, then, Ruskin's discussion "Of False Opinions Held Concerning Beauty" rejects them as valid standards for Beauty in painting, primarily because each of these views concerns ordinary, inauthentic modes of Being-with art. Typical and Vital Beauty in painting are, however, unusual, being concerned with apprehensions of art that are possible only for Ruskin; therefore, Typical Beauty and Vital Beauty are, in this sense, authentic.

The Aesthetic of Typical and Vital Beauty

In general, Typical Beauty is the symbolization of "Divine attributes" by the external appearances of objects and beings present in nature or portrayed in art. And Vital Beauty is the expression of happiness, vitality, and morality by such appearances (IV, 64, 210).

George P. Landow simply and clearly explains these concepts of Typical and Vital Beauty:

Typical Beauty is the beauty of forms and of certain qualites of forms, which Ruskin now tentatively and now firmly asserts to be aesthetically pleasing because they represent and

embody divine nature. Vital Beauty, on the other hand, is the beauty of living things, and it is concerned not with form but expression—with the expression of the happiness and energy of life, and, in a different manner, with the representation of moral truths by living things.[17]

Landow also gives a consistent interpretation of Ruskin's theory of Typical and Vital Beauty. In this interpretation, the objective forms of nature and of man in art are material. The subjective expression of Ruskin's beliefs and emotions is immaterial. The spiritual—i.e. the religious—informs both the material and the immaterial and thereby reconciles them:

> In both Typical and Vital Beauty the physical object expresses and represents the immaterial. In both forms of the beautiful, the material object, that which is directly perceived, whether it be a human face suffused by joy and nobility or a sweep of Alpine show glorying in unity and modernation, is a symbol through which, or on which, appear the signs of spiritual law. Vital Beauty expresses spirit, mind, and the energy of life, all informed, ultimately, by God. Typical Beauty expresses the nature of God. The twin, and in this case interchangeable, ideas of symbolization and expression grant Ruskin the means of reconciling material and immaterial, for they grant him a way of showing that the beautiful object is beautiful, as far as it is beautiful, because it is spiritual. These ideas of symbolization and expression permit Ruskin to state that beauty is, in the full sense of the word, essential, and they also allow him to defend the pleasures of aesthetic perception as moral, even religious exercises.[18]1

Critical tradition justifies Landow's implication that religion (i.e. the spiritual) is objective and, as such, informs both the material and the immaterial aspects of Typical and Vital Beauty. This implication is particularly evident in his explanation of the relation between Ruskin's loss of faith and his theory of beauty:

> The central theological principle is gone, and once it had departed the theory of Typical Beauty lost all its force; for whereas one can hold that the symbolization in material things of moral qualities is beautiful, unless one can also hold that such symbolization is universal and intentional—a law of nature—beauty becomes a matter of subjective responses. It was thus that the explanation of beauty which most emphasized the objective, universal nature of aesthetic qualities became, once Ruskin lost his faith, an implicitly subjective, personal theory. Vital Beauty, on the other hand, fared somewhat better when Ruskin's beliefs changed, for based as it was on an Aristotelian notion of the happinesss of function, it could easily be modified. To retain the theory of Vital Beauty Ruskin had only to return the central idea of function to its original Aristotelian acceptation and the theory could stand independently.[19]

When Ruskin lost his faith, Typical Beauty became a subjective theory, and Vital Beauty had to be returned "to its original Aristotelian acceptation" in order to "stand independently."

Thus, Landow implies that before Ruskin lost his faith, the theory of Typical and Vital Beauty was objective, because religion informed the

(otherwise) subjective elements of this theory. And thus, Landow's interpretation of symbolization and expression in Ruskin's theory implies that these elements of beauty are objective because they are spritural, or religious—"informed . . . by God." In particular, symbolization enables Ruskin to establish the objectivity of Typical Beauty. According to the aesthetic of Typical Beauty, Landow explains, the material painting symbolizes "the nature of God." That is, the work symbolizes the immaterial—Ruskin's belief in God's nature, a belief which is objective because it is religious. And expression enables Ruskin to establish the objectivity of Vital Beauty. According to Landow's interpretation, the material—the painting portraying plants, animals, and man—expresses Ruskin's "spirit, mind, and . . . energy of life." These characteristics are also objective, because they are spiritual, because God is immanent in them, that is, because they are religious in the Christian sense. Consequently, Ruskin's theory of Typical and Vital Beauty is, Landow implies, consistently objective. Although this interpretation is acceptable, nevertheless it depends on religion, a factor extrinsic to Ruskin's theory, because it became subjective when he abondoned his Evangelical belief in 1858.

Ruskin's theory of Typical and Vital Beauty may also be interpreted phenomenologically. This approach applies to the intrinsic aspects of his theory. Although Landow interprets Beauty primarily as the expression of Ruskin's religious experience—whether as belief or as emotion—nevertheless the intrinsic aspects of his theory concern expression of the *artist's* aesthetic experience, because Beauty in art is the product of Imagination (IV, 165). First, Typical Beauty is the symbolization, by the painting, of the artist's religious belief that God's attributes inform nature and man. When understood in the perspective of subject and object, this theory is inconsistent, because the painting is objective but the symbolization of the artist's religious belief is subjective. That is, in my view, religion itself is primarily subjective. But, when described with Husserl's theory of intentionality, this inconsistency does not appear. According to Husserl's *Logical Investigations,* whatever consciousness is directed toward—whether perceptual objects, feelings, or thoughts—is neither subjective nor objective, but instead is a correlate for intentional consciousness, its intentional object. Ruskin's painting is an intentional object, because he is aware of the work visually. Its symbolization of the painter's religious belief in God's attributes is also an intentional object, because Ruskin is aware of the artist's belief mentally. Second, Vital Beauty is the expression, by the painting, of the artist's happiness, energy, and conscience. Given the subject-object dichotomy, this theory is also inconsistent, because the work is objective but the experience it expresses is subjective. Described phenomenologically, however, the theory of Vital Beauty is

consistent. The painter's joy, energy, and conscience are not subjective, but are intentional. Ruskin becomes aware of these experiences mentally when looking at the art work. As intentional, these experiences can be embodied in the painting itself, because it is not objective but is also intentional. That is, the painting is the objective correlate for Ruskin's visual consciousness; the work is what he sees.

When understood in the perspective of Martin Heidegger's "The Origin of the Work of Art," these phenomenological descriptions of the painting become hermeneutic; they become phenomenological interpretations of it.

As we have seen, Ruskin's fundamental aesthetic of Beauty in nature and in painting has two basic elements; he explains these in detail:

> By the term Beauty, then, properly are signified two things. First, that external quality of bodies already so often spoken of, and which, whether it occur in a stone, flower, beast, or in man, is absolutely identical, which, as I have already asserted, may be shown to be in some sort typical of the Divine attributes, and which therefore I shall, for distinction's sake, call Typical Beauty: and, secondarily, the appearance of felicitous fulfilment of function in living things, more especially of the joyful and right exertion of perfect life in man; and this kind of beauty I shall call Vital Beauty. (IV, 64)

Typical Beauty concerns symbolic forms in the art work that typify characteristics of God. "Beauty," according to Heidegger's aesthetic, is the self's apprehension of expressive form in the work of art. In this sense, "beauty" is his Being-with the work by apprehending its form as an expression of its essential nature, its "Being." When Heidegger sees the form of the work, then he becomes aware of its essence, its "Being." This visual and cognitive apprehension of the work of art is "beauty." As phenomenological "beauty," Typical Beauty, then, is Ruskin's comprehension of the symbolic form of the painting. In particular, he is visually aware of the "external quality of bodies" portrayed in the art work. He sees, for example, the outward appearances of "a stone, flower, beast, or . . . man." By seeing these forms depicting external aspects of nature or of man, Ruskin then becomes aware of the painter's religious belief that God's attributes pervade both. Since these attributes, embodied in the work by the painter, constitute essential characteristics of God, Ruskin consequently knows that the natural or human forms of the painting symbolically express its essential character, its essence, or "Being." By looking at the forms of the painting, he thus apprehends its *divine* "Being." He realizes that the forms of "a stone, flower, beast, or . . . man" are "in some sort typical of the Divine attributes." In this sense, phenomenological "beauty" is Ruskin's Being-with natural or human forms that symbolize "the Divine attributes" belonging to the art work and constituting its divine "Being."

Whereas Typical Beauty concerns the symbolization of "Divine attributes," Vital Beauty concerns "the appearance of felicitous fulfilment of

function in living things, more especially of the joyful and right exertion of perfect life in man." When Ruskin sees appearances of nature and man in the painting, then he apprehends their expression of the artist's happiness and his joyful vitality. Heidegger's aesthetic explains that the visual appearances of the art work constitute its "earth" and that its understood meanings, including emotions, constitute its "world." Ruskin's consciousness of Vital Beauty in the painting is, then, his Being-with its "earth," or appearance, expressing an emotive meaning, or "world." The "earth" of the art work is his perception of the appearances of "living things" and of man. Seeing these forms, he then apprehends their expression of a "world," the emotive meaning of Vital Beauty in the art work. He knows that "the appearance of felicitous fulfilment of function in living things" is an expression of the *painter's* happiness. And Ruskin understands that "the appearance . . . of the joyful and right exertion of perfect life in man" is an expression of the artist's exuberant sense of physical vitality.

Ruskin's aesthetic of Beauty in *Modern Painters II* not only outlines the fundamental aspects of Typical Beauty and Vital Beauty but also elaborates them.

The Elements of Typical Beauty

George P. Landow maintains that the belief in order is central to Ruskin's theory of Typical Beauty.[20] Landow points out that the elements of typical Beauty embody a principal of order—that unity, proportion, and symmetry are kinds of order, that repose and moderation are associated with order, and that purity emphasizes order.[21] Furthermore, Landow asserts, Ruskin derived the elements of Typical Beauty from eighteenth century aesthetic theories concerned with order. Most Neo-classical critics, including Francis Hutcheson and Pope, in "An Essay on Man," affirmed an aesthetic of order derived from nature: "This general emphasis upon order in nature and its recreation or representation in art is related to the idea that the perception of order is itself pleasing and that order produces all or part of the phenomenon of beauty."[22] Thus, according to Landow, "a classical theory of beauty, such as that which he [i.e. Ruskin] elects, considers beauty as a quality which, residing in the object, embodies a principle of order." But "a romantic, or at least internalized, aesthetic considers beauty as an emotion and discusses it not in terms of external qualities of the object but in terms of the psychological experiences for the beholder."[23] "Ruskin's theory of Typical Beauty," Landow therefore concludes, "is an Apollonian, classical aesthetic of order" and hence is apparently inconsistent "with his romantic conceptions of painting and literature,"[24] that is, with his theory of Vital Beauty, which concerns his responses to the art work—happiness, for example.

Described by Edmund Husserl's phenomenological perspective of intentional consciousness and its intentional objects, the elements of Typical Beauty are consistent with Vital Beauty. According to Husserl, whatever consciousness is directed toward, whether a perceptual object, a feeling, or a thought, is neither subjective nor objective, but is instead an intentional correlate of consciousness, an intentional object. Ruskin's theory about the elements of Typical Beauty, based on order, concerns his awareness of intentional objects in painting. For instance, an element of Typical Beauty, Essential Unity concerns a particular way in which Ruskin is visually aware of the art work. Its form is an intentional object for his sight. He sees an order in the forms of the painting, because, although "separately imperfect," they combine "into a perfect whole" (IV, 95). Or, Moderation is an intentional correlate in thought for Ruskin's consciousness. Looking at the painting, he apprehends the painter's conception of divine law, the divine order in the appearances of "material things." Specifically, Ruskin apprehends the painter's thought about God's working, which is "always in consistent modes, called by us laws" (IV, 138). Just as the elements of Typical Beauty, based on order, are intentional objects, so also the aspects of Vital Beauty are intentional correlates for Ruskin's consciousness. Defining Vital Beauty, he maintains that (for example) "every being in a perfect state exhibits certain appearances or evidences of happiness . . ." (IV, 147). Here, perceiving the painting, Ruskin thereby apprehends its Beauty as an expression of emotion—the *painter's* happiness. Thus, the elements of Typical Beauty are consistent with those of Vital Beauty if each aesthetic is understood as a phenomenological description of particular ways in which Ruskin is aware of the art work, either by apprehending its expression of the painter's belief in divine order, or by apprehending its expression of his emotion.

In Ruskin's religious aesthetic of Typical Beauty in *Modern Painters II*, the first basic element of Beauty is Infinity. In general, Infinity is the Beauty of unlimited space (IV, 81). Speaking about the visual aspect of Infinity in nature, Ruskin describes "a light distance appearing over a comparatively dark horizon" (IV, 79). This natural phenomenon symbolizes religious belief:

It is not then by nobler form, it is not by positiveness of hue, it not by intensity of light (for the sun itself at noonday is effectless upon the feelings), that this strange distant space possesses its attractive power. But there is one thing that it has, or suggests, which no other object of sight suggests in equal degree, and that is—Infinity. It is of all visible things the least material, the least finite, the farthest withdrawn from the earth prison-house, the most typical of the nature of God, the most suggestive of the glory of His dwelling-place. For the sky of the night, though we may know it boundless, is dark; it is a studded vault, a roof that seems to shut us in and down; but the bright distance has no limit, we feel its infinity, as we rejoice in its purity of light. (IV, 81)

Described by Husserl's perspective of intentional consciousness, Infinity defines a way in which Ruskin directs his consciousness toward nature. His statements on the Typical Beauty of Infinity indicate a visual, emotional, and religious mode of being aware of nature. Infinity is Ruskin's consciousness of nature by seeing a limitless "light distance," by feeling the attraction of its boundlessness, and by comprehending its symbolization "of the nature of God."

Ruskin applies this way of apprehending nature to appreciation of art itself. In particular, he asserts that if the "expression of infinity is possible" in the art work, then its perfection and evaluation depend on this expression (IV, 81). By applying his apprehension of Infinity in nature to painting as a criterion for it, Ruskin describes not an actual awareness of it but rather a possible one. That is, he indicates what art should be for intentional consciousness.

If infinity were realized in art, initially Ruskin would visually percieve external aspects of nature portrayed in the painting. This apprehension, interpreted with Heidegger's aesthetic in "The Origin of the Work of Art," is Ruskin's possible Being-with the form of the painting, its "earth." Infinity, then, would include a visible "earth," Ruskin's perception of the art work's physical appearances. With respect to Infinity, Ruskin would see unlimited space portrayed in the art work. For instance, he would see "a light distance appearing over a comparatively dark horizon" and know that "the bright distance has no limit" Were Ruskin to see these natural phenomena in a painting, then he would also become aware of his emotional responses to them. These would constitute the emotive meanings of Infinity for his consciousness. And these meanings would therefore constitute what Heidegger calls the "world" of the art work. Thus, the Beauty of Infinity in art is Ruskin's possible Being-with his emotional responses to the visual aspects of Infinity. When seeing such boundless distance, then he would also feel "that this strange distant space possesses . . . attractive power" and would "rejoice in its purity of light."

In that sight of painting and feeling about it contrast, then Ruskin's perception of "distant space" and his apprehension of emotional responses to it would establish what Heidegger calls the "conflict" of the work of art, the complementary contrast between (visual) form and (emotive) meaning. Thus, a visual perception of "a light distance appearing over a comparatively dark horizon" would not have any meaning if Ruskin were not aware "that this strange distant space possesses . . . attractive power." Conversely, this possible emotive significance of the work for Ruskin's consciousness would be irrelevant without a reference to the appearance of distance in the work—its formal aspect, or "earth."

Furthermore, the concept of Infinity shows that sight of infinite distances would *simultaneously* include feeling about them. Thus, the two phenomenological aspects of the painting—its form (or "earth") and its emotive meaning (or "world")—would complete each other and thereby establish a unity. Similarly, according to "The Origin of the Work of Art," the "rift" of the work is the observer's consciousness of the unity of "earth" and "world." The Typical Beauty of Infinity implies such a "rift," or unity, because Ruskin would become aware of his responses to the work, its emotive meanings for him, *when* seeing it. Hence, perception and meaning, "earth" and "world," would be unified in a "rift." For example, "this strange distant space" seen in art would be simultaneously completed by its emotive meaning for Ruskin, because this space "possesses . . . attractive power." Or, when seeing this space, he would simultaneously "feel its infinity . . . [and] rejoice in its purity of light."

And Ruskin would also rejoice in Infinity, because its visual aspects would be "in some sort typical of" a divine attribute belonging to Typical Beauty (IV, 64) which was "typical of the nature of God." Through "the bright distance" of Infinity in the work, the painter could express an aspect of his religious belief concerning "Divine attributes" immanent in nature. Were Ruskin to see Infinity in the painting, he then would become aware of a characteristic of God, embodied in the work by the painter and constituting its essential nature. In this way, Ruskin would become aware of phenomenological "beauty." "Beauty" is, according to Heidegger in "The Origin of the Work of Art," the self's Being-with artistic form expressing the essential character, the "Being," of the art work.

With reference to Infinity, then, Ruskin would first be visually conscious of form in the work—for instance, "a light distance appearing over a comparatively dark horizon." He might see "a light which the eye invariably seeks with a deeper feeling of the beautiful,—the light of the declining or breaking day, and the flakes of scarlet cloud burning like watch-fires in the green sky of the horizon . . ." (IV, 79). And he might see other forms portrayed in the work, such as "the level twilight behind purple hills, or the scarlet arch of dawn over the dark troublous-edged sea" (IV, 80). Seeing such distant, infinite space in art, Ruskin would then know that "there is one thing that it has, or suggests, which no other object of sight suggests in equal degree, and that is— Infinity" (IV, 81). Ruskin would see forms in the work and then know that these express the painter's religious belief in Infinity as one of "the Divine attributes" immanent in nature and now constituting the divine essence, the divine "Being," of the painting itself. Seeing distant natural forms in the work, then he would become conscious that Infinity "is of all visible things the least material, the least finite, the farthest withdrawn from the earth prison-house, the most typical of the nature of God, the most suggestive of the glory of His dwelling-place." As Infinity, phenomenological "beauty" is therefore an

aspect of Typical Beauty, because Ruskin would see aspects of distance and of space symbolizing an aspect of the divine "Being" of the art work and because Typical Beauty concerns its formal aspects that are "in some sort typical of the Divine attributes" (IV, 64).

The second basic element of Typical Beauty is Unity. In general, Unity concerns the interdependence and interconnection of objects portrayed in art (IV, 92). Ruskin distinguishes four basic kinds of Unity: (1) Unity of Origin, in which different things are unified by their common source; (2) Subjectional Unity, in which different things are affected by the same impulse or influence; (3) Unity of Sequence, in which diverse things are unified by an ascending, progressive sequence based on order; and (4) Essential Unity (Unity of Membership), in which different things imperfect when separated yet in combination form "a perfect whole." Essential Unity necessarily includes difference, the variety of things "separately imperfect" that nevertheless combine and perfect each other, forming a harmonious unity in the painting (IV, 94-97). Specifying Essential Unity, Ruskin remarks:

> And there is the unity of Membership, which we may call Essential Unity, which is the unity of things separately imperfect into a perfect whole; and this is the great unity of which other unities are but parts and means; it is in matter the harmony of sounds and consistency of bodies, and among spiritual creatures their love and happiness and very life in God. (IV, 95)

In the painting, Essential Unity is thus a conjunction of natural images, imperfect when separate but perfect when joined together in a whole.

Insofar as Ruskin's consciousness is aware of it visually, such an organic form is what Martin Heideger, in "The Origin of the Work of Art," calls the "Gestalt" of the work. According to Heidegger, the forms of the art work constitute its "earth" for visual consciousness. And insofar as these varied forms are unified in the work, then they constitute its "Gestalt." In other words, the "Gestalt" is the observer's consciousness of, his Being-with, the work of art by seeing its varied but unified form. Thus Essential Unity concerns Ruskin's visual perceptions of the "Gestalt," the unified form, of the painting. Looking at the work, he sees forms of nature having the variety of things that are "separately imperfect" but that combine "into a perfect whole." He sees a "consistency of bodies," a harmony of diverse natural forms portrayed in the work of art. Consequently, when looking at the work, he sees its organically unified "Gestalt."

As a portrayal of animals or of man, the organic visual form of the painting also has an expression—for instance, "among spiritual creatures their love and happiness and very life in God." In effect, since the artist's Imagination creates the painting, then its forms express his love, happiness, and religious life. And the expression of the artist's religious life, his belief in God, by the painting, is clearly implied by Ruskin's opening statement in the chapter "Of Unity, or the Type of Divine Comprehensiveness":

Hence the appearance of separation or isolation in anything, and of self-dependence, is an appearance of imperfection; and all appearances of connection and brotherhood are pleasant and right, both as significative of perfection in the things united, and as typical of that Unity which we attribute to God (IV, 92)

Although imperfect when separated, the forms of nature, of animals, and of man in the painting are perfect when unified. And when unified, these forms typify the painter's belief in one of God's attributes—Unity. In this sense, Essential Unity is an instance of Typical Beauty, which concerns the symbolic "quality of bodies" portrayed in the painting, a quality "which, whether it occur in a stone, flower, beast, or . . . man, . . . may be shown to be in some sort typical of the Divine attributes" (IV, 64).

Thus, when Ruskin sees the organic form of the painting, he then becomes aware of the painter's love and his happiness. He also apprehends the painter's religious belief in one of "the Divine attributes" of Typical Beauty—Unity. Here, Ruskin apprehends the phenomenological "beauty" of the art work—its "Being," or essential nature, manifested by its form. This awareness is Ruskin's Being-with the Typical Beauty of Essential Unity in the work. Although, Ruskin says, "the appearance of separation or isolation in anything . . . is an appearance of imperfection," nevertheless "all appearances of connection and brotherhood are pleasant and right," signifying to the mind the perfection of the natural, animal, and human forms portrayed. Seeing these perfected and unified forms in the painting, Ruskin knows that they express the painter's belief in Unity, one of God's attributes. Embodied in the painting, this concept of divine Unity becomes the essential nature of the work, its *divine* "Being." An instance of Typical Beauty, which concerns the symbolization of "the Divine attributes" by the forms of the art work, the phenomenological "beauty" of Essential Unity is thus Ruskin's awareness of unified forms of nature, animals, and man insofar as these forms symbolize an aspect of God's "Being," and as they are "typical of that Unity which we attribute to God."

Ruskin continues with a discussion of two minor elements of Typical Beauty, Repose and Symmetry, which, although not central to his theory of Typical Beauty, nevertheless deserve mention in passing.

Repose concerns the condition of objects at rest. But "Repose demands for its expression the implied capability of its opposite, Energy: and this even in its lower manifestations, in rocks and stones and trees" (IV, 114, 116). Ruskin characterizes Repose with a description of a natural event. Repose is

. . . the rest of things in which there is vitality or capability of motion actual or imagined: and with respect to these the expression of repose is greater in proportion to the amount and sublimity of action which is *not* taking place, as well as to intensity of the negation of it

having once seen a great rock come down a mountain side, we have a noble sensation of its rest, now bedded immovably among the fern; because the power and fearfulness of its motion were great, and its stability and negation of motion are now great in proportion. (IV, 114-15)

The Repose of objects in nature is their state of rest, which, however, implies their opposite potential for energy and motion. Thus, as Ruskin says, "having once seen a great rock come down a mountain side, we have a noble sensation of its rest, now bedded immovably among the fern" Applying the concept of Repose in nature to the art work, Ruskin then argues that the greatness of the work depends on its appearance of Repose. Repose, he asserts, is "the most unfailing test of beauty" in the work of art (IV, 117-18).

Although Ruksin thus maintains the importance of Repose in art, yet this theory has only secondary importance for his aesthetic of Typical Beauty, primarily because Repose includes an aspect of Evangelical theology concerned with man's fallen, sinful state. Repose, Ruskin explains,

> . . . is the especial and separating characteristic of the eternal mind and power. It is the "I am" of the Creator opposed to the "I become" of all creatures And as we saw before that the infinity which was a type of the Divine nature on the one hand, became yet more desirable on the other from its peculiar address to our prison hopes, and to the expectations of an unsatisfied and unaccomplished existence; so the types of this third attribute of the Deity might seem to have been rendered farther attractive to mortal instinct through the infliction upon the fallen creature of a curse necessitating a labour once unnatural and still most painful; so that the desire of rest planted in the heart is no sensual nor unworthy one, but a longing for renovation and for escape from a state whose every phase is mere preparation for another equally transitory, to one in which permanence shall have become possible through perfection. (IV, 113-14)

Thus, from the perspective of Evangelical theology, Repose is a central element of Typical Beauty; however, from the perspective of aesthetic theory as such, Repose has only secondary importance as an element of Typical Beauty in art.

The other secondary aspect of Typical Beauty is Symmetry, the balance of nearly equal or equal parts of an object:

> Symmetry is the *opposition* of *equal* qualitities to each other; proportion, the *connection* of *unequal* quantities with each other. The property of a tree sending out equal boughs on opposite sides is symmetrical; its sending out shorter and smaller towards the top, proportional. In the human face, its balance of opposite sides is symmetry; its division upwards, proportion. (IV, 125-26)

Ruskin applies this aesthetic of Symmetry to "all perfectly beautiful objects," including paintings (IV, 125). And, as an aspect of Typical Beauty, and the symbolization of "Divine attributes" by art (IV, 64). Symmetry in the work is a

"Type of Divine Justice" (IV, 125). In general, as a balance in forms of nature and of man portrayed in art, Symmetry has secondary importance for Ruskin's aesthetic of Typical Beauty, because Essential Unity, concerning the unification and perfection of diverse natural or human forms in art, implies Symmetry.

Complementing Essential Unity, Purity is the vital energy that pervades the natural world and should be expressed by the work of art. Rejecting the "merely metaphorical" view of purity as perfection of moral virtue, Ruskin defines Purity as the appearance of living energy in objects (IV, 132-33). Concerning Purity, Ruskin says, particularly,

> . . . that the only idea which I think can be legitimately connected with purity of matter, is this of vital and energetic connection among its particles Thus the purity of the rock . . . is expressed by the epithet "living," very singularly given to rock, in almost all languages (singularly, because life is almost the last attribute one would ascribe to stone, but for this visible energy and connection of its particles); and so to flowing water, opposed to stagnant. (IV, 132-33)

In *John Ruskin, or the Ambiguities of Abundance: A Study in Social and Economic Criticism* (1972), James C. Sherburne explains the connection between Essential Unity (Unity of Membership) and Purity:

> Ruskin's emphasis on "unity of membership" is not original. Behind it, there lies a tradition of Romantic theorizing which views organic unity as the characteristic of living things and the key to the transference of metaphors from the realm of nature to that of art. In Ruskin, this tradition is reinforced by a much older tradition of Platonists, Aristotelians, and Christian philosophers like Richard Hooker and Jeremy Taylor who view oneness or unity as the attribute of ultimate reality. Ruskin inherits these traditions in a haphazard fashion, selects what he finds useful, and creates his own vocabulary of organicism.
>
> The most important word in this vocabulary is "purity," the key to organic unity and a crucial element in typical beauty. In his discussion of purity, the "type of divine energy," Ruskin is pointing to the unifying ground which makes possible the fusing of apparent contraries in nature and art. Romantics described this ground or energy in terms which blend the spiritual and the physical. The word most often chosen is "life." Coleridge speaks of the "one life within us and abroad," and Wordsworth of the "one interior life that lives in all things." For both poets, this life is transcendental.[25]

According to Sherburne, then, "the fusing of apparent contraries in nature and art"—for instance, the combination of natural forms, imperfect when separated, into a perfect unity—is Unity of Membership. Purity, Sherburne explains, is the organic basis for Essential Unity. Derived from Wordsworth's and Coleridge's concepts of the one organic life pervading both man and nature, Ruskin's organic concept of Purity concerns the living energy causing their separate and imperfect forms to fuse into a perfect unity in the painting, thereby establishing its Essential Unity.

Purity itself is, then, the organic life underlying the forms of nature, whether actual or portrayed in art. Interpreted according to the phenomenological perspective, Purity concerns ways in which Ruskin apprehends nature and could apprehend art. These apprehensions of nature concern what Husserl calls acts of intentional consciousness, which is directed toward phenomena. Apprehending Purity in nature, Ruskin is visually aware of natural aspects—for example, rock or "flowing water." Observing these natural phenomena, Ruskin also apprehends their underlying organic life—a "vital and energetic" force. Applied to the painting, this apprehension of nature's forms and life-forces establishes a standard for the art work itself. Purity is an aspect of Typical Beauty that should inform the work. If Purity were present in the painting, Ruskin would see natural forms expressing their underlying organic life.

In the phenomenological perspective of Martin Heidegger's "The Origin of the Work of Art," such an apprehension of Purity would be Ruskin's Being-with the "beauty" of the art work. When seeing the form of the work and thereby apprehending the expression of this form, its expression of the essence, or "Being," of the work, then, Heidegger says, the observer apprehends "beauty." Similarly, if Purity were embodied in the work, then Ruskin would apprehend its "beauty"—the formal expression of the painter's concept about the living essence of nature, about its energy, constituting the living "Being" of the painting. For example, Ruskin would see forms of rocks and of "flowing water," both portrayed in the work. Thereby, he would become aware of their vital energy. That is, he would apprehend the "purity of matter," a "vital and energetic connection among its particles." Apprehending this organic energy, constituting the "Being" underlying the forms of the painting, Ruskin would know that

> . . . the purity of the rock [portrayed in art] . . . is expressed by the epithet "living," very singularly given to rock, . . . (singularly, because life is almost the last attribute one would ascribe to stone, but for this visible energy and connection of its particles); and so to flowing water, opposed to stagnant.

As phenomenological "beauty," Purity in art is Ruskin's possible awareness of natural form as the expression of the painter's concept not only about the organic essence of nature but also about its divine being. Referring to the divine aspect of Purity, Ruskin says that "in all cases I suppose that pureness is made to us desirable, because expressive of that constant presence and energizing of the Deity by which all things live and move, and have their being . . ." (IV, 133). As one of "the Divine attributes" of Typical Beauty that could be symbolized by appearances of nature, Purity, if embodied in art, would be the expression of the artist's religious belief in an attribute of God, His living energy pervading nature. Thus, when apprehending Purity in the

painting, Ruskin would be aware of divine "beauty," understood in the phenomenological sense as form manifesting an aspect of divine "Being." Purity, then is Ruskin's possible Being-with phenomenological "beauty," because he would see natural forms that express the painter's belief in one of God's attributes, constituting the divine essence, the divine "Being," of the work. For example, Ruskin would see forms of rock or of "flowing water" portrayed in the painting. Then he would know that these forms express an attribute of the divine "Being" of the work; he would know that they are "expressive of that constant presence and energizing of the Deity by which all things live . . ., and have their being."

Like Purity, Moderation is an aspect of Typical Beauty, the "external quality" belonging to "a stone, flower, beast, or . . . man" that symbolizes "the Divine attributes" (IV, 64). Moderation, God's capacity to operate through nature according to law, is one of these "Divine attributes." Specifically, Moderation is the appearance of the restrained operation of God in nature according to laws:

> And if, bringing down our ideas of it [i.e. Moderation] from complicated objects to simple lines and colours, we analyze and regard them carefully, I think we shall be able to trace them to an under-current of constantly agreeable feeling, excited by the appearance in material things of a self-restrained liberty; that is to say, by the image of that acting of God with regard to all His creation, wherein, though free to operate in whatever arbitrary, sudden, violent, or inconstant ways He will, He yet . . . restrains in Himself this His omnipotent liberty, and works always in consistent modes, called by us laws. (IV, 138)

Moderation, described with Husserl's perspective of intentional consciousness, indicates a particular manner in which Ruskin's consciousness is directed toward nature itself. By seeing "simple lines and colours" of natural forms, Ruskin then becomes aware of God's operation in nature according to law.

Since this mode of operation is one of God's attributes, therefore Moderation, when applied to painting, would concern Ruskin's awareness of visual forms portraying nature and expressing the painter's religious conviction that Moderation is an aspect of God's being. Expressed by form, this belief would constitute the essential character of the painting itself, its divine being. In this sense, Moderation in the work of art would be Ruskin's apprehension of phenomenological "beauty"—his Being-with form insofar as it expresses the essence, the "Being," of the work. For example, Ruskin might see "simple lines and colours" of natural objects portrayed in the painting. Then he would know that these simple natural forms express the painter's belief in God's Moderation, an attribute belonging to Him and constituting the divine "Being" of the work. Specifically, Ruskin would know that these "lines and colours" are

... the image of that acting of God with regard to all His creation, wherein, though free to operate in whatever arbitrary, sudden, violent, or inconstant ways He will, He yet . . . restrains in Himself this His omnipotent liberty, and works always in consistent modes, called by us laws.

In general, then, the phenomenological "beauty" of Moderation in painting would be an aspect of typical Beauty, because the natural forms of the work would manifest to Ruskin's consciousness one of "the Divine attributes"— God's operation in nature according to "consistent modes, called by us laws."

Finally, Ruskin's response to such an experience of God's "Being," manifested by form in the painting, would constitute for him its emotive meaning, its phenomenological "world." This "world" would be Ruskin's experience of "an under-current of constantly agreeable feeling, excited by the appearance in material things of . . . [God's] self-restrained liberty."

In general, then, the central elements of Typical Beauty are Infinity, Unity, Purity, and Moderation, all of which are "Divine attributes" of Typical Beauty and are symbolized by natural forms portrayed in the art work.

The Elements of Vital Beauty

Vital Beauty in art—"the appearance of felicitous fulfilment of function in living things, more especially of the joyful and right exertion of perfect life in man" (IV, 64)—has two basic elements, one concerned with man and the other with plants and animals.

In part, Ruskin's concept of the Vital Beauty of man is related to an important seventeenth century work called *The Sacred Theory of the Earth* (1681-89), by Thomas Burnet. M. H. Abrams, in *Natural Supernaturalism: Tradition and Revolution in Romantic Literature* (1971), explains two central aspects of Burnet's work:

On the one side, this immensely popular book fostered the development of "physico-theology," which undertook to demonstrate the existence and attributes of God, and especially the justice of His ways to men in the creation, entirely by reasoning from the phenomena of nature; on the other side, it served as an influential model for translating theological and moral concepts into an aesthetics of landscape.[26]

In parallel to Burnet's " 'physico-theology,' " Ruskin's theory of Vital Beauty concerns the relationship between *man's* physical appearance and his divine (i.e. religious) attributes. Ruskin, however, reasons primarily from man's religious attributes to his appearances as well as from the latter to the former. In general, then the Vital Beauty of man has three basic aspects, all concerned with his ideal form. In particular, the removal of sensual appearances by "the intellectual powers" is the first aspect. The second is the result of "the

operation of the moral feelings conjointly with the intellectual powers of both the features and form" (IV, 179). And the third concerns effects of his moral and spiritual development on his appearance:

> The third point to be considered with respect to the corporeal expression of mental character is, that there is a certain period of the soul-culture when it begins to interfere with some of the characters of typical beauty belonging to the bodily frame, the stirring of the intellect wearing down the flesh, and the moral enthusiasm burning its way out to heaven, through the emaciation of the earthen vessel; and that there is, in this indication of subduing of the mortal by the immortal part, an ideal glory of perhaps a purer and higher range than that of the more perfect material form. We conceive, I think, more nobly of the weak presence of Paul than of the fair and ruddy countenance of David. (IV, 182)

Ruskin therefore advises the painter:

> Hence, then, it will follow, that we must not determinedly banish from the human form and countenance, in our restoration of its ideal, everything which can be ultimately traced to the Adamite Fall for its cause, but only the immediate operation and presence of the degrading power of sin. (IV, 186)

Thus, connecting man's physical appearances to his moral qualities and to the results of the Fall, Ruskin's theory of Vital Beauty in man is an instance of the seventeenth century concept of "physico-theology."

Furthermore, this aesthetic of Vital Beauty is Evangelical. Emphasis on human depravity and corruption, George P. Landow maintains, "reveals an important reason why the second volume of *Modern Painters* was the most Evangelical of Ruskins' works."[27] In Ruskin's statements on the Vital Beauty of man, Evangelical pessimism is certainly evident. His features and form show the results of his efforts to overcome sensuality, degradation, and sin, all of which are inherent in his nature, impaired by the Fall of Man. Specifically, Ruskin maintains

> ... that there is a certain period of the soul-culture when it begins to interfere with some of the characters of typical beauty belonging to the bodily frame, the stirring of the intellect wearing down the flesh, and the moral enthusiasm burning its way out to heaven, through the emaciation of the earthen vessel

The painter, then, should not exclude from his portrayal of man "every-thing which can be ultimately traced to Adamite Fall for its cause, but only the immediate operation and presence of the degrading power of sin." Since the Vital Beauty of man thus primarily concerns aspects of Evangelical religion, which are not directly revelant to aesthetic theory *per se* this Evangelical aesthetic does not require further discussion.

According to Ruskin, the Theoretic Faculty apprehends the second (as well as the first) element of Vital Beauty in art—that of plants and animals. Concerning this aspect of Vital Beauty as a subject of the Theoretic Faculty, Ruskin maintains:

> In the first or sympathetic operation of the Theoretic faculty, it will be remembered, we receive pleasure from the signs of mere happiness in living things. In the second theoretic operation of comparing and judging, we constituted ourselves such judges of the lower creatures as Adam was made by God when they were brought to him to be named; and we allowed of beauty in them as they reached, more or less, to that standard of moral perfection by which we test ourselves. (IV, 163-64)

According to its first operation the Theoretic Faculty, by means of sympathy, apprehends the Vital Beauty of happiness in plants and animals that is expressed by their forms, portrayed in painting. Understood in the perspective of the Theoretic Faculty, this element of Vital Beauty is derived from an eighteenth century theory of sympathy set forth by Adam Smith (and explained by Landow). Smith's *Theory of Moral Sentiments* explains, that through imagination, sympathy participates in the emotions of another person. Then, sympathizing or not with his motives, the observer thereby perceives the morality of his actions.[28] When applied to the Vital Beauty of happiness in plants and animals, Landow argues, Ruskin's theory of sympathy, derived from Adam Smith's, is, however, untenable:

> Although the history of moral sympathy clarifies to an extent what Ruskin means by the beauty of human happiness, his remarks on the Vital Beauty of plants and animals remain difficult to understand. For since happiness implies a form of consciousness rarely accorded to dogs and never to delphiniums, it seems confusing to apply the notion of happiness to animals, and even meaningless to mention it in relation to plants[29]

Here, Landow implies that Ruskin, arguing from the notion of sympathy, projects happiness, probably his own, into plants and animals portrayed in the art work. In this sense, Landow implies, the theory concerning sympathetic perception of Vital Beauty is inconsistent, because happiness is subjective but the forms of plants and animals in art are objective.

Adam Smith's theory of sympathy also applies to the second operation of the Theoretic Faculty, the recognition of the Vital Beauty in "the lower creatures," insofar "as they . . . [reach], more or less, to that standard of moral perfection by which we test ourselves" (IV, 163-64). According to Smith, the morality of a person's acts can be apprehended by participating in his emotions through imagination and then by sympathizing or not with his motives. Ruskin applies this theory to his apprehension of plants and animals portrayed in art. He participates in their happiness imaginatively and then, sympathizing or not with their inward predisposition, allows "of beauty in

them" insofar as they reach his own moral standards. Interpreted thus, however, this theory is also untenable, because morality depends on human consciousness and therefore cannot be present in the plants and animals portrayed by painting. They have no moral consciousness. In effect, Ruskin projects his own morality, which is subjective, into these objective forms of art.

Thus, the inconsistencies in the theory of Vital Beauty in plants and animals arise from the conflict of subjective with objective factors. Husserl's theory of intentional consciousness and intentional object can be used to eliminate this subject-object distinction and with it the inconsistency in Ruskin's theory. According to Husserl, insofar as consciousness is directed toward visual objects, thoughts, or even feelings—all these phenomena (whether visual, mental, or emotional) are neither subjective nor objective, but instead are correlates for and intentional objects of consciousness. With respect to "the first or sympathetic operation of the Theoretic Faculty," then, Ruskin sees forms of plants and animals in art. And he directs his awareness toward the emotion that these forms express. A correlate of Ruskin's consciousness, this expression of emotion is an intentional object. Particularly, Ruskin is aware of "the signs of . . . happiness in living things." But, since the painting itself is the result of Imagination (IV, 165) Ruskin apprehends not their happiness but rather that of the painter, which their visual forms express. And with respect to "the second theoretic operation of comparing and judging" Vital Beauty in art, Ruskin sees formal appearances of plants and animals and then allows "of beauty in them as they . . . [reach], more or less, to that standard of moral perfection by which we test ourselves." This expression of the *painter's* moral views is not subjective, but instead is intentional because Ruskin is aware of these moral concepts, corresponding to his own, when he looks at the portrayal of plants and animals in the painting.

Understood hermeneutically, these phenomenological descriptions of Vital Beauty in plants and animals become the "earth" and the "world" of the work of art. Martin Heidegger explains these two elements of the work in "The Origin of the Work of Art." When the observer sees the form and appearance of the art work, then he apprehends its "earth." When he directs his consciousness toward the emotions or the thoughts expressed by this form, then he understands its meaning, or "world." These apprehensions constitute his Being-with the "earth" and the "world" of the work of art with its appearances and their significance. Thus, when Ruskin sees forms of plants and animals portrayed in the painting, then he apprehends its "earth." Apprehending the painter's joy and morality expressed by these forms, Ruskin then understands the "world" of the painting, its emotive and moral meaning.

Ruskin further specifies this theory of Vital Beauty, apprehended by the Theoretic Faculty:

Throughout the whole of the organic creation every being in a perfect state exhibits certain appearances or evidences of happiness; and is in its nature, its desires, its modes of nourishment, habitation, and death, illustrative or expressive of certain moral dispositions or principles in our right accepting and reading of all this, consists, I say, the ultimately perfect condition of that noble Theoretic Faculty, whose place in the system of our nature I have already partly vindicated with respect to typical, but which can only fully be established with respect to vital beauty. (IV, 147)

Since the Theoretic Faculty perceives Beauty both in nature and in art (IV, 35), then this statement on the elements of Vital Beauty applies to nature *and* to the art work. Phenomenologically, Ruskin's apprehension of the Vital Beauty of plants and animals by means of his Theoretic Faculty is his Being-with the "earth" and the "world" of painting, with its forms and their meanings whether emotive or moral. He sees forms of plants and animals belonging to "the whole of the organic creation." Since "every [such] being in a perfect state exhibits certain appearances or evidences of happiness," Ruskin understands the "world" of the painting, an expression of the *painter's* happiness by forms of plants and animals. Or, Ruskin sees forms of a plant or of an animal that indicate its physical characteristics "its nature, its desires, its modes of nourishment, habitation, and death." Constituting the "earth" of the painting, these forms express a meaning, a "world," to Ruskin's Theoretic Faculty; that is, they are "illustrative or expressive of certain moral dispositions or principles" held by the painter. In these ways, Ruskin's Theoretic Faculty accomplishes "the moral perception and appreciation of ideas of beauty" (IV, 35) particularly of Vital Beauty in plants and animals, portrayed by painting.

In general, then, apprehended phenomenologically by Ruskin's Theoretic Faculty the entire range of beauty in painting includes Typical Beauty and its elements as well as Vital Beauty and its elements. With respect to Typical Beauty Ruskin sees aspects of nature and of man in art and knows that their forms symbolize the painter's religious belief in "the Divine attributes" (IV, 64): Infinity, Unity, Repose, Symmetry, Purity, and Moderation. With respect to Vital Beauty in art, Ruskin knows that "the appearance of felicitous fulfilment of function in living things, more especially of the joyful and right exertion of perfect life in man" (IV, 64) is the expression of the painter's happiness and his joyful sense of physical vitality. And with respect to the elements of Vital Beauty in art, Ruskin knows, by means of his Theoretic Faculty, that forms of plants and animals also express the painter's moral dispositions concerning human conduct as well as his happiness.

6

The Aesthetic of Imagination
in *Modern Painters II*

The final part of Ruskin's aesthetic in *Modern Painters II* develops a theory of Imagination, concerned with the manner in which the painter creates the work of art.

Ruskin takes his starting point for this theory from Beauty. Existing "in the external creation," the sources of Beauty are the appearances of the natural world. Portrayed in art, they are modified by the painter's Imagination:

> These sources of beauty, however, are not presented by any very great work of art in a form of pure transcript. They invariably receive the reflection of the mind under whose influence they have passed, and are modified or coloured by its image.
> This modification is the Work of Imagination. (III, 223)

In the production of the art work, however, the painter's Imagination does not fundamentally change appearances of natural creation. Instead, he rearranges these natural aspects, placing them in a new perspective. Thus, referring to the operations of Imagination, Ruskin says that they do not radically alter the appearances of nature,

> ... that no new ideas are elicited by them, and that their whole function is only a certain dealing with, concentrating, or mode of regarding the impressions received from external things: that therefore, in the beauty to which they will conduct us, there will be found no new element, but only a peculiar combination or phase of those elements that we now know.... (III, 209-210)

This general theory of Imagination originates in an aspect of the psychology of Hobbes and Locke, current in the eighteenth century. According to George P. Landow, "Thomas Hobbes and John Locke were the chief sources of the belief, so widely encountered in eighteenth-century critics, that the mind deals with visual images."[1] In Ruskin's theory, then, the visual images encountered by the painter's mind are forms and appearances of the

natural world, sources of Beauty in art. The painter's visual activity with these images includes modification and arrangement of them. Such visual and mental operations constitute what Hobbesian-Lockean psychology calls an "idea," a visual image of the mind.[2] According to Ruskin's concept of Imagination, then, the "idea" includes the painter's visual images of nature and his imaginative activity with them. Subsequently, the Imagination of the artist incorporates this aesthetic "idea" into his painting.

At this point, the inconsistency implicit in Ruskin's general theory of creative Imagination becomes evident. On one hand, the aesthetic Idea is subjective, because the painter's Imagination modifies his visual perceptions of nature. In this sense, the Idea reflects his mental subjectivity. On the other hand, the painting itself, created by the artist, is objective. Creating the work, he embodies his subjective Idea, comprising his modified perceptions of nature, into the objective work. In this sense, the theory of Imagination is inconsistent.

Derived from the psychological criticism of Hobbes and Locke, this subjective aesthetic Idea, then, cannot be present objectively in the painting. In order to resolve this inconsistency, the subject-object dichotomy between the Idea and the painting must be eliminated. This resolution can be accomplished by removing the psychological perspective from the Idea; specifically, by interpreting it not as an expression of the painter's psychological nature but instead as an intentional correlate for his consciousness.

Edmund Husserl's theory of intentionality shows that an intentional object—whether a visually perceived entity, a thought, or even a feeling—is neither subjective nor objective, but is the correlate of intentional consciousness. Consciousness can be directed toward a tree or a painting by seeing them. And consciousness can apprehend a thought or a feeling. In this sense, the painting and the tree are intentional objects of sight, and the thought as well as the feeling are intentional objects of the mind. Furthermore, several intentional objects can coalesce into one. For instance, a thought about a painting and a perception of it coalesce into one intentional object—the painting as a meaningful phenomenon for consciousness.

This perspective of intentionality can be applied to Ruskin's theory of Imagination. The Idea itself includes visual intentional objects; the artist is visually aware of aspects of "the external creation." The Idea also includes the painter's modification of these visual impressions of nature. These impressions, Ruskin says, "invariably receive the reflection of the mind under whose influence they have passed, and are modified or coloured by its image." Accomplished by the artist's mind, this modification is not subjective, but is also intentional; he is aware of these natural aspects in so far as his Imagination has selected, regarded, concentrated, or otherwise dealt with them. Specifically, these functions are a "certain dealing with, concentrating,

or mode of regarding the impressions received from external things."
Consequently, the painter's Idea is an intentional object combining visual
ones and a mental one; the Idea combines visual awareness of the "sources of
beauty" in nature and mental awareness of their modification. Since the
painter embodies this Idea of Beauty, a visual and mental intentional object,
into the painting, it is not, therefore, an objective fact but an intentional object
also. That is, the painting is what he sees. And, since the painter modifies but
does not fundamentally alter the "sources of beauty" in nature when he creates
an Idea of Beauty in the art work Ruskin argues that, "in the beauty to which
they will conduct us, there will be found no new element, but only a peculiar
combination or phase of those elements that we now know"

Given this phenomenological perspective of Imagination, its separate
elements must also be phenomenological; these include Associative Imagina-
tion, Penetrative Imagination, and Contemplative Imagination. Each sepa-
rate function of Imagination concerns a specific way in which the artist
apprehends the painting when creating it.

Near the beginning of the second part of *Modern Painters II*, Ruskin
outlines these three basic functions of Imagination—first as Associative,
second as Contemplative, and third as Penetrative:

> We find, then, that the Imagination has three totally distinct functions. It combines, and
> by combination creates new forms, but the secret principle of this combination has not been
> shown by the analysts. Again, it treats, or regards, both the simple images and its own
> combinations in peculiar ways; and thirdly, it penetrates, analyzes, and reaches truths by no
> other faculty discoverable. (III, 228)

And throughout the remainder of *Modern Painters II*, Ruskin prefaces
discussion of each type of Imagination with analysis of a corresponding aspect
of Fancy.

Although Ruskin concludes *Modern Painters II* with a discussion of
Contemplative Imagination and of the aspect of Fancy corresponding to it,
this discussion has only minor importance for his aesthetic of Imagination.
According to Ruskin, the painter's Contemplative Imagination functions by

> . . . depriving the subject of material and bodily shape, and regarding such of its qualities
> only as it chooses for particular purpose, . . . forges these qualities together in such groups
> and forms as it desires, and gives to their abstract being consistency and reality, by striking
> them as it were with the die of an image belonging to other matter, which stroke having once
> received, they pass current at once in the peculiar conjuction and for the peculiar value
> desired. (III, 291)

In effect, when creating the painting, the painter's Contemplative Imagination
selects, for example, the qualities of life and growth in trees and expresses
these qualities in art not through images of trees but instead possibly through

those of plants. The painter's Imagination thus disassociates certain qualities from their corresponding natural forms and expresses these qualities with *other* forms, to which these qualities do not directly belong. In this sense, the aesthetic of Contemplative Imagination is somewhat incoherent and therefore secondary in importance to the theories of Associative Imagination and of Penetrative Imagination, which are fundamentally coherent.

The Aesthetic of Associative Imagination

In *Modern Painters II,* the first important element in the aesthetic of creative Imagination concerns the painter's Associative Imagination whereby, creating art, he combines and unifies his separate Ideas of the natural world.

Ruskin contrasts the operation of Fancy to that of Associative Imagination. In a dissertation called *A Study of Ruskin's Concept of the Imagination* (1947), Sister Mary Dorothea Goetz clearly explains the difference between Imagination and Fancy:

> In contrast to . . . [the Theoretic Faculty], he [i.e. Ruskin] presents the *imagination* as the highest faculty of the active intellect, changing sense impressions to the vision of a unified whole, a vision which may eventually lead to the production of a work of art. He presents *fancy* as a lower power which promiscuously reproduces or changes sense impressions, effecting thereby pleasant yet incoherent transformations.[3]

Thus, according to Ruskin, the aspect of Fancy corresponding to Associative Imagination mechanically associates appearances and forms of the natural world in order to create the painting. In particular, without establishing a harmonious unity in the work, Fancy associates similar or dissimilar visual images of nature (III, 232-33). Ruskin explains the operation of Fancy clearly:

> The most elevated power of all these [capacities for mechanical composition] is that of association, by which images apposite or resemblant, or of whatever kind wanted, are called up quickly and in multitudes. When this power is very brilliant, it is called Fancy; not that this is the only meaning of the word Fancy; but it is the meaning of it in relation to that function of the imagination which we are here considering (III, 232)

Phenomenologically, this aspect of Fancy concerns an inauthentic "creation" of the appearance, the "earth," of the art work. Heidegger, in "The Origin of the Work of Art," maintains that the "creation" of the "earth" in the work is the painter's visual awareness of establishing its appearance. But if this appearance is ordinary or usual in some way, then any artist can create it. In this sense, "creation" is inauthentic. An artist's awareness of creating such appearances can also be expressed as his Being-with the art work by

establishing an inauthentic "earth" through the comprising of forms that are ordinary. Creating the ordinary forms of the painting with Fancy, any painter can be visually aware of mechanically connecting images of nature in it. He creates through "association, by which images apposite or resemblant, or of whatever kind wanted, are called up quickly and in multitudes." He is thus visually aware of mechanically associating these "apposite or resemblant" images of nature and of thereby creating ordinary appearances in the painting, without, however, establishing a harmonious unity in them.

On the other hand, the type of association characterizing the operation of Associative Imagination is not incoherent and hence ordinary. Instead, by means of Associative Imagination, the artist creates his painting by coherently relating and organically unifying visual and conceptual apprehensions of the natural world. This way of creating the work is unusual and therefore (in the phenomenological sense of Heidegger's aesthetic) authentic.

In the chapter of *Modern Painters II* called "Of Imagination Associative," Ruskin examines the artist's capacity to select and combine natural Ideas—concepts about nature that are joined with visual perceptions of it. At the moment of selection, Imagination conceives the unity of visual Ideas that are imperfect when separate and chooses among them accordingly. Thus, from a body of Ideas, Associative Imagination selects only those which are imperfect separately but which in mutual relationship perfect each other and thereby establish a unity in the painting. Ruskin explains these creative operations in detail:

> By its operation [i.e. that of Associative Imagination], two ideas are chosen out of an infinite mass (for it evidently matters not whether the imperfections be conceived out of the infinite number conceivable, or selected out of a number recollected), two ideas which are *separately wrong,* which together shall be right, and of whose unity, therefore, the idea must be formed at the instant they are seized, as it is only in that unity that either is good, and therefore only the *conception of that unity can prompt the preference.* (III, 234)

Thus, by means of Associative Imagination, the painter establishes an organically unified form in the painting itself.

In that the painter is aware of creating this unified form in the painting, he is aware of establishing its phenomenological "Gestalt." Martin Heidegger's "The Origin of the Work of Art" explains the artist's "creation" of the "Gestalt":

> The strife that is brought into the rift and thus set back into the earth and thus fixed in place is *figure, shape, Gestalt.* . . . What is here called figure, *Gestalt,* is always to be thought of in terms of the particular placing . . . and framing or framework . . . as which the work occurs when it sets itself up and sets itself forth.[4]

Hans Jaeger, in "Heidegger and the Work of Art," explains the "Gestalt," the unified form, created in the work by the artist:

> The strife between elucidation and concealment in the opposition of world and earth is reinstated in the earth and consolidated. This does not mean that strife is abolished. On the contrary, the very tension and intimate intensity of the strife with which the contenders are at grips and set each other off is tensioned and consolidated by assuming structure *(Gestalt)* in the work of art. This is the essential nature of artistic structure as Heidegger conceives it[5]

When creating the work of art, the artist is aware of establishing its coherent structure—its unified form, or "Gestalt," which expresses meaning. In particular, he is aware of consolidating the separate appearances of the art work, constituting its "earth," into a unity. He is aware of expressing the meaning of the work, its "world," through this unified form. And he becomes aware of "tensioning," of contrasting as well as unifying, "earth" with "world," form with meaning, by interrelating separate appearances of the work into this "Gestalt" and by expressing meaning with it. These ways of apprehending the work of art while creating it constitute the painter's "creation" of the work, his Being-with it by establishing its meaningful "Gestalt."

And in general, the operation of the painter's Associative Imagination is the "creation" of the "Gestalt," the unified form, of the painting. This "creation" of the work concerns activities that the painter is aware of when creating it. He is visually aware of unifying the separate natural appearances of the art work, constituting its "earth," because he selects, for instance, two mental images that together imply a concept of their unity. That is, "two ideas are chosen out of an infinite mass (for it evidently matters not whether the imperfections be conceived out of the infinite number conceivable, or selected out of a number recollected), two ideas which are *separately wrong,* which together shall be right" He unifies these two *"separately wrong"* natural images on the basis of a spontaneous conception of their implicit unity, because this conception "must be formed at the instant they are seized, as it is only in that unity that either is good, and therefore only the *conception of that unity can prompt the preference."* Thus, while creating the unified natural forms of the painting that constitute its "Gestalt," the painter is simultaneously aware of establishing their meaning, or "world," his *conception* of their unity, "as it is only in that unity that either is good."

This operation of the painter's Associative Imagination establishes an important aspect of Typical Beauty—Essential Unity, or Unity of Membership—in the painting itself. Ruskin explains Essential Unity from the perspective of Associative Imagination:

This faculty is indeed something that looks as if man were made after the image of God. It is inconceivable, admirable, altogether divine; and yet, wonderful as it may seem, it is palpably evident that no less an operation is necessary for the production of any great work: for, by the Definition of Unity of Membership (the essential characteristic of greatness), not only certain couples or groups of parts, but *all* the parts of a noble work must be separately imperfect; each must imply, and ask for all the rest, and the glory of every one of them must consist in its relation to the rest; neither while so much as one is wanting can any be right. And it is evidently impossible to conceive, in each separate feature, a certain want or wrongness which can only be corrected by the other features of the picture (not by one or two merely, but by all), unless, together with the want, we conceive also of what is wanted, that is, of all the rest of the work or picture. (III, 236)

And Ruskin concludes that Unity of Membership, the result in art of Associative Imagination, has a divine aspect:

The final tests, therefore, of the work of associative imagination are, its intense simplicity, its perfect harmony, and its absolute truth. It may be a harmony, majestic or humble, abrupt or prolonged, but it is always a governed and perfect whole; evidencing in all its relations the weight, prevalence, and universal dominion of an awful inexplicable Power; a chastising, animating, and disposing Mind. (III, 248)

And thus, by establishing Unity of Membership in the painting, the painter creates one of "the Divine attributes" belonging to Typical Beauty (III, 64).

Phenomenologically, this aesthetic of Imagination concerns the "creation" of "beauty." Martin Heidegger's "The Origin of the Work of Art" maintains that when the artist is aware of creating artistic form as the expression of the "Being," the essential nature, of the art work, then this "creation" is his Being-with it by creating "beauty." And, by means of Associative Imagination, the painter establishes the "beauty" of Essential Unity (Unity of Membership) in the work of art. Knowing that "*all* the parts of a noble work must be separately imperfect" but that "each must imply, and ask for all the rest," the painter is visually aware of creating the unified form of the painting, a form unifying separate visual perceptions of nature. And he is aware of establishing a harmony in the painting among these natural images, "a harmony, majestic or humble, abrupt or prolonged, but it is always a governed and perfect whole" By creating this "Gestalt," he becomes aware of expressing a belief through it. He expresses his religious conviction that Essential Unity is one of "the Divine attributes" of Typical Beauty. Embodying this belief about the divine attribute of Unity into the work, he therefore knows that he is establishing an aspect of its essential nature, or divine "Being." Thus, through the unified form of the painting, he expresses "in all its relations the weight, prevalence, and universal dominion of an awful inexplicable Power; a chastising, animating, and disposing Mind." And thus, he is aware of embodying the phenomenological "beauty" of Essential Unity

into the work, "both as significative of perfection in the things united, and as typical of that Unity which we attribute to God" (III, 92) as an aspect of Typical Beauty.

Ruskin not only explains the operations and results of the painter's Associative Imagination at length, but also gives the reader of *Modern Painters II* an opportunity to experience, and be aware of, the results of J.M.W. Turner's Associative Imagination. Assuming that the reader has Turner's *Cephalus and Procris* (or a reproduction of it) before him, Ruskin guides him through an experience of this work:

> I know of no landscape more purely or magnificently imaginative, or bearing more distinct evidence of the relative and simultaneous conception of the parts. Let the reader first cover with his hand the two trunks that rise against the sky on the right, and ask himself how any termination of the central mass so *ugly* as the straight trunk which he will then painfully see, could have been conceived or admitted without *simultaneous conception* of the trunks he has taken away on the right? . . . and if proof be required of the vital power of still smaller features, let him remove the sunbeam that comes through beneath the faint mass of trees on the hill in the distance. (III, 245)

In this statement, Ruskin invites the reader to experience the results of Turner's Imagination intentionally, by looking at *Cephalus and Procris* and by then thinking about this painting. Thus, Ruskin asks his reader to direct his attention—that is, his consciousness—toward the work in these ways. When interpreted with aspects of Heidegger's aesthetic, the reader's intentional participation in this painting is a "preservation" of it. "Preservation," Heidegger explains, includes the observer's visual awareness of the "Gestalt" of the art work (its unified formal appearances) and his mental awareness of its "world" (their meaning). As a "preservation" of art, this visual and mental apprehension of the work is the observer's Being-with it by seeing unified forms and by understanding their significance.

When preserving the results of Turner's Associative Imagination in *Cephalus and Procris,* the reader initially apprehends the results of Turner's imaginative power to unify his visual and mental apprehensions of nature— that is, to choose and interrelate "two [or more] ideas which are *separately wrong,* which together shall be right" (III, 234). Here, the reader visually apprehends the "Gestalt," the unified form, of Turner's painting. In particular, by first covering "with his hand the two trunks that rise against the sky on the right" or by removing "the sunbeam that comes through beneath the faint mass of trees on the hill in the distance," the reader can see that removal of one such natural form from the painting renders the others imperfect and that therefore these natural forms together constitute a perfect and unified whole. Through this kind of visual comparison, the reader becomes aware of the second result of Turner's Associative Imagination.

This result is his concept of unity. According to Ruskin, the Associative Imagination unifies two or more "ideas which are *separately wrong,* which together shall be right, and of whose unity, therefore, the ideas must be formed at the instant they are seized . . ." (III, 234). When observing Turner's *Cephalus and Procris,* Ruskin's reader apprehends such a unifying concept constituting the meaning (the "world") of the unified visual forms in the work. When looking at the painting, he understands Turner's concept unifying its natural forms, which are *"separately wrong."* And the reader does so by asking "himself how any termination of the central mass so *ugly* as the straight trunk which he will then painfully see, could have been conceived or admitted without *simultaneous conception* of the trunks he has taken away on the right?" In this sense, by looking at the painting, he apprehends Essential Unity, "which is the unity of things separately imperfect into a perfect whole" (IV, 95).

Following the aesthetic of Associative Imagination and of its results in art, the theory of Penetrative Imagination constitutes the second major element of Ruskin's discussion about artistic creation in *Modern Painters II.*

The Aesthetic of Penetrative Imagination

In general, the artist with Penetrative Imagination apprehends the inner nature, the essence, of his particular subject and embodies this essence in his painting.

In contrast, the artist possessing only Fancy merely apprehends external details of a natural phenomenon and then simply portrays them in his work (III, 253). When creating the painting, the painter is phenomenologically aware of merely portraying natural forms without expressing any meaning through them.

According to Heidegger's aesthetic, "concealment as refusal" is knowledge of particular being only as fact[6]—fact that has no meaning whatsoever. When creating a "refusal" of meaning in the art work, the painter is, therefore, visually aware of establishing meaningless facts in it. In this sense, his "creation" of a "refusal" in art is simply his Being-with the work by portraying meaningless visual facts. And since any artist can create a work in this manner, therefore this creative activity is ordinary, or inauthentic.

Similarly, creating the painting with Fancy, the painter is aware of merely portraying external aspects of nature: "The fancy sees the outside, and is able to give a portrait of the outside, clear, brilliant, and full of detail" (III, 253). Here, since Ruskin does not describe an actual production of art by the artist's Fancy but instead explains briefly how this faculty *could* create a painting, therefore the operation of Fancy concerns a *possible* way of creating the art work phenomenologically. The painter could be aware of creating a "refusal"

of meaning in it. As a possible mode of artistic "creation," this activity would be the artist's Being-with the painting by merely establishing visual facts of nature in it without expressing any meaning whatsoever through them. In particular, were he to create an art work with Fancy, he would first see "the outside" of natural objects and then would be "able to give a portrait of the outside, clear, brilliant, and full of detail." Since any artist could be aware of creating a painting by merely portraying his visual perceptions of natural aspects, then this possible operation of Fancy is comonplace, inauthentic.

The operation of Penetrative Imagination, however, is authentic, because the artist's apprehension of essences and his embodiment of them in art are both unusual activities. That is, Penetrative Imagination "sees the heart and inner nature [of its subject], and makes them felt" (III, 253).

In general, when seeing something in the world, whether a fact of nature or a human being, the artist apprehends not only the external appearances, the "outward images," of his particular subject, but also its basic character, its essence, its "very central fiery heart," its fundamental "truth, life, and principle." Subsequently, creating the painting itself on the basis of these visual and mental apprehensions, the artist, by means of Penetrative Imagination, establishes both the outward appearance of his particular subject and its essence in the painting itself (III, 250-51).

Interpreted in the perspective of subject and object, however, the aesthetic of Penetrative Imagination is inconsistent. Because although the appearances of man and nature in art are objective, their expression of the emotions and thoughts *attributed* to them by the artist is subjective. But, when described according to Husserl's phenomenological perspective of intentional consciousness and its intentional objects, Ruskin's theory of Penetrative Imagination is consistent. According to Husserl, intentional consciousness has a direction toward something. The correlate of this intention is called an intentional object. Thus, since the eye can be visually aware of an entity, it is not an objective fact but instead an intentional object. Or, since the mind can be aware of emotions and concepts, then feelings and thoughts are not subjective, but are also intentional objects. With respect to the operation of Penetrative Imagination, then "the very central fiery heart," the underlying "truth, life, [or] principle," of aspects of nature or of man constitute the emotion or the thought that the painter is aware of when he looks at nature or a human being. In this sense, these essences are intentional objects of the painter's consciousness. He can embody them in the painting itself, because it is not an objective entity but is also an intentional object, the visual correlate of his consciousness. Thus, he can be aware of portraying the appearances of man or of nature in the art work and of expressing their essential being, their "very central fiery heart," through their forms. And thus, in this phenomeno-

logical perspective, "the virtue of the Imagination is its reaching, by intuition and intensity of gaze (not by reasoning, but by its authoritative opening and revealing power), a more essential truth than is seen at the surface of things" and its embodying this essence into the painting itself (III, 284).

Ruskin explains this intuitive operation of Penetrative Imagination in detail:

> Such is always the mode in which the highest imaginative faculty seizes its materials. It never stops at crusts or ashes, or outward images of any kind; it ploughs them all aside, and plunges into the very central fiery heart; nothing else will content its spirituality; whatever semblances and various outward shows and phases its subject may possess go for nothing; it gets within all fence, cuts down to the root, and drinks the very vital sap of that it deals with: once therein, it is at liberty to throw up what new shoots it will, so always that the true juice and sap be in them, and to prune and twist them at its pleasure, and bring them to fairer fruit than grew on the old tree; but all this pruning and twisting is work that it likes not, and often does ill; its function and gift are the getting at the root, its nature and dignity depend on its holding things always by the heart. Take its hand from off the beating of that, and it will prophesy no longer; it looks not in the eyes, it judges not by the voice, it describes not by outward features; all that it affirms, judges, or describes, it affirms, from within. (III, 250-51)

Thus, Penetrative Imagination, Ruskin contends, operates intuitively rather than by intellectual analysis: "There is no reasoning in it; ... all is alike divided asunder, joint and marrow, whatever utmost truth, life, principle it has, laid bare, and that which has no truth, life, nor principle, dissipated into its original smoke at a touch" (III, 251). Creating the painting on the basis of these apprehensions, the painter becomes aware of portraying appearances of man as well as nature and of thereby expressing their essential character. In this phenomenological manner, the painter creates the art work.

Martin Heidegger's "The Origin of the Work of Art" maintains that the essence of the work is the origin of its "creation":

> Art lets truth originate. Art, founding preserving, is the spring that leaps to the truth of what is, in the work. To originate something by a leap, to bring something into being from out of the source of its nature in a founding leap—this is what the word origin (German *Ursprung,* literally, primal leap) means.[7]

As an origination, the "creation" of the art work concerns the artist's awareness of certain activities. Initially, he is aware of establishing the form of the work. And, by a "spring that leaps to the truth of what is," he is aware of expressing the essential nature of the work, its "Being," through its form. In this sense, he is aware of bringing the work "into being from out of the source of its nature": that is, he founds the work on its "Being," or essence. This manner of creating the art work is, according to Heidegger's aesthetic, the

"creation" of its "beauty," the manifestation of its "Being" through its form. Consequently, the "creation" of "beauty" in the art work by "a founding leap" is the artist's Being-with the work by expressing its essence through its form.

And the "creation" of the painting according to the operation of Penetrative Imagination is the painter's Being-with the work by establishing its "beauty"—an expression of its essential nature, or "Being," through its form. This creative activity has several steps, beginning with nature and man and ending with the painting itself.

Initially, the painter sees external aspects of nature, but "never stops at crusts or ashes, or outward images of any kind." Therefore, his Imagination apprehends the essential nature, the essence, of these images. In particular, his mind

> . . . ploughs them all aside, and plunges into the very central fiery heart; nothing else will content its spirituality; whatever semblances and various outward shows and phases its subject may possess go for nothing; it gets within all fence, cuts down to the root, and drinks the very vital sap of that it deals with

Or, the artist sees the external forms of man and then becomes aware of his inward nature, because, Ruskin says, Imagination "looks not in the eyes, it judges not by the voice, it describes not by outward features; all that it affirms, judges, or describes, it affirms, from within."

Having thus seen forms of nature and of man and apprehended their inward essences, the artist then creates the "beauty" of the painting itself. He becomes aware of creating a visual form that expresses the essential nature, the essence, or "Being," of the work. First, he is visually aware of portraying forms of man and of nature in the painting. And, through this activity, he becomes aware of expressing their essence, their inward "Being." Specifically, he knows that he expresses "the very central fiery heart," "the very vital sap," of the natural forms portrayed in the work. Or, he knows that he expresses man's emotional being through human forms, because the "nature and dignity" of the Imagination "depend on its holding things always by the heart" and because "all that it affirms, judges, or describes, it affirms, from within." Thus, through Penetrative Imagination, the painter is aware of creating "beauty" in the painting by means of what Heidegger calls "a founding leap," which brings the work "into being from out of the source of its nature."[8] That is, the painter is aware of founding the painting on its source, its essential nature, its "Being," by portraying forms of nature and man that express their "utmost truth, life, principle."

The Results of Penetrative Imagination in Art

Applying the aesthetic of Penetrative Imagination, Ruskin explains the results of this creative faculty in several paintings by Tintoretto (1518-1594).

Just as *Modern Painters I* helped to establish the fame of J.M.W. Turner, so also *Modern Painters II* was "successful in establishing the fame of Tintoret."[9] Summarizing his commentary on several works by Tintoretto, Ruskin says:

> The power of every picture depends on the penetration of the imagination into the TRUE nature of the thing represented, and on the utter scorn of the imagination for all shackles and fetters of mere external fact that stand in the way of its suggestiveness. In the Baptism it cuts away the trunks of trees as if they were so much cloud or vapour, that it may exhibit to the thought the completed sequency of the scene; in the Massacre it covers the marble floor with visionary light, that it may strike terror into the spectator without condescending to butchery; it defies bare fact, but creates in him the fearful feeling; in the Crucifixion it annihilates locality, and brings the palm leaves to Calvary, so only that it may bear the mind to the Mount of Olives; as in the Entombment it brings the manger to Jerusalem, that it may take the heart to Bethlemen; and all this it does in the daring consciousness of its higher and spiritual verity, and in the entire knowledge of the fact and substance of all that it touches. (IV, 278)

In each of these pictures, the results of Tintoretto's Penetrative Imagination are evident. As we have seen, Penetrative Imagination itself "never stops at crusts or ashes, or outward images of any kind; it ploughs them all aside, and plunges into the very central fiery heart . . . " (IV, 250). Thus, the Imagination apprehends the essence of its particular subject and then embodies this quality in the art work. Similarly, Tintoretto's Imagination has embodied into each painting that Ruskin mentions "the TRUE nature of the thing represented." For example, in *The Massacre of the Innocents*, the painter has covered "the marble floor with visionary light," which expresses "the TRUE nature," the essence, of the scene representing a biblical event—the massacre of infants by soldiers of Herod. And the essence of this scene is horror. Consequently, the "visionary light'" on the floor strikes "terror into the spectator without condescending to butchery; it defies bare fact, but creates in him . . . [a] fearful feeling"

Ruskin also describes his experience of Tintoretto's *The Last Judgment*, another example of the results in art of Penetrative Imagination:

> By Tintoret only has this unimaginable event [the final judgment] been grappled with in its Verity; not typically nor symbolically, but as they may see it who shall not sleep, but be changed. Only one traditional circumstance he has received with Dante and Michael Angelo, the Boat of the Condemned; but the impetuosity of his mind burst out even in the adoption of this image; he has not stopped at the scowling ferryman of the one, nor at the sweeping blow and demon dragging of the other, but seized Hylas-like by the limbs, and tearing up the earth in his agony, the victim is dashed to his destruction: nor is it the sluggish Lethe, nor the fiery lake that bears the cursed vessel, but the oceans of the earth and the waters of the firmament gathered into one white, ghastly cataract; the river of the wrath of God, roaring down into the gulf where the world has melted with its fervent heat, choked with the ruin of nations, and the limbs of its corpses tossed out of its whirling, like water-

wheels. Batlike, out of the holes and caverns and shadows of the earth, the bones gather and the clay heaps heave, rattling and adhering into half-kneaded anatomies, that crawl, and startle, and struggle up among the putrid weeds, with the clay clinging to their clotted hair, and their heavy eyes sealed by the earth darkness yet, like his of old who went his way unseeing to the Siloam Poo; shaking off one by one the dreams of the prison-house, hardly hearing the clangour of the trumpets of the armies of God, blinded yet more, as they awake, by the white light of the new Heaven, until the great vortex of the four winds bears up their bodies to the judgment-seat: the Firmament is all full of them, a very dust of human souls, that drifts, and floats, and falls in the interminable, inevitable light; the bright clouds are darkened with them as with thick snow, currents of atom life in the arteries of heaven, now soaring up slowly, and higher and higher still, till the eye and the thought can follow no farther, borne up, wingless, by their inward faith and by the angel powers invisible, now hurled in countless drifts of horror before the breath of their condemnation.

Now, I wish the reader particularly to observe throughout all these works of Tintoret [i.e. among several, particularly *The Last Judgment*], the distinction of the Imaginative Verity from falsehood on the one hand, and from realism on the other. The power of every picture depends on the penetration of the imagination into the TRUE nature of the thing represented, and on the utter scorn of the imagination for all shackles and fetters of mere external fact that stand in the way of its suggestiveness. (IV, 276-78)

Here, Ruskin is aware of visual aspects of *The Last Judgment* and meanings that they express. He sees the rising of the dead, their ascent "to the judgment-seat," and their final separation—the saved rising into heaven and the condemned descending into hell. And he thereby knows that these scenes express Tintoretto's apprehension of "the TRUE nature" of the final judgment, its essential meaning. Correspondingly, according to Martin Heidegger's aesthetic theory in "The Origin of the Work of Art," when the self is visually aware of the appearances of the art work, then it apprehends its "earth." And when aware of the meanings, the thoughts and emotions, expressed by these visual forms, then he apprehends the "world" of the work. These apprehensions are his Being-with the "earth" and the "world," the appearances and the meaning, of the work of art.

The visible appearances of *The Last Judgment* constitute the "earth" of the painting for Ruskin's sight. He sees, for example, that, "seized Hylas-like by the limbs, and tearing up the earth in his agony, the victim [a condemned soul] is dashed to his destruction" Ruskin sees "the river of the wrath of God, roaring down into the gulf where the world has melted with its fervent heat." He sees the souls of humanity rising from the dead, "rattling and adhering into half-kneaded anatomies, that crawl, and startle, and struggle up among the putrid weeds, with the clay clinging to their clotted hair, and their heavy eyes sealed by the earth darkness yet." He sees souls "shaking off one by one the dreams of the prison-house, hardly hearing the clangour of the trumpets of the armies of God, blinded yet more, as they awake, by the white light of the new Heaven, until the great vortex of the four winds bears up their bodies to the judgment-seat" And he sees that souls now judged by God

separate, some "soaring up slowly, and higher and higher still, till the eye and the thought can follow no farther" and others "now hurled in countless drifts of horror before the breath of their condemnation." All these visual apprehensions constitute Ruskin's Being-with the "earth" of Tintoretto's *The Last Judgment*, its visual representation of the final event in the religious destiny of mankind.

When looking at this representation, Ruskin then becomes aware of its expression. This apprehension is his Being-with the "world," the essential meaning, of the painting, embodied in the work by Tintoretto's Penetrative Imagination. Comprehending this meaning, Ruskin apprehends an expression of "the penetration of the imagination into the TRUE nature of the thing represented," the final and decisive event in Christian spiritual history. Seeing, for instance, human souls "shaking off one by one the dreams of the prison-house . . . , until the great vortex of the four winds bears up their bodies to the judgment-seat," Ruskin knows that this scene expresses the essential meaning of spiritual destiny for human beings, the decisive moment in their spiritual history, when God determines their success or failure during life in choosing goodness and rejecting evil, in opting for faith and against disbelief.

Furthermore, expressing Tintoretto's insight into "the TRUE nature" of the final Christian drama, the religious significance of *The Last Judgment* is concerned with time—the present, the past, and the future. Since Ruskin is aware of this temporal significance, consequently it is part of the "world," the phenomenological meaning, of the painting. And the temporal aspects of this "world" are modes of phenomenological "understanding." According to Heidegger in *Being and Time,* "understanding" has three temporal modes. "Repetition" is the self's apprehension of past possibilities of existence. "Moment of vision" is the consciousness of a present moment and a present situation. And the apprehension of the future is "anticipation," the self's Being-with its own possible modes of existence in the future. Among these modes of "understanding," the future is the most important, because it concerns one's awareness of what one can become.

Looking at *The Last Judgment*, Ruskin first understands Tintoretto's apprehension of "the TRUE nature," the essential religious significance, belonging to the past life of human souls. Ruskin sees that

> . . . out of the holes and caverns and shadows of the earth, the bones gather and the clay heaps heave, rattling and adhering into half-kneaded anatomies, that crawl, and startle, and struggle up among the putrid weeds, with the clay clinging to their clotted hair, and their heavy eyes sealed by the earth darkness yet . . .

And he knows that this scene of rising dead expresses Tintoretto's views concerning the essential meaning of their past life. Ruskin's apprehension of this significance is a "repetition," for his mind, of their past possibilities of

existence. In particular, he knows that, during their lives, these souls, now "rattling and adhering into half-kneaded anatomies," existed according to standards of good or evil, of faith or disbelief—possibilities of existence that had originally been established by the Fall and that therefore constituted their fundamental moral alternatives.

Next, Ruskin sees risen souls

> . . . shaking off one by one the dreams of the prison-house, hardly hearing the clangour of the trumpets of the armies of God, blinded yet more, as they awake, by the white light of the new Heaven, until the great vortex of the four winds bears up their bodies to the judgment-seat

Seeing this ascent of human souls to the judgment, Ruskin experiences a "moment of vision," constituting the essential significance of the present moment and the present situation for these souls. He is aware of the essential religious meaning of their ascent, its fundamental significance as originally apprehended by Tintoretto's Penetrative Imagination. He understood "the TRUE nature" of the scene portraying the ascent to judgment and then expressed this essential meaning through the scene. Consequently, Ruskin knows that the scene of ascent, during which human souls awake and rise through the air "to the judgment-seat," implies Tintoretto's insight into God's power and justice. In particular, through a "moment of vision" concerning the present situation of human souls, Ruskin understands God's absolute power, awakening the dead to consciousness and His justice, leading all of them alike to judgment of their present moral state whether good or evil.

And finally, looking at *The Last Judgment*, Ruskin mentally experiences an "anticipation" of the ways in which human souls will exist in the future. Depending originally "on the penetration of the imagination into the TRUE nature of the thing represented" and on Tintoretto's subsequent embodiment of this essential meaning into the painting itself, this meaning, Ruskin knows, concerns the soul's essential possibilities of existence in the future. An apprehension of future possibilities for human souls, Ruskin's "anticipation" of their destinies is his Being-with two contrasting possibilities of existence. He knows that those souls who adopted faith in God during life now expect to exist forever in heaven and to experience infinite joy, perfect goodness, and complete faith. Ruskin is aware of this possibility of salvation, because he sees the saved "now soaring up slowly, and higher and higher still, till the eye and the thought can follow no farther, borne up, wingless, by their inward faith and by the angel powers invisible." And, when Ruskin sees other souls "now hurled in countless drifts of horror before the breath of their condemnation," he anticipates their future possibilities of existence in hell. He knows that the condemned, having rejected faith in God during life, have become evil and therefore in the future will experience all the possibilities of suffering.

In these ways, then, Ruskin apprehends the essential temporal meanings of the final judgment and knows that they constitute "the TRUE nature" of this event, its fundamental character, apprehended by Tintoretto's Penetrative Imagination and then embodied into the work. Furthermore, the visual aspects of *The Last Judgment* express essential aspects of God's divine being, aspects which also constitute "the TRUE nature" of the work. Heidegger, in "The Origin of the Work of Art," explains the divine aspect of a Greek temple as an art work: "The temple, in its standing there, first gives to things their look and to men their outlook on themselves. This view remains open as long as the work is a work, as long as the god has not fled from it"[10] Insofar as the temple is a genuine work of art, its form expresses its divine essence to the observer's consciousness. And since consciousness of form expressing the essential nature, the essence, or "Being," of the art work is "beauty," the observer's Being-with form expressing the divine essence, the divine "Being,' of the temple-work, or of a painting, is an apprehension of divine "beauty."

Similarly, Ruskin apprehends divine "beauty" when he looks at *The Last Judgment*, because he knows that its forms, depicting events of the judgment, express Tintoretto's insight into aspects of the *divine* "Being," which constitute the essential nature of the painting. For example, Ruskin knows that the painting expresses divine wrath at the sins of men, because he sees "the river of the wrath of God, roaring down into the gulf where the world has melted with its fervent heat." When Ruskin sees that "bat-like, out of the holes and caverns and shadows of the earth, the bones gather and the clay heaps heave, rattling and adhering into half-kneaded anatomies . . . ," then he becomes aware of another aspect of divine "Being:" God's absolute power, resurrecting the souls of human beings. And finally, Ruskin sees souls borne up "to the judgment-seat" and then separated into the good and the evil, "soaring up slowly . . . , borne up, wingless, by their inward faith and by the angel powers invisible" and others "now hurled in countless drifts of horror before the breath of their condemnation." Seeing these events, Ruskin apprehends a final aspect of the divine "Being:" His justice in judging human souls according to the faith or disbelief that they adhered to during life and in rewarding or punishing them according to the good or the evil that they consequently brought about. And thus, in these ways, Ruskin apprehends wrath, omnipotence, and justice as "Divine attributes" of Typical Beauty in art.

In general, then, Ruskin's aesthetic of Penetrative Imagination primarily concerns both the painter's awareness of embodying the essence of his subject into his work and also Ruskin's apprehension of "the TRUE nature" of *The Last Judgment* incorporated into it by Tintoretto.

Conclusions—the Tripartite Aesthetic in *Modern Painters II*

In conclusion, Ruskin's religious aesthetic in *Modern Painters II* centers on a phenomenological theory of Beauty in painting. By means of his Theoretic Faculty, Ruskin apprehends Beauty in art, because this faculty "is concerned with the moral perception and appreciation of ideas of beauty" (IV, 35). As phenomenological "beauty," the expression of the essence of the work by its form, Typical Beauty in the painting concerns its formal expression of "Divine attributes." Looking at the forms of, for instance, "a stone, flower, beast, or . . . man," Ruskin understands the painter's religious belief that attributes of God pervade nature (IV, 64). And since Vital Beauty in art concerns "the appearance of felicitous fulfilment of function in living things, more especially of the joyful and right exertion of perfect life in man" (IV, 64), Ruskin apprehends an expression of the *painter's* happiness and his joyful exuberance by looking at forms of plants, animals, or man portrayed in the work. This happiness and exuberance constitute its emotive meaning, or "world,' for Ruskin's consciousness. Finally, Ruskin's aesthetic of Imagination concerns the painter's "creation" of "beauty" in art. By means of Associative Imagination, the painter becomes aware of modifying, perfecting, and unifying his visual and cognitive apprehensions of nature so that "two ideas which are *separately wrong* . . . together shall be right" (IV, 234). In this way, he establishes the coherent and unified form, the phenomenological "Gestalt," of the work. And by doing so, he becomes aware of establishing one aspect of Typical Beauty, one of "the Divine attributes," in the painting, its essence, or "Being," its Essential Unity, constituted by "appearances of connection and brotherhood," which "are pleasant and right, both as significative of perfection in the things united, and as typical of that Unity which we attribute to God" (IV, 92). And by means of Penetrative Imagination, the painter is initially conscious of the "utmost truth, life, principle" underlying forms of nature or man and then becomes aware of expressing such essences through natural or human forms in art (IV, 250—51). Insofar as these essences are divine he is therefore, when creating the painting, aware of expressing "Divine attributes" of Typical Beauty through, for instance, the forms of "a stone, flower, beast, or . . . man" (IV, 64). Generally, whether by means of Associative or Penetrative Imagination, the painter is aware of establishing phenomenological "beauty"—an expression of its essential nature, its divine "Being," through visual form—in the painting. And the commentary on *The Last Judgment* concerns Ruskin's phenomenological apprehension of it as a result of Tintoretto's Penetrative Imagination.

7

The Style of *Modern Painters I* and *II:* an Introduction

In a recent article, Seymour Chatman and Samuel Levin distinguish several fundamental concepts of literary style, the earliest of which originated during the Renaissance:

> ... the earliest sense already contained the element of value judgment which still clings to the term despite all attempts to expunge it. "Style" in this first sense means "good writing".... But a purely descriptive sense also developed at an early stage: just as faces, bodies, personalities, clothes, ways of behaving, so handwritings and by extension the messages they impart differ from individual to individual and group to group, serving as *cues* to these individuals and groups. So a second definition of "style" is "individual manner"; this is not quite the same as what is conveyed by the modern linguistic term "idiolect," since it refers not so much to the *totality* of language use in a given individual as to the set of differences between his use and that of the rest of the community (whence "deviation from the norm" theories of style). But there are still other senses of the term. Since "individual manner" is expressed in details, as preference for one rather than another option, "style" is also used to refer to detail of form as opposed to over-all structure, and that quite independently of individual manner
>
> Still another sense recorded by the dictionary [i.e. *The Shorter Oxford English Dictionary*] is "a manner of discourse, or tone of speaking, adopted in addressing others in ordinary conversation." This fourth sense, more often referred to as "tone," is clearly based on the larger communicational situation, entailing the relations of speaker to auditor....
>
> "Style" is often used to refer to class distinctions, as for example in the classical idea ... of "levels" of style—low, mean, and high. Obviously what is being referred to is the character of the diction—the use of the vulgar, or ordinary colloquial, or elevated vocabulary—in relation to a static-class conception of society.[1]

These major concepts of style are primarily rhetorical. Several others are concerned with stylistics, the application of linguistics to the study of style. Nils E. Enkvist's essay "On Defining Style" lists six basic linguistic concepts of style:

> ... style as a shell surrounding a pre-existing core of thought or expression; as the choice between alternative expressions; as a set of individual charcteristics; as deviations from a

norm; as a set of collective characteristics; and as those relations among linguistic entities that are statable in terms of wider spans of text than the sentence.[2]

In addition to these linguistic concepts of style, a third set of concepts is phenomenological. One basic concept adopts the reader's phenomenological perspective; the prose style of a literary work is its formal detail *as* apprehended by the reader. Another fundamental concept is concerned with the author's intentional perspective; prose style is the detailed record of his phenomenal experience *of* some entity, such as a work of art.

Whether rhetorical, stylistic, or phenomenological, such concepts of style are, in effect, bases for analysis of style in prose. The literary critic can approach style as, for example, "detail of form as opposed to over-all structure."[3] The linguist can deal with style "as a set of individual characteristics."[4] Or, the phenomenologist can approach the style of a literary work as a record of the author's phenomenal experience.

In this introduction to analysis of the prose style in John Ruskin's *Modern Painters I* and *II,* I will be concerned with establishing not a stylistics approach but instead a rhetorical one and a phenomenological one. Certainly, however, stylistics is an acceptable approach to style. Roger Fowler's essay "Lingistics, Stylistics; Criticism?" carefully explains the use of stylistics in criticism:

> However one defines style, pure verbal analysis [i.e. linguistic analysis] is not the same thing as stylistic description. One is concerned to *characterize* a style, not simply list all the features of the language of a text. One seeks to provide objective evidence for feelings about the distinctive linguistic character of an author or a text. A feature, or group of features, is usually isolated as the result of asking not "what linguistic choices are made here?" but "what sorts of linguistic choices are made here?" These features are characteristic—they identify a text (or author) against a norm, a norm defined by reference to the language as a whole (a difficult concept) or that of some other text or author
>
> The lingist's "formal meaning" perhaps provides a clue to the limits of stylistics as a branch of criticism. Stylistics examines the cues of only a narrow range of responses in the reading of literature: one's response to form and pattern.[5]

Stylistics, understood in these ways, could be used to justify interpretative responses to the linguistic forms and patterns of *Modern Painters I* and *II.* As far as I know, no stylistics study of these particular works has been done. Thus, a possibility for further study of them exists. Such a study would involve establishing the linguistic norm on which Ruskin bases his linguistic choices and would thus include at least a limited linguistic analysis of the general language of the Victorians, the language of an author, or the language of a particular prose work. And this study would deal with each type of linguistic choice that Ruskin makes in the first two volumes of *Modern Painters.* Consequently, a stylistic analysis of these two works would require a full-length study.

However, since the first part of my study of *Modern Painters I* and *II* interprets their aesthetic theory, then the second will attempt not a comprehensive but rather a selective study of their style and of those aspects of style directly related to theory. Requiring a full-length study, the stylistics approach to prose is therefore inappropriate for implementing this limited purpose of describing selected aspects of style and of interpreting their relation to Ruskin's aesthetic theory. In order to implement this purpose, I will rely rather on a rhetorical approach to prose style and on a phenomenological one. The former will implement accurate description of the particular rhetorical features and functions of Ruskin's style, and the latter will implement interpretation of the relation between this style and the aesthetic of *Modern Painters I* and *II.*

By way of developing this dual approach, the following material will deal analytically with several representative approaches to prose style that are relevant to Ruskin's style in these works. Although some of these approaches apply to style in poetry as well as in prose, nevertheless I shall explain each approach primarily from the latter perspective, since my concern is with the prose style of *Modern Painters I* and *II.*

Rhetorical Approaches to Prose Style

Recent work in the theory of literary style has developed two basic types of approach for the study of prose style. According to the first, style is a detailed aspect of meaning in the prose text. And, according to the second, style is the individual or characteristic, manner expressing the writer, or speaker in the prose work. In this sense, style is his signature.

Two contemporary approaches to prose style conceive it as an aspect of meaning. Seymour Chatman, in his article "On the Theory of Literary Style," acknowledges the importance of these approaches:

> We are indebted to W.K. Wimsatt, Jr. and Monroe Beardsley for making precise issues that must be faced in formulating a theory of style. Opposing the idea of style as a mere ornament, as a set of rhetorical devices which remain after meaning is extracted . . . , they have asserted its intrinsic meaningfulness.[6]

W.K. Wimsatt presents his semantic theory of prose style primarily in the introduction to *The Prose Style of Samuel Johnson* (1941). Wimsatt considers style to be the final or greatest elaboration of meaning in the prose work:

> That which has for centuries been called style differs from the rest of writing only in that it is one plane or level of the organization of meaning; it would not be happy to call it the outer cover or the last layer; rather it is the furthest elaboration of the one concept that is the center. As such it can be considered. The terms of rhetoric, spurned by Croce and other

moderns, did have a value for the ancients, even though they failed to connect all of rhetoric with meaning. To give the terms of rhetoric a value in modern criticism it would be necessary only to determine the expressiveness of the things in language to which the terms refer.[7]

Grammatical forms, sentences for example, express *elements* of meaning; however, the rhetorical devices express *details* of meaning,

> . . . not ideas like "grass" or "green," but relations. The so-called "devices," really no more devices than a sentence is a device, express more special forms of meaning, not so common to thinking that they cannot be avoided, like the sentence, but common enough to reappear frequently in certain types of thinking and hence to characterize the thinking, or the style. They express a kind of meaning which may be discussed as legitimately as the more obvious kinds such as what a man writes about—the vanity of human wishes or the River Duddon.[8]

Thus, whether expressed by rhetorical devices or not, prose style "is the furthest elaboration of the one concept that is the center." In different words, the style of a prose text is the most extensive development of its basic element of meaning.

In *Aesthetics: Problems in the Philosophy of Criticism* (1958), Monroe C. Beardsley develops Wimsatt's semantic approach to style. Beardsley bases his approach to the style of either poetry or prose on texture and meaning. The texture of a literary work includes "diction and syntax" as well as rhetorical figures.[9] Meaning has two aspects—one primary (or explicit) and the other secondary (or implicit).[10] And there are three kinds of meaning. *"Cognitive purport"* concerns "the *beliefs* of the speaker" in the work. *"Emotive purport"* concerns his "feelings, or emotions." And *"general purport"* concerns "other characteristics of the speaker, his nationality, social class, religious affiliations, state, status, or condition"[11] Combining these concepts of texture and meaning, Beardsley formulates his concept of style in three steps. First, he says, "'style' can be defined, tentatively, in some such way as this: the style of a literary work consists of the recurrent features of its texture of meaning." Second, "style is detail of meaning or small-scale meaning." And third, since a difference in style may be a difference in meaning as "general purport," then Beardsley includes this distinction in his completed definition of style:

> Let us modify the Semantical Definition, then, to take account of this: style is detail, or texture, of secondary meaning plus general purport. Or, in another way, two discourses differ in style when they differ either in their details or meaning or in their general purport.[12]

And, summarizing his theory of literary style, Beardsley, in "Style and Good Style" (1965), maintains: "My argument is that a difference in style is always a difference in meaning—though implicit—and an important and notable difference of style is always a sizeable difference in meaning."[13]

In general, then, Beardsley's semantical theory of style maintains that the texture of language in the literary work is meaning. The syntax, the diction, and the rhetorical figures of a prose work, for example, are elements of style insofar as these textures are detailed meanings, implicit meanings about the speaker's emotions and thoughts ("emotive purport" and "cognitive purport") or about his general, identifying characteristics ("general purport").

The theories of style proposed by Wimsatt and Beardsley are semantic approaches to style in prose. A second type of approach is concerned with style as the expression of the author in the work. Seymour Chatman, in the articles "On the Theory of Literary Style" (1966) and "The Semantics of Style" (1967), adopts this kind of approach to style in prose (or in poetry).[14]

A dualistic approach to style, Chatman's contrasts with Wimsatt's and with Beardsley's monistic approaches. In their respective ways, Wimsatt and Beardsley identify style with aspects of meaning. Chatman, however, distinguishes between style and what it expresses:

> For "style" to be maximally useful as a critical term, it ought to be limited . . . to refer to a literary manner which is homogeneous and recognizable. The stylists are those whose manners have a sufficient persistence of quality, a characterizing density such that no matter where one cuts the discourse he is likely to get something which is characteristically *it.*[15]

That is, style is the individually expressive manner of the prose text; style is the "individual manner" expressing the author of the prose work.[16] And, of course, the author is not necessarily the historical author. Chatman makes this point emphatically:

> But as modern critics have shown us, the literary context is different from the ordinary speech situation: the *persona,* the literary speaking voice is not necessarily the author's, although it may be close to his. But the author we know only by extra-literary, hence irrelevant information anyway.[17]

In general, then, prose style expresses the speaker in the work.[18]

Chatman develops his approach to prose style by reinterpreting and expanding Beardsley's concept of "general purport," meaning identifying general characteristics of the speaker: his nationality, his religious orientation, and so on. Reinterpreting the idea of "general purport," Chatman asserts: "As far as style is concerned, the semantic arrow points toward the author, not toward the detail of the message." Expanding the concept of "general purport," Chatman argues: "I object to the name, which I find insufficiently descriptive. I shall substitute the term 'identification purport' instead, and shall mean by this 'purport which serves to identify the speaker as such and such a person.'"[19] Thus, the "identificational purport" of style concerns not

only the general characteristics of the speaker but also his individual ones. In this way, Chatman broadens Beardsley's concept of "'general purport' to include *any* feature which seems to distinguish the speaker (author) from the multitude of other language users"[20] Completing the range of meaning that can be expressed by style, Chatman includes "emotive purport" and "cognitive purport": "It is clear that in many cases general purport is not fully interpretable by itself but only in close combination with the other two kinds of purport."[21] Thus, in addition to being the expression of the speaker's individual as well as general characteristics ("identificational purport"), style is the expression of his feelings and thoughts ("emotive purport" and "cognitive purport"). In general, then, the style of a prose text is its characteristic manner in language, its "individual manner," that expresses "emotive purport," "cognitive purport," and "identificational purport," that is to say the speaker's feelings, his thoughts, and his individual as well as general characteristics.

Designating style as "individual manner" expressing the speaker, Chatman's theory contrasts with Wimsatt's, which concerns prose style as elaborated meaning, and also contrasts with Beardsley's, which concerns style as detailed meaning, implicit meaning concerning the speaker's emotions and beliefs or identifying his general characteristics. Regardless of these differences, however, each theory is a representative approach to prose style in general.

Since the early part of the fifties, several literary critics have attempted, in different ways, to formulate approaches to the aesthetic aspects, including the style, of Victorian prose in particular.

Rhetorical Approaches to Victorian Prose Style

In a recent article, "Victorian Nonfiction Prose" (1973), G.B. Tennyson summarizes the development of critical interest in the aesthetic aspects of Victorian non-fiction prose:

> . . . if we look at the major Victorian anthologies of prose prior to our own period of interest, we see that the focus of study in Victorian nonfiction prose has not been aesthetic. The Carlyle of all Victorian prose anthologies—if we think of precedence and amplitude—is surely the Harrold and Templeman of 1938. The approach to the great body of material in that collection is historical, political, social, economic. It was the dominant approach to Victorian prose up to the middle fifties. Holloway's study [*The Victorian Sage: Studies in Argument* (1953)] signals the shift, for he was to treat in it a number of Victorian prose masters as artists worth ranking with such as George Eliot (who finds a place in his book even while Ruskin, alas, does not). Holloway's book was followed by a series of probing articles in the publication sponsored by this group, the *Victorian Newsletter*. Such scholars as Dwight Culler, Martin Svaglic, R.C. Schweik, and George Levine contributed to the discussion of the character of prose as art that went on well into the sixties.[22]

Holloway's approach to Victorian prose style concerns the use of style for persuasion. According to Holloway, the author of the prose work attempts to bring the reader, through his own experience, to an understanding previously not held. The author's basic substance of communication is his view of the world, of man's relation to it, and of his proper mode of living. In order to convey this view to the reader the author relies not primarily on logical proof but instead on resources belonging to the language and to its figurative, imaginative uses.[23] That is, the Victorian author employs rhetorical devices of language, rather than of logic, in order to convey a particular moral view of the world and of human life to the reader. And the articles in the *Victorian Newsletter* on Victorian prose as art are primarily exploratory. For example, George Levine, in "Nonfiction as Art" (1966), maintains: "We need, that is, to discover the ways in which language is expressive, the way it operates as self-revelation even while it purports to be objective rapportage or argument."[24]

In the introduction to *The Art of Victorian Prose* (1968), the most important recent contribution to scholarship in this area, George Levine and William Madden discuss the problem of determining an approach to Victorian prose in its aesthetic dimension:

> Although a number of studies in recent years have attempted to treat this problem, to our knowledge there is at present no satisfactory over-all rationale, no adequate method or combination of methods, by which non-fiction might be studied and evaluated as imaginative vision—as art. Despite the large body of existing scholarship about most of the relevant works, relatively little attention has been given to the structure and style of these works, to what in them has caused them to survive while other prose, some of it far more popular in its own day, has been forgotten.[25]

Although Levine and Madden do not develop an approach to the style of Victorian non-fiction prose, yet they do specify what makes non-fiction an art. Non-fiction is art, they maintain, when the language of non-fiction refers to the personality, the self, of the writer, his "emotional relation . . . to the object" of his prose. That is, expressive language is art. Consequently, "the literary critic of non-fiction must take into account the free awareness of the producer as revealed in the nature of the text produced."[26] Thus, in order to properly understand non-fiction as art, the critic must analyze its *language* as the expression of its producer, the writer. Starting from a similar concept, that of *style* as the expression of the writer in the work, G. Robert Stange develops a well defined approach to the prose of Victorian art criticism.

According to Stange's article "Art Criticism as a Prose Genre," "art criticism can be defined as a writer's attempt to give a prose account of the aesthetic values and affective qualities of a work of visual art."[27] Stange explains the character of non-fictional prose as art criticism from a historical perspective:

> The conscious prose stylists from, let us say, Lamb to Pater display the shift of direction I wish to describe. The effect of their work is to break down traditional distinctions between prose and poetry; logical organization and a conceptual framework are more and more often abandoned in favor of emotive effects and a perceptual scheme. The serious writers offer us not systems, but insights, persuasive glimpses of truth. The prose writer tends to avoid the abstract in favor of the immediate: he will try to imitate a speaking voice, or express the rhythm of the mind as it responds to or perceives concrete experience. Special value is attached to image sequences, to discrete data of precise observation; the emphasis is not so much on the object of imitation as on the medium of expression, on *surface* in both experience and artifact, and, in general, on the representation of particular aesthetic as well as emotional experiences.[28]

This theory is remarkably similar to elements of Seymour Chatman's theory of style. Part of his theory concerns prose style as an individual "literary manner" expressing "emotive purport" and "cognitive purport," the speaker's feelings and thoughts about his particular subject.[29] Similarly, when embodying in prose "the rhythm of the mind as it responds to or perceives concrete experience," the writer, or speaker, of art criticism both describes his visual perceptions of a painting (for example) and also expresses his responses to it—his thought and emotions about it, his "particular aesthetic as well as emotional experiences."[30] Such description and expression enables the reader of this art criticism to share imaginatively in the writer's original experience of the painting.

Stange diagrams the relationships between the writer and his prose work and between the work and its reader. The following scheme reproduces the basic elements of this diagram:

Work of Art

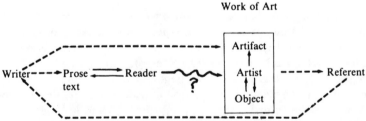

In this scheme, the dotted line indicates the writer's response to the painting and his subsesequent creation of prose art criticism. The solid line indicates the reader's perception of this non-fictional prose. And the curved line indicates his option to refer the prose work to the original artifact, the painting. Independent of the artifact itself, the writer's referent is the fusion of his perceptual response to the painting, of what he knows about the artist and "his period," and of the values that he attributes to "his experience of the work of art." The writer then transforms this referent "into prose, which is perceived by the reader through a combination of reception and projection."[31]

According to Stange, then, the prose style of Victorian art criticism is, in general, a representation, perceived by the reader, of the writer's visual, emotional, and aesthetic experience of a particular artifact. Stange, concluding his essay, remarks that he finds "it helpful to consider Ruskin's and Pater's descriptive passages as *expressive imitations* of the experience produced by a work of art."[32]

Writing also in *The Art of Victorian Prose,* John D. Rosenberg formulates an approach to the style of Ruskin's early prose. Rosenberg, however, approaches Ruksin's early style not as the expression of his experience of art but rather as the expression of an aspect of his personality. According to Rosenberg's article "Style and Sensibility in Ruskin's Prose,"

> . . . word ["style"] has also a rarer and more elusive sense, which everything in this essay is an imperfect attempt to elucidate. I have in mind not an outward adaptation to the exigencies of subject and audience, but an inner manifestation: style as the incarnation of sensibility. Style of this kind has nothing whatever to do with levels of speech; it *is* speech, the unique voice of the writer, the felt presence that hovers over his pages and intones its way into our consciousness. We acknowledge its presence when we say of a very great writer that he "has genius" or is "immortal"; we know that his words, like the books which house them, cannot last forever. But he has suceeded in re-creating *himself,* not in the flesh, as we can do, but in the spirit, and his anima has miraculously passed into our own minds. In this ultimate sense, Ruskin is the greatest prose stylist in English.[33]

This theory of style is related to an aspect of Seymour Chatman's theory of style. According to Chatman, the style of a prose text expresses "identificational purport," meaning identifying the speaker's personal as well as general characteristics. Similarly, according to Rosenberg's approach to Ruskin's early prose, style expresses an aspect of the speaker's personality, his sensibility.[34] Style is an "incarnation of sensibility."

Applications

Among the foregoing approaches to prose style, three are particularly appropriate for analysis of John Ruskin's style in *Modern Painters I* and *II.* These are Wimsatt's approach to style as meaning, Stange's approach to style as the expression of the writer's aesthetic experience, and Rosenberg's approach to Ruskin's early style as the expression of his sensibility.

A semantic approach is appropriate for understanding the style of Ruskin's statements on aesthetic theory, concerned with the general meaning of painting. According to Beardsley's semantic approach, diction, syntax, and rhetorical figures are textures of the prose work; these textures constitute its style insofar as they are implicit meanings about the speaker's emotions, his beliefs, or his general characteristics. And according to Wimsatt, the prose style of a literary work is the greatest elaboration of its meaning. Although

Beardsley's semantic approach can implement analysis of the style of Ruskin's theoretical statements, Wimsatt's is preferable, because it is the simpler and more direct approach to prose style as meaning.

In *Modern Painters I*, Ruskin employs antithesis to state the theory of Truth in landscape painting. Truth itself concerns both accurate representation of nature and expression of the painter's emotions and thoughts. Ruskin phrases these two functions of the landscape painting antithetically: "Truth has reference to statements both of the qualities of material things, / and of emotions, impressions, and thoughts" (III, 104). Wimsatt, we have seen, understands prose style as "the furthest elaboration" of meaning in the prose text; and the rhetorical devices express such "special forms of meaning."[35] Understood according to this semantic approach to prose style, Ruskin's statement on Truth has two levels of meaning. The fundamental level concerns both representation of nature and expression of the painter's experience by the landscape work. The stylistic level, expressed by antithesis, is the final elaboration of this meaning. *As* this special meaning, the style of Ruskin's statement on Truth is the *intensity* of the contrast in the painting between representation of nature and expression of the painter's responses to it, between "statements both of the qualities of material things, / and of [his] emotions, impressions, and thoughts" about them.

In *Modern Painters II*, Ruskin employs parallelism to summarize the different aspects of Beauty in the art work. Beauty, he maintains, "is either the record of conscience, written in things external, / or it is a symbolizing of Divine attributes in matter, / or it is the felicity of living things . . ." (IV, 210). The core of meaning in this statement concerns expression of the painter's conscience, of his belief in divine characteristics, and of his happiness by nature, animals, and man, as these things are portrayed in the painting. The rhetorical device of parallel sentence structure, when analyzed in terms of Wimsatt's perspective on style, expresses the furthest extension of the painter's happiness, the manifestation of his conscience, and the symbolization of his belief in "Divine attributes" are *equally* important functions of the art work. This elaboration of meaning constitutes the style of Ruskin's summary of the qualities of Beauty in painting.

Thus, W.K. Wimsatt's semantic theory of prose style is a useful approach to the style of Ruskin's theoretical statements on painting in *Modern Painters I* and *II*. The practical criticism in these volumes is primarily a record of his actual experiences of particular works.

Concerned with the prose writer's use of rhetorical devices to convey a particular moral view of *human existence* to the reader, Holloway's approach to Victorian prose style, in order to be useful for analysis of the style in Ruskin's practical criticism, would have to be adapted to its concern with conveying views about certain *paintings*. Consequently, Holloway's approach

is not directly applicable to analysis of this style. But each of the "expressivist" approaches reviewed—Chatman's, Stange's, or Rosenberg's—is adequate for analysis of the style in this criticism. As we have seen, Chatman approaches style as the "individual manner" expressing the emotion, the thought, and the personality of the speaker in the work. According to Stange, the style of art criticism is the expression of the writer's experience of visual art. And Rosenberg understands Ruskin's early style as the expression of his sensibility. Since Chatman's approach, concerned with a general concept of style, does not apply specifically to the style of Ruskin's practical criticism of painting in *Modern Painters I* and *II* but since both Stange's and Rosenberg's approaches do, these consequently are preferable to Chatman's for analysis of this style.

The most important instance of practical criticism in *Modern Painters I* is Ruskin's commentary on J.M.W. Turner's *The Slave Ship*. This work represents the aftermath of a murder on the sea. Before the onset of a storm, slaves were thrown overboard from a ship. According to Ruskin,

> . . . the noblest sea that Turner has ever painted, and, if so, the noblest certainly ever painted by man, is that of the Slave Ship, the chief Academy picture of the Exhibition of 1840. It is a sunset on the Atlantic, after prolonged storm; but the storm is partially lulled, and the torn and streaming rain-clouds are moving in scarlet lines to lose themselves in the hollow of the night Purple and blue, the lurid shadows of the hollow breakers are cast upon the mist of night, which gathers cold and low, advancing like the shadow of death upon the guilty ship as it labours amidst the lightning of the sea, its thin masts written upon the sky in lines of blood, girded with condemnation in that fearful hue which signs the sky with horror, and mixes its flaming flood with the sunlight, and, cast far along the desolate heave of the supulchral waves, incarnadines the multitudinous sea. (III, 571-72)

G.R. Stange's approach to the style of Victorian art criticism can implement analysis of the style of this comentary. According to Stange, the prose style of art criticism is both descriptive and expressive. Style describes the writer's, the speaker's, visual experience of the art work and expresses his emotional and aesthetic responses to it. The prose style in Ruskin's art criticism of *The Slave Ship* functions similarly. Images describe his visual experience of the painting. And insofar as these images are symbolic, they express the speaker Ruskin's emotional and aesthetic responses to the work, his feelings and thoughts about it. For example, the image of "the torn and streaming rain-clouds" that move "in scarlet lines to lose themselves in the hollow of the night" describes Ruskin's visual perception of the sky in the painting and symbolically expresses his horror at the agony of the dying slaves. Or, the image of the "ship as it labours amidst the lightning of the sea" describes his visual experience of the ship on the sea and also symbolizes his thought about those on the ship— that they are guilty of murder. In the ways outlined, then, the style of Ruskin's commentary is a reflex of his visual, emotional, and conceptual experience of *The Slave Ship*.

The style of the commentary on Tintoretto's *The Last Judgment* typifies the style of Ruskin's practical criticism in *Modern Painter II*. At the end of his commentary, Ruskin, having described the rising of the dead, remarks:

> ... the Firmament is all full of them, a very dust of human souls, that drifts, and floats, and falls in the interminable, inevitable light; the bright clouds are darkened with them as with thick snow, currents of atom life in the arteries of heaven, now soaring up slowly, and higher and higher still, till the eye and the thought can follow no farther, borne up, wingless, by their inward faith and by the angel powers invisible, now hurled in countless drifts of horror before the breath of their condemnation. (IV, 277)

Throughout this passage, Ruskin is concerned with the division of mankind into the saved and the damned at the final judgment. Understood according to Rosenberg's approach to Ruskin's early style as the embodiment, or incarnation, of his sensibility, the style of this commentary expresses his divided religious sensibility. On one hand, the symbolic image of the saved, "soaring up slowly, and higher and higher still . . . , borne up, wingless, by their inward faith and by the angel powers invisible" expresses Ruskin's predilection to hope for his own salvation. On the other hand, the symbolic image of the condemned, "now hurled in countless drifts of horror before the breath of their condemnation," expresses his proclivity to fear damnation.

In the different ways outlined, then, Wimsatt's, Stange's, and Rosenberg's respective approaches to prose style will contribute to an understanding of the prose style of *Modern Painters I* and *II*. In general, these approaches can implement description of Ruskin's style. Described with Wimsatt's semantic approach, the style of Ruskin's purely theoretical statements on painting is the final elaboration of their meaning. Described according to Stange's approach, the style of Ruskin's applied criticism expresses his experience of particular paintings. And Rosenberg's approach can implement description of this style as the expression of Ruskin's sensibility. In effect, these approaches implement description both of the rhetorical devices Ruskin employs and also of what they express, whether elaborations of meaning, experience of art, or aesthetic sensibility.

Since each of these approaches concerns *description* of prose style, none can be held accountable for any problems that might arise when Ruskin's style is *interpreted* as the embodiment of his theoretical and practical aesthetic in *Modern Painters I* and *II*.

As we have seen, when understood according to Wimsatt's approach to style, the antithetical style of Ruskin's statement on the Idea of Truth (for instance) is its final detail of meaning, expressing the intensity of the contrast between representation of nature and expression of the painter's feelings and thoughts by the landscape painting. Since Wimsatt's approach does not

interpret prose style aesthetically but rather describes it semantically, then this approach, applied thus to the antithetical phrasing expressing the Idea of Truth, produces consistent results even though its two elements of meaning are inconsistent with each other (i.e. objective representation of nature conflicts with subjective expression of the painter). But, when the relation between Ruskin's style and his aesthetic is considered, when style is interpreted as the expression of aesthetic theory, then Ruskin's antithetical style simply emphasizes the inconsistency between these two aspects of Truth by contrasting them with balanced phrasing. That is, Truth refers "to statements both of the [objective] qualities of material things, / and of [subjective] emotions, impressions, and thoughts" experienced by the painter (III, 104).

The same type of inconsistency between the subjective and the objective arises when an attempt is made not to describe but to interpret the style of Ruskin's practical criticism of *The Slave Ship* or the style of his commentary on *The Last Judgment*. When analyzed with Rosenberg's approach to Ruskin's early style as the expression of his sensibility, the prose style of his commentary on *The Last Judgment,* for example, is an expression of his religious sensibility, divided between predispositions to hope for salvation and to fear damnation. Again, since Rosenberg's approach thus implements description of Ruskin's style as the expression of his religious sensibility, this approach cannot be held accountable for the inconsistency arising when the style of this commentary is interpreted as the reflex of an aesthetic theory. According to Ruskin, *The Last Judgment* is the expression of Tintoretto's Penetrative Imagination: "The power of every picture [i.e. including *The Last Judgment*] depends on the penetration of the imagination into the TRUE nature of the thing represented . . ." (IV, 278). In other words, the painting expresses Tintoretto's insight into the essential nature of the Christian judgment of man. Interpreted as a reflex of this theory, the symbolic image of the saved, "borne up, wingless, by their inward faith and by the angel powers invisible," and that of the damned, "now hurled in countless drifts of horror before the breath of their condemnation" (IV, 277), both describe particular aspects of the judgment represented in the painting and also express Tintoretto's insight into the true inner states of the saved and the condemned— into the hope of the former for eternal joy and into the despair of the latter, condemned to perdition. On one hand, then, these images describe *objective* appearances of the painting, its representation of the ascent of the saved and the descent of the damned. But, on the other, these images, in so far as they are symbolic, express Tintoretto's *subjective* insights into the emotional states of the judged. Thus, the descriptive (or objective) mode of this symbolic style is inconsistent with its expressive (or subjective) one.

Dealing with these problems, arising from the relation between Ruskin's aesthetic and his style in *Modern Painters I* and *II,* seems justified. The first part of this study interprets his aesthetic in these works. The second should therefore attempt to show a consistent relation, if any, between their aesthetic and their style. And if this style is interpreted phenomenologically, then such a relation does exist. Martin Heidegger's phenomenological theory of prose style is appropriate for such interpretation.[36]

A Phenomenological Approach

Heidegger's phenomenological approach to style in prose (or in poetry) has two perspectives, one basically similar to and the other essentially different from the descriptive perspective of the approaches already considered. These implement description of style, either as meaning or as expression of the speaker. For these approaches, prose style is an aesthetic object *per se.* Heidegger's approach can be understood not only in a descriptive perspective but also in a hermeneutic one. According to the first perspective, prose style, such as small scale form expressing meaning, is a phenomenon apprehended by the *reader's* consciousness and as such is subject to phenomenological description and analysis. And second, understood from an interpretive perspective, prose style is the embodiment of the *writer's* apprehension of the work of art and hence is the reflex of his phenomenological aesthetic about it. Of these two phenomenological approaches to style in prose, the latter is more appropriate for interpretation of Ruskin's style in *Modern Painters I* and *II,* because style expresses a complement to his theory of and commentary on painting.

Heidegger presents his approach to style in two stages. In "The Origin of the Work of Art," he explains the fundamentals of this approach; and in "Building-Dwelling-Thinking," he elaborates them.[37]

According to "The Origin of the Work of Art," style in prose is "language," which refers to the contrast in the art work between form and meaning, "earth" and "world":

> Projective saying ["language"] is poetry: the saying of world and earth, the saying of the arena of their conflict and thus of the place of all nearness and remoteness of the gods. Poetry is the saying of the unconcealedness of what is. Actual language at any given moment is the happening of this saying, in which a people's world historically arises for it and the earth is preserved as that which remains closed. Projective saying is saying which, in preparing the sayable, simultaneously brings the unsayable as such into a world. In such saying, the concepts of an historical people's nature, i.e., of its belonging to world history, are formed for that folk, before it.[38]

Heidegger founds his theory of "language" on his phenomenological concept of the art work. The elements of the work are intentional objects of

Heidegger's—i.e. the writer's—consciousness. It is *directed toward* them. The "earth" of the art work is its appearance and form, both of which he sees. His consciousness is directed toward the "world," the meaning of the work. This meaning includes the emotion and the thought expressed by the visual aspects of the work. And he apprehends the "conflict," the complementary contrast, between "earth" and "world." He knows that visual form contrasts with emotive and cognitive meaning, but he also knows that form needs to have a significance and that meaning needs to have a referent in form. Therefore, Heidegger says, "Poetry is the saying of the unconcealedness of what is." The writer is aware of "poetry" not as verse but in a general sense as the manifestation "of what is," the essential nature of the work. Its essence—its "truth," or "Being"—comprises form, meaning, and their complementary contrast. Just as the writer's consciousness is directed toward "poetry" (understood in this comprehensive sense), so also his "language" refers *to* or is *about* the "poetry" of the art work, the manifestation of its composite "Being." Here, "language" refers to the essential nature of the art work by describing its form, by suggesting its meaning, and by implying the contrast and complementary relationship between form and meaning.

Thus, "language" refers to the elements of the art work, and the writer's consciousness is directed toward them. Since both "language" and consciousness have this reference *to* the work, therefore "language" is the writer's consciousness itself. And since consciousness is *Dasein,* the writer's act of being-aware-of, or Being-with art, therefore prose style as "language" is his Being-with the "poetry" of the art work, the manifestation of its "truth," or "Being," which comprises an "earth," a "world," and their "conflict." In different words, style is the writer's consciousness of the art work's essential nature, which includes form, meaning, and their complementary contrast. Finally, the different rhetorical devices of prose style are simply different modes in which the writer is aware of the art work. For example, the image is his visual apprehension of the appearances belonging to the work. Or, symbol is his way of knowing the meaning of the work through the understanding of the significance of its appearances.[39]

The second and simpler way of interpreting the approach to style presented in "The Origin of the Work of Art" follows from the first, just given. As we have seen, the writer's consciousness intends the elements of the art work. His consciousness is directed toward its "earth," its "world," its "conflict," and its "truth," or "Being." Thus, the contrast of form with meaning constitutes the "Being," the essential nature of the work. "Language" reveals this essence. According to Walter Biemel's article, "Poetry and Language in Heidegger," the "circumscription of the essence of art becomes concretized to the extent that language is that through which openness (unconcealment) comes to pass."[40] That is, "language" indicates, or "uncon-

ceals," the essence, the "Being," of the work of art—its essential nature, its contrast between form and meaning. In general, then, "language" refers to the interrelated elements of the art work, which the writer apprehends. Thus, he employs "language" *to show* what he is aware *of* in the work. In particular, he uses prose style as "language" to describe his perception of the appearance and form of the art work (its "earth"), to suggest his comprehension of its emotive and conceptual meaning (or "world"), to imply his apprehension of its complementary contrast (or "conflict") between form and meaning, and thereby to reveal his experience of its essential nature—its "truth," or "Being." Prose style as "language," then, shows the writer's modes of Being-with the work of art. The symbol, for example, both describes his visual perception of the form (the "earth") of the art work and also suggests his mental awareness of its significance (its "world").

Admittedly, Martin Heidegger's theory of prose style as the writer's consciousness or as the indicator of what he is aware of in the art work has significant limitations. Identifying style with the writer's consciousness, Heidegger fails to develop an independent concept of style as such. Furthermore, he identifies prose style with "language" and thereby ignores even the fundamental distinction between language as the vehicle of meaning and style as the manner of its expression. This identification also omits concern for the particular rhetorical devices that are part of prose style. Finally, Heidegger's view of prose style as the indicator of what the writer apprehends in the work disregards the particular personal qualities, the characteristics, of the *writer* that his style might express.

In spite of these limitations, however, the approach to style set forth in "The Origin of the Work of Art" is useful for interpretation of Ruskin's prose style, particularly that of his theoretical criticism, in *Modern Painters I* and *II*.

When style is interpreted as the expression of aesthetic theory the antithetical phrasing of Ruskin's statement on the Idea of Truth simply emphasizes the inconsistency between the two functions of the landscape painting, between objective representation of nature and subjective expression of the painter's feelings and thoughts. Interpreted with Heidegger's approach, however, the style of Ruskin's statement on Truth does not show this inconsistency. According to Martin Heidegger's perspective on style, since prose style as "language" refers to the elements of the art work, since the writer's consciousness is directed toward them, and since style and consciousness thus have the same referents style is then his consciousness of the work of art. In particular, prose style is his Being-with form, meaning, and their contrast—respectively, an "earth," a "world," and their "conflict." Furthermore, by referring to the elements of the work, which are also intended phenomenally by the writer's consciousness, style shows, in effect, *what* he is aware of (the contrast of form with meaning in the work of art) and *how* he is aware of it (visually and mentally).

The relation betrween style and aesthetic theory in Ruskin's statement on Truth is essentially phenomenological. He uses antithesis to phrase the two basic functions of the landscape painting: "Truth has reference to statements both of the qualities of material things, / and of emotions, impressions, and thought" (III, 104). Since Ruskin's antithetical phrasing of the Idea of Truth implicitly refers to the contrast between representation and expression in the landscape work and since he is aware of this contrast, therefore his antithetical style is his consciousness of, his Being-with, the sharp contrast in the painting between an "earth" and a "world," form and meaning. In this phenomenological perspective, antithesis does not emphasize a contradiction in the work between objective representation of nature and subjective expression of the painter's experience, but instead shows how Ruskin the writer is aware of the landscape painting and what he apprehends in it. In particular, antithesis shows that he *intensely* apprehends the *sharp* contrast in the work between visual form and aesthetic meaning, between representation of natural forms and their expression of the painter's emotions and thoughts, specifically between "statements both of the qualities of material things, / and of [the painter's] emotions, impressions, and thoughts" about them.

Similar phenomenological interpretation can be given for the parallelism that Ruskin employs to state the central aspect of the religious aesthetic in *Modern Painters II,* its theory about the qualities of Beauty in painting.

Martin Heidegger's expansion of the approach to style presented in "The Origin of the Work of Art" is particularly appropriate for interpretation of the style of Ruskin's practical criticism in *Modern Painters I* and *II.* Heidegger presents this expansion primarily in the essays "Building-Dwelling-Thinking" and in "The Nature of Language."

"The Nature of Language" maintains that the "World" of an art work or of any other thing comprises not only its meaning but also its appearance. Prose style as "language" refers to this "World."[41] "Language" indicates the "World" of a jug, for example. Heidegger's essay called "The Thing" argues that even a jug may have a "World": "The jug's presencing is the pure, giving gathering of the onefold fourfold into a single time-space, a single stay."[42] The "onefold fourfold" is the four part "World" of the jug, its form and meaning, each having two elements. Albert Borgmann's article "Language in Heidegger's Philosophy" explains the composite nature of this "World": "Heidegger's way leads him to the realization that language grants a fourfold order of earth and heaven, the divine ones and the mortals in simple things such as a pitcher, a bridge, or a plow."[43] In other words, "language" refers to the fourfold "World" of the pitcher, the jug. The "earth" and the "sky" are, respectively, the structural form of the jug and the space it encloses. And, a composite of form and space, the appearance of the jug expresses the meanings of "divinities" and of "mortals."

Another thing that "language" can speak about is a building, a farmhouse in the Black Forest for instance. Heidegger, in the essay "Building-Dwelling-Thinking," understands the farmhouse not as a merely mechanical construction but rather as dwelling manifestating a fourfold "World." According to Heidegger,

> . . . "on the earth" already means "under the sky." Both of these *also* mean "remaining before the divinities" and include a "belonging to men's being with one another." By a *primal* oneness the four—earth, sky, divinities and mortals—belong together in one.
>
> Earth is the serving bearer, blossoming and fruiting, spreading out in rock and water, rising up into plant and animal. When we say earth, we are already thinking of the other three along with it, but we give no thought to the simple oneness of the four.
>
> The sky is the vaulting path of the sun, the course of the changing moon, the wandering glitter of the stars, the year's seasons and their changes, the light and dusk of day, the gloom and glow of night, the clemency and inclemency of the weather, the drifting clouds and blue depth of the ether. When we say sky, we are already thinking of the other three along with it, but we give no thought to the simple oneness of the four.
>
> The divinities are the beckoning messengers of the godhead. Out of the holy sway of the godhead, the god appears in his presence or withdraws into this concealment. When we speak of the divinities, we are already thinking of the other three along with them, but we give no thought to the simple oneness of the four.
>
> The mortals are the human beings. They are called mortals because they can die. To die means to be capable of death *as* death. Only man dies, and indeed continually, as long as he remains on earth, under the sky, before the divinities. When we speak of mortals, we are already thinking of the other three along with them, but we give no thought to the simple oneness of the four.
>
> This simple oneness of the four we call *the fourfold.*[44]

The fourfold "World" of the farmhouse includes "earth," "sky," "divinities," and "mortals"—respectively, structural form, enclosed space, divine significance, and human meaning. And since, "by a *primal* oneness the four—earth, sky, divinities and mortals—belong together in one," then together they constitute the "Being" of the farmhouse, its essential nature. According to Walter Biemel, "language is thus understood as that which governs the interplay of the four world regions."[45] In particular, "language" describes the forms and the spaces of the farmhouse, suggests their divine significance and human meaning, and shows that these aspects of the building together constitute its essential nature, or "Being." And such a fourfold "World" constitutes the "Being" not only of the farmhouse but also of other things, such as a work of art.

This theory of "language" is an expansion of the one presented in "The Origin of the Work of Art." According to this essay, prose style as "language" refers to the form and the meaning of the work of art, to its "earth" and its "world." In "Building-Dwelling-Thinking," "earth" becomes "earth" and "sky," and "world" becomes "divinities" and "mortals." The "World" of the work thus includes two aspects of form and two of meaning, whether emotive

or conceptual. The formal aspects of a painting, for instance, include an "earth" and a "sky"—respectively, forms of the ground and appearances of the atmosphere. These aspects of form express two aspects of meaning, one divine and the other human. Heidegger calls these meanings "divinities" and "mortals." "Language" refers to this four part "World," the elements of which constitute the essential nature, the "Being," of the work of art. And the writer's consciousness is *directed toward* this "World," constituting the essence of the work. Since both "language" and consciousness have the same referent, therefore "language" is the writer's consciousness. And since his consciousness of the work is the same as his Being-with it, consequently prose style as "language" is his Being-with the essential nature of the work of art, its "being," comprising forms of "earth" and "sky" and meanings of "divinities" and "mortals."

Martin Heidegger's theory of "language" in "Building-Dwelling-Thinking" can be interpreted not only as an identification between prose style and the writer's consciousness of art but also as an indication of the particular function of style in the prose text.

Prose style as "language," we have seen, indicates the four aspects of "World," which together constitute the essential "Being" of the art work. Since the writer's consciousness is also directed toward these elements and this essence, the "language" shows what he is aware of in the art work and how he apprehends it. "Language" describes his visual perception of forms of "earth" and "sky" in a painting (for instance) and suggests his apprehension of the meanings of "divinities" and "mortals" that are expressed by these forms. On the one hand, "language" describes the writer's visual perception of an "earth," including forms of the ground, "the serving bearer, blossoming and fruiting, spreading out in rock and water, rising up into plant and animal." And "language" describes the visual appearances of the "sky," of

> . . .the vaulting path of the sun, the course of the changing moon, the wandering glitter of the stars, the year's seasons and their changes, the light and dusk of day, the gloom and glow of night, the clemency and inclemency of the weather, the drifting clouds and blue depth of the ether.[46]

On the other hand, "language" refers to the emotive and conceptual meanings that the writer becomes aware of when looking at the forms of the painting. "Language" suggests his apprehension of the "divinities," the divine significance belonging to the forms of "earth" and "sky." And "language" also suggests his comprehension of the meaning of "mortals" that belongs to these forms. This meaning concerns both the general significance of human beings and their significance, in particular, as mortal, as beings who "can die," who are "capable of death *as* death," as *non*-existence. Finally, by describing these two aspects of visual form and by suggesting these two elements of understood

meaning, "language" reveals the essence of the painting, its essential nature, or "Being" as apprehended by the writer. In sum, then, prose style as "language" refers to the writer's apprehension of, his Being-with, the essential nature of the painting, its "Being," constituted by forms of "earth" and "sky" and by meanings of "divinities" and "mortals." In this phenomenological perspective, the particular rhetorical modes of style show, in different ways, what the writer apprehends in the work. An image suggesting meaning, the symbol, for instance, can both describe his perception of "earth" and "sky" in the painting and also suggest his understanding of its meanings concerning "divinities" and "mortals." In these ways, symbol can indicate the writer's apprehension of the "World," the composite of form and meaning, in the work of art.

According to "Building-Dwelling-Thinking," prose style as "language" is either the writer's consciousness of the art work or is the means whereby he shows what he is aware of in it, its fourfold "World." This approach to prose style elaborates the one presented in "The Origin of the Work of Art," but also has the same limitations. In "Building-Dwelling-Thinking," Heidegger's identification of style with the writer's consciousness fails to actually define style itself. His identification of style with "language" ignores the distinction between language as a vehicle for meaning and style as the manner of its expression. This identification also disregards the particular rhetorical devices traditionally associated with prose style. And this approach to style as the means the writer uses to indicate the "World" apprehended in the *work* fails to account for characteristics of the *writer* that style could express. Nevertheless, Heidegger's approach is useful for understanding the style of Ruskin's practical criticism in *Modern Painters I* and *II*, particularly, the style of his commentary on *The Slave Ship* (in volume one) and on *The Last Judgment* (in volume two).

In the commentary on *The Last Judgment* (for example), Ruskin describes the rising of the dead, their ascent to the seat of judgment, and their separation into the good and the evil—the former rising into heaven and the latter falling into hell:

> Bat-like, out of the holes and caverns and shadows of the earth, the bones gather and the clay heaps heave, rattling and adhering into half-kneaded anatomies, that crawl, and startle, and struggle up among the putrid weeds, with the clay clinging to their clotted hair, and their heavy eyes sealed by the earth darkness yet . . . , blinded yet more, as they awake, by the white light of the new Heaven, until the great vortex of the four winds bears up their bodies to the judgment-seat: the Firmament is all full of them . . . , now soaring up slowly, and higher and higher still, till the eye and the thought can follow no farther, borne up, wingless, by their inward faith and by the angel powers invisible, now hurled in countless drifts of horror before the breath of their condemnation. (IV, 277)

With certain other paintings by Tintoretto, this work, Ruskin says, depends on the penetration of the imagination into the TRUE nature of the thing represented . . . " (IV, 278).

As already indicated, when the style of Ruskin's commentary on *The Last Judgment* is interpreted as the expression of Tintoretto's insight "into the TRUE nature of the thing represented," then an inconsistency between an objective function of style and a subjective one arises. On one hand, imagery describes the *objective* appearances of the judgment, represented in the painting. Yet, on the other, this imagery, which is symbolic, expresses Tintoretto's *subjective* impressions of the inner states of souls undergoing judgment. The phenomenological approach to prose style set forth in Heidegger's "Building-Dwelling-Thinking" can resolve this inconsistency.

This essay, we have seen, has two related but distinct views of prose style. According to the first, style is the writer's consciousness of the work. Prose style as "language," Heidegger maintains, is about, or refers to, the fourfold "World" of the work of art, such as a painting. Furthermore, the writer's consciousness is directed toward its forms of "earth" and "sky" and its meanings of "divinities" and "mortals." Since "language" and writer's consciousness both refer to these elements of the painting, consequently prose style is his consciousness of, his Being-with, its four part "World." Similarly, since Ruskin is aware of the visual form and the expressed meaning of *The Last Judgment* and since his symbolic style describes this representation and suggests its significance, therefore style, having the same referents as consciousness, is Ruskin's Being-with form and meaning in the work, which constitute its "World." Images do not describe an objective representation of the judgment, but instead constitute his visual awareness of the represented scene. And these images, as symbolic, do not suggest the painter's subjective insights into the final judgment. Rather, symbolic imagery constitutes Ruskin's mental awareness of the meaning belonging to the represented event, its expression of Tintoretto's imaginative insight "into the TRUE nature" of the last judgment.

This interpretation can be expanded with the second view of style set forth in "Building-Dwelling-Thinking." According to Heidegger, prose style as "language" refers to the four elements of the art work, all of which are apprehended by the writer's consciousness; hence, prose style shows what the writer apprehends in the work and how he apprehends it. In other words, style indicates his visual and mental apprehension of the fourfold "World" of the work. Style describes his visual perception of forms of "earth" and "sky" in, for instance, a painting. And style suggests his mental apprehension of the meaning belonging to these forms, the significance of "divinities" and that of "mortals," who can experience death. The style of Ruskin's commentary on *The Last Judgment* also refers to its forms and meanings, which are phenomenal objects of his consciousness. Consequently, his descriptive and symbolic style indicates his apprehensions of the "World," the unity of form and meaning, in this work.

Imagery describes not an objective representation but rather Ruskin's perception of the "earth" and the "sky" of *The Last Judgment*. For example, images describe his visual perception of an "earth," including the ground and decayed forms of human beings emerging form it; "Out of the holes and caverns and shadows of the earth, the bones gather and the clay heaps heave, rattling and adhering into half-kneaded anatomies" Imagery also depicts Ruskin's visual awareness of a "sky" suffused with light shining on the resurrected dead, who are "blinded yet more, as they awake, by the white light of the new Heaven, until the great vortex of the four winds bears up their bodies to the judgment-seat" Furthermore, as symbolic, the imagery of Ruskin's commentary both describes his visual perception of *The Last Judgment* and also has this description suggest his mental apprehension of the meaning belonging to the painting, its expression of Tintoretto's imaginative insight "into the TRUE nature" of the Christian judgment. Symbolism, then, does not express the painter's subjectivity, but rather suggests Ruskin's phenomenological apprehension of Tintoretto's imaginative ideas about the scene. Constituting the meaning of the events represented in the painting, these insights concern the significance of the "divinities" and of "mortals" who died. For example, Ruskin concludes his commentary with the symbolic image of souls "now soaring up slowly, . . . borne up, wingless, by their inward faith and by the angel powers invisible, now hurled in countless drifts of horror before the breath of their condemnation." This symbol suggests Ruskin's awareness of Tintoretto's insight into the scene, into the power of the Divine over man's spiritual destiny and into the joy of the saved and the despair of the damned.

Conclusions

A critical understanding of the style of John Ruskin's *Modern Painters I* and *II* depends on several diverse approaches to prose style. W.K. Wimsatt's, G.R. Stange's, and John D. Rosenberg's approaches can be used to describe Ruskin's style in these works. Wimsatt's approach, considering style to be the greatest elaboration of meaning in the prose text, is appropriate for understanding the style of Ruskin's purely theoretical statements in both volumes, because here he is concerned solely with the meaning of painting in general. And since the style of Ruskin's applied criticism in these volumes either expresses his acutal responses to certain paintings or suggests his personal characteristics, then the appropriate approaches are (respectively) Stange's concept of style as the expression of the writer's aesthetic experience and Rosenberg's concept of Ruskin's early style as the expression of his sensibility. When Ruskin's prose style in *Modern Painters I* and *II* is understood in relation to their aesthetic, whether theoretical or practical, then

interpretation according to Martin's Heidegger's phenomenological approaches is necessary in order to avoid the inconsistency in which Ruskin's style refers to both the objective qualities of the painting and also to its subjective expression of the painter's experience. The approach set forth in "The Origin of the Work of Art" is concerned with style in its reference to the basic phenomenal structure of the art work. Consequently, this approach is appropriate for interpreting the prose style of Ruskin's theoretical statements about painting. And the approach presented in "Building-Dwelling-Thinking" is appropriate for interpreting the style of Ruskin's usually elaborate practical criticisms of particular paintings, because this essay is concerned with phenomenological prose style in its reference to a wide range of visual form and aesthetic meaning in the work of art.

Throughout the following two chapters, I will refer to these different approaches in order both to describe and also to interpret John Ruskin's prose style in *Modern Painters I* and *II*.

8

The Prose Style of *Modern Painters I*

On several occasions, John Ruskin himself commented on the prose style of *Modern Painters I*. Usually, however, his criticisms were self-deprecating. For example, in a letter to H. G. Liddell on the style of this work, Ruskin remarks sarcastically:

> . . . it seems to me that the pamphleteer manner is not confined to these [introductory] passages: it is ingrained throughout. There is a nasty, snappish, impatient, half-familiar, half-claptrap web of young-mannishness everywhere. This was, perhaps, to be expected from the haste in which I wrote. I am going to try for better things; for a serious, quiet, earnest, and simple manner, like the execution I want in art.[1]

In his use of the phrase "pamphleteer manner," Ruskin may be referring to the prose of English journals popular during the first part of the nineteenth century. According to Ian A. Gordon's *The Movement of English Prose* (1966),

> . . . the long, often periodic, sentence with rhetorical "figures" and latinisms forms the basis of the prose of both journals [i.e. the *Edinburgh Review* (1802) and the *Quarterly Review* (1809)], which (consciously or unconsciously) imposed this style on their contributors, even when they wrote quite otherwise for a different audience.[2]

Having its antecedents in Samuel Johnson's prose style, this journalistic style, Gordon maintains, is the manner of "the gentleman conversing with the gentleman, or the educated with the educated."[3] Such a prose style, which may well be "the pamphleteer manner" that Ruskin objects to in *Modern Painters I,* is evident in his elaborate description of the Fall of Schaffhausen. Throughout, he addresses the reader in the journalistic manner of one gentleman speaking to another:

> Stand for half an hour beside the Fall of Schaffhausen, on the north side where the rapids are long, and watch how the vault of water first bends, unbroken, in pure polished velocity, over the arching rocks at the brow of the cataract, covering them with a dome of crystal twenty feet thick, so swift that its motion is unseen except when a foam-globe from above

darts over it like a falling star; and ı̇ .ʋ the trees are lighted above it under all their leaves, at the instant that it breaks into foam; and how all the hollows of that foam burn with green fire like so much shattering chrysoprase; and how, ever and anon, startling you with its white flash, a jet of spray leaps hissing out of the fall, like a rocket, bursting in the wind and driven away in dust, filling the air with light; and how, through the curdling wreaths of the restless crashing abyss below, the blue of the water, paled by the foam in its body, shows purer than the sky through white rain-cloud; while the shuddering iris stoops in tremulous stillness over all, fading and flushing alternately through the choking spray and shattered sunshine, hiding itself at last among the thick golden leaves which toss to and fro in sympathy with the wild water; their dripping masses lifted at intervals, like sheaves of loaded corn, by some stronger gush from the cataract, and bowed again upon the mossy rocks as its roar dies away; the dew gushing from their thick branches through drooping clusters of emerald herbage, and sparkling in white threads along the dark rocks of the shore, feeding the lichens which chase and chequer them with purple and silver. I believe, when you have stood by this for half an hour, you will have discovered that there is something more in nature than has been given by Ruysdael. Probably you will not be much disposed to think of any mortal work at the time; but when you look back to what you have seen, and are inclined to compare it with art, you will remember, or ought to remember, Nesfield. He has shown extraordinary feeling, both for the colour and the spirituality of a great waterfall (III, 529-31)[4]

In addition to the polite conversational tone of this passage (evident especially at the end), its style has another aspect in common with that of the reviews mentioned—a reliance on figures of speech. Ruskin uses several similes that now are, and probably were in his time, merely sensational. For example, foam passes over the waterfall "like a falling star," and "all the hollows of that foam burn with green fire like so much shattering chrysoprase." Or, using another similie obviously trite and sensational, Ruskin asks the reader to observe "how, ever and anon, startling you with its white flash, a jet of spray leaps hissing out of the fall, like a rocket, bursting in the wind and driven away in dust, filling the air with light" In these ways, then, the style of Ruskin's passage exemplifies "the pamphleteer manner" that he objects to in *Modern Painters I.*

However, Ruskin's criticism of its prose style as a whole seems too severe. An early unsigned article in the *Spectator* (1890) concerned with Ruskin's early prose style in general and in particular with that of *The Seven Lamps of Architecture,* maintains:

Of conscious, often vituperative criticism on his earlier style of writing however, we are also given full measure in the preface and notes of the present volume. In very few cases does it affect the quality of our admiration; but it is somewhat disturbing in the course of an impressive sentence or paragraph, to find a note calling it "useless sputter;" or "very pretty, but, unfortunately, nonsense;" or to have the language of the whole book referred to as "overlaid with gilding, and overshot too splashily and cascade fashion [sic] with gushing of words." The whole process is so very suggestive of having to brush away an importunate fly which persists in obscuring our vision of a beautiful landscape; and our difficulty is only increased by our reverence for Mr. Ruskin, which obliges us to examine into the nature of our small causes of annoyance, and to the finding of a decided amount of interest in them.[5]

Similarly, Ruskin's disparaging criticism of the style in *Modern Painters I* tends to distract critical attention from the actual qualities and functions of prose style in this work.

Furthermore, although *Modern Painters I* certainly contains numerous passages written in the careless and sensational "pamphleteer manner" that Ruskin rightly censures, nevertheless nearly all of these passages including the one on the Fall of Schaffhausen are concerned with secondary aspects of aesthetic theory, commentary on painting, or theory and comment combined. But the prose style in his primary statements of aesthetic theory or art criticism is usually not marred by this journalistic manner. In this study, I am concerned primarily with the style of these central statements; thus, Ruskin's criticism of "the pamphleteer manner" in *Modern Painters I* is not directly relevant to this concern.

The first part of John Ruskin's *Modern Painters I* is concerned primarily with a theory of landscape painting. The second part is concerned with applications of this theory to criticism of particular landscape works, primarily certain ones by J. M. W. Turner. In turn, the prose style of Ruskin's central theoretical statements usually relies on expressive devices appropriate for generalization. And the style of his important practical criticism usually relies on concrete figurative language appropriate both for pictorial description of particular paintings and also for expression of their significance.

Generalization, Antithesis, and Ruskin's Theory of Landscape Art

William K. Wimsatt's *The Prose Style of Samuel Johnson* points out the relationship between abstract generalization and the thetorical device of antithesis: "Abstraction and generality are conditions which favor antithesis. . . . Generality and abstraction are concentration of meaning into the pure forms which admit sharp contrast."[6]

This type of relationship between abstract, general meaning and antithesis is evident in Ruskin's comparison of the landscape painter with the versifier at the beginning of *Modern Painters I*. The abstract and general nature of Ruskin's statement enables him to contrast them with antithesis:

> Speaking with strict propriety, therefore, we should call a man a great painter only as he excelled in precision and force in the language of lines, and a great versifier, as he excelled in precision and force in the language of words. A great poet would then be a term strictly, and in precisely the same sense, applicable to both, if warranted by the character of the images or thoughts which each in their respective language conveyed. (III, 88)

In this statement, Ruskin contrasts the "great painter" with the "great versifier" by means of two antithetical noun phrases. Wimsatt calls this type of juxtaposition "antithesis I," which "in pointing out opposite notions either

affirms or denies both in the same respect."[7] Ruskin's antithesis affirms the nature of the landscape painter and that of the versifier with respect to their use of language, understood in a general sense as any expressive medium. This antithesis contrasts the painter with the versifier on the basis of the type of language used by each; that is, "we should call a man a great painter only as he excelled in precision and force in the language of lines, / and a great versifier, as he excelled in precision and force in the language of words." The basic meaning of this antithetical statement concerns the painter as one who excels with a brush and the versifier as one who excels with words. And the device of antithesis implies a refinement or elaboration of this basic meaning that (according to Wimsatt's perspective) constitutes an aspect of style. According to this perspective, the elaborated meaning, the style, of Ruskin's antithetical statement comparing the landscape painter with the versifier is that both, although employing different "languages," are potentially alike in that both can thereby express meaning. And if they do, then each becomes "a great poet," "a term . . . applicable to both, if warranted by the character of the images or thoughts which each in their respective languages conveyed."

From his comparison of the versifier with the landscape painter, Ruskin proceeds to a characterization of the landscape painting itself. As in this comparison, the abstract and general nature of Ruskin's statement on the landscape painting, on what it should and should not be, allows extended antithetical constructions. He contrasts Imitation with Truth. The Central aspect of Ruskin's aesthetic theory in *Modern Painters I,* the Idea of Truth, applied to landscape painting, concerns first accurate representation of appearances of the natural world and second expression of the painter's "emotions, impressions, and thoughts" about it (III, 104). Ruskin employs one kind of antithesis to contrast Truth with Imitation and another to contrast representation with expression; thereby, he elaborates the meaning of his statement.

Understood in the perspective of *The Prose Style of Samuel Johnson,* these two types of antithesis are what Wimsatt calls "antithesis I" and "antithesis II." According to Wimsatt, "while antithesis I in pointing out opposite notions either affirms or denies both in the same respect, antithesis II makes a distinction in order to affirm one part and deny the other."[8] A fundamental variation of this second type of antithesis is "a negative implication through a comparative."[9] Such devices express special aspects of meaning, its final elaborations—constituting prose style.

Employing the variation of "antithesis II" just mentioned, Ruskin contrasts two possibilities of landscape art. He compares duplication of natural aspects with accurate representation of them and concomitant expression of the painter's feelings and thoughts about them:

Imitation can only be of something material, / but truth has reference to statements both of the qualities of material things, and of emotions, impressions, and thoughts Hence, truth is a term of universal application, / but imitation is limited to that narrow field of art which takes cognizance only of material things. (III, 104)

These antithetical clauses constitute a negative comparison between Imitation and Truth and thereby imply a denial of the fomer and an affirmation of the latter. Concerning a rejection of Imitation and an acceptance of Truth, this refinement, or final elaboration, of Ruskin's basic meaning contrasting Imitation with representation and expression constitutes one aspect of the style belonging to his statement on Truth in landscape art.

The second aspect concerns a refinement of meaning belonging to Ruskin's antithetical statement on Truth itself. In this statement, he relies on what Wimsatt calls "antithesis I," which can affirm contrary ideas "in the same respect."[10] "In every antithesis," Wimsatt explains, "the two affirmations or the affirmation and negation are made with respect immediately to some third notion more or less explicit in the context."[11] Ruskin's antithetical statement affirms two notions—representation of nature and expression of the painter's responses to it—with respect to a third, the Truth of the landscape work. Truth, Ruskin affirms,

. . . has reference to statements both of the qualities of material things, / and of [the artist's] emotions, impressions, and thoughts. There is a moral / as well as material truth,—a truth of impression / as well as of form,—of thought / as well as of matter; and the truth of impression and thought is a thousand times the more important of the two. (III, 104)

Throughout, antithetical phrasing contrasts the two opposite aspects of Truth and thereby implies an extension of its basic meaning, concerned with representation and expression in the landscape work. And this elaborated meaning is style.

Suggested by these antitheses, the first aspect of this elaborated meaning is the equality of importance between representation and expression in the work; however, this implicit meaning contradicts Ruskin's explicit statement concerning the relative importance of these two elements of Truth: "The truth of impression and thought is a thousand times the more important of the two." Consequently, here Ruskin's style is flawed, in Wimsatt's sense of "a deviation of meaning from meaning,"[12] of implicit from explicit meaning, of elaborated (or stylistic) meaning from fundamental meaning.

For the most part, however, the style of Ruskin's statement on Truth— the most extensive development of its basic aspects of meaning—is consistent with them. They concern accurate representation of nature and expression of the artist's feelings and thoughts about it. Ruskin's initial antithesis affirms these two opposite meanings of Truth. Implied by antithetical phrasing, the

greatest elaboration of meaning, the style, of this statement on Truth is the *intensity* of the contrast in the painting between representation and expression—between "statements both of the qualities of material things, / and of [the painter's] emotions, impressions, and thoughts" about them. Then, continuing with a series of antithetical phrases, Ruskin contrasts elements of representation with aspects of expression, while affirming both: "There is a moral / as well as material truth,—a truth of impression / as well as of form,— of thought / as well as of matter . . . " These antithetical phrases refine the basic meaning of Truth by suggesting that representation of nature and expression of the painter not only intensely contrast but also combine, forming a coherent unity in the landscape painting itself. And this refinement of meaning (i.e. that representation and expression form a unity in the work) constitutes the final aspect of the style, the greatest elaboration of meaning, belonging to Ruskin's antithetical statement on the Idea of Truth.

Thus, when *described* by Wimsatt's approach to style, that of Ruskin's statement on Truth is its final elaboration of meaning, the intense contrast between and the coherent unity of representation and expression in the landscape painting. And, when *interpreted* with Martin Heidegger's phenomenological approach to prose style set forth in "The Origin of the Work of Art," the style of Ruskin's statement is a reflex of the Idea of Truth.

According to Heidegger's essay, prose style as "language" is about the "truth" of the work of art. "Truth," the essential nature of the work, includes visual form, expressed meaning, and their complementary contrast. In different words, "truth" includes an "earth," a "world," and their "conflict." Similarly, the writer's consciousness is directed toward the contrast of "truth" in the art work. He knows that form needs to have meaning, that meaning needs to have a referent in form, and that both form and meaning, complementing each other in these ways, thereby establish a unity of opposites in the work, its "truth" in the work. And consequently, prose style as "language" is the writer's consciousness of, his Being-with, the contrast of "earth" and "world" in the work of art. Furthermore, having the same referents as the writer's consciousness, phenomenological style shows, in effect, what he apprehends in the work and how he apprehends it. Specifically, style indicates his visual apprehension of form and suggests his mental apprehension of its meaning and of the complementary contrast between the two that constitutes the unity, the "truth," of the art work.

Ruskin employs antitheses, syntactical constructions emphasizing contrasts in meaning, to indicate the basic contrasts in the Idea of Truth:

> The word Truth, as applied to art, signifies the faithful statement, either to the mind or senses, of any fact of nature.
> We receive an idea of truth, then, when we perceive the faithfulness of such a statement.

> The difference between ideas of truth and of imitation lies chiefly in the following points: First,—Imitation can only be of something material, but truth has reference to statements both of the qualities of material things, and of emotions, impressions, and thoughts. There is a moral as well as material truth,—a truth of impression as well as of form,—of thought as well as of matter; and the truth of impression and thought is a thousand times the more important of the two. Hence, thought is a thousand times the more important of the two. Hence, truth is a term of universal application, but imitation is limited to that narrow field of art which takes congizance only of material things. (III, 104)

Here Ruskin indicates that either visually or mentally, either with "the mind or senses" he is aware of Truth in the landscape painting. And he employs antithesis to affirm the contrasting aspects of Truth itself, including both representation of nature and expression of the painter's responses to it, specifically including "statements both of the qualities of material things, / and of emotions, impressions, and thoughts." Thus, antithesis refers to the same elements of the work that Ruskin is aware of visually or mentally. And thus, this antithetical hestyle, or manner, is his consciousness of the phenomenological "conflict" between "earth" and "world" in the painting— its *sharp* contrast between form and meaning, between accurate representation of natural aspects and clear expression of the painter's emotions and thoughts about them. The antithetical phrasing of Ruskin's explanation of Truth can also be understood from a slightly different phenomenological perspective, in which style shows how Ruskin apprehends the landscape painting and what he apprehends in it.

Commencing his characterization of the Idea of Truth, Ruskin, we have seen, maintains that he apprehends it in the work either with "the mind / or senses." Here, Ruskin explicitly indicates that his apprehension of Truth is either mental or visual. The antithesis of words in his statement not only explicitly affirms these two opposite modes of apprehension but also implies that they complement each other, combining into a visual *and* mental apprehension of Truth in the landscape painting.

Ruskin then explains Truth, which he is aware of in the work. Speaking literally, he explains his visual and mental apprehension of Truth as both accurate representation of natural aspects and also as expression of the artist's emotional and mental responses to them. Antithetical phrasing details both the manner of Ruskin's apprehension and its content concerning representational form and expressed meaning, "earth" and "world," in the landscape painting. An antithesis of phrases affirms its opposite "statements both of the qualities of material things, / and of [the artist's] emotions, impressions, and thoughts." Phenomenologically, this antithetical construction suggests that Ruskin is *intensely* aware of the *sharp* contrast, the "conflict," between visual form representing natural aspects and expressed meaning concerning the painter's emotional and conceptual responses to them.

Additional antithetical constructions follow: "There is a moral / as well as material truth,—a truth of impression / as well as of form,—of thought / as well as of matter" This statement explicitly enumerates various aspects of representation and of expression that Ruskin is aware of in the painting. And his successive antithetical phrases implicitly affirm that these intentional aspects of representational form and expressed meaning, of "earth" and "world," not only contrast but also complement each other, establishing the unity, the phenomenological "truth," of the work. Thus, these antitheses suggest Ruskin's awareness that meaning (including the painter's moral precepts, impressions, and thoughts) needs a vehicle for expression, that this vehicle (form corresponding to nature) needs meaning, and that form and meaning, complementing each other in these ways, establish a unity, an Idea of Truth, in the landscape painting.

In general, then, Ruskin's characterization of Truth in landscape art explicitly states his visual perception of accurate representation and his mental apprehension of the painter's feelings and thoughts. The antithetical phrases throughout the characterization elaborate this apprehension. Antitheses imply Ruskin's intense visual *and* mental apprehension of the sharp contrast between representation and expression, which complement each other and thereby unify into an Idea of Truth.

Throughout his comparison of the landscape painter with the versifier and his characterization of Truth in landscape painting, Ruskin, we have seen, relies on antithesis, which is appropriate for the generalization and abstraction necesary in exposition of aesthetic theory. But when exemplifying aspects of representational Truth, Ruskin relies primarily on figurative language, which is appropriate for a concrete, pictorial account of the particular work.

Word-Sounds in the Commentary on *The Téméraire*

This movement from abstract, general aesthetic theory to concrete, particular criticism of specific paintings is especially evident when Ruskin speaks about Truth of Tone (concerned with accurate representation of light and shade in nature) and then about Turner's *The Téméraire*.

According to Ruskin, the first meaning of Tone concerns the proper relationship of shaded objects with respect to distance and to the primary light in the picture (III, 259). And, employing abstract and general terms, he defines the second meaning of Tone as

> . . . the exact relation of the colours of the shadows to the colours of the lights, so that they may be at once felt to be merely different degrees of the same light; and the accurate relation among the illuminated parts themselves, with respect to the degree in which they are influenced by the colour of the light itself, whether warm or cold; so that the whole of the picture (or, where several tones are united, those parts of it which are under each) may be

felt to be in one climate, under one kind of light, and in one kind of atmosphere; this being chiefly dependent on that peculiar and inexplicable quality of each colour laid on, which makes the eye feel both what is the actual colour of the object represented, and that it is raised to its apparent pitch by illumination. (III, 259-60)

Relying on abstractions such as "colours," "tones," and "pitch," Ruskin here presents a concept of Tone in landscape painting concerning first a harmonization of shaded colors with lighted ones in which both levels of color appear as "different degrees of the same light" and second a harmonization of lights with each other in which they all take "the colour of the [primary] light itself." But, concerned with Truth of Tone as harmonization of colors of sunlight and sky with colors of twilight, shadows, and falling darkness, Ruskin's pictorial account of J.M.W. Turner's *The Fighting 'Téméraire' Tugged to Her Last Berth to Be Broken Up 1838,*[13] relies not on abstractions and generalizations but on concrete, particular description of the seascape. Describing "the evening effect with the Téméraire," Ruskin elaborates the scene:

That picture will not, at the first glance, deceive as a piece of actual sunlight but this is because there is in it more than sunlight, because under the blazing *veil* of vaulted *fire* which lights the *vessel* on her last *path,* there is a blue, deep, desolate *hollow* of *darkness,* out of which you can hear the *voice* of the night *wind,* and the dull *boom* of the disturbed *sea;* because the cold deadly *shadows* of the *twilight* are gathering through every *sunbeam,* and moment by moment as you look, you will fancy some new *film* and *faintness* of the *night* has risen over the *vastness* of the departing *form* [italics mine]. (III, 275)

Based on word-sounds and their patterns, the concrete prose style of this passage can be described as the expression of Ruskin's aesthetic experience and interpreted as a reflex of his aesthetic concerning Truth of Tone.

When understood according to G. R. Stange's approach to the style of art criticism, the prose style of this commentary expresses Ruskin's experience of *The Téméraire.* According to Stange, the prose style of art criticism represents the speaker's visual experience of an art work (such as a painting) and expresses his responses to it, his emotions and thoughts about it. Herbert Read's *English Prose Style* (1952) presents a similar approach. He maintains that the book "is not primarily concerned with the reader's point of view, but with the writer's. I take the need [he says] for self-expression as granted, and seek only to formulate the means."[14] Read's explanation of words not imitating but suggesting what they refer to is, with respect to the style of Ruskin's commentary, a particularly useful supplement for Stange's approach to the style of art criticism. Certain words, Read explains, have sounds that are "not imitative [i.e. onomatopoeic], but suggestive (musical equivalents): *glitter, swoon, mood, sheen, horror, smudge, still (tranquil), womb, jelly,* etc."[15] According to Read's perspective, then, such words can suggest what

they refer to as well as express the writer; transposed into Stange's perspective, they can suggest the writer's visual perceptions of the art work as well as express his emotions and thoughts about it.

Beginning his commentary on *The Téméraire,* Ruskin describes "the blazing veil of vaulted fire which lights the vessel on her last path." Here, the sounds of "blazing" and "veil" suggest his visual perception of blinding red and yellow sunlight suffusing the sky like mist; the sounds of "vaulted" and "fire" suggest that the painting leads his eye up to an immense dome of light; and together the sounds of all these words express his awe at the brilliant and vast sunset depicted. Next, in Ruskin's description of the "blue, deep desolate hollow of darkness, out of which you can hear the voice of the night wind, and the dull boom of the disturbed sea," word-sounds implicitly develop his perceptions of and responses to Turner's painting. The sounds of "deep," "desolate," and "hollow" suggest Ruskin's perception of a seemingly endless void of darkness gathering on the sea and imply fear, a response to this void. The sounds of "voice" and "wind" implicitly express his melancholy reaction to the scene. And those of "dull," "boom," and "sea" together suggest vague uneasiness. Ending his commentary, Ruskin remarks that "some new film and faintness of the night has risen over the vastness of the departing form." Suggesting his visual perception of thin evening mist rising off the sea and enveloping the ship, the sounds of "film" and "faintness" also express his responses in thought and feeling to the ghost-like ship. He associates death with it and therefore feels fear. In general, then, word-sounds develop Ruskin's visual perception of a vast sky lit by the descending sun, a void of gathering darkness on the sea, and mist around the ship; and these sounds express awe, fear of the unknown, and fear of death, all of which developed in him as he looked at *The Fighting 'Téméraire' Tugged to Her Last Berth to Be Broken Up.*

Throughout Ruskin's commentary on *The Téméraire,* the relationship between style, based on sounds in words, and aesthetic theory is not explicit.

Referring to particulars of the sea, the vessel, and the twilight, the dense concrete style of this commentary exemplifies (in part, at least) a criticism in *The Reader Over Your Shoulder* (1943) of Ruskin's early style and, by implication, that of *Modern Painters I.* The writers, Robert Graves and Alan Hodge, maintain:

> Pictorial styles were also used by John Ruskin and Walter Pater, who were not novelists but literary preachers and therefore indulged in even greater complexity of language. When Ruskin confined himself to expounding moral or aesthetic theory his style was fairly straightforward, but this was rare: his elaborate word-painting usually crowded out the precepts it was supposed to illustrate.[16]

In most of Ruskin's important practical criticism in *Modern Painters I*, "word-painting" does, in fact, replace theory (at least on the explicit level). Style replaces "the precepts it was supposed to illustrate." Having a vividly descriptive, concrete style, Ruskin's commentary on *The Téméraire* explicitly concerns the work itself—rather than precepts concerning Truth of Tone. In this commentary and throughout the noteworthy practical criticism of *Modern Painters I*, however, Ruskin's pictorial style nevertheless *implies* a relationship between the particular work under discussion and particular aesthetic precepts, and thereby illustrates them indirectly.

This implication can be interpreted with the phenomenological approach to style presented in "The Origin of the Work of Art." The "earth" of the art work, Heidegger maintains, is its form and appearance as visually perceived by the writer. His prose style as " language" can refer to this "earth" by means of description, rhythm, word-sounds, and so on. Style, then, can indicate his visual apprehension of the appearance and form of the art work, of (for instance) a landscape painting.

Ruskin the writer uses word-sounds to suggest his visual perception of formal aspects of Tone in *The Téméraire* that constitute its "earth." Although he introduces this work as an example of J.M.W. Turner's capacity to achieve Truth of Tone, a coherent pattern of light and shade, in landscape painting, yet Ruskin does not explicitly point out this achievement; instead, he implies it. He implies that the visual form, the "earth," of *The Téméraire* possesses a Truth of Tone, an "exact relation of the colours of the shadows to the colours of the lights, so that they may be at once felt [i.e. seen] to be merely different degrees of the same "light" (III, 259). He makes this implication about Tone with euphony and alliteration—with sequences, respectively, of harmonious word-sounds and of identical initial sounds. And in these ways, he suggests his visual perception of Tone in *The Téméraire*.

He first implicitly details his apprehension of "the exact relation of the colours of the shadows to the colours of the lights"—in particular, a contrast between and a congruence of shaded colors and lighted ones.

Referring to the painting, Ruskin remarks that "under the blazing veil of vaulted fire which lights the vessel on her last path, there is a blue, deep, desolate hollow of darkness, out of which you can hear the voice of the night wind, and the dull boom of the disturbed sea " Here, in the description of the "veil of vaulted fire which lights the vessel" and that of the "deep, desolate hollow of darkness," alliteration on "v" contrasts with that on "d" and thereby suggests Ruskin's visual awareness of a contrast in the appearance, or "earth," of the painting between colors of sunlight in the sky and those of dusk on the sea.

Euphonious vowels and diphthongs do not, however, basically contrast between the description of "the blazing veil of vaulted fire which lights the vessel" and that of the "blue, deep, desolate hollow of darkness, out of which

you can hear the voice of the night wind, and the dull boom of the disturbed sea." Furthermore, certain word-sounds in the first statement are similar to certain ones in the second. For instance, the vowel sound in "vaulted" corresponds to the vowel sounds in "hollow," "voice," "dull," and "boom." Throughout both statements, then, the marked absence of any sharp contrast in the sequence of euphonious vowel sounds and the positive similarity of certain ones in the first statement with certain ones in the second suggest that Ruskin perceives a harmonious relationship in *The Téméraire* between the colors of the sunset in the sky and those of the dusk on the sea. In this sense, an elaborate sequence of vowel and diphthong sounds implies Ruskin's visual consciousness of congruence between sunlight and twilight in the painting.

Concerned with this relationship between light and shadow, Ruskin concludes his account of the painting: "The cold deadly shadows of the twilight are gathering through every sunbeam, and moment by moment as you look, you will fancy some new film and faintness of the night has risen over the vastness of the departing form," the ship. Throughout this statement, Ruskin, by means of alliteration, implies that the coherent visual appearances of sunlight and twilight in the painting are, with respect to Tone, "merely different degrees of the same light" (III, 259). The "s" alliteration of "shadows" and "sunbeams" implies his visual apprehension of this Tone, a blending of sunlight with shadow into one light, the dim half-light of dusk. And, when he says that "you will fancy some new film and faintness of the night has risen over the vastness of the departing form," Ruskin uses alliteration on the sound of "f" in order to suggest his own visual awareness of this half-light, distorting very slightly the outlines of the Téméraire.

Understood according to G.R. Stange's perspective on prose style, then, the suggestive word-sounds in Ruskin's commentary on *The Tèmèraire* detail his perceptions of the work and express his responses to it—awe, a vague fear of the unknown, and the fear of death. And when interpreted from Heidegger's phenomenological perspective, the alliteration and the euphony in Ruskin's commentary imply a Truth of Tone, an agreement as well as contrast of sunlight with shadow in the painting and their combination into its major light.

And throughout the remainder of *Modern Painters I,* prose style, when described, functions as an expression of Ruskin the speaker and, when interpreted, functions as a phenomenological reflex of theory about or commentary on art.

Alliteration in the Art Criticism of Llanthony Abbey

Describing the rain in the sky portrayed by Turner's *Llanthony Abbey,* Ruskin employs imagery and alliteration extensively:

From this picture [i.e. Turner's Jumièges] we should pass to the Llanthony, which is the rendering of the moment immediately following that given in the Jumièges. The shower is here half exhausted, half passed by, the last drops are rattling faintly through the glimmering hazel boughs, the white torrent, swelled by the sudden storm, flings up its hasty jets of springing spray to meet the returning light; and these, as if the heaven regretted what it had given, and were taking it back, pass as they leap, into vapour, and fall not again, but vanish in the shafts of the sunlight; hurrying, fitful, wind-woven sunlight, which glides through the thick leaves, and paces along the pale rocks like rain; half conquering, half quenched by the very mists which it summons itself from the lighted pastures as it passes, and gathers out of the drooping herbage and from the streaming crags; sending them with messages of peace to the far summits of the yet unveiled mountains, whose silence is still broken by the sound of the rushing rain. (III, 401-402)

Throughout this passage, Ruskin employs imagery in order to represent his visual perception of *Llanthony Abbey* and alliteration in order to suggest his imaginative responses to it.

Understood according to G.R. Stange's approach to the style of art criticism, this prose style based on imagery and alliteration, is an instance of the writer's attempt to "express the rhythm of the mind as it responds to or perceives concrete experience."[17] First, throughout the art criticism of *Llanthony Abbey*, the writer Ruskin relies on visual images in order to describe his concrete perceptual experience of the shower represented in the work. For example,

. . . the last drops are rattling faintly through the glimmering hazel boughs, the white torrent flings up its hasty jets of springing spray to meet the returning light; and these . . . pass as they leap, into vapour, and fall not again, but vanish in the shafts of the sunlight; . . . wind-woven sunlight, which glides through the thick leaves and paces along the pale rocks like rain (III, 401-2)

Second, Ruskin employs alliteration throughout this description of perceptual experience in order to express the imaginative response of his mind to it. Sequences of identical sounds beginning words in this passage are onomatopoeic. However, since the painting is a purely visual artifact, then this alliteration imitates sounds that would exist in an actual scene parallel to the one represented in the work, and thereby implies Ruskin's imaginative response to it. The alliteration suggests sounds that he imagines when looking at the painting. For instance, in the description of the torrent flinging "up its hasty jets of *s*pringing *s*pray," alliteration on "s" suggests that he imagines the hiss of water striking rocks. Or, repetition of initial "s's" and "w's" in the description of "*s*hafts of the *s*unlight; . . . *w*ind-*w*oven sunlight" suggests that he imagines sounds of rain and of blowing wind.

Thus, imagery in Ruskin's commentary on *Llanthony Abbey* represents his visual perception of it, and alliteration suggests natural sounds that he imagines in response to this perception.

Understood as the expression of an aspect of representational Truth, a Truth of Clouds, the imagery and the alliteration characterizing the style of Ruskin's commentary have a phenomenological orientation that can be interpreted with an aspect of the approach to style presented by Martin Heidegger in "Building-Dwelling-Thinking." Prose style as "language," Heidegger explains, refers to the "sky" of the art work; similarly, the writer's consciousness is directed toward its "sky"—in a painting (for example), appearances of the atmosphere. Thus, style indicates what the writer apprehends in the painting. In particular, prose style as "language" indicates his apprehension of, for instance, "the vaulting path of the sun, . . . the light and dusk of day, . . . the clemency and inclemency of the weather, the drifting clouds and blue depth of the ether."[18] Likewise, in the commentary on *Llanthony Abbey,* prose style describes its "sky," its Truth of Clouds, particularly, "of the rain-cloud," to which "belong . . . all the phenomena of . . . white steaming vapour rising in evaporation from moist and open surfaces, and everything which visibly affects the condition of the atmosphere without actually assuming the form of cloud" (III, 395). And since Ruskin sees such natural aspects represented in the painting, consequently his style shows what he is aware of in the work.

Throughout Ruskin's commentary, imagery and alliteration combine, indicating his visual and imaginative apprehension of aspects "of the rain-cloud" in the "sky." Images represent his visual perceptions, and alliteration suggests his imaginative association of particular natural sounds with them. In particular, images represent his visual experience of water flung into the air by the swollen torrent: "The white torrent, swelled by the sudden storm, flings up its hasty jets of springing spray to meet the returning light " And the repetition of "s" at the beginning of several words in this description suggests his imaginative awareness of the hissing sound heard from such movement of water in nature itself.

Ruskin continues his pictorial description of jets of spray, which

> . . . pass as they leap, into vapour, and fall not again, but vanish in the shafts of the sunlight; hurrying, fitful, wind-woven sunlight, which glides through the thick leaves, and paces along the pale rocks like rain; half conquering, half quenched by the very mists which it summons itself from the lighted pastures as it passes, and gathers out of the drooping herbage and from the streaming crags (III, 395)

Moving from description of spray to that of wind, the images in this passage represent visual phenomena perceived in the "sky" of the painting. Images describe Ruskin's perception of rays of sunlight shining on the torrent and its environs. Characterized by phenomena of the rain-cloud, by "white steaming vapour rising in evaporation from moist and open surfaces," by rising mist blown in the wind, this sunlight thus indicates movement of wind. Describing this perception with images, Ruskin suggests concomitant imaginative

apprehensions with an elaborate pattern of alliteration. The alliteration on "w," aspirated in the phrase "*w*ind-*w*oven sunlight," suggests the deep tone of steadily blowing wind that he imagines when looking at this sunlight, pervaded by mist. Elaborating this imagination, Ruskin, again relying on aspirated sounds, employs a pattern of alliteration alternately suggesting first (with the initial letters "th" or "h") the even sound of steadily moving wind and then (with initial "p's") the more abrupt sound of gust. He repeats this pattern once, describing sunlight, "which glides *th*rough *th*e *th*ick leaves, / and *p*aces along the *p*ale rocks like rain; / *h*alf conquering, *h*alf quenched / by the very mists which it summons itself from the lighted *p*astures as it *p*asses "

Concluding his commentary on *Llanthony Abbey,* Ruskin employs imagery describing his visual apprehension of the distant "sky," in which sunlight, having gathered mists from the land, sends "them with messages of peace to the far summits of the yet unveiled mountains, whose silence is still broken by the sound of the rushing rain." And, in this alliterative description of mountains, "whose *s*ilence is *s*till broken by the *s*ound of the *r*ushing *r*ain," repetition of initial "s's" and "r's" suggests Ruskin's imaginative awareness of the muted hiss and roar of distant rain.

Thus, Ruskin's style not only pictorially describes his visual perceptions of the "sky," particularly of phenomena associated with "the rain-cloud," in *Llanthony Abbey,* but also, by means of alliteration, implies his imaginations of auditory phenomena connected with wind and rain in the natural world.

Levels of Usage and the Aesthetic of Foreground Painting

After discussing Truth of Clouds, Ruskin deals with Truth of Earth in landscape painting. A major aspect of this theory is concerned with advice to the landscape painter about the way to paint foreground correctly:

A really great artist dwells on every inch of exposed soil with care and delight, and renders it one of the most essential, speaking, and pleasurable parts of his composition. And be it remembered, that the man who, in the most conspicuous part of his foreground, will violate truth with every stroke of the pencil, is not likely to be more careful in other parts of it; and that, in the little bits which I fix upon for animadversion, I am not pointing out solitary faults, but only the most characteristic examples of the falsehood which is everywhere, and which renders the whole foreground one mass of contradictions and absurdities. Nor do I myself see wherein the great difference lies between a master and a novice, except in the rendering of the finer truths of which I am at present speaking. To handle the brush freely, and to paint grass and weeds with accuracy enough to satisfy the eye, are accomplishments which a year or two's practice will give any man: but to trace among the grass and weeds those mysteries of invention and combination by which nature appeals to the intellect; to render the delicate fissure, and descending curve, and undulating shadow of the mouldering soil, with gentle and fine finger, like the touch of the rain itself; to find even in all that appears most trifling or contemptible, fresh evidence of the constant working of the Divine

power "for glory and for beauty," and to teach it and proclaim it to the unthinking and the unregarding; this, as it is the peculiar province and faculty of the master-mind, so it is the peculiar duty which is demanded of it by the Diety. (III, 483)

N.N. Feltes, in an article called "The Quickset Hedge: Ruskin's Early Prose," makes a comment about the structure of his early style that can implement explanation of the style in this passage. According to Feltes:

> . . . the image of the hedge can also represent the "arborescence" of Ruskin's early prose, writhed into every form of nervous entanglement, digressive, interspersing abstract theory and particular description, or, to be more precise, moving from the vantage point of abstract speculation down through the description of particular surfaces to the life within. For the celebrated "purple passages" seem to me generally to be organized in this manner, accumulation becoming structure by a process that moves from vantage point through specific details to their "life."[19]

In Ruskin's passage on the painting of foreground, first in an abstract and general manner, he compares the artist to the beginner with respect to their respective procedures. Then, making the same comparison in more specific terms, he concentrates on the pure artist's capacity by moving from "the description of particular surfaces to the life within" (in Feltes' words); from a rendering of (for instance) "the delicate fissure, and descending curve" to their expression of the divine life immanent in nature, "the constant working of the Divine power" (in Ruskin's words).

W.K. Wimsatt, in *The Prose Style of Samuel Johnson,* explains an aspect of diction that is particularly useful for understanding this stylistic movement from the abstract to the concrete. Explaining the distinction in words between "sensory and non-sensory," Wimsatt maintains "that particular or more specific words tend to be more sensory than general or abstract ones."[20] When understood in the context of Wimsatt's view of style as elaborated meaning, a *predominance* of sensory or of non-sensory diction in a prose text can implicitly complement and elaborate its basic meaning. And this elaboration of fundamental meaning is an aspect of style in the prose work. Understood according to this semantic view of prose style, the style of Ruskin's passage on the painting of foreground is an elaboration of its basic meaning, concerned on one hand with the novice, who is apt to make errors in representation, and on the other with the master, who is capable not only of accurately representing nature but also of expressing the divine force inherent in it. Ruskin implicitly elaborates this meaning with a gradual movement in diction from the non-sensory, the general and abstract, to the sensory, the particular and concrete.

Comparing the novice with the master, Ruskin first employs abstractions when characterizing the novice as capable only of copying natural foreground. According to Ruskin, "to paint grass and weeds with *accuracy*

enough to satisfy the eye, are *accomplishments* which a year or two's *practice* will give any man."(Italics mine.) The predominance of abstract terms in this passage elaborates its meaning by suggesting that the novice's painting of foreground has a merely theoretical correctness, devoid of expression and meaning.

But, characterizing the master as one capable of both accurate representation of nature and meaningful expression of the divine immanent in it, Ruskin gradually moves from the general and the abstract in diction to the particular and the concrete, maintaining that

> . . . to trace among the *grass* and *weeds* those *mysteries* of *invention* and *combination* by which *nature* appeals to the *intellect;* to render the delicate *fissure,* and descending *curve,* and undulating *shadow* of the mouldering *soil,* with gentle and fine *finger,* like the *touch* of the *rain* itself, to find even in all that appears most trifling or contemptible, fresh evidence of the constant working of the Divine power . . . ; this, as it is the peculiar province and faculty of the master-mind, so it is the peculiar duty which is demanded of it by the Deity [Italics mine]. (III, 483)

Here, the level of diction changes from non-sensory words such as "invention" or "combination" to more sensory ones such as "fissure," "curve," "shadow," or "soil." This movement from general and abstract (i.e. non-sensory) diction to diction more particular and concrete (i.e. sensory) implicitly elaborates the meaning of Ruskin's statement by emphasizing details of representation and thereby suggesting that the master is able to express "the Divine power" in nature *through* exact and delicate representation of it. In Ruskin's statement on foreground painting, then, these elaborated meanings implied by contrasting levels of diction are, according to Wimsatt's perspective, aspects of style.

When not described semantically but interpreted phenomenologically, the complex patterns of diction in Ruskin's passage on painting foreground suggest an aspect of aesthetic theory in *Modern Painters I.*

As we have seen, Ruskin's passage concerns, on one hand, the limitations of the novice and, on the other, the mastery of the great artist. The former, who "will violate truth with every stroke of the pencil," concerns himself merely with Ideas of Imitation, with mere duplication of natural aspects—with, for instance, painting "grass and weeds with accuracy enough to satisfy the eye." But the latter, able to represent (for example) "the delicate fissure, and descending curve" and to express "the constant working of the Divine power 'for glory and for beauty,' " is concerned (respectively) with a Truth of Earth, a "faithful representation of the facts and forms of the bare ground" (III, 425) and also with an Idea of Beauty, an expression of the nature of God through representational form (III, 109). Phenomenologically, the novice is visually aware of merely imitating natural phenomena. But the great

landscape artist is both visually aware of establishing an accurate correspondence to nature and also mentally aware of thereby expressing natural divinity.

Although, according to Martin Heidegger's phenomenological theory of style in "The Origin of the Work of Art," prose style as "language" refers to the elements of the art work as phenomenal objects of the writer's (i.e. the observer's) consciousness, style can nevertheless also refer to these elements as objects of the *artist's* consciousness. In different words, style can suggest the artist's creative apprehensions—what a painter, for example, is aware of when he creates a painting. Style can indicate his awareness of establishing the "earth" and the "Being," the essential nature, of the work. Implicit in this approach to prose style is the fundamental characteristic not only of Heidegger's phenomenology but of phenomenology in general. Herbert Spielberg, in *The Phenomenological Movement,* explains this characteristic as a movement " 'To the things themselves.' " This movement "bids us to turn toward phenomena which had been blocked from sight by the theoretical patterns in front of them."[21] In order to avoid creating his work merely on the basis of theoretical preconceptions about artistic technique, the artist, then, must suspend these in order to be aware of a movement "To the things themselves," by first establishing the "earth," or form, of his work and then its "Being," or essence. That is, he is aware of a creative movement from appearance to essence. Prose style as "language" can indicate this apprehension.

The prose style of Ruskin's passage on painting foreground exemplifies a movement away from preconceptions and "To the things themselves." The movement in diction from the general and abstract to the particular and concrete implies such a movement in phenomenological experience, by suggesting first the novice's merely theoretical experience of copying nature and second the master's apprehension of establishing not only the formal "earth" of his work but also its essential nature, or "Being"—the divine force immanent in the natural world.

When referring to the great painter, Ruskin employs diction more particular and concrete than that which he uses when referring to the novice:

> Nor do I myself see wherein the great difference lies between a master and a novice, except in the rendering of the finer truths of which I am at present speaking. To handle the brush freely, and to paint grass and weeds with accuracy enough to satisfy the eye, are accomplishments which a year or two's practice will give any man: but to trace among the grass and weeds those mysteries of invention and combination by which nature appeals to the intellect, to render the delicate fissure, and descending curve, and undulating shadow of the mouldering soil, with gentle and fine finger, like the touch of the rain itself; to find even in all that appears most trifling or contemptible, fresh evidence of the constant working of the Divine power "for glory and for beauty," and to teach it and proclaim it to the unthinking and the unregarding; this, as it is the peculiar province and faculty of the master-mind, so it is the peculiar duty which is demanded of it by the Deity.

Here, with a pattern of abstract terms such as "accuracy" and "accomplishments," Ruskin suggests that the novice, working on his painting, is visually aware of merely imitating nature, of copying it according to theoretical guidelines without expressing any meaning thereby. He avoids painting natural forms *as* themselves, by merely copying them according to accepted techniques, formulated beforehand. When establishing a Truth of Earth, a "faithful representation of the facts and forms of the bare ground" (III, 425)—the master, however, includes in the "earth," or form, of his work details of the natural scene that evoke thought. Employing general terms as well as abstract ones, Ruskin explains that the master traces "among the *grass* and *weeds* those *mysteries* of *invention* and *combination* by which *nature* appeals to the *intellect*." (Italics mine.) Particularly appropriate as a transition from the diction characterizing Ruskin's statement on the novice, the pattern of general and abstract words in this statement on the master changes into a pattern at once more particular and concrete. The true painter is aware of rendering "the delicate *fissure*, and descending *curve*, and undulating *shadow* of the mouldering *soil*, with gentle and fine *finger*, like the *touch* of the *rain* itself." (Italics mine). Here, the pattern of evenly spaced, particular and concrete words implicitly elaborates Ruskin's basic meaning about the artist's accurate representation of detailed aspects of foreground. Including the words "fissure," "curve," "shadow," and "soil," this pattern suggests his exact visual perception and meticulous representation of these natural forms *as* they themselves appear in nature.

Finally, Ruskin's diction reverts to a more general and abstract mode in his explanation of the artist's capacity and duty "to find even in *all* that appears most trifling or contemptible, fresh *evidence* of the constant *working* of the Divine *power* 'for *glory* and for *beauty*,' and to teach it and proclaim it to the *unthinking* and the *unregarding*." (Italics mine.) Here, general terms such as "all" and "evidence" as well as abstract ones such as "power," "glory," and "beauty"—in juxtaposition to the preceding pattern of concrete and particular words (such as "fissure," "curve," and "shadow")—imply an extension of Ruskin's meaning about the artist's awareness of embodying the divine force of nature into the painting. These contrasting levels of diction, one particular and concrete, followed by another more general and abstract, suggest that the painter is aware of expressing *through* "the things themselves" (such as fissures and curves), their essence, the divine "Being"—"the constant working of the Divine power 'for glory and for beauty.' "

Thus, by carefully alternating patterns of general and abstract words with patterns of particular and concrete ones, the style in Ruskin's explanation of foreground painting suggests the phenomenological movement "To the things themselves." By using predominantly general and abstract diction, Ruskin suggests that the inexpert painter, his mind obstructed by preconceptions

about technique, merely copies foreground. And, by juxtaposing patterns of particular, concrete words with patterns of general, abstract ones, Ruskin's style suggests that the expert painter moves away from technical preconceptions and "To the things themselves," by meticulously representing actual details of foreground and thereby expressing their essence, Beauty, the divine "Being" immanent in the natural world.

Figurative Language in the Art Criticism of *The Slave Ship*

Ruskin, we have seen, contrasts levels of diction in order to implicitly elaborate his theoretical views about painting foreground. Included in the discussion "Of Truth of Water," Ruskin's commentary on J.M.W. Turner's *The Slave Ship,* depicting slaves cast from a slaver, reverts to the particular and concrete diction predominant in his art criticisms of *The Téméraire* and of *Llanthony Abbey.* Characterized by particular, concrete words such as "sunset," "rain-clouds," "swell," "ocean," "shadows," "ship," and "lightning" (III, 571-72), the prose style, understood according to G.R. Stange's approach to art criticism, represents Ruskin's experience of *The Slave Ship* in a vividly pictorial way.

According to Stange in "Art Criticism as a Prose Genre", when the prose writer apprehends a work of visual art, such as a painting, he combines his knowledge of the painter, his visual experience of the work, his responses to it, and his estimation of their values into the referent for his art criticism. By describing his visual experience of the work and by expressing his emotional responses to as well as his critical thoughts about it, the writer embodies this referent into the prose text. In consequence, its prose style is a "representation of particular aesthetic as well as emotional experiences."[22]

Describing his visual perceptions of the art work, the writer of art criticism, Stange explains, "tends to avoid the abstract in favor of the immediate Special value is attached to image sequences, to discrete data of precise observation. . . . "[23] Similarly, Ruskin, in his statement on *The Slave Ship,* avoids the general and the abstract and employs sequences of particular and concrete images in order to describe his visual experience of the work. For example, tending to the immediate in description, he depicts his visual experience of the sunset and the ocean:

> It is a sunset on the Atlantic, after prolonged storm; but the storm is partially lulled, and the torn and streaming rain-clouds are moving in scarlet lines to lose themselves in the hollow of the night. The whole surface of the sea included in the picture is divided into two ridges of enormous swell. . . . Between these two ridges the fire of the sunset falls along the trough of the sea, dyeing it with an awful but glorious light. . . . (III, 571-72)

Again employing concrete images representing his visual experiences of *The Slave Ship,* Ruskin describes perceptions of the dusk, the ship, lightning, and red sunlight on the sea:

> Purple and blue, the lurid shadows of the hollow breakers are cast upon the mist of night, which gathers cold and low, advancing like the shadow of death upon the guilty ship as it labours amidst the lightning of the sea, its thin masts written upon the sky in lines of blood, girded with condemnation in that fearful hue which signs the sky with horror. . . , and . . . incarnadines the multitudinous sea. (III, 572).

Thus, by means of particular, concrete imagery, Ruskin represents his visual experience of *The Slave Ship*—in full, *Slavers Throwing Overboard the Dead and Dying—Typhoon Coming On* (1840).[24]

By not only describing his perception of the painting but also by having its visual aspects suggest his responses to them, the imagery of Ruskin's commentary becomes symbolism. According to G.R. Stange, in art criticism "the emphasis is not so much on the object of imitation as on the medium of expression, of *surface* in both experience and artifact, and, in general, on the representation of particular aesthetic as well as emotional experiences."[25] And in Ruskin's commentary, style—surface, or manner—is symbolic, expressing his own emotions and thoughts about visual aspects of Turner's painting, especially about the slaves thrown from the ship. Ruskin expresses his impression of the agony of dying slaves and suggests his horror at their murder with a symbolic image referring to the sky and the ocean: "It is a sunset on the Atlantic, after prolonged storm; . . . the torn and streaming rain-clouds are moving in scarlet lines to lose themselves in the hollow of the nightthe fire of the sunset falls along the trough of the sea, dyeing it with an awful but glorious light " He continues with another symbol referring to various aspects of the scene of death in the painting: "The lurid shadows of the hollow breakers are cast upon the mist of night, which gathers cold and low, advancing like the shadow of death upon the guilty ship as it labours amidst the lightning of the sea " In this symbol, the shadowed mist advancing on the ship suggests Ruskin's thought about impending divine retribution against those who murdered the slaves. And the lightning in the sky expresses his thought about the power of this retribution, which could bring about violent death for the murderers themselves.

In Ruskin's commentary on *The Slave Ship,* then, images represent his visual impresseion of the work and symbols express his intense revulsion at and religious reactions to the scene of death.

Understood descriptively, the style of Ruskin's commentary thus expresses his aesthetic experience. Interpreted phenomenologically, this prose style embodies

the central aesthetic of *Modern Painters I*. And, in its entirety, this commentary does explicitly refer, at the end, to this theory—that is, to the Idea of Truth:

> But, I think, the noblest sea that Turner has ever painted, and, if so, the noblest certainly ever painted by man, is that of the Slave Ship, the chief Academy picture of the Exhibition of 1840. It is a sunset on the Atlantic, after prolonged storm; but the storm is partially lulled, and the torn and streaming rain-clouds are moving in scarlet lines to lose themselves in the hollow of the night. The whole surface of the sea included in the picture is divided into two ridges of enormous swell, not high, nor local, but a low broad heaving of the whole ocean, like the lifting of its bosom by deep-drawn breath after the torture of the storm. Between these two ridges the fire of the sunset falls along the trough of the sea, dyeing it with an awful but glorious light, the intense and lurid splendour which burns like gold, and bathes like blood. Along this fiery path and valley, the tossing waves by which the swell of the sea is restlessly divided, lift themselves in dark, indefinite, fantastic forms, each casting a faint and ghastly shadow behind it along the illumined foam. They do not rise everywhere, but three or four together in wild groups, fitfully and furiously, as the under strength of the swell compels or permits them; leaving between them treacherous spaces of level and whirling water, now lighted with green and lamp-like fire, now flashing back the gold of the declining sun, now fearfully dyed from above with the undistinguishable images of the burning clouds, which fall upon them in flakes of crimson and scarlet, and give to the reckless waves the added motion of their own fiery flying. Purple and blue, the lurid shadows of the hollow breakers are cast upon the mist of night, which gathers cold and low, advancing like the shadow of death upon the guilty ship as it labours amidst the lightning of the sea, its thin masts written upon the sky in lines of blood, girded with condemnation in that fearful hue which signs the sky with horror, and mixes its flaming flood with the sunlight, and, cast far along the desolate heave of the sepulchral waves, incarnadines the multitudinuous sea.
>
> I believe, if I were reduced to rest Turner's immortality upon any single work, I should choose this. Its daring conception, ideal in the highest sense of the word, is based on the purest truth, and wrought out with the concentrated knowledge of a life; its colour is absolutely perfect, not one false or morbid hue in any part or line, and so modulated that every square inch of canvas is a perfect composition; its drawing as accurate as fearless; the shop buoyant, bending, and full of motion; its tones as true as they are wonderful; and the whole picture dedicated to the most sublime of subjects and impressions (completing thus the perfect system of all truth, which we have shown to be formed by Turner's works)—the power, majesty, and deathfulness of the open, deep, illimitable sea. (III, 571-73)

Concerned explicitly with an Idea of Truth in Turner's *The Slave Ship,* Ruskin thus praises first its representational excellence and then its depth of expression. In the perspective of Truth, the painting both accurately represents the ship as well as nature and also expresses not Ruskin's but Turner's impressions and thoughts about the represented scene. And thus, Ruskin explicitly refers to these aspects of the Idea of Truth in *The Slave Ship.* Furthermore, the style of his entire commentary implies these and others.

Just as Ruskin's prose style implicitly refers to the elements of Truth—to representation and expression, form and meaning—in Turner's painting, so also according to Martin Heidegger in "Building-Dwelling-Thinking," prose

style as "language" implicitly refers to the elements of the "World," of form and meaning, in the work of art. According to this essay, the prose writer visually perceives the forms of "earth" and "sky," of the ground and the atmosphere, in the work of art,—a painting, for instance. And he mentally apprehends the meanings of "divinities" and of "mortals" that are expressed by these forms. Similarly, prose style as "language" refers to this four part "World" of the painting. Since style and the writer's consciousness both have the same referent, then style indicates the manner and the substance of the writer's apprehension of the work. That is, style indicates his visual and mental apprehension of form and meaning in the work of art, which constitute its "World."

Commenting explicitly on the Idea of Truth in *The Slave Ship,* Ruskin indicates his apprehension of visually accurate representation and its expression of meaning, Turner's impression of the scene. Particularly, Ruskin sees that Turner's "drawing [is] as accurate as fearless; the ship buoyant, bending, and full of motion . . . , " and so on. And thereby he apprehends Turner's impression of "the power, majesty, and deathfulness of the open, deep, illimitable sea." Furthermore, by describing the painting and by suggesting Turner's aesthetic experience, the prose style of Ruskin's commentary implies an Idea of Truth, including "statements both of the qualities of material things, and of [the artist's] emotion, impressions, and thoughts" concerning them (III, 104). Having the same referents as Ruskin's consciousness, his prose style, as phenomenological "language," therefore indicates his visual and mental apprehension of Truth, of the form and meaning constituting the phenomenological "World" of *The Slave Ship.*

Particularly, imagery in Ruskin's commentary describes his visual perceptions of forms of "earth"and "sky" in the painting. The "sky" of an art work (such as a painting), Heidegger explains, includes visual forms of "the vaulting path of the sun, . . . the light and dusk of day, the gloom and glow of night, the clemency and inclemency of the weather, the drifting clouds and blue depth of the ether."[26]

Initially, the imagery of Ruskin's commentary on *The Slave Ship* describes his perception of visual forms of the "sky" that are basically similar to those described by Heidegger. Vivid, concrete images represent Ruskin's visual apprehension of decreasing sunlight, storm clouds, inclement weather, and falling dusk; "It is a sunset on the Atlantic, after prolonged storm; but the storm is partially lulled, and the torn and streaming rain-clouds are moving in scarlet lines to lose themselves in the hollow of the night."

Succeeding images represent Ruskin's visual apprehension of the "earth" of *The Slave Ship*—its forms, in this case, not of the ground but rather of an expanse of ocean. Correspondingly, according to Heidegger, the "earth" of a painting can include not only visual appearances of the ground but also forms

of the sea, "spreading out in . . . water."[27] Employing imagery, Ruskin describes his perception of a vast expanse of ocean, having a huge swell rising on each side, a sunlit trough dividing them, and smaller waves in it colored dark red by the sky:

> The whole surface of sea included in the picture is divided into two ridges of enormous swell, not high, nor local, but a low broad heaving of the whole ocean, like the lifting of its bosom by deep-drawn breath after the torture of the storm. Between these two ridges the fire of the sunset falls along the trough of the sea, dyeing it with an awful but glorious light, the intense and lurid splendour which burns like gold, and bathes like blood. Along this fiery path and valley, the tossing waves by which the swell of the sea is restlessly divided, lift themselves in dark, indefinite, fantastic forms, each casting a faint and ghastly shadow behind it along the illumined foam. They do not rise everywhere, but three or four together in wild groups, fitfully and furiously, as the under strength of the swell compels or permits them; leaving between them treacherous spaces of level and whirling water, now lighted with green and lamp-like fire, now flashing back the gold of the declining sun, now fearfully dyed from above with the undistinguishable images of the burning clouds, which fall upon them in flakes of crimson and scarlet, and give to the reckless waves the added motion of their own fiery flying.

And, finally, the imagery of Ruskin's commentary reverts to a concrete description of the "sky," including visual appearances of shaded mist, gathering darkness, lightning, and pervasive red light throughout:

> Purple and blue, the lurid shadows of the hollow breakers are cast upon the mist of night, which gathers cold and low, advancing like the shadow of death upon the guilty ship as it labours amidst the lightning of the sea, its thin masts written upon the sky in lines of blood, girded with condemnation in that fearful hue which signs the sky with horror, and mixes its flaming flood with the sunlight, and, cast far along the desolate heave of the sepulchral waves, incarnadines the multitudinous sea.

Thus, by means of imagery, Ruskin describes his visual perceptions of the "sky" and of the ocean portrayed in *The Slave Ship*. And thereby he suggests its representational Truth, its "faithful statement, either to the mind or senses, of any fact of nature" (III, 104). Furthermore, throughout these two passages, rhetorical figures, not primarily descriptive but instead expressive, imply Ruskin's mental apprehension of the meaning expressed by the forms of the painting—their expressive Truth, comprising "statements . . . of [Turner's] emotions, impressions, and thoughts" (III, 104) about the scene of death on the ocean.

Phenomenologically, this significance includes the meanings of the "divinities" and of "mortals," who can experience death. Initially, by means of symbolism, Ruskin describes his visual perception of representational aspects of *The Slave Ship,* has them suggest his mental apprehension of a meaning about "mortals," a meaning constituted by Turner's responses to the scene of

dying and dead slaves. According to Ruskin, "the torn and streaming rain-clouds are moving in scarlet lines to lose themselves in the hollow of the night." This symbol implies that he apprehends Turner's impression of the agony experienced by the dead and dying. Then, by means of simile, Ruskin suggests his understanding of Turner's reflections about the nature and condition of the divine being immanent in the natural world. Describing the depression between two great swells, Ruskin remarks: "The fire of the sunset falls along the trough of the sea, dyeing it with an awful but glorious light, the intense and lurid spendour which burns like gold, and bathes like blood." Here, the "awful but glorious light" on the sea "burns like gold, and bathes like blood." The main stylistic emphasis in these phrases is on simile. Ruskin explicitly compares gold and blood to the light on the sea in one respect, that of color. By comparing the brilliant orange-yellow color of gold to the reflected light on the ocean, he associates connotations of nobility and majesty, belonging to the appearance of gold, with this "glorious light" which, in turn, symbolizes the divine being of nature. In this way, Ruskin's simile (in conjunction with symbol) suggests that he understands Turner's conception of the nobility and the majesty of this Divinity. Furthermore, the intense light on the water "bathes like blood"; that is, the red sunlight spreads over the water in the way blood spreads over a wound. And since the light itself is symbolic of the divine, then this simile (again by way of symbol) implies that Ruskin apprehends Turner's impression of God's suffering for the slaves.

Next, relying on metaphor in order to indicate his consciousness of Turner's thought about those on the slave ship, Ruskin describes the "ship as it labours amidst the lightning of the sea, its thin masts written upon the sky in lines of blood." Here, he implicitly identifies the "thin masts" of the ship with "lines of blood" and thereby suggests his consciousness of Turner's thought about the "mortals" on the slaver, specifically about their guilt for murdering slaves.

With the noteworthy exception of this metaphor, suggesting the guilt of those on the ship, the final pictorial part of Ruskin's commentary is primarily symbolic. Representing his perception of the seascape in the painting and having it suggest a meaning of "divinities," symbolism indicates, mentally apprehends Turner's comprehension of the attitude adopted by the natural Divinity toward the murderers of the slaves. For instance, the symbol of the shadowed "mist of night" advancing on the ship, implicitly indicates that Ruskin is aware of Turner's thought about divine condemnation of and impending divine retribution against the murderers. The "lightning of the sea" flashing over the vessel symbolizes Ruskin's apprehension of the destructive power that this retribution will have. And, with the symbol of "that fearful hue which signs the sky with horror, and mixes its flaming flood with the sunlight, and, cast far along the desolate heave of the sepulchral waves, incarnadines

the multitudinous sea," Ruskin suggests his apprehension of the painter's emotional response of revulsion and horror to this impending retribution, which signifies that the murderers are damned and portends their violent death.

Referring to the appearances of the ocean and the "sky" and to the meanings of "divinities" and "mortals" in *The Slave Ship,* imagery, simile, metaphor, and symbol thus indicate Ruskin's apprehension of an Idea of Truth in this painting, its faithful representation of sky and sea as well as its expression of Turner's emotions and thoughts about the scene of death and the natural Divinity.

Concluding his criticism, Ruskin employs prose rhythm constituted initially by successive parallel clauses and finally by an irregular but discernable meter in order to imply his consciousness of the congruence between these two aspects of Truth in the painting:

> Its daring conception, ideal in the highest sense of the word, is based on the purest truth, and wrought out with the concentrated knowledge of a life; its colour is absolutely perfect, not one false or morbid hue in any part or line, and so modulated that every square inch of canvas is a perfect composition; its drawing as accurate as fearless; the ship bouyant, bending, and full of motion; its tones as true as they are wonderful; and whole picture dedicated to the most sublime of subjects and impressions (completing thus the perfect system of all truth, which we have shown to be formed by Turner's works)—the power, majesty, and deathfulness of the open, deep, illimitable sea.

In this statement, Ruskin, praising the representational Truth of *The Slave Ship,* begins with parallel independent clauses; "Its daring conception . . . is based on the purest truth . . . ; / its colour is absolutely perfect." Then, slightly accelerating the movement of these long clauses with ellipses of the verbs in the succeeding clauses, he continues, emphasizing the work's Truth of representation as well as of impression:

> Its drawing [is] as accurate as fearless; / the ship buoyant, bending, and full of motion; / its tones as true as they are wonderful; / and the whole picture dedicated to the most sublime of subjects and impressions . . . the power, majesty, and deathfulness of the open, deep, illimitable sea.

Having thus increased the tempo of these successive clauses by means of ellipsis, Ruskin here cadences them with a final metrical pattern. The painting, he says, is dedicated to Turner's impression of

> the power, majesty, and deathfulness
> of the open, deep, illimitable sea.

The first division, or line, of this phrase has three stresses and progresses from feet of three to a foot of four syllables. The second line has four stresses,

progresses from a foot of four syllables to one of five, and ends on the stressed word "sea." In this way, Ruskin slows the movement of the immediately preceding clauses and brings them to a rhythmic close.[28]

Consequently, having a rhythmic movement of full parallel clauses, then a slightly increased tempo of elliptical clauses, and finally a roughly metrical cadence, the prose rhythm in Ruskin's conclusion on the Truth of *The Slave Ship* implies his phenomenological apprehension of congruence in its "World"—a harmony between form and meaning, between (for instance) "drawing as accurate as fearless" and its meaning, constituted by Turner's impression of "the power, majesty, and deathfulness of the open, deep, illimitable sea."

Concluding Remarks

Throughout *Modern Painters I,* John Ruskin employs rhetorical devices of prose in two basic ways. On one hand, formulating aesthetic theory, he relies on devices particularly appropriate for exposition and argument. That is, when explaining the relation between the versifier and the landscape artist and when explaining the theory of Truth, Ruskin employs different types of antithesis in order to elaborate the meaning of both theories and his phenomenological apprehension of the Idea of Truth in the landscape painting. On the other hand, when commenting on particular works by Turner, such as *The Téméraire* or *The Slave Ship*, Ruskin relies on a primarily pictorial style. This style—based on concrete diction, imagery, simile, metaphor, symbol, or prose rhythm—is appropriate for expression of experience, whether his perception of and responses to the work or his phenomenological consciousness of its visual forms and their adumbration of Turner's feelings and thoughts.

The Prose Style of *Modern Painters II*

In his letter to H.G. Liddell on *Modern Painters I,* Ruskin, we have seen, dissatisfied with its prose style, assures his reader: "I am going to try for better things; for a serious, quiet, earnest, and simple manner, like the execution I want in art."[1] Here, Ruskin is probably referring to the style he was contemplating for the second volume of *Modern Painters,* eventually published in 1846. But the rhetorical manner, the style, of this work, like that of volume one, did not fully satisfy him. In the editor's introduction to *Modern Painters II,* E.T. Cook explains Ruskin's attitudes toward its style:

> In theory he was opposed to any tricks of style which departed from simplicity In practice, however, he fell into some mannerisms—afterwards exposed unmercifully by himself. He had been sent to Hooker by his old tutor, Osborn Gordon, and imitation led him into affectations,—"in the notion," as he elsewhere says, "of returning as far as I could to what I thought the better style of old English literature." The second volume contains throughout high thought wedded to stately language But probably Ruskin's own verdict is likely to stand: the style of the second volume is too self-conscious; it was an experiment rather than a development; "it was not," he says, "my proper style."[2]

In a note to one of the additional manuscripts of *Modern Painters III,* Ruskin himself gives a specific criticism of the style of volume two:

> . . . though, on looking back to this second volume after the lapse of nine years, I find it disfigured by affectation and encumbered by obscurities, . . . still the main statements of it are all true, and I think its meaning may be got at with as little pains as that of metaphysical works in general begging the sensible reader to pardon the involutions of language, the imitations of Hooker, and the tiresome length of sentences, I shall permit myself to refer to the book as if it had been better written (V, 438)

Such flaws are indeed evident in some passages of *Modern Painters II,* notably in Ruskin's theoretical statement on the Vital Beauty of plants and animals:

> Throughout the whole of the organic creation every being in a perfect state exhibits certain appearances or evidences of happiness; and is in its nature, its desires, its modes of

nourishment, habitation, and death, illustrative or expressive of certain moral dispositions or principles. Now, first, in the keenness of the sympathy which we feel in the happiness, real or apparent, of all organic beings, and which, as we shall presently see, invariably prompts us, from the joy we have in it, *to look upon those as most lovely which are most happy;* and, secondly, in the justness of the moral sense which rightly reads the lesson they are all intended to teach, and classes them in orders of worthiness and beauty according to the rank and nature of that lesson, whether it be of warning or of example, in those that wallow or in those that soar;—in our right accepting and reading of all this, consists, I say, the ultimately perfect condition of that noble Theoretic faculty, whose place in the system of our nature I have already partly vindicated with respect to typical, but which can only fully be established with respect to vital beauty. (IV, 147)

Certainly the second sentence here is unnecessarily as well as tediously long and has, in Ruskin's words, numerous "involutions of language"—an unnecessarily involved syntax, in this case. Furthermore, this sentence is an imitation of Hooker's prose style. In his *Laws of Ecclesiastical Polity* (1593-1597), a defense of the Anglican position,[3] Richard Hooker writes in the Ciceronian style. According to James Sutherland's *On English Prose* (1957), the sixteenth century Ciceronian style is "balanced and periodic," combining both variety and regularity.[4] And in *The Movement of English Prose* (1966), Ian Gordon characterizes Hooker's Ciceronian style: "The long periodic sentence is his staple, but it is Hooker, not Cicero, who is in command One of . . . [Hooker's] commonest sentence-structures consists of a series of subordinate clauses with 'like beginnings' followed by a resounding conclusion."[5] Ruskin's statement on Vital Beauty includes an imitation of such a periodic sentence. He begins three introductory prepositional phrases with the same word, "in," and finally concludes with an independent clause:

> . . . in the keenness of the sympathy which we feel in the happiness . . . of all organic beings..., in the justness of the moral sense which rightly reads the lesson they are all intended to teach . . . ;—in our right accepting and reading of all this, consists . . . the ultimately perfect condition of that noble Theoretic faculty

Thus, Ruskin's concluding sentence on Vital Beauty is certainly an imitation of Hooker's periodic prose style.

In the ways outlined, then, Ruskin's religious statement on Vital Beauty in painting exemplifies his criticism of "the involutions of language, the imitations of Hooker, and the tiresome length of sentences" in *Modern Painters II*.

Ruskin's criticism of the prose style of *Modern Painters I,* we have seen, applies to the style of secondary but not primary statements of aesthetic theory and of art criticism. Similarly, his criticism of the prose style in volume two applies to the style of statements (including that on the Vital Beauty of plants and animals) having secondary importance for his theory and criticism

of painting. Since I am concerned with the prose style of his primary statements of theory and of art criticism, then his comment on the style of *Modern Painters II,* although noteworthy, has secondary importance for the present study.

Ruskin's first central statement of aesthetic theory concerns Beauty in painting and has a style based on parallelism.

Parallelism and the Theory of Beauty

According to W.K. Wimsatt's *The Prose Style of Samuel Johnson,* style "is the furthest elaboration of the one concept that is the center"—the furthest extension of explicit, fundamental meaning in the text. The rhetorical devices, including parallelism, can express such elaborations of meaning, which constitute the style of the prose work.[6] And he discusses parallelism in detail. According to Wimsatt, "any series of connected meanings is in some degree a parallel series."[7] Furthermore, parallelism can be explicitly indicated

> . . . by the use of conjunctive or disjunctive words; by the syntax of words, that is, the relation of one word to two or more others; and by the repetition of identical words Repetition of an initial word, especially of some more emphatic or special word, is called by the rhetoricians "anaphora."[8]

Parallelism, in these or other forms, is, Wimsatt explains, one way of "attaining generalization" in the prose text.[9]

Defining the Typical and Vital Beauty of the art work in general terms, Ruskin relies on a syntactical parallelism of two roughly identical noun phrases:

> By the term Beauty, then, properly are signified two things. First, that external quality of bodies already so often spoken of and which, whether it occur in a stone, flower, beast, or in man, is absolutely identical, which, as I have already asserted, may be shown to be in some sort typical of the Divine attributes, and which therefore I shall, for distinction's sake, call Typical Beauty: / and, secondarily, the appearance of felicitous fulfilment of function in living things, more especially of the joyful and right exertion of perfect life in man; and this kind of beauty I shall call Vital Beauty. (IV, 64)

While the symbolization of the painter's belief in "The Divine attributes" and the expression of his happiness by the painting constitute the fundamental meaning of this statement, its parallelism of noun clauses implies an extension of this meaning. That is, symbolization of the painter's religious belief in a natural Divinity and expression of his happiness are *equally* important functions of the painting. Understood in Wimsatt's perspective on prose, this elaboration of meaning is the style of Ruskin's initial characterization of Beauty.

Throughout his final summary of the qualities of Beauty in art, not only parallelism of syntax but also the other types of parallelism explained by Wimsatt are evident. In order to indicate parallelism, Ruskin employs disjunction and repetition as well as balanced syntax when summarizing the qualities of Beauty, the subject of the Theoretic Faculty.

Since the painting expresses its creator, the painter (IV, 165), the basic meaning of this summary of the qualities of Beauty first concerns the expression, by the painting, of his conscience, his belief in a natural Divinity, his happiness in plants and animals, and his thoughts about their orderly functions, and second concerns the divine, or religious, qualities of Beauty, which Ruskin then enumerates (IV, 210). Implied by parallelism, the elaborations of these fundamental meanings constitute, in Wimsatt's semantical perspective, the style of Ruskin's statement.

In each of the last two sentences in this summary, disjunctive words and syntax indicate parallelism. First, the disjunctive pattern "either . . . or" and a syntax of independent clauses establish a parallel series: "it [i.e. Beauty] is *either* the record of conscience, written in things external, / *or* it is a symbolizing of Divine attributes in matter, / *or* it is the felicity of living things, / *or* the perfect fulfilment of their duties and functions" (IV, 210). (Italics mine.) A similar disjunctive pattern, now in combination with noun phrases, establishes another series: "In all cases it [i.e. Beauty] is something Divine; *either* the approving voice of God, / the glorious symbol of Him, / the evidence of His kind presence, / *or* the obedience to His will by Him induced and supported" (IV, 210). The correspondence between these two sentences with respect to their disjunctive words and syntactical patterns suggests particular extensions of Ruskin's basic meaning about Beauty, which concerns expression of the painter and of the Divine by art. This correspondence implies that each element of the first sentence is complemented respectively by an element of the second. In particular, by expressing the painter's conscience, the work indicates his belief in "the approving voice of God." The work symbolizes "Divine attributes" in nature and thereby suggests his belief in it as "the glorious symbol of Him." By expressing his happiness in "living things," the work thereby indicates his belief in God's "kind presence" in the natural world. And the work expresses his thought about "the perfect fulfilment of their duties and functions" and thereby expresses his belief in their obedience to God's will "by Him induced and supported."

Finally, throughout both sentences, Ruskin, employing anaphora, repeats words at the beginning of clauses and phrases and thereby suggests a harmony or congruence in the painting between its expression of the painter's moral and emotional dispositions and of his correspondent religious beliefs. For instance, Ruskin suggests the congruence between the painter's happiness

in the existence of "living things" and his belief in the natural presence of God by repeating the word "it": "*It* [i.e. Beauty] is the felicity of living things In all cases *it* is something Divine; . . . the evidence of His kind presence"

Thus, in order to indicate parallelism in his summary of the qualities of Beauty in art, Ruskin employs disjunctive words, identical clauses and phrases, and anaphora.

Interpreted from a phenomenological perspective, these aspects of parallelism elaborate Ruskin's apprehension of Beauty in the painting, the expression of its creator through its form. Phenomenological prose style as "language," Heidegger explains in "The Origin of the Work of Art," can suggest the writer's Being-with, his consciousness of, the meaning, or "world," expressed by the form of the art work, its "earth." And this meaning can include the artist's thoughts and feelings. Ruskin's religious statement on Beauty in the art work concerns his consciousness of its "earth," or form, as the expression of meaning, the painter's moral thoughts, emotions, and religious belief. Parallelism elaborates Ruskin's mental apprehension of this meaning, the "world" of the work.

Particularly, employing anaphora, Ruskin repeats the initial word "it" and thereby suggests his apprehension of a congruence among all the aspects of meaning in the work: its expression of the painter's "conscience, written in things external," of his belief in "Divine attributes in matter," of his happiness in "living things," and of his satisfaction in "the perfect fulfilment of their duties and functions."

And anaphora combines with two other indications of parallelism, disjunction and identical syntax, first in clauses and then in phrases, as follows:

> *It* [Beauty] is *either* the record of conscience, written in things external, / *or it* is a symbolizing of Divine attributes in matter, / *or it* is the felicity of living things, / *or the* perfect fulfilment of their duties and functions. In all cases *it* is something Divine; *either the* approving voice of God, / *the* glorious symbol of Him, / *the* evidence of His kind presence, / *or the* obedience to His will by Him induced and supported. (IV, 210)

Here, the initial series of independent clauses and the final one of noun phrases are based on the disjunctive pattern "either . . . or." This parallelism, indicated thus by words and syntax, implies that Ruskin is aware of the painter's morality, emotion, and thought *as* divine, as religious. That is, Ruskin is aware of the painter's conscience as a reflection of his belief in "the approving voice of God." He knows that the work symbolizes the artist's thought about and his belief in "Divine attributes in matter," "the glorious symbol of Him." He apprehends the painter's joyful response to "living things" and knows that this emotion corresponds to his belief in God's "kind presence." And he is conscious of the painter's satisfaction in "the perfect

fulfilment of their duties and functions." Thereby, he understands that this satisfaction coincides with the painter's belief in their obedience to God's "will by Him induced and supported."

In these senses, then, the different types of parallelism in Ruskin's summary of Beauty implicitly detail his apprehension of the meanings concerning the artist that are expressed by the painting itself.

Simile, Metaphor, and Ruskin's Theory of Associative Imagination

Following his discussion of Beauty in painting, Ruskin explains the operation of the painter's Associative Imagination. This operation is based on the aesthetic Idea. At the beginning of *Modern Painters I,* Ruskin explains the Idea as the combination of perception and meaning the painter embodies in his work (III, 87-88). Similarly, according to the theory of Associative Imagination, the painter combines certain visual perceptions of the natural world and certain meanings, particularly emotions and thoughts, that he associates with these perceptions. In this sense, he creates Ideas of nature. But, separated from each other, these Ideas are imperfect; they are *"separately wrong."* Creating his work, the painter, by means of Associative Imagination, combines only those natural Ideas which, although *"separately wrong,"* "together shall be right," which will perfect each other and establish a unity of form and meaning (IV, 234).

Ruskin illustrates the operation of the painter's Imagination with a simile based on the movement of a snake:

> But a powerfully imaginative mind seizes and combines at the same instant, not only two, but all the important ideas of its poem or picture; and while it works with any one of them, it is at the same instant working with and modifying all in their relations to it, never losing sight of their bearings on each other; as the motion of a snake's body goes through all parts at once, and its volition acts at the same instant in coils that go contrary ways. (IV, 235-36)

W. K. Wimsatt's semantic approach to style, we have seen, maintains that the furthest extension of meaning in the prose text, whether or not expressed by rhetorical devices, constitutes its style. The basic meaning of Ruskin's statement concerns the operation of the painter's Associative Imagination and its capacity to modify and thereby perfect several Ideas at once, combining them into a unity in the painting. Expressed by simile, the extension of this meaning constitutes the style of Ruskin's statement. Thus, "as the motion of a snake's body goes through all parts at once, and its volition acts at the same instant in coils that go contrary ways," so the artist's mind combines Ideas when creating the painting. Here, Ruskin explicitly compares the artist's mind to a snake's body in one respect, that of function. This comparison implies that his Imagination, when occupied with the work, imposes an *organic* unity

of Ideas of nature, even though some, before modification, may be incongruous with others.

Ruskin also illustrates the operation of Associative Imagination metaphorically:

> The imagination will banish all that is extraneous; it will seize out of the many threads of different feeling which nature has suffered to become entangled, one only; and where that seems thin and likely to break, it will spin it stouter, and in doing this, it never knots, but weaves in the new thread; so that all its work looks as pure and true as nature itself, and cannot be guessed from it but by its exceeding simplicity, (*known* from it, it cannot be; so that herein we find another test of the imaginative work, that it looks always as if it had been gathered straight from nature, whereas the unimaginative shows its joints and knots, and is visibly composition. (IV, 246-47)

Phenomenologically, this statement about the function of Associative Imagination explains the manner in which the painter is aware of establishing form and meaning in the work. Conscious of creating the painting, he eliminates all extraneous aspects in its visual form and interrelates its emotive meanings into a congruent system. And Ruskin's metaphor, based on weaving, complements this explanation of the painter's creative activity.

This metaphor elaborates the painter's mode of being-aware-of the painting when creating it. Heidegger, in "The Origin of the Work of Art," indicates that prose style as "language" may refer to the observer's (i.e. the writer's) *or* the artist's apprehension of the work. Style can suggest, for instance, the artist's awareness of creating form and meaning in the art work, of establishing its formal "earth" as well as its meaningful "world." In Ruskin's statement, metaphor shows that the painter is aware of establishing a coherent form and an emotive meaning, (respectively) an "earth" and a "world," in the painting. According to Ruskin, the painter's Imagination "will seize out of the many threads of different feeling which nature has suffered to become entangled, one only" This metaphor implicitly compares the weaver's selection of a thread from a tangled skein to the painter's selection of Ideas of nature. He is visually aware of diverse, conflicting aspects of a natural scene and also responds emotionally to these perceptions. He then selects one of them and its concomitant emotive meaning, together constituting an Idea of nature. And, just as the weaver, seeing where his chosen thread "seems thin and likely to break, . . . will spin it stouter, and doing this . . . never knots, but weaves in the new thread," so also the imaginative artist, perceiving flaws in his natural Idea, will perfect it when incorporating it into the painting. That is, he will be aware of *coherently* establishing the "earth" and the "world" of his work by eliminating flaws in his original perception of nature and incongruencies in its emotive significance for him. Associative Imagination can accomplish this task so skillfully "that all its work looks as pure and true as nature itself, and cannot be guessed from it but by its exceeding simplicity."

As in his second illustration of Associative Imagination, Ruskin employs metaphor, albeit more extensively, in his explanation of Penetrative Imagination, in order to implicitly detail its operation.

Metaphor in Ruskin's Account of Penetrative Imagination

W. K. Wimsatt's semantic approach to prose is based on a conception of style as the greatest extension of fundamental significance in the text. And rhetorical devices can express such elaborated meaning. When understood according to this perspective, the style of Ruskin's statement on the operation of Penetrative Imagination is the final elaboration, expressed by metaphor, of his aesthetic meaning.

In this statement, Ruskin maintains that Penetrative Imagination

> ... never stops at crusts or ashes, or outward images of any kind; it ploughs them all aside, and plunges into the very central fiery heart; nothing else will content its spirituality; whatever semblances and various outward shows and phases its subject may possess go for nothing (IV, 250-51)

And Ruskin concludes; "There is no reasoning in it [i.e. Imagination] . . . ; no matter what be the subject submitted to it, substance or spirit; all is alike divided asunder. . . , whatever utmost truth, life, principle it has, laid bare . . ." (IV, 251). In both of these statments, Ruskin is concerned with the artist's intuition of the essence, the "utmost truth, life, principle," of his subject, whether it be "substance or spirit," perception or concept. Metaphor elaborates this view of Imagination. Ruskin makes an implicit comparison between a geologist's probing under partially hardened lava and the creative activity of the artist's mind. This comparison suggests his experience of directly apprehending, immanent in the merely visual aspects of his subject, the primary *energy* informing it. And this metaphorical extension of Ruskin's concept of Penetrative Imagination constitutes an aspect of style in his statement.

John D. Rosenberg, in "Style and Sensibility in Ruskin's Prose," perceptively remarks: "Metaphor was the habitual mode of Ruskin's thought."[10] Although this statement does not apply to the prose style of *Modern Painters II* as a whole, nevertheless it does apply to Ruskin's entire statement on the function of Penetrative Imagination:

> It never stops at crusts or ashes, or outward images of any kind; it poughs them all aside, and plunges into the very central fiery heart; nothing else will content its spirituality; whatever semblances and various outward shows and phases its subject may possess go for nothing; it gets within all fence, cuts down to the root, and drinks the very vital sap of that it

deals with: once therein, it is at liberty to throw up what new shoots it will, so always that the true juice and sap be in them, and to prune and twist them at its pleasure, and bring them to fairer fruit than grew on the old tree; but all this pruning and twisting is work that it likes not, and often does ill; its function and gift are the getting at the root, its nature and dignity depend on its holding things always by the heart. Take its hand from off the beating of that, and it will prophesy no longer; it looks not in the eyes, it judges not by the voice, it describes not by outward features; all that it affirms, judges, or describes, it affirms, from within.

It may seem to the reader that I am incorrect in calling this penetrating possession-taking faculty Imagination. Be it so; the name is of little consequence; the faculty itself, called by what name we will, I insist upon as the highest intellectual power of man. There is no reasoning in it; it works not by algebra, nor by integral calculus; it is a piercing pholas-like mind's tongue, that works and tastes into the very rock heart; no matter what be the subject submitted to it, substance or spirit; all is alike divided asunder, joint and marrow, whatever utmost truth, life, principle it has, laid bare, and that which has no truth, life, nor principle, dissipated into its original smoke at a touch.[11] The whispers at men's ears it lifts into visible angels. Vials that have lain sealed in the deep sea a thousand years it unseals, and brings out of them Genii.

Every great conception of poet or painter is held and treated by this faculty. (IV, 250-51)

Ruskin, in this statement, is explicitly concerned with the painter's ability to apprehend the essence of any particular subject and to embody this essence into his painting.

According to the phenomenological aesthetic of "The Origin of the Work of Art," the artist, creating the work, can be aware of embodying its essential nature, its "Being," into its form. And as "language," prose style can refer to his consciousness of creating the visual form, the "earth," of the work and expressing its "Being" through this form. The explicit meaning of Ruskin's statement on Penetrative Imagination and his metaphorical style have a similar phenomenological orientation. The fundamental meaning of this statement concerns the painter's direct apprehension of the essence belonging to his particular subject. For instance, he intuitively apprehends the essential nature, the "truth, life, principle," of particular objects perceived in nature. When creating the painting, he is aware both of establishing its visual form on the basis of natural phenomena and also of embodying their "truth, life, principle," their essence, or "Being," into this form. And, throughout Ruskin's statement, he employs a series of metaphors implicitly elaborating these creative apprehensions.

Initially, Ruskin maintains that the artist's Penetrative Imagination

... never stops at crusts or ashes, or outward images of any kind; it ploughs them all aside, and plunges into the very central fiery heart; nothing else will content its spirituality; whatever semblances and various outward shows and phases its subject may possess go for nothing(IV, 250)

Implicitly comparing the activity of a geologist probing under the hardened surface of molten lava to the activity of the artist's Imagination, the metaphor in this statement suggests that he apprehends the energy underlying "outward images of any kind," external forms of the natural world.

Ruskin continues with a metaphor based on the activity of a gardener. The painter's Imagination

> . . . gets within all fence, cuts down to the root, and drinks the very vital sap of that it deals with: once therein, it is at liberty to throw up what new shoots it will, so always that the true juice and sap be in them, and to prune and twist them at its pleasure, and bring them to fairer fruit than grew on the old tree; but all this pruning and twisting is work that it likes not, and often does ill; its function and gift are the getting at the root(IV, 250)

Here, Ruskin implicitly compares the operation of Penetrative Imagination to the work of a gardener who prunes a tree in order to enhance its growth and, more importantly, cuts into the root (i.e. probably the core) beneath the bark in order to obtain the sap. This metaphorical comparison suggests that the painter is able to sense the organic life underlying the surfaces, the visual appearances, of nature.

And Ruskin expands his account of Penetrative Imagination with a metaphor based on human love:

> . . . its nature and dignity depend on its holding things always by the heart. Take its hand from off the beating of that, and it will prophesy no longer; it looks not in the eyes, it judges not by the voice, it describes not by outward features; all that it affirms, judges, or describes it affirms, from within. (IV, 250)

Metaphor, in this statement, apparently refers to the gesture of a lover, who, not concerned with the eyes, voice, or other external features of his beloved, places his hand over her heart. Implying a comparison between this gesture and the function of Penetrative Imagination, Ruskin's metaphor suggests that, when observing natural or human phenomena, the painter apprehends emotion underlying their external forms.

Thus, the metaphors of the geologist's investigation, of the gardener's activity, and of the lover's gesture suggest the painter's apprehension of (respectively) energy, life, and emotion underlying external forms of the natural world and of man. The painter then creates the painting on the basis of his perception of natural and human phenomena and his apprehension of their essences. He is visually aware of portraying natural and human forms, thereby creating the "earth" of the painting. And he is mentally aware of expressing the essences of these forms—their energy, life, and emotion— through them, thereby creating the essential nature, the "Being," of his art work, its "utmost truth, life, principle."

Having thus elaborated the aesthetic of Imagination with a series of related metaphors, Ruskin then comments on religious paintings embodying the results of Penetrative Imagination. He concentrates on certain works by Tintoretto.

Description, Narration, and Symbolism in the Commentary on *The Massacre of the Innocents*

At the beginning of his commentary on Tintoretto's *The Massacre of the Innocents*, Ruskin argues:

> ... All the ordinary representations of this subject, are, I think, false and cold: the artist has not heard the shrieks, nor mingled with the fugitives; he has sat down in his study to convulse features methodically, and philosophize over insanity. Not so Tintoret. Knowing, or feeling, that the expression of the human face was, in such circumstances, not to be rendered, and that the effort could only end in an ugly falsehood, he denies himself all aid from the features, he feels that if he is to place himself or us in the midst of that maddened multitude, there can be no time allowed for watching expression. Still less does he depend on details of murder and ghastliness of death; there is no blood, no stabbing or cutting, but there is an awful substitute for these in the chiaroscuro. (IV, 272)

Describing the effect achieved with chiaroscuro, with a pattern of light and shade, in *The Massacre of the Innocents,* Ruskin continues:

> The scene is the outer vestibule of the palace, the slippery marble floor is fearfully barred across by sanguine shadows, so that our eyes seem to become bloodshot and strained with strange horror and deadly vision; a lake of life before them, like the burning seen of the doomed Moabite on the water that came by the way of Edom; a huge flight of stairs, without parapet, descends on the left; down this rush a crowd of women mixed with the murderers; the child on the arms of one has been seized by the limbs, *she hurls herself over the edge, and falls head downmost, dragging the child out of the grasp by her weight;*—she will be dashed dead in a second;—close to us is the great struggle; a heap of mothers entangled in one mortal writhe [i.e. a "twisted formation"[12]] with each other and the swords, one of the murderers dashed down and crushed beneath them, the sword of another caught by the blade and dragged at by a woman's naked hand; the youngest and fairest of the women, her child just torn away from a death grasp, and clasped to her breast with the grip of a steel vice, falls backwards, helplessly over the heap, right on the sword points; all knit together and hurled down in one hopeless, frenzied, furious abandonment of body and soul in the effort to save. Far back, at the bottom of the stairs, there is something in the shadow like a heap of clothes. It is a woman, sitting quiet,—quite quiet,—still as any stone; she looks down steadfastly on her dead child, laid along the floor before her, and her hand is pressed softly upon her brow.
> This, to my mind, is the only Imaginative, that is, the only true, real, heart felt representation of the being and actuality of the subject, in existence. (IV, 272-74)

And finally, Ruskin explains the relation of *The Massacre of the Innocents* to the operation of Tintoretto's Penetrative Imagination:

> The power of every picture [i.e. including *The Massacre*] depends on the penetration of the imagination into the TRUE nature of the thing represented, and on the utter scorn of the imagination for all shackles and fetters of mere external fact that stand in the way of its suggestiveness in the Massacre it covers the marble floor with visionary light, that it may strike terror into the spectator without condescending to butchery (IV, 278)

While pointing out the relation of the painter's Imagination to the work, Ruskin here also emphasizes his own (i.e. the spectator's) response of terror to its "visionary light." Correspondingly, when understood according to G. R. Stange's approach to Victorian art criticism, the prose style of Ruskin's commentary on *The Massacre of the Innocents* expresses his visual, emotional, and mental experience of the painting.

Stange's article "Art Criticism as a Prose Genre" maintains that the prose style of art criticism expresses a referent, the writer's visual experience of and his emotional and aesthetic responses to the work of art. According to Stange, the writer of art criticism tends to avoid "logical organization and a conceptual framework" and concentrates on emotive effects and a perceptual scheme." And, Stange asserts, Ruskin's prose account of *The Massacre of the Innocents* is representative of his practice of art criticism. Not the painting itself but rather his aesthetic experience is "the principle object of the description"—"its referent."[13]

Continuing, Stange explains that Ruskin's "passage begins by communicating a sense of the painter's 'scene'"[14] That is, with imagery and concrete description, Ruskin represents his visual perception of the scene of murder:

> The scene is the outer vestibule of a palace, the slippery marble floor is fearfully barred across by sanguine shadows, so that our eyes seem to become bloodshot and strained with strange horror and deadly vision; a lake of life before them, like the burning seen of the doomed Moabite on the water that came by the way of Edom(IV, 272)

At this point, Ruskin moves from pure description of the visual scene to expression of his responses to it, by explicitly mentioning his horror and revulsion at the pattern of red shadows on the floor.

Then he implicitly expresses other emotional and aesthetic responses to the painting with several rhetorical devices of prose style. According to Stange, Ruskin, commenting on *The Massacre of the Innocents*,

> . . . pointedly ascribes to the work precisely those features which are impossible to painting: literary comparison, movement in space, extension in time Let me illustrate.
> Ruskin's biblical simile of the doomed Moabite provides a rich association that enhances the significance of the painting. Though this kind of allusion is one of the simplest of literary devices, it nevertheless is something that cannot be achieved within the limits of Tintoretto's medium He [i..,e. Ruskin] avoids passive forms of language: there are no "are painted-s," but a series of active verbs (descends, rush, seized, hurls) which suggest a

frenzied movement in space which the writer has supplied to Tintoretto's canvas. Further, by prediction, the frozen events of the painting are projected in time; one of the women will, for example, "be dashed dead in a second." It may be unnecessary to point out that, by concentrating on movement and continuity, Ruskin has endowed a painting with the function that Lessing reserved for poetry—the power of depicting action in time.[15]

Thus, employed extensively in Ruskin's commentary, a narrative style relies on active verbs and future prediction in order to suggest an imaginative response to the painting. In particular, verbal style suggests that Ruskin, looking at the scene depicting the murder of children, imagines that it is actually occurring before his eyes:

> . . . a huge flight of stairs, without parapet, "descends" on the left; down this "rush" a crowd of women mixed with the murderers; the child in the arms of one "has been seized" by the limbs, *she "hurls" herself over the edge, and "falls" head downmost, "dragging" the child out of the grasp by her weight;*—she "will be dashed" dead in a second[16]

Also based on verbal constructions implying Ruskin's imagination of an actual event, his concluding account of a woman looking at her dead child functions primarily as a profound symbol. Interpreted phenomenologically, the meaning of this symbol concerns the connection between Ruskin's aesthetic of Penetrative Imagination and *The Massacre of the Innocents.*

Phenomenological prose style as "language," according to Heidegger's theory of style in "The Origin of the Work of Art," can refer to the "earth" and the "world" of the art work, (respectively) its visual form and aesthetic meaning. The writer is also aware of this form and meaning. Consequently, style suggests this apprehension of the "earth" and the "world" of the work—a painting, for example. Representing Ruskin's visual perception of an aspect of the "earth," the form, of Tintoretto's painting, description and narration portray a woman, removed from the confusion around her:

> . . . at the bottom of the stairs, there is something in the shadow like a heap of clothes. It is a woman, sitting quiet,—quite quiet,—still as any stone; she looks down steadfastly on her dead child, laid along the floor before her, and her hand is pressed softly upon her brow.

And insofar as this statement is symbolic, it suggests Ruskin's mental apprehension of the "world," the significance, belonging to these aspects of visual form—their expression of Tintoretto's imaginative insight "into the TRUE nature" of the woman. Her indistinct form "in the shadow" and her demeanor, her "sitting quiet,—quite quiet,—still as any stone," suggest Ruskin's awareness of the painter's insight into her vague fear of death and her shock at the murder of the child. By describing the woman looking "down steadfastly on her dead child, laid along the floor before her," Ruskin implies that he apprehends the painter's empathy with her grief from the murder. And

the symbol of "her hand," "pressed softly upon her brow," implies his comprehension of the painter's insight into her astonishment and disbelief that this kind of cruelty against her child, innocent and defenseless, could have occurred. These "penetrative" insights into the woman's responses to murder constitute the central meaning, for Ruskin's consciousness, of *The Massacre*.

Prose Style and the Dual Vision of Ruskin's Commentary on *The Last Judgment*

As we have seen, the prose style of Ruskin's commentary on *The Massacre of the Innocents* represents his imaginative responses to as well as his visual perceptions of it and suggests his phenomenological apprehension of its meaning, an expression of Tintoretto's Penetrative Imagination. Near the end of his discussion on the operation of Penetrative Imagination, Ruskin comments at length on another painting by Tintoretto, *The Last Judgment*. The style of this commentary expresses Ruskin's divided sensibility and suggests his phenomenological apprehension of the painting as a result of Penetrative Imagination.

John D. Rosenberg, in "Style and Sensibility in Ruskin's Prose," maintains that Ruskin's early prose style, including that of *Modern Painters II*, expresses his sensibility:

> I have in mind not an outward adaptation to the exigencies of subject and audience, but an inner manifestation: style as the incarnation of sensibility. Style of this kind has nothing whatever to do with levels of speech; it *is* speech, the unique voice of the writer, the felt presence that hovers over his pages and intones its way into our consciousness In this ultimate sense, Ruskin is the greatest prose stylist in English.[17]

Referring to a letter in *Fors Clavigera* called "Benediction," Rosenberg maintains that "Ruskin distinguishs [sic] between the contrary states of blessedness and accursedness" and "that the contrary states Ruskin is defining are in fact his own divided consciousness, split into a heightened awareness of felicity and pain."[18]

The prose style of Ruskin's commentary on *The Last Judgment* expresses a similar division in his consciousness, particularly in his sensibility. He refers to the opposed states of the saved and of the damned:

> ... The Firmament is all full of them, a very dust of human souls, that drifts, and floats, and falls in the interminable, inevitable light; the bright clouds are darkened with them as with thick snow, currents of atom life in the arteries of heaven, now soaring up slowly, and higher and higher still, till the eye and the thought can follow no farther, born up, wingless, by their inward faith and by the angel powers invisible, now hurled in countless drifts of horror before the breath of their condemnation. (IV, 277)

Here, after the judgment by God, the saved ascend into heaven, and the condemned descend into hell. Furthermore, each aspect of Ruskin's description symbolizes one aspect of his divided sensibility. On one hand, he depicts the saved, "now soaring up slowly, and higher and higher still, till the eye and the thought can follow no farther, borne up, wingless, by their inward faith and by the angel powers invisible." This scene symbolizes Ruskin's predisposition to hope for and predilection to joyfully anticipate his own salvation. On the other hand, the symbol of the damned, "now hurled in countless drifts of horror before the breath of their condemnation," expresses his proclivity to fear and perhaps to exaggerate the possibility of his own damnation. In these ways, then, the symbolic style of Ruskin's statement on the saved and the condemned expresses his divided religious sensibility.

Commenting generally on Ruskin's early style, Rosenberg maintains that nearly "invariably the greatest passages in Ruskin's prose are structured around two opposing visions, one of felicity and the other of some form of hell."[19] Such a dual vision, comprising good and evil as well as salvation and damnation, is evident throughout his entire commentary on *The Last Judgement*:

> By Tintoret only has this unimaginable event [i.e. the final judgment] been grappled with in its Verity; not typically nor symbolically, but as they may see it who shall not sleep, but be changed. Only one traditional circumstance he has received with Dante and Michael Angelo, the Boat of the Condemned; but the impetuosity of his mind bursts out even in the adoption of this image; he has not stopped at the scowling ferryman of the one, nor at the sweeping blow and demon dragging of the other, but seized Hylas-like by the limbs, and tearing up the earth in his agony, the victim is dashed to his destruction: nor is it the sluggish Lethe, nor the fiery lake that bears the cursed vessel, but the oceans of the earth and the waters of the firmament gathered into one white, ghastly cataract; the river of the wrath of God, roaring down into the gulf where the world has melted with its fervent heat, choked with the ruin of nations, and the limbs of its corpses tossed out of it whirling, like water-wheels. Bat-like, out of the holes and caverns and shadows of the earth, the bones gather and the clay heaps heave, rattling and adhering into half-kneaded anatomies, that crawl, and startle, and struggle up among the putrid weeds, with the clay clinging to their clotted hair, and their heavy eyes sealed by the earth darkness yet, like his of old who went his way unseeing to the Siloam Pool; shaking off one by one the dreams of the prison-house, hardly hearing the clangour of the trumpets of the armies of God, blinded yet more, as they awake, by the white light of the new Heaven, until the great vortex of the four winds bears up their bodies to the judgment-seat: the Firmament is full of them, a very dust of human souls, that drifts, and floats, and falls in the interminable, inevitable light; the bright clouds are darkened with them as with thick snow, currents of atom life in the arteries of heaven, now soaring up slowly, and higher and higher still, till the eye and the thought can follow no farther, borne up, wingless, by their inward faith and by the angel powers invisible, now hurled in countless drifts of horror before the breath of their condemnation.
>
> Now, I wish the reader particularly to observe throughout all these [other] works of Tintoret, the distinction of the Imaginative Verity from falsehood on the one hand, and

from realism on the other. The power of every picture [including *The Last Judgment*] depends on the penetration of the imagination into the TRUE nature of the thing represented, and on the utter scorn of the imagination for all shackles and fetters of mere external fact that stand in the way of its suggestiveness . . . While we are always placed face to face with whatever is to be told, there is in and beyond its reality a voice supernatural; and that which is doubtful in the vision has strength, sinew, and assuredness, built up in it by fact. (IV, 26-78)

Interpreted phenomenologically, the prose style of this commentary both describes Ruskin's visual apprehension of *The Last Judgment* and suggests his mental apprehension of its dual meaning, its expression of Tintoretto's insight "into the TRUE nature of the thing represented," the Christian judgment. Correspondingly, prose style as "language," according to Martin Heidegger in "Building-Dwelling-Thinking," indicates, either explicitly or implicitly, the writer's apprehension of the "World," the compositie of form and meaning, in the work of art—such as a painting. To explain, style indicates the elements of this "World"—the forms of "earth" and "sky" as well as the meanings of "divinities" and "mortals"—all apprehended by the writer's consciousness. Consequently, prose style, having the same referents as consciousness, refers to the writer's visual and mental apprehensions of the four part "World" of the painting. And the style of Ruskin's commentary on *The Last Judgment* refers to his apprehension of its visual form and its aesthetic meaning, each of which has a fundamental contrast.

By means of a specific and concrete style, Ruskin represents his apprehension of the form of the painting, having a contrast between "earth" and "sky." That is, the forms of the ground and of human souls rising from it contrast with those of the atmosphere and of souls borne up or cast down in it.

Rosenberg comments on Ruskin's account of the dead rising from the ground:

Consonance, alliteration, and assonance all function onomatopoeically in the following example, in which Ruskin describes the rising of the dead in Tintoretto's *The Last Judgment*. As so often, the force of Ruskin's writing derives from the peculiar vivacity of his metaphors of decay The agonized efforts of the dead to shake off the encumbrance of earth is echoed [sic] in the repeated hard *c's*, and their decomposed, now re-composing, bodies take on dough-like structurelessness as they *heave* themselves into half-kneaded anatomies:

Bat-like, out of the holes and *c*averns *and* shadows of the earth, the bones gather *and* the *c*lay *h*eaps *h*eave, rattli*ng* and a*d*heri*ng* i*n*to half-*k*neaded anatomies, that *c*rawl, *and* s*t*artle, and s*t*ruggle up among the putrid weeds, with the *c*lay *c*lingi*ng* to their *c*lotted hair, and their heavy eyes sealed by the earth darkness yet (IV, 277)[20]

In this analysis, Rosenberg is concerned primarily with ways in which sound and metaphor indicate visual aspects of the painting—particularly, indistinct forms of the dead struggling to escape from the ground. Con-

sequently, he is concerned, albeit indirectly, with these onomatopoeic word-sounds and with metaphor insofar as they suggest particular ways in which Ruskin visually perceives the painting. Phenomenologically then, in the description of the dead "that crawl, and startle, and struggle up among the putrid weeds, with the clay clinging to their clotted hair," alliteration on "c" suggests his visual perception of their contorted, agonized postures, assumed as they struggle free from the ground. Furthermore, the metaphorical comparison between the forms of the rising dead and "half-kneaded anatomies" suggests that he sees indistinct human forms, without definite outline and structure.

Thus, alliteration and metaphor detail Ruskin's perception of an "earth," including forms depicting human souls rising from the ground in *The Last Judgment*. Metaphor also details his visual apprehension of the second formal aspect of the work, its "sky," crowded with risen souls. For example, according to Ruskin, "the Firmament is all full of them, a *very dust* of human souls, that drifts, and floats, and falls in the interminable, inevitable light...." (Italics mine.) The implicit comparison here between vast clouds of dust in the atmosphere and human souls floating in the air suggests that he perceives innumerable souls, represented as mere specks in the distance.

In addition, while looking at the formal aspects of "earth" and "sky" in *The Last Judgment*, Ruskin imagines that its represented events are presently occurring. By means of narration based on active verbs and verbals, he indicates a temporal sequence, particularly throughout the final pictorial sentence in his commentary: "Bat-like out of the holes . . . , the bones gather . . ."

However, in a brief monograph called "Ruskin's *Modern Painters, II*," Ernest L. Fontana argues, though unconvincingly, that the verbal structure of this sentence implies *simultaneity* for the events represented:

> The awakening of the dead and their ascent to Paradise or descent to Hell are described in a single long sentence. The effect of the single sentence in the present tense is to suggest the simultaneity by which the painting represents multitudinous actions. The sentence opens with "the bones" and "clay heaps" as the active subjects of the verbs "gather" and "heave"; but as the sentence moves forward through a series of present participial phrases, which suggests a dense fusion of moves, the "bones" and "clay heaps" become "bodies," which in turn become the grammatical objects of the "four winds." After the colon, the "bodies" are the objects of passive verbs—"borne up" and "hurled"—and the subjects of the present participle "soaring up," and through their appositive, "a very dust of human souls," the subjects of the verbs "drifts," "floats," and "falls." This elaborate syntax, which enables Ruskin to place twenty-five verbs or verbals in one sentence, demonstrates how carefully the sentence attempts to join together in a syntactical unity the multiple actions which are visually joined and unified in Tintoretto's painting.[21]

It is certainly true that Ruskin uses one long sentence to narrate the resurrection of the dead and their judgment. In the sense that these events are

represented in the painting, they are visual facts, *without* a temporal dimension. When looking at them, Ruskin, however, associates time *with* them. He apparently does not, however, imagine them occurring simultaneously but instead sequentially, because the verbal structure of this sentence refers to the *same* souls throughout. In other words, since the actions narrated differ but since the participants in them remain the same, then Ruskin imagines that these souls participate in a complex *sequence* of action.

Phenomenologically, then, the concatenated verbal structure of this single long sentence suggests the following temporal sequence that Ruskin imagines when looking at the contrasting forms of "earth" and "sky" in *The Last Judgment:*

> Bat-like, out of the holes and caverns and shadows of the earth, the bones "gather" and the clay heaps "heave," "rattling" and "adhering" into half-kneaded anatomies, . . . "blinded" . . . , as they "awake" . . . , until the great vortex of the four winds "bears" up their bodies to the judgment-seat: the Firmament "is" all full of them, a very dust of human souls, that "drifts," and "floats," and "falls" . . . ; the bright clouds "are darkened" with them . . . , now "soaring" up slowly, . . . now "hurled" in countless drifts of horror before the breath of their condemnation [quotation marks mine]. (IV, 277)

Thus, the verbal structure of this sentence suggests Ruskin's imaginative apprehension of a temporal sequence that he associates with the judgment, represented in the painting. And since some of these imagined occurrences contrast with others (e.g. the ascent of the saved with the descent of the damned), then this apprehension has a dual character.

Concluding his commentary on *The Last Judgment,* Ruskin maintains that its power "depends on the penetration of the imagination into the TRUE nature of the thing represented." And, "while we are always placed face to face with whatever is to be told, there is in and beyond its reality a voice supernatural" Thus, in addition to the forms of "earth" and "sky" in the painting that are perceived by Ruskin, he becomes aware of their meaning, the second aspect of its phenomenological "World." This meaning is the expression, by these forms, of the painter's imaginative insight "into the TRUE nature of the thing represented." Throughout the commentary, rhetorical devices suggest Ruskin's apprehension of Tintoretto's insight into the dual significance, the meaning of "divinities" and of "mortals," belonging to the painting.

The beginning of his commentary employs allusion and symbol prominently. Ruskin describes a "mortal" thrown into "the Boat of the Condemned":

> . . . seized Hylas-like by the limbs, and tearing up the earth in his agony, the victim is dashed to his destruction: nor is it the sluggish Lethe, nor the fiery lake that bears the cursed vessel,

but the oceans of the earth and the waters of the firmament gathered into one white, ghastly cataract; the river of the wrath of God, roaring down into the gulf where the world has melted with its fervent heat, choked with the ruin of nations, and the limbs of its corpses tossed out of its whirling, like water-wheels. (IV, 276-77)

Here, Ruskin, with a classical allusion based on simile, compares the fate of a damned soul to that of Hylas. In Greek mythology, Hylas, the favorite of Heracles, journeyed with the Argonauts to Kilchis in search of the golden fleece. H. J. Rose, in *Gods and Heroes of the Greeks* (1958), describes an event in their journey:

Rowing in . . . disturbed water, Heracles broke his oar with a too vigorous stroke, and they landed to spend the night and get material for another. Hylas . . . went to fetch water for their supper, and came upon a fountain inhabited by Naiads, who were so attracted by his beauty that they pulled him in to live with them. Heracles sought long and vainly for him and at last the ship left without him.[22]

By explicitly comparing the damned soul, seized by a demon, to Hylas, seized by Naiads, Ruskin suggests his apprehension of a meaning of "mortals," expressed by the painting. The substance of this meaning is Tintoretto's comprehension of the inner state of this damned soul, his utter despair at losing free volition.

Thus, on one hand, Ruskin understands Tintoretto's insight into an aspect of evil connected with the judgment. On the other, he apprehends a meaning of the "divinities" comprehended by the painter's Imagination and embodied into the work. Following the simile comparing the sinner to Hylas, Ruskin describes the river bearing "the Boat of the Condemned," into which the sinner has been thrown. Composed of waters from the ocean and the sky, "the river of the wrath of God" roars "down into the gulf . . . , choked with the ruin of nations, and the limbs of its corpses tossed out of its whirling" In part, the river is an explicit symbol, expressing Ruskin's awareness of Tintoretto's insight into the wrath of the Divine against the evil of mankind. Furthermore, composed of water from the oceans and the sky, carrying off "the ruin of nations," and tossing up "the limbs of . . . corpses," the river implicitly symbolizes Ruskin's understanding of another aspect of divine significance in the painting—a meaning concerning the painter's imaginative vision of God's universal power, capable of bringing retribution against the evil portion of humanity.

Again relying on simile, allusion, and symbol, Ruskin continues his account of *The Last Judgment:*

Bat-like, out of the holes and caverns and shadows of the earth, the bones gather and the clay heaps heave, rattling and adhering into half-kneaded anatomies, that crawl, and

startle, and struggle up among the putrid weeds, with the clay clinging to their clotted hair, and their heavy eyes sealed by the earth darkness yet, like his of old who went his way unseeing to the Siloam Pool; shaking off one by one the dreams of the prison-house, hardly hearing the clangour of the trumpets of the armies of God, blinded yet more, as they awake, by the white light of the new Heaven, until the great vortex of the four winds bears up their bodies to the judgment-seat

At the beginning of this statement, Ruskin employs simile to explicitly compare the dead rising from the earth with innumerable bats emerging from caves. Thereby, he suggests his mental apprehension of the artist's imaginative insight into the inner state of these "mortals," animate but not yet able to feel, think, or recognize themselves. Then unconscious and unable to see, these souls "struggle up . . . their heavy eyes sealed by the earth darkness yet, like his of old who went his way unseeing to the Siloam Pool." Phrased as a simile, this biblical allusion refers to Christ's curing a blind man by spreading a paste of earth and spittle on his eyes and then sending him to wash in the pool. Christ explains that this man "was born blind so that God's power might be displayed in curing him."[23] Thus, the allusion comparing the resurrected dead to the blind man suggests that Ruskin the writer understands a meaning of the "divinities" concerning Tintoretto's conception, embodied in the painting, about the power of the Divine to open their eyes and to awaken their minds. Therefore, they awake, Ruskin says, "blinded . . . by the white light of the new Heaven, until the great vortex of the four winds bears up their bodies to the judgment-seat." Here, the symbol of "the white light of the new Heaven" implies his comprehension of another meaning belonging to the "divinities." He mentally apprehends the painter's religious vision of the wisdom pervading the being of God as the judge of mankind.

Finally, Ruskin relies on metaphor as well as symbol in his concluding account of the fate of the dead:

. . . the Firmament is all full of them, a very dust of human souls, that drifts, and floats, and falls in the interminable, inevitable light; the bright clouds are darkened with them as with thick snow, currents of atom life in the arteries of heaven, now soaring up slowly, and higher and higher still, till the eye and the thought can follow no farther, borne up, wingless, by their inward faith and by the angel powers invisible, now hurled in countless drifts of horror before the breath of their condemnation.

The vehicle of Ruskin's initial metaphor concerning "a very dust of human souls, that drifts, and floats, and falls in the interminable, inevitable light" is the image of dust clouds floating high in the atmosphere and blowing in the winds. Expressed by the implicit comparison between this image and "human souls," the tenor of Ruskin's metaphor concerns his mental apprehension of a meaning belonging to "mortals." This significance is the expression of the painter's insight into their essential mortality. That is, they were doomed to

death (i.e. to non-existence) without the power of the Divine to animate them. And, whether good or evil, they exist by means of this power immediately before and after the judgment.

Furthermore, Ruskin, with an extended symbol, implies his apprehension of a dual significance of "mortals"—an expression, by the scene, of Tintoretto's penetrative understanding of "the TRUE nature" of the saved and of the damned. Ruskin depicts the saved "now soaring up slowly, and higher still, till the eye and the thought can follow no farther, and the damned "now hurled in countless drifts of horror before the breath of their condemnation." By means of this symbol, Ruskin suggests his awareness of the painter's imaginative insights (on one hand) into the joy and hope of the saved and (on the other) into the despair and hopelessness of the damned. A similar dichotomy characterizes Ruskin's apprehension, also suggested by this symbol, of the central significance of the "divinities" in *The Last Judgment*. That is, Ruskin is aware of Tintoretto's comprehension of the dual nature of God, his power over the ultimate spiritual destiny of mankind to save the good and damn the evil.

In general, then, whether described as an expression of his sensibility or interpreted as a reflex of his phenomenological awareness of the work, the style, or rhetorical manner, of Ruskin's commentary on *The Last Judgment* establishes fundamental contrasts. Style expresses his aesthetic-religious sensibility, divided between predispositions for hope of salvation and fear of damnation. And, interpreted phenomenologically, style both represents his visual perceptions of souls rising from the "earth" and floating in the "sky" represented by the painting and also suggests his mental apprehension of its dual significance, concerned with "mortals" and "divinities." As we have seen, this significance concerns Tintoretto's insights into the essential nature of the represented scene—into the wisdom of the Divine to know good and evil, into His power to save or damn human souls accordingly, and into the joy of the saved and the despair of the damned.

Concluding Remarks

In *Modern Painters II,* as in *Modern Painters I,* Ruskin, when presenting aesthetic theory, employs a style, a manner, appropriate for generalization. Thus, summarizing the general qualities of Beauty, he relies on parallelism in order to implicitly extend the meaning of this theory and to elaborate his phenomenological apprehension of these qualities—expressions, by the painting, of the painter's emotions, thoughts, and religious beliefs. And as in *Modern Painters I,* Ruskin, now commenting on particular works, employs a concrete, pictorial style, appropriate both for expressing experience or sensibility and also for indicating his phenomenological apprehensions of

these paintings. In the commentary on *The Last Judgment* (for example), concrete images, classical or biblical allusions, simile, metaphor, and symbol express Ruskin's divided religious sensibility and indicate his phenomeno-logical apprehensions of both the formal qualities belonging to the painting and also their expression of Tintoretto's "penetrative" insights into the scene, particularly, into the power and wisdom of the Divine, the exultation of the saved, and the despair of the damned.

Conclusion: Eclecticism in the Aesthetic and the Style of *Modern Painters I* and *II*

Throughout *Modern Painters I* and *II*, the major aspects of aesthetic theory and of style are eclectic in origin, being related not to one but to several traditions of English aesthetics and of English prose style.

George P. Landow, in *The Aesthetic and Critical Theories of John Ruskin,* maintains, in particular, that Ruskin's theories of beauty are eclectic:

> ... they embody that characteristically Victorian eclecticism which appears throughout his thought. His conceptions of Typical and Vital Beauty draw upon Aristotle, Plato, Hooker, Bacon, Pope, Dr. Johnson, Wordsworth, Reynolds, and many others; they combine notions derived from neoclassical poetry and criticism, Evangelical Anglican conceptions of scripture, and the late eighteenth-century Scottish moral philosophers.[1]

And not only Ruskin's theories of Beauty but also that of Truth (in *Modern Painters I*) and those of Theoria and of Imagination (in volume two) are eclectic, relating to theories of art prominent during the seventeenth and eighteenth centuries (such as Reynolds' aesthetic of general representation in landscape painting) and during the nineteenth century (such as Wordsworth's theory of art as individual expression).

The eclecticism of Ruskin's aesthetic in *Modern Painters I* and *II* leads, however, to the same problem discussed in chaper two, a conflict between the subjective and the objective. And, as we have seen in chapter five, Landow implies that this type of conflict exists between Ruskin's Romantic theories of painting and his Neo-classical theory of Typical Beauty. That is, according to Landow, "Ruskin's theory of Typical Beauty is an Apollonian, classical aesthetic of order, and as such apparently incongruous with his romantic conceptions of painting and literature [e.g. of Vital Beauty]."[2] Here, Landow implies that the aesthetic of Typical Beauty, concerned with order, is objective and consequently inconsistent with the Romantic theory of Vital Beauty (for instance), which is concerned with expression and is therefore subjective. He also makes this implication from a slightly different perspective, by explaining

that Typical Beauty "was concerned with emotional states and their expression."[3] Here, he implies that Typical Beauty (concerned with visual qualities of art) is objective, that Vital Beauty (concerned with Ruskin's responses to art) is subjective, and that (in consequence) the former theory is inconsistent with the latter. And when understood according to their connection with the traditions of English aesthetic theory, not only the theories of Typical and of Vital Beauty but also other major elements of Ruskin's aesthetic in *Modern Painters I* and *II* have this type of inconsistency.

Since the Neo-classical elements of Ruskin's aesthetic in these works usually stress objective aspects of art but the Romantic elements usually stress subjective ones, then resolving this inconsistency according to these traditions, which imply the subject-object distinction, does not seem possible. But, since this inconsistency is essentially the same as that already discussed in Ruskin's aesthetic apart from its relations to traditional aesthetics (e.g. since representational Truth as objective conflicts with expressive Truth as subjective), then the former inconsistency can be resolved as the latter has been throughout the first part of this study—that is, phenomenologically. Thus, described from Husserl's perspective of intentional consciousness, the theory of Typical Beauty (for instance) is not an objective Neo-classical aesthetic of order but instead a phenomenological description, by Ruskin, of the order that he apprehends *in* art. Or, the theory of Vital Beauty is not a subjective Romantic aesthetic concerning expression of *Ruskin's* feeling, but is rather a phenomenological one concerning his apprehension *of* the *painter's* emotion, expressed by the painting. And Martin Heidegger's aesthetic in "The Origin of the Work of Art" can implement phenomenological interpretation of these descriptions. Of course, the obvious limitation in this phenomenological approach is that it cannot account for the relationships between the aesthetic of *Modern Painters I* and *II* and the traditions of English aesthetic theory. That is, Ruskin's theory *as* a consistent body of thought is phenomenological, is thus concerned neither with the subjective nor the objective but rather with his phenomenological apprehensions *of* art, and (in this sense) is neither Neo-classical nor Romantic. Given this limitation, however, recapitulation of the phenomenological analyses of Ruskin's theory that have been presented in this study will nevertheless show the essential consistency of his theory which, understood according to its relationships with the tradition, is often inconsistent.

Representation and Expression in the Aesthetic of *Modern Painters I*

At the beginning of *Modern Painters I,* Ruskin compares the painter with the versifier. The "great painter" excels "in precision and force in the language of lines," the "great versifier" excels "in precision and force in the language of

words," and if justified by the nature of the thoughts expressed through "their respective languages" each is "a great poet" (III, 88). Here, Ruskin's analogy between the painter and the versifier implies one between painting and poetry. And *this* analogy is an instance of the eighteenth century aesthetic of *ut picturapoesis*. According to Cicely Davis in the article "Ut Pictura Poesis,"

> . . . painting was found to resemble poetry in having definite "fables" or thought to convey to the intellect
> The fashion was to find literary characteristics in painting. But there was a reciprocal though less pronounced bias in the conception of poetry. Its frequent and often mechanical association with painting resulted in a merging of their principles; and some of the obvious characteristics of visual art were looked for in poetry. As Horace had remarked, and the early eighteenth century echoed, poetry was "a speaking picture"; then it should endeavour to present ideas in the same way; that is, it should convey them throught the visible appearances of things. And this should be its chief aim.[4]

Thus, whether described by verse or represented in painting, "the visible appearances" of nature, for instance, should express thought. Ruskin implies such an analogy between painting and verse by way of a comparison between the painter and the versifier. By comparing the "great painter" with the "great versifier" and by identifying both with the "great poet," Ruskin implies that landscape painting and verse are examples of poetry, understood in a general sense as meaningful expression by a formal medium, which he calls "language." "The language of words" in verse describes nature, "the language of lines" represents visual aspects of it, and both types of language thereby express "the images or thoughts" of the "great poet," whether versifier or painter.

Finally, Ruskin's version of *ut pictura poesis* includes a Romantic aspect. To the older concept that the arts of verse and painting are analogous, Landow maintains, Ruskin "added a romantic emphasis . . . the expression of emotion."[5] Comparing "the mere botanist's knowledge of plants" with "the great poet's or painter's knowledge of them," Ruskin explains that "the one notes their distinctions for the sake of swelling his herbarium, the other, that he may render them vehicles of expression and emotion" (III, 36). Here, Ruskin implies that verse and landscape painting themselves are analogous in that they express not only the thoughts but also the feelings of, respectively, the poet and the painter.

The explicit analogies between poet and painter and the implicit ones between poem and painting lead directly to the basis of the aesthetic in *Modern Painters I*—the Idea of landscape art.

Ruskin derives his concept of the aesthetic Idea from John Locke's *An Essay Concerning Human Understanding* (1690). According to Ruskin,

> . . . the term idea, according to Locke's definition of it, will extend even to the sensual impressions themselves as far as they are "things which the mind occupies itself about in thinking;" that is not as they are felt by the eye only, but as they are received by the mind through the eye. So that, if I say that the greatest picture is that which conveys to the mind of the spectator the greatest number of the greatest ideas, I have a definition which will include as subjects of comparison every pleasure which art is capable of conveying. (III, 91—92).

Henry Ladd's *The Victorian Morality of Art* explains that, according to Locke, "ideas" are perceptions of the mind, not real external qualities. Ruskin, Ladd explains, does not distinguish "ideas" according to their external quality or inward reality.[6] In other words, deriving the Idea of landscape painting from Locke, Ruskin does not distinguish the Idea either as objective or as subjective; consequently, it is phenomenological, in Husserl's sense of being an intentional correlate of the spectator's (i.e. Ruskin's) consciousness. That is, the Idea of landscape painting comprises the visual form that he sees and its expressed thought, which he apprehends. And as perceived form and understood meaning, the Idea is the basis of the landscape painting.

According to Martin Heidegger in "The Origin of the Work of Art," the "Being" of the art work is its basis, its origin. The visual form of the work (its "earth," a formal "language") and its apprehended meaning (its "world") together constitute its "Being," or essential nature, for intentional consciousness. Phenomenologically, the Idea of landscape painting is Ruskin's consciousness of its "Being," its essential nature, a unity comprising a formal "earth" and a meaningful "world." When seeing form representing nature, he then apprehends meaning, expressed by this formal "language" of colors and lines. He understands the artist's thought about the aspects of nature represented in the painting. A unity of visual form and apprehended significance, the Idea is, then, Ruskin's Being-with the origin, the essential nature, or "Being," of the landscape painting.

In general, the Idea, understood in this phenomenological perspective, is the origin not only of the landscape work itself but also of the artist's "creation" as well as the spectator's "preservation" of it, because the former embodies Ideas in the work and the latter apprehends them through it. Consequently, Ruskin maintains that "he is the greatest artist who has embodied, in the sum of his works, the greatest number of the greatest ideas" and "that the greatest picture is that which conveys to the mind of the spectator the greatest number of the greatest ideas" (III, 92).

In general, then, the theoretical basis of Ruskin's aesthetic in *Modern Painters I* includes the analogy between poetry and painting (i.e. *ut pitutra poesis*) and (primarily) the concept of the landscape Idea, derived from Locke's empirical psychology. And the primary development of the Idea in *Modern Painters I* and its central concept is the Idea of Truth.

Ruskin rejects Imitation, mere duplication of natural forms in landscape painting, and advocates Truth, which has two basic elements. First, with respect to the formal element, the landscape painting is an accurate correspondence to visual qualities of natural objects. And second, the primary element of Truth concerns formal expression of the landscape painter's impressions, emotions, and thoughts concerning these natural aspects (III, 104).

Ruskin's theory of representation involves accurate correspondence between the painting and aspects of the natural world. In this sense, representation is an instance of the Neo-classical aesthetic of art as imitation, not as duplication of but rather as correspondence to something else. According to M.H. Abrams in *The Mirror and the Lamp,* the concept of imitation is central to the mimetic theory of art:

> The mimetic orientation—the explanation of art as essentially an imitation of aspects of the universe—was probably the most primitive aesthetic theory, but mimesis is no simple concept by the time it makes its first recorded appearance in the dialogues of Plato. The arts of painting, poetry, music, dancing, and sculpture, Socrates says [in *The Republic*], are all imitations. "Imitation" is a relational term, signifying two items and some correspondence between them.[7]

And according to Abrams, "through most of the eighteenth century, the tenet that art is an imitation seemed almost too obvious to need iteration or proof."[8]

Ruskin's aesthetic of representational Truth corresponds in general and in particular to the Neo-classical theory of art as imitation of, as a correspondence to, nature (for example). In general, "the faithful statement ... of any fact of nature" by the landscape work (III, 104) concerns its accurate visual correspondence to aspects of nature. And in particular, Ruskin maintains that specific details of representation should not duplicate but rather correspond to nature:

> If . . . we give a dark form with the brush, we convey information of a certain relation of shade between the bough and sky, recognizable for another idea of truth: but we have still no imitation [in the sense of a copy], for the white paper is not the least like air, nor the black shadow like wood. (III, 105)

In these ways, then, Ruskin's theory of representational Truth exemplifies the Neo-classical aesthetic of imitation, signifying a correspondence between the work and the object. And thus, in the sense that the landscape work corresponds to "qualities of material things" in nature (III, 104), representational Truth is objective.

According to the Idea of Truth, the painting also states the landscape artist's "emotions, impressions, and thoughts" about the natural aspect

represented in it (III, 104). This element of Truth is in the Romantic tradition of poetry and art as individual expression. Abrams explains the two forms of this theory:

> "Poetry," Wordsworth announced in his Preface to the *Lyrical Ballads* of 1800, "is the spontaneous overflow of powerful feelings." . . . Almost all the major critics of the English romantic generation phrased definitions or key statements showing a parallel alignment from work to poet. Poetry is the overflow, utterance, or projection of the thought and feeling of the poet; or else (in the chief variant formulation) poetry is defined in terms of the imaginative process which modifies and synthesizes the images, thoughts, and feelings of the poet. This way of thinking, in which the artist himself becomes the major element generating both the artistic product and the criteria by which it is to be judged, I shall call the expressive theory of art.[9]

Ruskin's concept of expressive Truth is romantic in the Wordsworthian sense of poetry (or art) as "the overflow, utterance, or projection of the thought and feelings of the poet [or artist]." According to Ruskin, the landscape work projects, that is embodies, the feelings and thoughts of the artist; that is, "truth has reference to statements . . . of [his] emotions, impressions, and thoughts" (III, 104). And since the painting expresses these aspects of the landscape painter's aesthetic experience, then this element of Truth is subjective.

Thus, concerning accurate correspondence to natural forms, the Neo-classical element of Truth in landscape painting is objective. But the Romantic element is subjective, concerning expression of the painter. Consequently, having an opposition between the objective and the subjective, the Idea of Truth is inconsistent. The Neo-classical aspect of Truth is inconsistent with its Romantic one; in other words, the landscape work cannot include *both* representational (i.e. objective) and expressive (i.e. subjective) elements. However, Ruskin's theory can be consistently described with Edmund Husserl's phenomenological perspective of intentional consciousness and intentional object.

Husserl's *Logical Investigations* explains that intentional consciousness is directed toward something, whether it be a visual fact, an emotion, or a thought. As correlates of consciousness, these are neither subjective nor objective, but instead are intentional. They are intentional objects, which consiousness is aware *of*. Furthermore, several can coalesce into one. For instance, an observer can apprehend a painting as an intentional unity of visual form and expressed meaning. Truth in landscape painting, then, includes first a visual intentional object for Ruskin's sight, because he sees an accurate correspondence to "any fact of nature" (III, 104). He also apprehends by this form an expression of meaning, constituted by the artist's "emotions . . . and thoughts" (III, 104). These are intentional objects for Ruskin's mind. Consequently, the Idea of Truth concerns a single intentional object

which he apprehends visually and mentally: the landscape painting as a unity of form and expression, as a statement "*both* of the qualities of material things, and of [the painter's] emotions . . . and thoughts" (III, 104). (Italics mine.)

Presented in "The Origin of the Work of Art," Martin Heidegger's aesthetic concerning the "truth" of the art work can implement interpretation of this phenomenological description, concerning Truth in the landscape work. According to Heidegger, "truth" is the observer's Being-with the "earth," the "world," the "conflict," and the "rift" of the work of art. In other words, he is conscious of (respectively) form, its meaning, their complementary contrast, and their unity, all of which constitute the essential nature of the work, its "truth."

Similarly, the Idea of Truth is the essential nature of the landscape work. The essence of the painting, its phenomenological "truth," comprises four basic aspects. First, Ruskin sees an "earth," a representational form corresponding to aspects of nature, a "faithful statement, either to the mind or senses, of any fact of nature" (III, 104). He then apprehends a formal expression of meaning, a "world" constituted by "statements . . . of [the painter's] emotions, impressions, and thoughts" about these natural facts (III, 104). Knowing that this visual form is merely sensory without an expression and that this meaning is irrelevant without a reference to form, Ruskin is aware of the "conflict" of the landscape painting, its complementary contrast between visual form and expressed meaning. That is, "there is a moral as well as material truth,—a truth of impression as well as of form,—of thought as well as of matter . . ." (III, 104). Finally, since form and meaning complete each other, then Ruskin's Being-with the unity of representation and expression is the "rift" of the landscape painting. He apprehends the complementary unity of visual form and meaningful expression, because "truth has reference to *statements both* of the qualities of material things, and of [the artist's] emotions, impressions, and thoughts" (III, 104). (Italics mine.) In these four senses, then, the Idea of Truth is Ruskin's Being-with the phenomenological "truth," the essential nature, of the landscape painting.

And in general, then, just as Ruskin, the spectator of the landscape work, apprehends its Idea of Truth, so also the landscape painter establishes Truth in it. That is, he is aware of establishing an accurate correspondence to natural facts and of thereby expressing his feelings and thoughts about them in order "to induce in the spectator's mind the faithful conception of any natural objects whatsoever; . . . and to inform him of the thoughts and feelings with which these were regarded by the artist himself" (III, 133).

At this point, the aesthetic theory of *Modern Painters I* is essentially complete. Throughout the remainder of the work Ruskin concentrates primarily on detailing ways in which the landscape painter should represent

nature and on explaining ways in which certain works by J.M.W. Turner accurately represent nature and clearly express his feelings and thoughts. Thus, Ruskin expands the representational aspect of Truth with respect to the painter's goals and applies both aspects of Truth (i.e. representation and expression), especially in his commentary on *The Slave Ship.*

Developments and Applications of the Idea of Truth

Among the representational Truths of landscape painting, all of which constitute suggestions to and standards for the landscape painter, Truth of Tone includes and hence takes precedence over the Truths of Colour, Chiaroscuro, and Space.

In general, Truth of Tone concerns first the correct shading of objects with respect to their place in the actual scene and the major light of the picture itself, and second the correct "relation of the colours of the shadows to the colours of the lights, so that they may be at once felt to be merely different degrees of the same light" (III, 259). Here, Ruskin instructs the landscape artist on an aspect of representation, the first element of Truth—"the faithful statement . . . of any fact of nature" in landscape painting (III, 104).

This aesthetic of Tone is in the Neo-classical tradition of art as imitation, that is, as correspondence to, but not literal reproduction of, aspects of the natural universe.[10] More specifically, Tone in landscape painting is related to aspects of Reynolds' mimetic theory of painting. However, as we have seen in chapter two, Ruskin rejects Reynolds' concept of general representation; that is, "the principle on which they [i.e. Reynolds and others] base their selection [for painting] (that general truths are more important than particular ones) is altogether false" (III, 154). But here, Ruskin has partially misinterpreted Reynolds' view of representation. And not only Ruskin but also other commentators have made the same mistake. Abrams explains this error:

> It has seemed to some later commentators that the neo-classic stress on the typical, the uniform, the salient, and the familiar as ideals of . . . imitation makes originality, or even diversity, impossible What we often overlook, however, is that the particular and the circumstantial were not employed as simple and exclusive contraries of the general and uniform; as Reynolds put it, "he that does not at all express particulars, expresses nothing"; and in many passages these critics proposed achieving the general by the just selection of those particulars which are most widely possessed.[11]

Thus, Reynolds emphasizes particularity of representation insofar as detail is typical of the general, or ideal, characteristics of nature.[12] Furthermore, according to Edward Alexander in *Matthew Arnold, John Ruskin, and the Modern Temper* (1973), "Reynolds had said that the injunction to imitate nature must not be taken literally"[13] In sum, Reynolds' Neo-classical

aesthetic of painting thus advocates particular representation that corresponds to, but does not duplicate, the natural world and is typical of it. On the subject of representation, Ruskin's views of representational Truth in general and of Truth of Tone in particular are essentially similar to Reynolds' view of particular imitation, corresponding to nature.

Representational Truth, as we have already seen, involves an accurate correspondence to, a "faithful statement . . . of any fact of nature" (III, 104). Truth of Tone, a guideline for the painter, elaborates and specifies this correspondence. A parallel to Reynold's emphasis on particular representation of nature, the first aspect of Tone (for instance) concerns gradation of shade and light with respect to distance—"the *exact* [i.e. particular] relief and relation of objects against and to each other in substance and darkness, as they are nearer or more distant, and the *perfect* relation of the shades of all of them to the chief light of the picture . . ." (III, 259-60). (Italics mine.) This standard for the painter concerns not only particularity in representation but also, like Reynolds' aesthetic, accurate correspondence to nature. Ruskin makes this point with a general comment on Tone in Turner's landscape painting. The particularity of representation and its correspondence to nature that Reynolds emphasizes are evident in Ruskin's statement. Turner

> . . . boldly takes pure white . . . for his highest light, and lampblack for his deepest shade; and between these he makes *every* degree of shade indicative of a *separate* degree of distance, giving each step of approach, not the exact difference in pitch which it would have in nature, but a different bearing the same *proportion* to that which his sum of possible shade bears to the sum of nature's shade. . . . [italics mine]. (III, 262-63)

In general, then, constituting a standard for the painter, the first aspect of Tone, concerned with shading and distance, emphasizes particular and proportionate representation in landscape painting and, in this sense, correponds to Reynolds' Neo-classical aesthetic concerning particular representation correspondent to nature. And since Ruskin's Neo-classical concept of Tone concerns this mimetic relationship between the work and nature, then Truth of Tone, like representational Truth in general, is objective.

Interpreted with Heidegger's aesthetic, Truth of Tone is not objective but phenomenological. It concerns what the painter should be visually aware of when representing nature—that is, a "Gestalt." The "creation" of the art work, according to Heidegger, can include the artist's consciousness of, his Being-with, it by creating its "Gestalt," its varied but unified visual form. With respect to Truth of Tone, the landscape painter's "creation" of the "Gestalt" of the painting should be his Being-with it by establishing coherent formal patterns of shadow, light, and color. With respect to the first aspect of Tone, he should be visually aware of graduating the shade of represented natural objects "as they are nearer or more distant" in the actual scene and relating

their shades "to the chief light of the picture" (III, 259). With respect to the second aspect of Tone, he should relate "the colours of the shadows to the colours of the lights," interrelate all these colors with each other, and harmonize them with the basic light of the painting, "so that the whole of the picture . . . may be felt [i.e. seen by him] to be in one climate, under one kind of light . . ." (III, 259-60). Consequently, when representing a natural scene, the painter should be visually aware of fusing such formal patterns of shadow, of light, and of color into a unity, because each aspect of Tone should be subordinate to the primary light of the picture.

Following his discussion of the representational Truths, including especially Truth of Tone, Ruskin comments on several of Turner's landscape works according to the perspective of Truth. Presented in the section of Truth of Water, the most representative of these commentaries is concerned with *The Slave Ship,* which depicts (we have seen) the aftermath of a murder, in which slaves were cast overboard from a slaver before the onset of a typhoon. This commentary is related to two major aspects of Romantic aesthetic theory—first, its emphasis on sight, and second, on expression.

In *Natural Supernaturalism: Tradition and Revolution in Romantic Literature* (1971), M.H. Abrams explains the Romantic emphasis on sight:

> . . . of all Romantic innovations, none has so preempted the attention of poets, novelists, and painters (and the critics of poetry, novels, and painting) as the concern with the eye and the object and the need for a revolution in seeing which will make the object new. And to our own day the chief definitions of transforming vision have continued to be recognizable, if sometimes distorted, variations on the Romantic categories of freshness of sensation, relevatory Moments, and the rectified outlook which inverts the status of the lowly, the trivial, and the mean.[14]

This Romantic "concern with the eye and the object"—the painting, for example—is evident in Ruskin's commentary on *The Slave Ship,* because he describes visual appearances of the painting in detail:

> It is a sunset on the Atlantic, after prolonged storm; but the storm is partially lulled, and the torn and streaming rain-couds are moving in scarlet lines to lose themselves in the hollow of the night.... Purple and blue, the lurid shadows of the hollow breakers are cast upon the mist of night, which gathers cold and low, advancing like the shadow of death upon the guilty ship as it labours amidst the lightning of the sea, its thin masts written upon the sky in lines of blood, girded with condemnation in that fearful hue which signs the sky with horror, and mixes its flaming flood with the sunlight, and, cast far along the desolate heave of the sepulchral waves, incarnadines the multitudinous sea.
>
> I believe, if I were reduced to rest Turner's immortality upon any single work, I should choose this its drawing [is] as accurate as fearless; the ship buoyant, bending, and full of motion; its tones as true as they are wonderful (III, 571-73)

Thus, by recreating the painting with this account of his perceptions, by describing visual aspects of the sea, the sky, and the ship, Ruskin's commentary exemplifies the Romantic "concern with the eye and the object and the need for a revolution in seeing which will make the object new,"[15] and thus is concerned with the representational element of Truth—"the faithful statement, either to the mind of *senses* [Italics mine], of any fact of nature" (III, 104), in Ruskin's words. Of course, as we have seen, this aspect of Truth is related to the tradition of Neo-classical aesthetics concerned with art as an imitation of, a correspondence to, nature. However, Ruskin's descriptive commentary is primarily concerned with visual aspects of *The Slave Ship* and hence, in this sense, is Romantic. And, as visual, these representational aspects are objective.

Furthermore, Ruskin's commentary is concerned with expressive Truth in the painting, its "statements . . . of [the artist's] emotions, impressions, and thoughts" about the scene represented (III, 104). Specifically, the painting expresses "the most sublime of subjects and impressions [i.e. experienced by Turner] (completing thus the perfect system of all truth, which we have shown to be formed by Turner's works)—the power, majesty, and deathfulness of the open, deep, illimitable sea" (III, 573). This concern with an expressive aspect of Truth is Romantic in a sense explained by Abrams in *The Mirror and the Lamp:*

> In general terms, the central tendency of the expressive theory may be summarized in this way: A work of art is essentially the internal made external, resulting from a creative process operating under the impulse of feeling, and embodying the combined product of the poet's perceptions, thoughts, and feelings. The primary source and subject matter of a poem [or an art work], therefore, are the attributes and actions of the poet's [or the artist's] own mind[16]

According to this Romantic theory, e.g. Wordworth's aesthetic of individual expression, the poem or art work expresses the feelings and thoughts of the artist. Ruskin's view of *The Slave Ship* is Romantic in this sense. In general, he explains that the work expresses Turner's emotional impression of "the power, majesty, and deathfulness of the open, deep, illimitable sea." And, in particular, Ruskin suggests that the work expresses Turner's horror at the murder of the slaves and his thought about divine condemnation of the murderers, because the masts of the ship are "girded with condemnation in that fearful hue which signs the sky with horror." And, as Romantic in these ways, Ruskin's view of expressive Truth in *The Slave Ship* concerns its subjective expression of Turner's experience.

Thus, one Romantic aspect of Ruskin's commentary emphasizes visual appearances in the painting (which are objective) and therefore conflicts with the other Romantic aspect, emphasizing their expression of Turner's emo-

tions and thoughts (which are subjective). Described according to Husserl's phenomenological perspective of intentional consciousness and its correlates, however, Ruskin's commentary is consistent throughout. Representation is not objective but rather intentional; it is what consiousness is *directed toward* visually. For example, Ruskin is visually aware *of* accurate drawing corresponding to nature. And expression is not subjective, but is also intentional. Thus, Ruskin is mentally aware of a formal expression of meaning, Turner's impression of "the power, majesty, and deathfulness of the . . . sea."

Interpreted according to Martin Heidegger's aesthetic in "The Origin of the Work of Art," representational Truth in *The Slave Ship* is its phenomenological "earth," the form that Ruskin sees. And expressive Truth is the "world," the meaning, that he apprehends. His perceptual apprehension of the painting is his Being-with its "earth," representational form. He sees, for example, a sunset, in which "torn and streaming rain-clouds are moving in scarlet lines to lose themselves in the hollow of the night" (III, 571). Or, he perceives "the mist of night, which gathers cold and low, advancing like the shadow of death upon the guilty ship as it labours amidst the lightning of the sea" (III, 572). And, apprehended by Ruskin, the expressive aspect of Truth in the painting is its phenomological meaning, its "world," constituted by Turner's emotions and thoughts about the scene and expressed by it. For instance, Ruskin sees the masts of the ship, "girded with condemnation in that fearful hue which signs the sky with horror" (III, 572), and thereby apprehends Turner's horror at the murder of the slaves and his thought about divine condemnation of their murderers.

Ruskin's apprehension of the "world" of *The Slave Ship,* its emotive and cognitive significance, constitutes an important instance of historical Truth in *Modern Painters I.* The "most historical" Truths, Ruskin earlier maintains, are those "which tell us most about the past and future states of the object to which they belong" (III, 163). Heidegger in *Being and Time,* calls such temporal meanings (respectively) "repetition" and "anticipation." The former is the self's consciousness of past possibilities of existence. And the latter is his Being-with future possibilities of existence. A "repetition" of past existence, the first aspect of historical Truth concerns Ruskin's Being-with Turner's thoughts, expressed by the scene, about past events that occurred on the sea. Seeing "the mist of night, . . . advancing . . . upon the guilty ship . . . , its thin masts written upon the sky in lines of blood" (III, 572), Ruskin apprehends Turner's certainty about the past—about the murder of the slaves—and his thought about the guilt of their murderers. And second, seeing the masts of the ship "girded with condemnation in that fearful hue which signs the sky with horror, and mixes its flaming flood with the sunliight, and . . . incarnadines the multitudinous sea" (III, 572), Ruskin apprehends Turner's thought about the

future of the murderers. This apprehension is an "anticipation" of their future possibilities of existence. In particular, Ruskin knows that, as the result of divine condemnation, they will suffer, degenerate, and probably encounter a violent death.

Ruskin's commentary on *The Slave Ship* essentially completes the noteworthy practical criticism of *Modern Painters I*. Having expanded the landscape Idea and the Idea of Truth into the aesthetic of volume one, he then expands the Idea of Beauty into that of *Modern Painters II*. In general, the artist's Imagination creates Beauty in art, Typical and Vital Beauty characterize the work itself, and the observer's Theoretic Faculty apprehends Beauty in it.

Theoria and the Aesthetic of Beauty in *Modern Painters II*

In *Modern Painters I*, the Idea of Beauty is essentially a theory of response to art, because "any material object," especially one represented in landscape art and adumbrating the natural Divinity, that "can give us pleasure in the simple contemplation of its outward qualities" is beautiful (III, 109). And in *Modern Painters II*, Ruskin expands this theory into one including several responses to painting, which constitute "an idea of beauty":

> For, as it necessary to the existence of an idea of beauty, that the sensual pleasure which may be its basis should be accompanied first with joy, then with love of the object, then with the perception of kindness in a superior intelligence, finally, with thankfulness and veneration towards that intelligence itself; and as no idea can be at all considered as in any way an idea of beauty, until it be made up of these emotions . . . ; it is evident that the sensation of beauty is not sensual on the one hand, nor is it intellectual on the other, but is dependent on a pure, right, and open state of the heart. (IV, 48-49)

Constituting an Idea of Beauty, these responses themselves are operations of the Theoretic Faculty. And these operations are Evangelical and Romantic. George P. Landow gives an excellent analysis of the relation between Evangelicalism and Romanticism in Ruskin's early aesthetic theory:

> This emphasis upon a felt emotional religious experience, so central to Evangelical belief, provided support for the Romantic critical theory upon which Ruskin drew in formulating his own views of art and aesthetics. First of all, the Evangelical preacher and the individual worshipper demanded the same qualities of religious experience as did the romantic poet and theorist: both Evangelicalism and romanticism required spontaneous, personal, intense, sincere emotions upon which to found one's life or one's art.[17]

This Evangelical and Romantic tradition concerning "a felt emotional religious experience" of art informs Ruskin's religious aesthetic of the Theoretic Faculty. When looking at the painting and contemplating it

morally, he responds in several ways, which are "spontaneous, personal, intense, [and] sincere." He feels spontaneous joy. He feels a personal "love of the object," the painting. He experiences an intense "perception of kindness in a superior intelligence" (i.e. the Divine). And he feels sincere "thankfulness and veneration towards that intelligence itself." In these ways, Ruskin's theoretic apprehension of Beauty is both Evangelical and Romantic. Thus, he maintains "that the sensation of beauty is not sensual on the one hand, nor is it intellectual on the other, but is dependent on a pure, right, and open state of the heart."

Ruskin explains these theoretic apprehensions not only from the perspective of Beauty but also from that of the Theoretic Faculty itself:

> But when, instead of being scattered, interrupted, or chance-distributed, they [visual forms] are gathered together, and so arranged to enhance each other as by chance they could not be, there is caused by them not only a feeling of strong affection towards the object in which they exist, but a perception of purpose and adaptation of it to our desires; a perception, therefore, of the immediate operation of the Intelligence which so formed us, and so feeds us.
>
> Out of which perception arise Joy, Admiration, and Gratitude.
>
> Now the mere animal consciousness of the pleasantness I call AEsthesis; but the exulting, reverent, and grateful perception of it I call Theoria. (IV, 46-47)

This theory of response to art is, we have seen, both Romantic and Evangelical. Furthermore, this aesthetic includes an aspect of the Victorian "moral aesthetic," which Jerome H. Buckley explains in *The Victorian Temper.* According to Buckley, the spectator must be aware of "the vital reality" beneath the surface of the art work; thereby, he achieves "an empathic identification and so a moral self-effacement."[18] And according to Ruskin, when he looks at the orderly arrangement of natural forms in the painting, he becomes aware of its "vital reality," constituted by the painter's belief in the divine intelligence that created man. In this sense, he morally effaces himself and empathically identifies with the artist's religious imagination, "the operations of which become in their turn objects of the theoretic faculty to other minds" (IV, 36). And thereby, Ruskin experiences "a perception . . . of the immediate operation of the Intelligence which so formed us, and so feeds us."

Finally, Ruskin elaborates this apprehension of the Divine, embodied in the work. This moral apprehension "is the full comprehension and contemplation of the Beautiful as a gift of God; a gift not necessary to our being, but added to, and elevating it, and twofold: first of the desire, and secondly of the thing desired" (IV, 47). This final element in Ruskin's aesthetic of the Theoretic Faculty is also an aspect of the Victorian "moral aesthetic." Buckley explains this aspect:

Like their eighteenth-century predecessors most early Victorian aestheticians strove to relate the beautiful to some fixed pattern in the harmony of nature, to an unchanging truth beyond the immediate object of contemplation. If art was to mirror a larger totality, its function, they thought, must be at least implicitly "moral"; the picture or the poem, the play or the statue was to edify as well as to delight by its reflection of an immutable design.[19]

Understood according to this Victorian theory, Ruskin's religious aesthetic of the Theoretic Faculty concerns his apprehension of divine Beauty in the art work and of the consequent elevation of his aesthetic sensibility. Believing that the creative intelligence of God underlies nature and man, the painter expresses this belief through the interrelated, organic forms of the art work, portraying nature and man. This expression of belief in divine intelligence by forms of the painting constitutes its relation to what Buckley calls "some fixed pattern in the harmony of nature, to an unchanging truth beyond the immediate object of contemplation." And, according to the Victorian "moral aesthetic," art "was to edify as well as to delight by its reflection of an immutable design." Reflecting the painter's religious belief in the operation of God's intelligence in nature and in man, the painting, apprehended by Ruskin's Theoretic Faculty, adds to his being, i.e. his sensibility, "elevating it, and twofold: first of the desire, and secondly of the thing desired." This, according to this Victorian aesthetic of the Theoretic Faculty, the manifestation of divine being through the interconnected forms of the work edifies his sensibility, refines his capacity to apprehend Beauty in art.

With respect to tradition, then, Ruskin's aesthetic of the Theoretic Faculty is both Romantic and Victorian. The Evangelical and Romantic aspects of this theory concern his deeply religious as well as intensely emotional responses to divine Beauty in art. The Victorian element of this theory includes two aspects of the Victorian "moral aesthetic." First, by apprehending the painter's religious concept of divine Beauty, Ruskin perceives the living reality underlying the appearances of the work and thereby morally effaces himself and identifies with the painter. And second, this apprehension edifies Ruskin's religious-aesthetic sensibility. In general, these relations between Romantic and Victorian theories and the aesthetic of the Theoretic Faculty show that its operations are primarily responses to art and are therefore subjective.

Understood from Husserl's phenomenological perspective of intentional consciousness, which is directed toward entities, feelings, or thoughts, the operations of Theoria are not subjective, but instead are intentional. Suspending Aesthesis, the purely sensory consciousness of art, Ruskin becomes aware *of* the painting, its divine Beauty, and his responses to it. And understood hermeneutically with the perspective of "The Origin of the Work of Art," these operations of the Theoretic Faculty constitute Ruskin's "preservation" of the work by "willing." "Preservation" of the art work,

according to Heidegger, first involves the observer's decision to suspend inauthentic, ordinary, modes of appreciation, such as "aisthesis," the merely sensory apprehension of art. Second, "willing" can then include his apprehension of, or Being-with, the work by seeing its form (or "earth"), by understanding its meaning (or "world"), and by apprehending its "beauty"— the expression of its essential nature, or "Being," by form. And insofar as they are unusual, all these elements of the work are authentic.

Ruskin's "preservation" of art according to the Theoretic Faculty involves "willing" to avoid Aesthesis, "mere animal consciousness of" the painting (IV, 47) as an apprehension which is commonplace and inauthentic. This suspension permits him to then apprehend the authentic aspect of the work. He first sees an authentic "earth," unusual natural forms, which "instead of being scattered, interrupted, or chance-distributed," "are gathered together, and so arranged to enhance each other as by chance they could not be" (IV, 46-47).

Seeing these forms, he then becomes aware of his emotional responses to them. These responses constitute the unusual emotive meaning that the painting has for him—its authentic "world." In particular, he becomes aware of a spontaneous "feeling of strong affection towards the object in which they [i.e. coherent forms] exist" (IV, 47). Seeing these forms and consequently experiencing "a perception of purpose and adaptation of it to our desires; a perception, therefore, of the immediate operation of the Intelligence which so formed us, and so feeds us," (i.e. an apprehension of the painter's *belief* in this operation) Ruskin consequently feels sincere "Joy, Admiration, and Gratitude" toward the Creator (IV, 47) All these responses, constituting the emotive significance of the work for Ruskin's consciousness, are authentic, or unusual because they are "exulting, reverent, and grateful" (IV, 47).

Furthermore, Theoria is Ruskin's "preservation" of, his intentional participation in, the unusual (authentic) phenomenological "beauty" of the painting. Here, Theoria is his Being-with form insofar as it expresses the essential nature, the *divine* "Being," of the work. As we have seen, Ruskin apprehends the expression, by coherently arranged forms, of the painter's religious belief concerning the operation of God in nature and in man. In this sense, Ruskin apprehends the divine essence, the essential divine "Being," of the painting. He apprehends "the immediate operation of the Intelligence which so formed us, and so feeds us" (IV, 47), an intelligence that is unusual because divine. And in this sense, Ruskin's "full comprehension and contemplation of the Beautiful as a gift of God" (IV, 47) is his apprehension of the authentic phenomenological "beauty" of the painting.

Finally, this apprehension by the Theoretic Faculty causes him to become aware of the enduring effect of divine "beauty" on him. Only Ruskin can be aware of this effect, because it is unique. It concerns a refinement of his

own individual, moral and aesthetic ability to apprehend manifestations of the Divine in art, because its gift to divine Beauty is "not necessary to our being, but added to, and elevating it, and twofold: first of the desire [i.e. for Beauty in art], and secondly of the thing desired [i.e. the art work itself]" (IV, 47). And in this sense, the effect of Beauty on Ruskin is authentic.

From the aesthetic of the Theoretic Faculty, Ruskin moves to that of Beauty itself. First, he rejects several "False Opinions" of beauty in painting and then advocates the concepts of Typical Beauty and of Vital Beauty as valid standards for it.

Concerned with symbolization of divine characteristics by nature and man portrayed in art (IV, 64), the theory of Typical Beauty is essentially a Neo-classical aesthetic of order. Landow shows that the aesthetic of Typical Beauty is related in general to Francis Hutcheson's aesthetic of beauty and in particular to John Dennis' aesthetic of beauty as order, set forth in "The Grounds of Criticism in Poetry" (1704):

> Even John Dennis, who was primarily concerned with the emotions of the violent sublime emphasized the importance of order:
>
>> The work of every reasonable creature must derive its beauty from regularity, for reason is rule and order As man is the more perfect the more he resembles his Creator the works of men must needs be more perfect the more they resemble his Maker's. Now the works of God, though infinitely various, are extremely regular.
>> The universe is regular in all its parts, and it is to that exact regularity that it owes its admirable beauty. The microcosm owes the beauty and health both of its body and soul to order.
>
> Ruskin, like Dennis, believes that order is a primary cause of the beautiful, or better, that order is itself beautiful. This belief lies at the center of Ruskin's theory of Typical Beauty. In outlining his theory, Ruskin shows that all forms of Typical Beauty please because these forms symbolize divine order in material things.[20]

That is, like John Dennis' Neo-classical theory of beauty as divine order and regularity, Ruskin's religious aesthetic of Typical Beauty in painting concerns its symbolization, by "a stone, flower, beast, or . . . man," of "Divine attributes" (IV, 64), including Infinity, Unity, Repose, Symmetry, Purity, and Moderation, all of which embody principles of order.

Consequently, Landow maintains, "Ruskin's theory of Typical Beauty is an Apollonian, classical aesthetic of order, and as such apparently inconsistent with his romantic conceptions of painting and literature."[21] That is, "a romantic . . . aesthetic considers beauty as an emotion and discusses it not in terms of external qualities of the object but in terms of the psychological experiences of the beholder."[22] In particular, then, Ruskin's Neo-classical

aesthetic of Typical Beauty is inconsistent with his Romantic theory of Vital Beauty (for instance), because it concerns "the appearance of felicitous fulfilment of function in living things, more especially of the joyful and right exertion of perfect life in man" (IV, 64). Vital Beauty concerns *Ruskin's* feelings of physical vitality and of happiness, both of which are responses to nature and man, portrayed in art. In this sense, the theory of Vital Beauty is subjective. Consequently, it conflicts with that of Typical Beauty, which is objective, because it is concerned with the divine order inherent in art and symbolized by its forms as portrayed by aspects of plants, animals, and man.

Ruskin's theory of Typical and Vital Beauty is not inconsistent, however, when interpreted with Husserl's theory of intentionality. Whether perceived entities, feelings, or thoughts, whatever consciousness is directed toward is neither objective nor subjective, but is a correlate for intentional consciousness, an intentional object. First, the painting itself, portraying stones, plants, animals, or man, is not objective; rather it is an intentional object for Ruskin's sight. Second, Typical Beauty in art is not objective but intentional. Since "the greater parts of works of art, more especially those devoted to the expression of ideas of beauty, are the results of the agency of imagination . . ." (IV, 165), Typical Beauty consequently concerns Ruskin's mental apprehension that the work's forms, portraying nature and man, are "in some sort typical of the Divine attributes" (IV, 64), that is, of the painter's belief in divine order. And finally, Vital Beauty, which is not subjective, is also intentional. It concerns Ruskin's emotional apprehension of "the appearance of felicitous fulfilment of function in living things, more especially of the joyful and right exertion of perfect life in man" (IV, 64). He is aware that the forms of the work express the painter's happiness in "living things" and his energetic vitality.

Furthermore, not only Typical Beauty but also Vital Beauty is informed by divine being. Summarizing the aspects of Typical and Vital Beauty, Ruskin asserts that Beauty

> . . . is either the record of conscience, written in things external, or it is a symbolizing of Divine attributes in matter, or it is the felicity of living things, or the perfect fulfilment of their duties and functions. In all cases it is something Divine; either the approving voice of God, the glorious symbol of Him, the evidence of His kind presence, or the obedience to His will by Him induced and supported. (IV, 210)

When Ruskin looks at the form of the art work, he then apprehends expressions of the painter's belief and experience. And since these expressions constitute Beauty, which, Ruskin asserts, "is something Divine," therefore the painter's belief and his experience themselves have a divine quality, constituting the essential character of the painting. Similarly, Heidegger's aesthetic in "The Origin of the Work of Art" explains that "beauty" in art is the observer's apprehension of form insofar as it expresses the essential nature,

the "Being," of the work. Phenomenologically, then, Ruskin's apprehension of Typical and Vital Beauty is his Being-with the "beauty" of the painting, its essential nature, its divine "Being," manifested by form. Looking at forms of nature, animals, and man in the painting, he first apprehends their expression of the painter's "conscience, written in things external" and embodying "the approving voice of God," an aspect of the work's divine "Being." Ruskin next understands the symbolic expression of the painter's religious belief in a God-pervaded world and thereby becomes aware of a "glorious symbol of Him . . . a symbolizing of Divine attributes in matter." Knowing that "the felicity of living things" is an expression of the artist's happiness and that this felicity has a divine quality, Ruskin then becomes aware of another aspect of the essence, the divine "Being," of the painting, its manifestation of "evidence of His kind presence." Finally, when Ruskin apprehends that "the perfect fulfilment of their duties and functions" concerns the *painter's* adherence to divine law, "the obedience to His will by Him induced and supported," Ruskin then knows that the forms of man and nature in the painting express the fundamental aspect of its divine "Being," the will of God. In these ways, then, the religious aesthetic of Typical and Vital Beauty concerns Ruskin's Being-with the phenomenological "beauty" of painting.

Following his account of Typical Beauty (including prominently its elements of Infinity, Unity, Purity, and Moderation) and his account of Vital Beauty (including especially its element concerning plants and animals), Ruskin concludes the aesthetic of *Modern Painters II* with accounts of Associative Imagination, Penetrative Imagination, and their respective results in art.

Romantic Theory and Ruskin's Aesthetic of Imagination

M.H. Abrams, we have seen, explains two forms of "the expressive theory of art," typical of Romantic aesthetics. According to the second, "poetry [or art] is defined in terms of the imaginative process which modifies and synthesizes the images, thoughts, and feelings of the poet [or artist]."[23] And Abrams explains Coleridge's aesthetic of imagination, representative of this form of "the expressive theory":

> That function of synthesizing opposites into a higher third, in which the component parts are *alter et idem,* Coleridge attributes, in the aesthetic province, to the imagination—"that synthetic and magical power," as he describes it in the *Biographia Literaria,* which "reveals itself in the balance or reconciliation of opposite or discordant qualities." And the affinity of this synthesis with the organic function of assimilating nutriment declares itself, when Coleridge goes on at once to cite Sir John Davies' description of the soul[24]

Abrams continues: "Imaginative unity is an *organic* unity: a self-evolved system, constituted by a living interdependence of parts, whose identity cannot survive their removal from the whole."[25]

Ruskin's aesthetic of Associative Imagination is Romantic in this Coleridgean sense, concerning reconciliation of opposites into "a living interdependence of parts," an organic whole. Concerned with Ideas of nature, with concepts referring to perceptions of it, the painter's Associative Imagination selects, for example,

> ... two ideas which are *separately wrong*, which together shall be right, and of whose unity, therefore, the idea must be formed at the instant they are seized, as it is only in that unity that either is good, and therefore only the *conception of that unity can prompt the preference*. (IV, 234)

According to Coleridge's theory of imagination, the artist's mind " 'reveals itself in the balance or reconciliation of opposite or discordant qualities.' " In Ruskin's aesthetic, these " 'discordant qualities' " are the painter's visual and cognitive Ideas of nature that are *"separately wrong."* Just as a plant assimilates different kinds of nourishment such as water, light, and minerals into a unified form, similarly the painter's Associative Imagination reconciles and balances these imperfect, discordant natural Ideas, by conceiving their unity "at the instant they are seized" and by then combining them into the perfect, organically unified form of the painting itself.

This unified form constitutes the Essential Unity, the Unity of Membership, belonging to the work and resulting from the operation of Associative Imagination (IV, 236). And Abrams shows that, according to Coleridge's aesthetic, the results of imagination establish an analogy between its creative function and that of the creative principle immanent in nature:

> All genuine creation—everything that is not a mimicking of given models, or a mere reassembly of given elements into a whole which is novel in its pattern but not in its parts— derives from the generative tension of opponent forces, which are synthesized, without exclusion, into a new whole. The imagination, in creating poetry [or art], therefore echoes the creative principle underlying the universe.[26]

Similarly, by creating essential unity in the painting, a unity of (for instance) "two ideas which are *separately wrong*, which together shall be right" (IV, 234), the painter's Associative Imagination echoes the mind of God, who unifies the aspects of nature into an organic whole. In this sense, Associative Imagination "is indeed something that looks as if man were made after the image of God" (IV, 236).

Not surprisingly, then, both Coleridge and Ruskin also adhere to similar standards of excellence for the work of art. Abrams explains Coleridge's view,

set forth in his essay "On Poesy or Art": "For a work of art, the gauge of greatness becomes, jointly, the richness—the quantity and diversity—of the component materials, and the degree to which these are bound together in the interdependence characteristic of an organic whole."[27] Ruskin's critieria are similar:

> The final tests, therefore, of the work of associative imagination are, its intense simplicity, its perfect harmony, and its absolute truth. It may be a harmony, majestic or humble, abrupt or prolonged, but it is always a governed and perfect whole; evidencing in all its relations the weight, prevalence, and universal dominion of an awful inexplicable Power; a chastising, animating, and disposing Mind. (IV, 248)

In general then, corresponding to Coleridge's Romantic aesthetic of imagination and its result, the work as an organically unified whole, Ruskin's theory of Associative Imagination concerns its operation with separate disparate materials and the organic result in the painting, Essential Unity. Understood in this perspective, however, Ruskin's aesthetic is inconsistent, because (on one hand) the operation of Imagination is subjective but (on the other) its result, an organic unity, belongs to the work itself and hence is objective.

When described with Husserl's perspective of intentional consciousness and its correlates, intentional objects, the theory of Associative Imagination does not, however, have this inconsistency. Not subjective, the operations of the painter's Associative Imagination are *what* he is aware of when creating the work and, in this sense, are intentional. Specifically, he is aware *of* perfecting and unifying imperfect, *"separately wrong"* Ideas of nature (IV, 234). Thereby, he establishes the Essential Unity of his painting, a unity which is not objective but also intentional. That is, he is aware *of* establishing a coherent unity of parts in which "each must imply, and ask for all the rest" (IV, 236).

The same theory, interpreted with Heidegger's aesthetic, concerns the painter's awareness of establishing a meaningful "Gestalt" in the painting. According to "The Origin of the Work of Art," the "creation" of the art work can include the artist's Being-with it by establishing its "Gestalt" and its "world." He is consious of (respectively) interrelating visual forms into a unified whole and thereby expressing its significance. And, insofar as he is aware of expressing the essence, or "Being," of the work through its unified form, then he creates the "beauty" of the work of art.

Phenomenologically, then, the artist's "creation" of the painting according to the operations of Associative Imagination is his Being-with it by first creating its "Gestalt." He is visually conscious of selecting, perfecting, and unifying his *"separately wrong"* images of nature—"two ideas," for instance, "which are *separately wrong*, which together shall be right." And he does so on

the basis of his mental apprehension of their implicit unity, because "only the *conception of that unity can prompt the preference"* for, the selection of, them. Thus, establishing the unified forms constituting the "Gestalt" of the painting, he becomes aware of thereby expressing its meaning, or "world"—his conception of their unity, "as it is only in that unity that either is good"(IV, 234). In these ways, the painter is visually and mentally aware of creating Essential Unity,

> ... for, by the definition of Unity of Membership ..., not only certain couples or groups of parts, but *all* the parts of a noble work must be separately imperfect; each must imply, and ask for all the rest, and the glory of every one of them must consist in its relation to the rest; neither while so much as one is wanting can any be right. (IV, 236)

And insofar as the painter is aware of expressing the essential nature of the painting, its "Being," through its unified form, he creates phenomenological "beauty." In particular, he is aware of creating a harmony of natural forms expressing the divine "Being":

> ... harmony, majestic or humble, abrupt or prolonged, but it is always a governed and perfect whole; evidencing in all its relations the weight, prevalence, and universal dominion of an awful inexplicable Power; a chastising, animating, and disposing Mind. (IV, 248)

By creating the harmonious "Gestalt" of the painting, the painter expresses his religious belief about Essential Unity as an attribute of the divine "Being,""as significative of perfection in the things united, and as typical of that Unity which we attribute to God" (IV, 92). In this sense, the painter's "creation" of phenomenological "beauty" in the painting is his Being-with, his consciousness of, it by expressing one of "the Divine attributes" of Typical Beauty through unified form.

Following his discussion of Associative Imagination, Ruskin discusses Penetrative Imagination and its results in art. Whereas the artist's Associative Imagination in general reassembles *"separately wrong"* visual images of nature into a perfect whole in the painting (IV, 234), his Penetrative Imagination directly apprehends the inward being, "the very central fiery heart," of nature or man and embodies this essence into the work (IV, 250).

This theory, concerned with Imagination as insight, is basically similar to the Romantic view of imagination as a cognitive faculty. In *Aesthetics from Classical Greece to the Present,* Monroe C. Beardsley outlines this theory. It can be traced, he explains, to the concept of " 'inner sense' " held by

> ... Shaftesbury and Hutcheson, at least to the theory of sympathy, or the moral sentiment, in Hume and Adam Smith. But in the Romantic poets and novelists, these epistemological

concepts blossomed into a more ambitious, if much less clear, notion of a special gift, the ability to participate feelingly, not only in the inner life of other human beings, but in the inner life of the world itself. . . .

It was the claim to this form of knowledge that gave rise to a new theory of the imagination—or, perhaps better, that was marked by a new extension of the term "imagination," to cover not only a faculty of inventing and reassembling materials, but a faculty of seizing directly upon important truth.[28]

In the sixth Book of *The Prelude,* Wordsworth, describing his experience of crossing the Alps, implies a similar concept of imagination. It "rose from the mind's abyss." And

> . . . in such strength
> Of usurpation, when the light of sense
> Goes out, but with a flash that has revealed
> The invisible world, doth greatness make abode[29]

Ernest Bernbaum's *Guide Through the Romantic Movement* (1949) gives a detailed explanation of such concepts, which Beardsley outlines. Bernbaum describes Romantic imagination as the mind's capacity to intuit meanings concealed beneath the appearances of things:

> The Imagination is pursuing its proper task when it is engaged in a free search for significant meanings in the world, when it tries to penetrate beneath the appearances which deceive the "vulgar sense." This it can achieve only when, so to speak, it loses itself; then it becomes identified with the innermost or essential nature and meaning of the object it contemplates. Imagination, thus functioning . . . senses the *real* life or nature of the object. . . .[30]

This statement explains both Wordsworth's view of imagination as intuitive insight and Ruskin's concept of Penetrative Imagination. When, as Wordsworth says, "the light of sense / goes out but with a flash that has revealed / the invisible world . . . ," then imagination penetrates "beneath the appearances which deceive the 'vulgar sense,' " "loses itself," and "becomes identified with the innermost or essential nature and meaning of the object it contemplates" (in Bernbaum's words). The painter's Penetrative Imagination operates in a similar manner. It passes by the external appearances of nature or man and apprehends their "very central fiery heart," their "utmost truth, life, principle" (IV, 250-51). The painter then embodies this essence into the painting itself. Thus, Ruskin, as Beardsley maintains, "was the heir of Romanticism—in his attempt to make the imagination into a supreme cognitive faculty"[31]

Ruskin's Romantic aesthetic of Penetrative Imagination is primarily subjective, because this theory concerns the artist's experience of "the very central fiery heart" of his subject (IV, 250)—i.e. his *projection* of emotion into it—and also concerns expression of this emotion through form in painting.

Phenomenologically, however, this aesthetic is not subjective but intentional. It concerns what the artist's consciousness is aware *of*. According to Husserl's *Logical Investigations,* intentional consciousness has a direction toward its correlates, intentional objects—including visual entities, feelings, or thoughts. These are neither subjective nor objective. Instead they are intentional; they are *what* consciousness is aware of. Ruskin's artist, then, becomes aware of the inner nature of his subject; his mind "never stops at crusts or ashes, or outward images of any kind," but "ploughs them all aside, and plunges into the very central fiery heart" (IV, 250). He apprehends the essence of his particular subject in nature, because Imagination "gets within all fence, cuts down to the root, and drinks the very vital sap of that it deals with" (IV, 250-51). Further, Imagination "looks not in the eyes, it judges not by the voice, it describes not by outward features; all that it affirms, judges, or describes, it affirms, from within" (IV, 251). Here, the painter, seeing external aspects of man, experiences his inward character.

Then, on the basis of these apprehensions, the painter creates the phenomenological "beauty" of the painting itself. The "creation" of "beauty" is, according to Heidegger's aesthetic, the artist's Being-with his work by expressing its essence through form. That is, he is aware of expressing the "Being" of the art work formally. According to Ruskin's aesthetic of Penetrative Imagination, the painter is first visually conscious of portraying natural or human forms. Thereby, he becomes mentally aware of expressing their essences, constituting the "Being" of the work itself. That is, he is aware of expressing "the very central fiery heart," "the very vital sap" of the natural forms portrayed. And he knows that he expresses man's essential emotional character through human forms, because Imagination holds "things always by the heart" and "all that it affirms, judges, or describes, it affirms, from within." In these ways, the artist creates "beauty" by means of what Heidegger calls "a founding leap," which brings the work of art "into being from out of the source of its nature" (77-78). That is, by portraying forms of nature and of man that express their "utmost truth, life, principle," the painter is conscious of founding the painting on its source, its essential nature, or "Being."

Following his discussion of Penetrative Imagination, Ruskin comments on several paintings by Tintoretto that embody its results. The most important of these works, judging by the length and detail of Ruskin's commentary on it, is *The Last Judgment.*

In part, this commentary exemplifies the Romantic emphasis on sight, which has already been discussed in connection with the commentary, in *Modern Painters I,* on *The Slave Ship.* In *Natural Supernaturalism,* Abrams, we have seen, explains this Romantic "concern with the eye and the object and the need for a revolution in seeing which will make the object new."[32] Similarly, in Ruskin's commentary on *The Last Judgment,* his account of a

sequence of events implies a Romantic concern with the work *as* seen. For example, he describes the dead rising from the earth and ascending "to the judgment-seat":

> Bat-like, out of the holes and caverns and shadows of the earth, the bones gather and the clay heaps heave, rattling and adhering into half-kneaded anatomies, that crawl, and startle, and struggle up among the putrid weeds, . . . until the great vortex of the four winds bears up their bodies to the judgment-seat (IV, 277)

Furthermore, Ruskin maintains that *The Last Judgment,* among other works by Tintoretto, "depends on the penetration of the imagination into the TRUE nature of the thing represented" (IV, 278) and thus implies that the painting embodies results of his Penetrative Imagination. The aesthetic of Penetrative Imagination itself, we have seen, corresponds to the Romantic theory of imagination as insight. And insofar as Ruskin's commentary on *The Last Judgment* indicates that it expresses Tintoretto's "penetrative" insights, his thoughts and feelings about his subject, this aspect of the commentary is also Romantic, albeit in a different sense. That is, Ruskin is concerned with art as expression, particularly in the following sense, defined by Abrams in *The Mirror and the Lamp:* "A work of art is essentially the internal made external, resulting from a creative process operating under the impulse of feeling, and embodying the combined product of the poet's [or artist's] perceptions, thoughts, and feelings."[33] Ruskin's account of the fate of the resurrected dead implies this kind of expression in *The Last Judgment:*

> . . . the Firmament is all full of them, a very dust of human souls, that drifts, and floats, and falls in the interminable, inevitable light; the bright clouds are darkened with them as with thick snow, currents of atom life in the arteries of heaven, now soaring up slowly, and higher and higher still, till the eye and the thought can follow no farther, borne up, wingless, by their inward faith and by the angel powers invisible, now hurled in countless drifts of horror before the breath of their condemnation. (IV, 277)

Here, Ruskin implies that visual aspects of the painting are expressive. For instance, the scene of souls "borne up, wingless, by their inward faith" expresses Tintoretto's insight into their faith in God and their joy from being saved. Or, the scene of other souls "now hurled in countless drifts of horror before the breath of their condemnation" expresses his thought about their pain and horror at being damned. Thus, in the ways here outlined, Ruskin's commentary is concerned with the expression, by the work, of Tintoretto's thoughts about his subject, the final judgment of mankind. And in this sense, Ruskin's commentary is Romantic.

Thus, insofar as Ruskin emphasizes visual aspects of *The Last Judgment,* his commentary is in the Romantic critical tradition concerning the impor-

tance of sight and therefore is objective. And insofar as he implies that the painting expresses Tintoretto's "penetrative" insights into the scene, this commentary is in the Romantic tradition concerned with art as expression and is, in this sense, subjective. In consequence, including *both* subjective and objective elements, Ruskin's commentary is inconsistent.

But this commentary is consistent when described phenomenologically with Husserl's perspective of intentional consciousness and its correlates, which are neither subjective nor objective but phenomenal. They are *what* consciousness is *directed toward.* That is, Ruskin's commentary shows that he visually perceives the appearances of the work, which represent the judgment, and that he mentally apprehends the meaning expressed by these forms— Tintoretto's "penetrative" insight into the scene, into the joy of the faithful and the despair of the faithless.

Interpreted with Heidegger's phenomenological perspective in "The Origin of the Work of Art," Ruskin's commentary concerns his visual awareness of the "earth" of *The Last Judgment* and his mental apprehension of its "world." According to Heidegger, the "earth" of the work of art is its form, as visually apprehended by the observer. And the "world" of the work, expressed by form, is its meaning, as mentally apprehended by him. These apprehensions constitute his Being-with the appearance and the meaning, the "earth" and the "world," of the art work.

Looking at the visual appearances of *The Last Judgment,* Ruskin apprehends its "earth." He sees, for example, the souls of humanity rising from the dead, "rattling and adhering into half-kneaded anatomies, that crawl, and startle, and struggle up among the putrid weeds." He sees them ascend, "until the great vortex of the four winds bears up their bodies to the judgment-seat." And finally, he sees the saved "soaring up slowly, and higher and higher still, till the eye and the thought can follow no farther" and the damned "now hurled in countless drifts of horror before the breath of their condemnation."

Perceiving these and other aspects of the painting, which constitute its "earth," Ruskin then apprehends their expression of meaning, embodied in the work by Tintoretto's Penetrative Imagination. This apprehension is Ruskin's Being-with the "world" of *The Last Judgment,* its essential meaning, an expression of "the penetration of the imagination into the TRUE nature of the thing represented." For example, when Ruskin sees souls "shaking off one by one the dreams of the prison-house . . . , until the great vortex of the four winds bears up their bodies to the judgment-seat" (IV, 277), he then realizes that this scene expresses the essential significance of their destiny—its decisive moment, when God determines whether they are good or evil, whether or not they have remained faithful to Him during life.

A result of Tintoretto's Penetrative Imagination, the meaningful "world" of *The Last Judgment* is temporal in three senses, which are defined by Heidegger in *Being and Time*. "Understanding," he explains, has three temporal modes: (1) "repetition," as the human being's awareness of past possibilities of existence, (2) "moment of vision," as his consciousness of the present moment and situation, and (3) "anticipation," as his Being-with future possibilities of existence.

First, Ruskin understands Tintoretto's insight into the fundamental religious significance of the past life experienced by human souls. This apprehension is a "repetition," for Ruskin's mind, of their past possibilities of existence. In particular, he sees that "out of the holes and caverns and shadows of the earth, the bones gather and the clay heaps heave" And then he knows that these souls, during their past life, existed according to alternatives originally established by the Fall of Man, that is, according to standards of faith or disbelief, of good or evil.

Second, experiencing a "moment of vision," Ruskin apprehends Tintoretto's view, discovered by Imagination and embodied in the work, concerning the significance of the present for human souls. Ruskin understands the scene of ascent, during which they rise "to the judgment-seat." He comprehends the significance of the present situation for them, the significance of God's power, which sustains their existence, and of His justice, which determines their present moral state, whether good or evil.

Finally, looking at the painting, Ruskin mentally apprehends its central meaning, its expression of Tintoretto's most important insight into the judgment, an insight resulting from "the penetration of the imagination into the TRUE nature of the thing represented." Knowing that this insight concerns judged souls' essential possibilities of existence in the future, Ruskin experiences an "anticipation" of their destiny. He knows that those who were faithful to God during life now expect to have perfect faith and experience infinite joy forever, because he sees them "now soaring up slowly . . . , borne up, wingless, by their inward faith and by the angel powers invisible." And seeing other souls "now hurled in countless drifts of horror before the breath of their condemnation," he experiences another "anticipation" of future existence. This "anticipation" is his consciousness of, his Being-with, their future possibilities of existence. He knows that since they were faithless during life, they are evil and therefore will experience all the possibilities of fear and suffering in hell.

Ruskin, then, apprehends these different temporal meanings of *The Last Judgment* intuited by Tintoretto's Penetrative Imagination, embodied in the work, and constituting part of its "TRUE nature," the essential significance of the judgment. Expressed by form, the true character of the work also includes aspects of the divine being. Correspondingly, Heidegger's discussion of a

Greek temple indicates that its formal expression of divine "Being" to the observer's consciousness is an epitome of "beauty" in the work of art. "Beauty," then, is his Being-with form expressing the essential nature, the "Being," of the work.

Apprehended by Ruskin's consciousness, wrath, power, and justice are aspects of the essential nature, the divine "Being," of Tintoretto's *The Last Judgment* and are results of "the penetration of . . . [his] imagination into the TRUE nature of the thing represented," the judgment. And since Typical Beauty in art concerns "that external quality of bodies . . . which, whether it occur in a stone, flower, beast, or in man, . . . may be shown to be in some sort typical of the Divine attributes" (IV, 64), then Ruskin's apprehension of phenomenological "beauty" in the painting is his Being-with its Typical Beauty, the formal expression of these three attributes of God's divine "Being." In particular, when Ruskin sees "the river of the wrath of God, roaring down into the gulf," when he sees "the bones gather and the clay heaps heave," and when he sees souls separate into two groups, some "borne up, wingless, by their inward faith" and others "now hurled in countless drifts of horror before the breath of their condemnation" (IV, 277), then Ruskin knows that each of these scenes implies a different attribute of God's "Being," His wrath against sin, His power to resurrect human souls, and His justice in rewarding or punishing them with salvation or damnation.

Ruskin's commentary on *The Last Judgment,* a result of Penetrative Imagination, essentially completes the aesthetic of *Modern Painters II.* Throughout both *Modern Painters I* and *II,* then, the eclectic relationships between his theory as well as criticism of art and the tradition of English aesthetics often involves him in inconsistencies. And, as we have seen, phenomenological interpretation of Ruskin's theories and criticisms can eliminate these inconsistencies—but, admittedly, with them the relations between his thought and the tradition.

The prose style of *Modern Painters I* and *II,* like their aesthetic, is essentially eclectic with respect to the traditions of style in English prose, involves similar problems, and admits of similar phenomenological resolution of them.

Tradition and the Style of *Modern Painters I and II*

In general, John Ruskin's style in *Modern Painters I* and *II* is essentially eclectic, being primarily both Neo-classical and Romantic. Although single passages do not often mix these two styles, nevertheless different passages usually employ either one or the other. Thus, the eclectic character of Ruskin's style in these works makes it difficult to speak of a Victorian prose style in them. Similarly, according to George Levine and William Madden in the

"Introduction" to *The Art of Victorian Prose:* "as Mr. Merritt's essay [in this volume] demonstrates, the Victorian sage produced an extraordinary variety of important nonfiction and of styles, so that one cannot talk usefully, even in a shorthand way, about a Victorian style."[34]

And the eclecticism of Ruskin's style raises a problem that can be explained with the perspective on subjective and objective styles presented by Marjorie Boulton in *The Anatomy of Prose* (1954):

> When we examine a style we are helped by a realization of how far it is objective or subjective, and it is often necessary to think hard about this. *Objective* in the sense, "looking at what is seen and not letting personal feelings come into the picture" and *subjective* in the sense, "from the point of view of the observer, coloured by personal feelings" are critical terms that have developed much later than the terms of rhetoric and comparatively late in literary history altogether
> A book describing scientific experiments is, or should be, almost completely objective. It [sic] we wish to imagine pure objectivity we may think of a proof of geometry. An autobiography is expected to be fairly subjective. Most argumentative prose and fiction will stand somewhere between these two.[35]

Here, Boulton indicates that an objective style is concerned, for example, with visual aspects of an entity and with its meaning, apart from experiences and characteristics of the writer himself. Subjective style, on the other hand, expresses the writer: his characteristics, his personal feelings and thoughts, and so on.

Understood according to this perspective on prose style, the style of *Modern Painters I* and *II* shows a conflict between Neo-classical elements that are objective and Romantic ones that are primarily subjective. Concerned with the meaning of landscape painting, apart from Ruskin's personal responses to it, the Neo-classical style of his antithetical statement on the Idea of Truth (for instance) is objective. But, expressing his responses to, his thoughts and feelings about, *The Slave Ship* (for example), the Romantic style of his commentary on this painting is subjective. In this sense, the style of volume one *as* a whole is inconsistent.

Presented in "The Origin of the Work of Art" and in "Building-Dwelling-Thinking," Heidegger's phenomenological approach to prose style can eliminate this inconsistency. Admittedly, however, interpretation according to this approach also eliminates any relation between Ruskin's early style and the traditions of style in English prose, because they include (albeit implicitly) the distinction between subjective and objective styles but the phenomenological approach eliminates it. Thus, the antithetical style of his statement on Truth is not Neo-classical and objective but phenomenological; style shows what his consciousness is *directed toward* with respect to landscape painting in general. And the expressive style of his art criticism on *The Slave Ship* is not Romantic and subjective, but is also phenomenological; style here shows what

he is aware *of* in the work—a visual representation of a ship on the sea and an expression of *Turner's* thoughts and feelings about the scene.[36]

In general, the antithetical constructions characterizing Ruskin's statement on the Idea of Truth constitute his first significant use of Neo-classical prose style in *Modern Painters I.* And in particular, these constructions exemplify an aspect of Samuel Johnson's prose style, the use of antithesis. Ruskin's early prose, according to Oliver Elton's *A Survey of English Literature, 1830-1880,* often employs Johnsonian balance and antithesis, which contribute to structure and coherence in his prose.[37]

First, the structure and coherence of Ruskin's comparison of Imitation with Truth is enhanced by Johnsonian antithesis. In this comparison, Ruskin employs what Wimsatt, in *The Prose Style of Samuel Johnson,* calls "antithesis II," which makes a distinction in order to affirm one part and deny the other."[38] This type of antithesis can make "a negative implication" by means of comparison.[39] And, according to Wimsatt's semantic perspective on prose, the elaboration of basic meaning expressed by rhetorical devices, including antithesis, is style. Ruskin, employing "antithesis II," compares mere duplication of nature with accurate representation of it and expression of the painter's feelings and thoughts about it: "First,—Imitation can only be of the qualities of material things, and of [his] emotions, impressions and thoughts" (III, 104). This antithetical construction, contrasting Imitation with Truth, implicitly denies the former and affirms the latter as a standard for the landscape painting. And this implicit elaboration of Ruskin's central meaning, concerning the fundamental difference between Imitation and Truth, constitutes the style of his statement.

Second, Ruskin employs another type of Johnsonian antithesis, which contributes to structure and coherence in his statement on Truth itself. He employs what Wimsatt calls "antithesis I," which can affirm contrary ideas "in the same respect."[40] Ruskin affirms both representation of nature and expression of the painter with respect to the Idea of Truth: "Truth has reference to statements both of the qualities of material things, / and of [his] emotions, impressions, and thoughts. There is a moral / as well as material truth . . ." (III, 104). The basic meaning of this statement concerns representation and expression in the landscape work. Ruskin's antithetical phrasing elaborates this meaning by suggesting that representation and expression not only intensely contrast but also combine, thereby establishing a coherent unity in the work, its Truth. And this elaboration of meaning, in Wimsatt's perspective, is the style of Ruskin's statement on the Idea of Truth in landscape art.

In these ways, then, the antithetical constructions in Ruskin's statements about Imitation and Truth are characteristic of the practice of Samuel Johnson, who, according to Ian A. Gordon in *The Movement of English*

Prose, often relied on "antithesis of words and clauses."[41] And, if understood in Marjorie Boulton's perspective on objective style, concerned with the meaningful object itself, apart from the writer's personal responses to it, Ruskin's antithetical style is essentially objective, because it is implicitly concerned with the significance of Truth in landscape art, not with his reactions to it.

Not described semantically but interpreted with Heidegger's approach to style, Ruskin's antithetical style is not objective but phenomenological. It shows what he is aware of in the landscape work—its Truth. Heidegger, in "The Origin of the Work of Art," maintains that "truth" in art is the observer's—i.e. the writer's—consciousness of, his Being-with, the complementary contrast between visual form and aesthetic meaning, "earth" and "world." Similarly, prose style as "language" is about this "conflict" of "truth" in the work. Consequently, style shows how he is aware of it and what he apprehends in it. That is, style indicates his visual and mental apprehension of "truth" in the work of art: its essential nature, the complementary contrast between and unity of a formal "earth" and a meaningful "world."

In Ruskin's statement, then, an antithesis of words shows that either visually or mentally, either with "the mind / or senses," he apprehends Truth in landscape art (III, 104). Here, antithesis implies that these two modes not only contrast but also combine into a visual *and* mental one. Then an antithesis of phrases elaborates both the manner and the substance of this apprehension, an apprehension of "statements both of the qualities of material things, / and of [the artist's] emotions, impressions, and thoughts" about them (III, 104). This antithesis suggests that Ruskin *intensely* apprehends the *sharp* contrast (or "conflict") between a visual form (an "earth") representing nature and an expressed meaning (a "world") concerning the painter's feelings and thoughts about it. Ruskin continues: "There is a moral / as well as material Truth,—a truth of impression / as well as of form,—of thought / as well as of matter . . ."(III, 104). The phrasal antitheses in this statement suggest Ruskin's apprehension that meaning (constituted by the painter's moral views, impressions, and thoughts) needs a referent in form, that form (representing nature) needs to have significance, and that form and meaning thus complement and complete each other, thereby establishing the essential nature, the "truth," of the landscape painting, its Idea of Truth.

From his characterization of the Idea of Truth, Ruskin, near the end of *Modern Painters I,* moves to a commentary on J. M. W. Turner's *The Slave Ship.*

Lamb and Hazlitt were the first practitioners of such commentary (art criticism).[42] But, according to Quentin Bell in *Ruskin* (1963), "Ruskin was the first Englishman to make of art criticism a major prose form," having painting

as its primary theme.[43] His commentary on *The Slave Ship* is representative of this genre. And the prose style of this commentary is Romantic. Although Ian A. Gordon maintains "that the criteria by which one may judge romantic prose are still not easy to determine,"[44] nevertheless there are several guidelines which can establish the Romantic orientation of Ruskin's style.

The "General Introduction" to Kenneth and Miriam Allott's *Victorian Prose, 1830-1880* mentions three such guidelines: "The underlying unity of Victorian prose seems to be largely constituted by its Romantic elements. Prominent among these are the three characteristics of Victorian prose which I have already promised to discuss—unevenness, seriousness of tone, concreteness and particularity."[45] The last Romantic characteristic, "concreteness and particularity," is evident throughout Ruskin's art criticism of *The Slave Ship*. Correspondently, the art critic, G. R. Stange asserts, "tends to avoid the abstract in favor of the immediate"[46] And, according to Stange's perspective on art criticism, the critic does so in order to describe his visual experience of the work. Similarly, describing his visual perceptions of *The Slave Ship*, Ruskin's Romantic commentary on it is both particular and concrete:

> It is a *sunset* on the *Atlantic*, after prolonged storm; but the *storm* is partially lulled, and the torn and streaming *rain-clouds* are moving in scarlet *lines* to lose themselves in the *hollow* of the *night*. The whole *surface* of the *sea* included in the picture is divided into two *ridges* of enormous *swell*[italics mine] (III, 571)

Art criticism, Stange explains, not only describes the writer's visual perceptions of art but also expresses his responses to it; that is, the stylistic emphasis is "on the representation of particular aesthetic as well as emotional experiences." Furthermore, the writer's going beyond description of the artifact by expressing his emotional and aesthetic experiences of it, is a central characteristic of Romantic literature.[47] Ruskin goes beyond simple description of visual forms in *The Slave Ship* by having them suggest his responses to, his feelings and thoughts about it. In this way, imagery, especially that describing the ship on the sea, becomes symbolic. And in this sense, the style of his commentary is Romantic. For instance,

> . . . the lurid shadows of the hollow breakers are cast upon the mist of night . . . , advancing like the shadow of death upon the guilty ship as it labours amidst the lightning of the sea, its thin masts written upon the sky in lines of blood, girded with condemnation in that fearful hue which signs the sky with horror (III, 572)

Here, the image of "the lurid shadows of the hollow breakers" is symbolic, expressing Ruskin's horror at the agony and death of the slaves, cast from the

ship. And the symbol of "the mist ... , advancing . . . upon the guilty ship," expresses his thought about impending divine retribution against their murderers.

Understood according to Boulton's perspective on subjective style as expressive of the writer, these Romantic aspects of Ruskin's style are subjective, because they symbolically express his personal responses to *The Slave Ship*, his feelings and thoughts about it. Consequently, this symbolic style is inconsistent not only with Ruskin's objective (albeit also Romantic) description of *visual* aspects of the painting but also with the objective, Neo-classical style of his statement on Truth, a style concerned with representation and expression in art, apart from his personal reactions to it.

Understood from Heidegger's perspective, however, the descriptive and symbolically expressive aspects of style in Ruskin's commentary are not (respectively) objective and subjective, but instead are consistently phenomenological. They show how he is aware of and what he apprehends in the painting—an Idea of Truth. And in this sense, his style is consistent with the phenomenological style of his statement on Truth itself. Interpreted phenomenologically, antitheses elaborate his apprehension of representational form and expressed meaning in landscape art.

In the essay "Building-Dwelling-Thinking," Martin Heidegger explains phenomenological prose style as "language." Style refers to the form and the meaning of the art work, both constituting its "World," apprehended by the writer's consciousness. Since both style and consciousness thus have the same referent, the "World" of the work, in effect, style shows what the writer is aware of in the work and how he apprehends it. In particular, style describes his visual perception of forms belonging to "earth" and "sky" (in a painting, for instance) and suggests his mental apprehension of its meanings concerning "divinities" and "mortals."

In Ruskin's commentary, concrete images describe his visual perceptions of the "earth" in *The Slave Ship*, its appearance, not of the ground but of the ocean. Here, he describes a visual aspect of representational Truth in the painting, an expanse of ocean with a huge swell on each side:

> The whole surface of the sea included in the picture is divided into two ridges of enormous swell, not high, nor local, but a low broad heaving of the whole ocean, like the lifting of its bosom by deep-drawn breath after the torture of the storm. (III, 571)

Particular and concrete imagery also depicts Ruskin's visual apprehension of another formal aspect of the painting, its "sky," including mist, dusk, and red light throughout:

> Purple and blue, the lurid shadows of the hollow breakers are cast upon the mist of night, which gathers cold and low, advancing like the shadow of death upon the guilty ship as it

labours amidst the lightning of the sea, its thin masts written upon the sky in lines of blood, girded with condemnation in that fearful hue which signs the sky with horror, and mixes its flaming flood with the sunlight, and, cast far along the desolate heave of the sepulchral waves, incarnadines the multitudinous sea. (III, 572)

In these ways, then, imagery describes Ruskin's visual perceptions of ocean and "sky" in *The Slave Ship* and thereby suggests that, with respect to representational Truth, the work is a "faithful statement, either to the mind or senses, of any fact of nature" (III, 104). And throughout his commentary, rhetorical figures suggest his apprehension of the second element of Truth in the painting, its meaning concerning "statements . . . of [the painter's] emotions, impressions, and thoughts" about the scene (III, 104).

This meaning concerns the phenomenological significance of "divinities" and of "mortals"—capable of death as non-existence. Ruskin employs metaphor (for example) in order to indicate his apprehension of Turner's thoughts about the "mortals" on the ship who murdered the slaves. In particular, the image of the "ship as it labours amidst the lightning of the sea, its thin masts written upon the sky in lines of blood," metaphorically identifies the masts with "lines of blood" and thereby suggests Ruskin's apprehension of Turner's thought about the moral guilt of the murderers. The symbolic image of "the mist of night," which advances "upon the . . . ship," implies Ruskin's mental apprehension of the painter's thought concerning divine condemnation of and possible retribution against the murderers. And the symbol of "that fearful hue which signs the sky with horror, and mixes its flaming flood with the sunlight, and, cast far along the desolate heave of the sepulchral waves, incarnadines the multitudinous sea," implies Ruskin's emotional awareness of Turner's horror and revulsion at this possibility, signifying that the murderers are damned and portending their violent death.

Finally, commenting explicitly on the Truth of *The Slave Ship,* Ruskin asserts:

Its daring conception, ideal in the highest sense of the word, is based on the purest truth . . . ; its drawing [is] as accurate as fearless; . . . and the whole picture dedicated to the most sublime of subjects and impressions . . . the power, majesty, and deathfulness of the open, deep, illimitable sea. (III, 572-73)

Here, employing parallel clauses accelerated by ellipsis and then cadenced by a rough but perceptible meter, in "the power, majesty, and deathfulness / of the open, deep, illimitable sea," Ruskin suggests his apprehension of a harmony in the "World" of the painting between representational form and expressed meaning, between "drawing as accurate as fearless" and Turner's impression of "the power, majesty, and deathfulness" of the sea, that is, between the two aspects of Truth as "statements both of the qualities of material things, and of [his] emotions, impressions, and thoughts" (III, 104).

In *Modern Painters I,* we have seen, the style of Ruskin's general statement on Truth in landscape art is based on antithesis; and, in volume two, that of his general summary of Typical and Vital Beauty in painting is based on parallelism.

One way "of attaining generalization," Wimsatt explains, is through parallelism.[48] Constituted by a "series of connected meanings," parallelism can be indicated by "conjunctive or disjunctive words," by syntax, and by repetition of initial words.[49] And, according to Ian A. Gordon, Samuel Johnson's Neo-classical prose, in addition to antithesis, relies on "parallelism of words and phrases."[50] Ruskin's summary of the qualities of Beauty indicates Johnsonian parallelism with the devices described by Wimsatt. The fundamental meaning of this summary concerns expression, by the work, of the painter's conscience, his belief in the Divine, his happiness from plants and animals, and his view of their ordered functions. All of these expressions, constituting Beauty, have a religious quality; that is, "in all cases it [i.e. Beauty] is something Divine . . ." (IV, 210). Ruskin elaborates this meaning with parallelism, indicated by the disjunctives "either . . . or, " sequences of identical clauses and phrases, and repetition of the initial words "it" and "the":

> *It* [i.e. Beauty] is *either* the record of conscience, written in things external, / *or it* is a symbolizing of Divine attributes in matter, / *or it* is the felicity of living things, / *or* the perfect fulfillment of their duties and functions. In all cases *it* is something Divine; *either* the approving voice of God, / *the* glorious symbol of Him, / *the* evidence of His kind presence, / *or the* obedience to His will by Him induced and supported. (IV, 210)

Here, both sentences employ anaphora, disjunction, and a parallel syntax, of clauses in the first and of phrases in the second. The correspondence between the two elaborates their fundamental meaning, concerning Beauty: the expression, by art, of the painter and of his belief in the Divine. This correspondence suggests that the elements of the first sentence are complemented by respective elements of the second. That is, parallelism suggests that the work expresses personal aspects of the artist and thereby corresponding aspects of his religious belief. In particular, the work expresses his conscience and thereby his belief in God's "approving voice," his apprehension of "Divine attributes" and thereby his belief in nature as a "symbol of Him," his happiness from "living things" and thereby his belief in God's natural presence, and his thought about their "perfect fulfilment of" duty and function and thereby his belief in their "obedience to His will by Him induced and supported."

In these ways, Ruskin's Johnsonian parallelism, based on disjunction, syntax, and anaphora, elaborates the basic significance of his summary of the qualities of Beauty in art. Understood in Wimsatt's semantic perspective on style as the furthest extension of central meaning in the prose text, Ruskin's

elaboration constitutes the style of his statement on Beauty. And, understood in Boulton's perspective on objective style, concerned with the meaning of something apart from the author's personal responses to it, the style of, and the elaborated meaning in, Ruskin's statement are objective, because he is concerned not with his own but instead with the painter's emotions, thoughts, and religious beliefs, all expressed by the work.

Interpreted phenomenologically with the approach to style presented by "The Origin of the Work of Art," Ruskin's parallel style is not an objective expression of meaning about Beauty in painting, but instead shows what he is aware *of* in it and, in this sense, is phenomenological. Prose style as "language," Heidegger explains, can indicate the writer's consciousness of, or Being-with, the art work's "world," its emotive or conceptual meaning, expressed by its form, or "earth."

Phenomenologically, Ruskin's summary of the qualities of Beauty concerns his apprehension of form as an expression of a meaningful "world," including the artist's thoughts, feelings, and beliefs, all *as* divine, i.e. religious. Ruskin elaborates this apprehension with parallelism first based on successive independent clauses, then on successive noun phrases, and throughout on the disjunctive pattern "either . . . or," Ruskin suggests his apprehension of each personal expression of the painter *as* an expression of a particular aspect of his religious belief. In particular, these aspects of parallelism suggest that Ruskin apprehends the painter's conscience as an indication of belief in "the approving voice of God," his experience of "a symbolizing of Divine attributes in matter" as a reflection of belief in a natural Divinity, his joy in "living things" as an instance of belief in God's "kind presence," and his satisfaction in "the perfect fulfilment of their duties and functions" as a reflection of belief in their obedience to divine will. Finally, throughout Ruskin's statement on Beauty, anaphora—in particular, repetition of the initial words "it" and "the"—suggests his apprehension of harmony and congruence among all these expressions of the painter's emotion, thought, and belief, which constitute the phenomenological significance, the "world," of the painting.

Following his aesthetic of Typical and Vital Beauty, Ruskin presents theories of Associative Imagination and of Penetrative Imagination, both of which can create Beauty in art. Finally, he exemplifies the results of Penetrative Imagination in *The Last Judgment,* by Tintoretto.

Described with John D. Rosenberg's approach to Ruskin's early style "as the incarnation of sensibility," as "the unique voice of the writer, the felt presence that hovers over his pages and intones its way into our consciousness,"[51] the prose style of Ruskin's commentary on *The Last Judgment* expresses his divided religious sensibility. And since, according to Ian Gordon, Romantic "prose continually asserts . . . [the writer's] personal

individuality, his uniqueness . . . ,"[52] consequently Ruskin's style, expressing an aspect of his personality, his sensibility, is Romantic. In particular, the image of the saved (for example) "now soaring up slowly, and higher and higher still, till the eye and the thought can follow no farther" (IV, 277) symbolizes Ruskin's predilection to hope for and anticipate his own salvation. But the symbol of the damned, who are "now hurled in countless drifts of horror before the breath of their condemnation" (IV, 277), expresses his proclivity to fear and exaggerate the possible alternative, his own damnation. Thus, expressing Ruskin's religious sensibility, divided between hope and fear, his symbolic style is Romantic.

And as expressive of Ruskin's personality in these ways, the Romantic style of his commentary is, in Boulton's perspective, subjective and hence inconsistent with the objective, Neo-classical style of his summary on Beauty, a style concerned with the meaning of painting apart from Ruskin's responses to it, with its expression of the artist's feeling, thought, and belief. But, interpreted phenomenologically, the style of this summary and that of Ruskin's commentary are consistent with each other, because both detail his apprehensions *of* painting. The former elaborates his apprehension of Beauty as an expression, by the work, of the artist's emotional, conceptual, and religious experience. And the latter elaborates his apprehensions of *The Last Judgment* as a result of Tintoretto's Penetrative Imagination.

This style, interpreted with the approach presented by Heidegger in "Building-Dwelling-Thinking," indicates Ruskin's visual and mental apprehension of the fourfold "World" of the painting, including its visual forms of "earth" and "sky" and its meanings of "divinities" and "mortals." In other words, style describes his mental apprehension of the meaning expressed by this form, a meaning concerning Tintoretto's "penetrative" insights "into the TRUE nature of the thing represented" (IV, 278).

A specific, concrete style represents Ruskin's visual perception of the contrasting forms of "earth" and "sky" in the painting.

He represents his visual perception of the ground and of human souls emerging from it with specific, concrete imagery, alliteration on "c," and metaphors concerned with decay:

> Bat-like, out of the holes and *c*averns and shadows of the earth, the bones gather and the *c*lay *heaps* heave, rattling and adhering into *half-kneaded anatomies,* that *c*rawl, and startle, and struggle up among the putrid weeds, with the *c*lay *c*linging to their *c*lotted hair, and their heavy eyes sealed by the earth darkness yet [italics mine] (IV, 277)

Here, alliteration on "c" suggests Ruskin's visual awareness of the contorted postures assumed by the dead as they struggle free from the earth. And the metaphor implicitly comparing them to "half-kneaded anatomies" suggests his visual apprehension of indistinct, undefined human forms.

Metaphor also elaborates his perception of souls floating in the "sky" of *The Last Judgment:* "The Firmament is all full of them, a *very dust* of human souls, that drifts, and floats, and falls in the interminable, inevitable light . . ." (IV, 277). (Italics mine.) Here, the metaphorical comparison between dust clouds blowing in the atmosphere and human souls floating in the air suggests Ruskin's visual perception of them as mere distant specks.

Furthermore, the concatenated verbal structure in this description of "earth" and "sky" implies that, when seeing their forms, Ruskin imagines a corresponding sequence of events, experienced by the resurrected dead as they rise "to the judgment-seat" and then separate, some ascending into heaven, others descending into hell.

Concluding his art criticism of *The Last Judgment* (as well as other paintings by Tintoretto), Ruskin asserts that "while we are always placed face to face with whatever is to be told, there is in and beyond its reality a voice supernatural . . ." (IV, 278). That is, seeing the forms of the painting, Ruskin apprehends their underlying significance, an expression of Tintoretto's insight "into the TRUE nature of the" represented scene—into the significance of "divinities" and of "mortals." According to Ruskin,

> . . . the Firmament is all full of them, a very dust of human souls, that drifts, and floats, and falls in the interminable, inevitable light; the bright clouds are darkened with them as with thick snow, currents of atom life in the arteries of heaven, now soaring up slowly, and higher and higher still, till the eye and the thought can follow no farther, borne up, wingless, by their inward faith and by the angel powers invisible, now hurled in countless drifts of horror before the breath of their condemnation. (IV, 277)

Here, the initial metaphor, comparing human souls to clouds of dust, indicates Ruskin's mental apprehension of a meaning of "mortals." This significance concerns the painter's insight into their essential mortality; they were doomed to non-existence without the animated power of the Divine and exist by means of this power before and after the judgment itself.

And Ruskin concludes with a comprehensive symbol, depicting (on one hand) the saved, "now soaring up slowly, . . . till the eye and the thought can follow no farther," and (on the other) the damned, "now hurled in countless drifts of horror before the breath of their condemnation." This symbol suggests Ruskin's apprehension of the dual significance of "mortals" and also of "divinities." Comprehending the central significance of "mortals" in *The Last Judgment,* Ruskin apprehends the painter's insight into the hope and joy of the saved and into the hopelessness and despair of the damned. And, understanding the central significance of "divinities" in the painting, Ruskin is mentally aware of Tintoretto's imaginative view of the power of the Divine over the spiritual destiny of man: a power to save the good, the faithful, and to damn the evil, the unfaithful. Since this twofold capacity, the power to save

and to condemn, is an attribute of the Divinity, apprehended by Tintoretto's Penetrative Imagination and embodied into the work, then this symbol implies Ruskin's phenomenological apprehension of an aspect of Typical Beauty, which concerns "that external quality" present "in a stone, flower, beast, or . . . man . . . , which . . . may be shown to be in some sort typical of the Divine attributes" (IV, 64).

Concluding Remarks

In general, then, the phenomenological aesthetic and style of *Modern Painters I* and *II* are primarily concerned, in different ways, with how Ruskin apprehends painting and what he apprehends in it. Aesthetic theory explains and prose style implicitly elaborates his apprehensions of Truth in landscape painting in general as well as in particular works by Turner, and of Beauty in painting as well as in works by Tintoretto. In these ways, the aesthetic and the style of *Modern Painters I* and *II* are concerned with Ruskin's phenomenological developments of the Lockean "idea," defined by the *Oxford Dictionary* as "whatever is in the mind and directly present to cognitive consciousness."[53]

Notes

Chapter 1

1. John Ruskin, *The Works of John Ruskin,* ed. E.T. Cook and Alexander Wedderburn, Library Edition, 39 vols. (London, 1903-1912), III and IV (1903), V and VI (1904), and VII (1905). Throughout this study all references to *Modern Painters I* and *II* (i.e. volumes III and IV in the Library Edition) and to the remaining volumes of *Modern Painters* will be enclosed with parentheses in the text.

2. Ruskin, "Original Advertisement, "*Modern Painters II.*

3. John D. Rosenberg, ed., *The Genius of John Ruskin: Selections from His Writings* (1963; reprint ed., Boston, 1965), pp. 17-18.

4. Van Akin Burd, "Background to *Modern Painters:* The Tradition and the Turner Controversy," *PMLA* 74 (1959): 262.

5. George P. Landow, *The Aesthetic and Critical Theories of John Ruskin* (Princeton, 1971), p. 24.

6. Graham Hough, *The Last Romantics* (1947; London: reprint ed., Barnes & Noble, 1961), p. 6.

7 I capitalize the major terms of Ruskin's aesthetic categories throughout this study in order to avoid ambiguity when referring to them and in order to remain consistent with his usual practice in *Modern Painters I* and *II.*

8. R.H. Wilenski, *John Ruskin: An Introduction to Further Study of His Life and Work* (London: Faber & Faber, 1933), p. 212.

9. Derrick Leon, *Ruskin: The Great Victorian* (London: Routledge & Kegan Paul, 1949), pp. 77-78.

10. Joan Evans, *John Ruskin* (London: Oxford University Press, 1954), pp. 93,98.

11. Jean Autret, *Ruskin and the French Before Marcel Proust* (Genève: Librairie Droz, 1965), pp. 13-17.

12. E.T. Cook, *Studies in Ruskin: Some Aspects of the Work and Teaching of John Ruskin* (1891; reprint ed., Port Washington, N.Y.: The Kennikat Press, 1972) pp. 11-12, 18-19.

13. W.G. Collingwood, *The Art Teaching of John Ruskin* (London: Percival, 1891), pp. 48, 77-78.

14. Frank D. Curtin, "Ruskin in French Criticism: A Possible Reappraisal," *PMLA* 77 (1962): 107-108.

15. Patricia M. Ball, *The Science of Aspects: The Changing Role of Fact in the Work of Coleridge, Ruskin and Hopkins* (London: The Athlone Press, 1971), p. 74.

16. Henry Ladd, *The Victorian Morality of Art: An Analysis of Ruskin's Aesthetic* (New York: R. Long & R.R. Smith, 1932), pp. 225, 337.

17. Landow, pp. 113-4.

18. Ibid., pp. 178-79.

19. Herbert Spiegelberg, *The Phenomenological Movement: A Historical Introduction* (The Hague: M. Nijhoff, 1960), I, 73.

20. Ibid., pp. 5-6.

21. Ibid., p. 107.

22. Ibid.

23. Martin Heidegger, "The Origin of the Work of Art," in *Poetry, Language, Thought*, by Martin Heidegger, trans. and ed. Albert Hofstadter (New York: Harper & Row, 1971), p. 63. Throughout this study, the major terms of Heidegger's theories of art and of style in this and in other essays will be enclosed with quotation marks in order to avoid ambiguity: thus "earth," "world," and so on.

24. John D. Rosenberg, "Style and Sensibility in Ruskin's Prose," in *The Art of Victorian Prose*, ed. George Levine and William Madden (New York: Columbia University Press, 1968), p. 179.

25. G. Robert Stange, "Art Criticism as a Prose Genre," in *The Art of Victorian Prose*, pp. 39-40.

26. William A. Gerhard and Brijen K. Gupta, "Literature: The Phenomenological Art," *Man and World* 3, No. 2 (1970): 105.

Chapter 2

1. This four part division of aesthetic theories is derived from M.H. Abrams' *The Mirror and the Lamp: Romantic Theory and the Critical Tradition* (1953; reprint ed., New York, 1958), pp. 6-29. Abrams presents four co-ordinates for aesthetic theories: the work, the universe, the artist, and the audience. From these he derives four major types of aesthetic theory. The mimetic theory views the work as "an imitation of aspects of the universe." The pragmatic theory views the work in terms of its effect on an audience. The expressive theory concerns art as an expression of the artist. And the objective theory considers the work itself as an autonomous entity. Throughout my evaluation of aesthetic theories in their relevance for interpretation of Ruskin's early aesthetic, I have classified and organized them according to these four types.

2. Monroe C. Beardsley, *Aesthetics From Classical Greece to the Present: A Short History* (New York: Macmillan, 1966), pp. 78-87.

3. Ibid., p. 86.

4. Ibid., p. 81.

5. Ibid., pp. 148-49.

6. Henry Ladd, *The Victorian Morality of Art: An Analysis of Ruskin's Aesthetic* (New York,: R. Long & R.R. Smith, 1932), p. 29.

7. Van Akin Burd, "Background to *Modern Painters:* The Tradition and the Turner Controversy," *PMLA* 74 (1959): 254.

8. George P. Landow, *The Aesthetic and Critical Theories of John Ruskin* (Princeton, 1971), p. 51.

9. Burd, p. 254.

10. Beardsley, pp. 185-87.

11. Ibid., p. 196.

12. M.H. Abrams, *The Mirror and the Lamp: Romantic Theory and the Critical Tradition* (1953; reprint ed., New York: W.W. Norton, 1958) pp. 21-22.

13. Ibid., p. 22.

14. Ibid., p. 21.

15. Ibid., pp. 122-23.

16. Ibid., p. 119.

17. Ibid., p. 21.

18. Ibid., p. 27.

19. Frank D. Curtin, "Ruskin in French Criticism: A Possible Reappraisal," *PMLA* 77 (1962): 107-8.

20. W.G. Collingwood, *The Art Teaching of John Ruskin* (London: Percival, 1891), pp. 70, 77-78.

21. Ibid.

22. Ibid., pp. 77-78.

23. Ibid., pp. 48, 57, 62, 66.

24. Ibid., p. 133.

25. Francis G. Townsend, *Ruskin and the Landscape Feeling: A Critical Analysis of His Thought During the Crucial Years of His Life, 1843-56,* Illinois Studies in Language and Literature., 35, No. 3 (Urbana, Ill.: University of Illinois Press), p. 15.

26. Ibid., p. 24.

27. Ibid., p. 35.

28. Ladd, p. 225.

29. Solomon Fishman, *The Interpretation of Art: Essays on the Art Criticism of John Ruskin, Walter Pater, Clive Bell, Roger Fry, and Herbert Read* (Berkeley: University of California Press, 1963), pp. 21-22.

30. Ibid.

31. Landow, pp. 113-14.

32. Ibid., p. 114.

33. Landow, p. 178.

34. Ibid., p. 179.

35. Ibid.

36. Ibid., p. 112.

37. John D. Rosenberg, *The Darkening Glass: A Portait of Ruskin's Genius* (New York: Columbia University Press, 1961), p. 5.

38. John D. Rosenberg, "The Geopoetry of John Ruskin," *Etudes Anglaises* 22 (1969): 44.

39. Martin Heidegger, "The Origin of the Work of Art," in *Poetry, Language, Thought,* ed. and trans. Albert Hofstadter (New York: Harper & Row, 1971), p. 17.

40. Hans Jaeger, "Heidegger and the Work of Art," *Journal of Aesthetics and Art Criticism* 17 (1958/59): 58-59.

41. Heidegger, "Work of Art," p. 31.

42. Ibid., pp. 33-34.

43. Jaeger, p. 61.

44. Heidegger, "Work of Art," p. 42.

45. Jaeger, p. 64.

46. William H. Bossart, "Heidegger's Theory of Art," *Journal of Aesthetics and Art Criticism* 27 (1968/69): 63.

47. Heidegger, "Work of Art," p. 78.

48. Herbert Spiegelberg, *The Phenomenological Movement: A Historical Introduction* (The Hague,: M. Nijhof, 1960), II, 658-59.

49. Ibid., p. 659.

50. Spiegelberg, I, 107-108.

51. Ibid., II, 659.

52. Ibid.

53. Ibid., I, 348-49.

54. Ibid., pp. 324-25.

55. W.B. Macomber, *The Anatomy of Disillusion: Martin Heidegger's Notion of Truth* (Evanston, Ill.: Northwestern University Press, 1967), p. 30.

56. William J. Richardson, *Heidegger: Through Phenomenology to Thought,* 2nd ed. (The Hague: M. Nijhoff, 1967), p. 408.

57. Algis Mickunas, "Heidegger's Origin of the Artwork and the End of Esthetics" (an unpublished paper written in 1970 at Ohio University), pp. 13-14.

58. Heidegger, "Work of Art," p. 39.

59. Ibid., p. 55.

60. Mickunas, pp. 21-22.

61. The assertion that Ruskin apprehends Truth in the landscape painting does not refer to the historical author Ruskin but instead to the author implicit in *Modern Painters I* and *II*—the speaker. The same reference will be used throughout this study in order to avoid the intentional fallacy.

62. Heidegger, "Work of Art," p. 63.

63. S.L. Bartky, "Heidegger's Philosophy of Art," *British Journal of Aesthetics* 9 (1969): 360.

64. Heidegger, "Work of Art," p. 63.

65. Lambert van de Water, "The Work of Art, Man, and Being: A Heideggerian Theme," *International Philosophical Quarterly* 9 (1969): 219.

66. Mickunas, pp. 19-20.

67. Heidegger, "Work of Art," p. 67.

68. Ibid., p. 62.

69. Mickunas, pp. 25, 27.

70. Ibid., pp. 30-32.

71. Ibid., pp. 30-32.

72. Martin Heidegger, *Being and Time,* trans. John Macquarrie and Edward Robinson (New York: Harper & Row, 1962), pp. 312-13.

73. Michael Gelven, *A Commentary on Heidegger's "Being and Time,"* (New York: Harper & Row, 1970), p. 170.

74. Heidegger, "Work of Art," p. 66.

75. Ibid., p. 77.

76. George J. Stack, "The Being of the Work of Art in Heidegger," *Philosophy Today* 13, No. 3/4 (1969): 166-67.

77. Heidegger, *Being and Time,* p. 401.

78. Gelven, pp. 191-92.

79. Similar to Heidegger's aesthetic is that of Maurice Merleau-Ponty, which, like Heidegger's, is founded on the concept of intentionality. Eugene F. Kaelin outlines this theory in *Art and Existence: A Phenomenological Aesthetics* (Lewisburg, Pa., 1970). According to Merleau-Ponty's phenomenological view of perception, man's organism physically intends (i.e. is aware *of*) objects in the world. This perceptual state is "prerational or nonreflective." Thus, man's world is "preobjectively constituted." Physical (e.g. visual) intentions are directed toward the preobjective world. With respect to art, the surface of painting (for instance) presents (i.e. causes) a tension similar in kind to that produced intentionally in man's organism through awareness of objects in the world. And, Kaelin explains,

 . . . within the content of an aesthetic theory, the nonreflective component of human experience represents our basic intuitive or prereflective intercourse with aesthetic stimuli. In reflecting upon these, that is, in an attempt to bring these experiences to fully conscious appreciation, we are led to the fullest heights of critical appreciation. (p. 318)

 Thus, the work of art achieves "the unity of the senses and the mind intending a single significant object" (p. 335).

 By placing the prereflective and the reflective elements of the art work on the one level of intentionality (respectively, visual and mental), Merleau-Ponty's aesthetic can implement a resolution of the basic inconsistency in Ruskin's early theory, between objective portrayal of nature, animals, or man in painting and subjective expression of the artist by it. In *Modern*

Painters I, for example, the Idea of Truth inconsistently combines objective representation of nature in landscape painting with subjective expression of the artist's feelings and thoughts by it. Or, in *Modern Painters II,* Typical Beauty has a conflict between objective portrayal of plants, animals, and man and their subjective expression of the artist's belief in "Divine attributes," informing both nature and man. Understood according to Merleau-Ponty's aesthetic, however, Ruskin's theories do not show this inconsistency. The Idea of Truth concerns his prerational, nonreflective perception *of* accurate representation in landscape painting and his reflective or mental apprehension *of* the painter's thoughts and feelings about the scene—expressed by it and constituting the meaning of the work. The inconsistency in the theory of Typical Beauty can be eliminated in a similar manner, which views the art work's portrayal of nature and man not as objective but as a preobjective correlate for the observer's visual consciousness and the work's expression of the painter's religious belief in the Divine not as subjective but as a reflective correlate for the observer Ruskin's mind.

Although Merleau-Ponty's theory can thus afford a consistent interpretation of Ruskin's early aesthetic, nevertheless the two theories have a significant difference, because the former concerns the process of raising, by means of reflection, prereflective aesthetic experience intended through the body-subject to conscious aesthetic appreciation, but the latter does not. That is, Ruskin is not concerned with the *general process* of raising aesthetic intentions from the visual to the cognitive level. Instead, he is concerned with the *specific aspects* of form and of expression in the painting. And consequently, concerned with the specifics of form and meaning, of "earth" and "world," in the work of art, Martin Heidegger's aesthetic theory is more appropriate than Merleau-Ponty's for interpretation of Ruskin's theory in *Modern Painters I* and *II.*

Chapter 3

1. Cicely Davis, "Ut Pictura Poesis," *Modern Language Review* 30 (1935): 160.

2. Martin Heidegger, "The Origin of the Work of Art," in *Poetry, Language, Thought,* ed. and trans. Albert Hofstadter (New York: Harper & Row, 1971), p. 74.

3. Henry Ladd, *The Victorian Morality of Art: An Analysis of Ruskin's Aesthetic* (New York: R. Long and R.R. Smith, 1932), pp. 36-37.

4. George J. Stack, "The Being of the Work of Art in Heidegger," *Philosophy Today* 13 (1969): 165-66.

5. Heidegger, "Work of Art," p. 74.

6. Solomon Fishman, *The Interpretation of Art: Essays on the Art Criticism of John Ruskin, Walter Pater, Clive Bell, Roger Fry, and Herbert Read* (Berkeley: University of California Press, 1963), p. 29.

7. Heidegger, "Work of Art," p. 55.

8. Ibid., pp. 53-54.

9. Ladd, p. 32.

10. Ibid., pp. 120, 124.

11. George P. Landow, *The Aesthetic and Critical Theories of John Ruskin* (Princeton, 1971), p. 112.

12. Ibid., pp. 113-14.

13. Francis G. Townsend, *Ruskin and the Landscape Feeling: A Critical Analysis of His Thought During the Crucial Years of His Life, 1843-56,* Illinois Studies in Language and Literature, 35, No. 3 (Urbana, Ill.: University of Illinois Press, 1951), p. 24.

14. Ibid., p. 35.

15. M.H. Abrams, *The Mirror and the Lamp: Romantic Theory and the Critical Tradition* (1953; reprint ed., New York: W.W. Norton, 1958), pp. 8-11.

16. Ibid., pp. v-vi.

17. Ibid., p. 22.

18. George P. Landow, "J.D. Harding and John Ruskin on Nature's Infinite Variety," *Journal of Aesthetics and Art Criticism* 28 (1969/70): 377.

19. Jerome H. Buckley, *The Victorian Temper: A Study in Literary Culture* (New York: Random House, 1951), pp. 154-56.

20. Fishman, pp. 21-22.

21. Buckley, pp. 153-54.

Chapter 4

1. R.G. Collingwood, *Essays in the Philosopy of Art,* ed. Alan Donagan (Bloomington: Indiana University Press, 1964), pp. 32-33.

2. Martin Heidegger, "The Origin of the Work of Art," in *Poetry, Language, Thought,* ed. and trans. Albert Hofstadter (New York: Harper & Row, 1971), p. 64.

3. S.L. Bartky, "Heidegger's Philosophy of Art," *British Journal of Aesthetics* 9 (1969): 360.

4. George P. Landow, "J.D. Harding and John Ruskin on Nature's Infinite Variety," *Journal of Aesthetics and Art Criticism* 28 (1969/70): 377.

5. René Wellek, *A History of Modern Criticism: 1750-1950; III, The Age of Transition* (1965; reprint ed., New Haven: Yale University Press, 1972), p. 140.

6. Heidegger, "Work of Art," p. 42.

7. Ibid.

8. Ibid.

9. Hans Jaeger, "Heidegger and the Work of Art," *Journal of Aesthetics and Art Criticism* 17 (1958/59): 64.

10. Heidegger, "Work of Art," p. 70.

11. Ibid.

12. Ibid., p. 42.

13. Ibid.

Chapter 5

1. Van Akin Burd, "Ruskin's Quest for a Theory of Imagination," *Modern Language Quarterly* 17 (1956), 60.

2. George P. Landow, *The Aesthetic and Critical Theories of John Ruskin,* (Princeton, 1971), p. 28.

3. J.R. Hale, *England and the Italian Renaissance: The Growth of Interest in Its History and Its Art* (London: Faber, 1954), p. 149.

4. Ibid., pp. 149-50.

5. Landow, p. 28.

6. Burd, p. 60.

7. Ibid., pp. 60, 66.

8. Ibid., p. 70. The quotations of Ruskin are from his 1845 notebook, *Works,* IV, xxxvi.

9. Ibid., p. 72.

10. In the "Preface" to the 1883 edition of *Modern Painters II,* Ruskin refers the reader to "the eighth number of *Deucalion"* for the reasons supporting his reprint of this volume, "after so often declaring that . . . [he] would reprint none of the book except the pieces relating to natural history" (IV, 3). And in the editor's introduction to this work, E.T. Cook explains Ruskin's decision. He excluded *Modern Painters II* "when contemplating a revised series of his Works in 1870-1871," because "he had outgrown its theological standpoint . . . ," "was ashamed of its sectarian narrowness," and "was displeased by its affectations of style." But eventually he did republish it (in 1883, for instance), in order to oppose the aestheticism in vogue and to vindicate (as he says in *Deucalion,* 1883) his faith " 'in the creating Spirit, as the source of Beauty' " (IV, xlvii-xlviii).

11. Henry A. Ladd, *The Victorian Morality of Art: An Analysis of Ruskin's Aesthetic* (New York: R. Long & R.R. Smith, 1932), pp. 36-37.

12. Martin Heidegger, "The Origin of the Work of Art," in *Poetry, Language, Thought,* ed. and trans. Albert Hofstadter (New York: Harper & Row, 1971), p. 79.

13. Ibid, p. 67.

14. Graham Hough, *The Last Romantics* (1947; reprint ed., New York: Barnes & Noble, 1961), p. 31.

15. Heidegger, "Work of Art," pp. 30-31.

16. Algis Mickunas, "Heidegger's Origin of the Artwork and the End of Esthetics" (an unpublished paper written in 1970 at Ohio University), p. 6.

17. Landow, p. 148.

18. Ibid., p. 178.

19. Ibid., p. 179.

20. Ibid., p. 117.

21. Ibid., p. 137.

22. Ibid., pp. 115-16.

23. Ibid., pp. 92-93.

24. Ibid., p. 146.

25. James C. Sherburne, *John Ruskin, or the Ambiguities of Abundance: A Study in Social and Economic Criticism* (Cambridge, Mass.: Harvard University Press, 1972), p. 4.

26.　M.H. Abrams, *Natural Supernaturalism: Tradition and Revolution in Romantic Literature* (New York: W.W. Norton, 1971) p. 99.

27.　Landow, p. 252.

28.　Ibid., p. 161.

29.　Ibid., p. 162.

Chapter 6

1.　George P. Landow, *The Aesthetic and Critical Theories of John Ruskin* (Princeton, 1971), p. 75.

2.　Ibid.

3.　Sister Mary Dorothea Goetz, *A Study of Ruskin's Concept of the Imagination*, Ph.D. diss., The Catholic University of America, 1947), p. ix.

4.　Martin Heidegger, "Origin of the Work of Art" in *Poetry, Language, Thought*, ed. and trans. Albert Hofstadter (New York: Harper & Row, 1971), p. 64.

5.　Hans Jaeger, "Heidegger and the Work of Art," *Journal of Aesthetics and Art Criticism* 17 (1958/59): 66.

6.　Heidegger, "Work of Art," p. 53.

7.　Ibid., pp. 77-78.

8.　Ibid.

9.　E.T. Cook, "Introduction," in *Modern Painters,* II, by John Ruskin, ed. E.T. Cook and Alexander Wedderburn (London, 1903), xlv-xlvi.

10.　Heidegger, "Work of Art," p. 43.

Chapter 7

1.　Seymour B. Chatman and Samuel R. Levin, "Linguistics and Literature," in *Current Trends in Linguistics, X: Linguistics in North America,* 2 vols., ed. Thomas A. Sebeok (The Hague: Mouton, 1973), pp. 275-76.

2.　Nils E. Enkvist, "On Defining Style," in *Linguistics and Style,* by Nils E. Enkvist, ed. John Spencer (London: Oxford University Press, 1964), p. 12.

3.　Chatman and Levin, p. 275.

4.　Enkvist, p. 12.

5.　Roger Fowler, "Linguistics, Stylistics; Criticism?" in *Contemporary Essays on Style: Rhetoric, Linguistics and Criticism,* ed. Glen A. Love and Michael Payne (Glenview, Ill.: Scott, Foresman, 1969), p. 173.

6.　Seymour B. Chatman, "On the Theory of Literary Style," *Linguistics* 27 (1966): 13.

7.　William K. Wimsatt, *The Prose Style of Samuel Johnson* (New Haven: Yale University Press, 1941), p. 11.

8.　Ibid., p. 12.

9. Monroe C. Beardsley, *Aesthetics: Problems in the Philosophy of Criticism* (New York: Macmillan, 1958), pp. 221-22, 225.

10. Ibid., pp. 122-23.

11. Ibid., p. 117.

12. Ibid., pp. 222-24.

13. Monroe C. Beardsley, "Style and Good Style," in *Contempoary Essays on Style*, ed. Love and Payne (Glenview, Ill.: Scott Foresman, 1969), p. 7.

14. Seymour B. Chatman, "On the Theory of Literary Style," *Linguistics*, 27 (1966): 13-25; and "The Semantics of Style," *Social Science Information* 6 (1967): 77-99.

15. Chatman, "On the Theory of Literary Style," p. 18.

16. Chatman, "The Semantics of Style," p. 96.

17. Ibid., p. 91.

18. This reference to the author as the speaker in the work is intended to avoid the intentional fallacy, the speculation that intentions of the *historical* author are evident in his work. Wimsatt and Beardsley explain this fallacy in "The Intentional Fallacy," *The Verbal Icon: Studies in the Meaning of Poetry*, by W.K. Wimsatt, Jr. and M.C. Beardsley (Lexington, Ky., 1954), pp. 2-18.

19. Chatman, "The Semantics of Style," pp. 86-87.

20. Chatman, "On the Theory of Literary Style," p. 21.

21. Chatman, "The Semantics of Style," p. 91.

22. G.B. Tennyson, "Victorian Nonfiction Prose," *Victorian Newsletter*, No. 43 (Spring 1973): 3-4.

23. John Holloway, *The Victorian Sage: Studies in Argument* 1 (London: Macmillan, 1953), pp. 9-11.

24. George Levine, "Nonfiction as Art," *Victorian Newsletter*, No. 30 (Fall 1966), p. 6.

25. George Levine and William Madden, "Introduction," in *The Art of Victorian Prose*, ed. George Levine and William Madden (New York: Oxford University Press, 1968), p. vii.

26. Ibid., pp. xvi, xviii.

27. G. Robert Stange, "Art Criticism as a Prose Genre," in *The Art of Victorian Prose*, ed. George Levine and William Madden (New York: Oxford University Press, 1968), p. 40.

28. Ibid., pp. 39-40.

29. Chatman, "On the Theory of Literary Style," pp. 13-25; and "The Semantics of Style," pp. 77-99.

30. Here, Chatman's concept of the speaker in the work is identified with Stange's of the writer in order to avoid any suggestion of the intentional fallacy.

31. Stange, p. 50.

32. Ibid., p. 51.

33. John D. Rosenberg; "Style and Sensibility in Ruskin's Prose," in *The Art of Victorian Prose*, ed. George Levine and William Madden (New York: Columbia University Press, 1968), p. 179.

34. Again, in order to avoid any suggestion of the intentional fallacy, Chatman's concept of the speaker is identified with Rosenberg's of the writer.

35. Wimsatt, *The Prose Style of Samuel Johnson,* pp. 11-12.

36. One of the most noteworthy phenomenological approaches to style in prose is that formulated by Roman Ingarden. René Wellek, in *Discrimimations: Further Concepts of Criticism* (New Haven: Yale University Press, 1970), outlines the basic elements of this approach:

 > His [i.e. Ingarden's] concept of stratification allows one to recognize that a literary work of art has a basic sound-stratum out of which the units of meaning arise, while these in turn project a world of objects (not of course identical with objects in the real world) which have a status of their own and can be described independently of the linguistic stratum through which we have access to them. (p. 333)

 Ingarden presents this approach to the prose work in *Das literarische Kunstwerk* (Halle, 1931). And this approach is phenomenological in that it concerns the *reader's* apprehensions of the *literary* work. That is, a sound-stratum in the work gives rise to one of meaning, which projects (intentional) objects to his consciousness. Although a well-reasoned and complex approach, Ingarden's view is not appropriate for interpretation of the relation between style and theory in *Modern Painters I* and *II,* because here the *writer's* apprehension of the *art* work is central. Heidegger's approach to style, however, can implement interpretation of this relation.

37. Martin Heidegger, "The Origin of the Work of Art," in *Poetry, Language, Thought,* by Martin Heidegger, ed. and trans. Albert Hofstadter (New York, 1971), pp. 15-87; and "Building-Dwelling-Thinking," in *Poetry, Language, Thought,* pp. 143-61.

38. Heidegger, "Work of Art," p. 74.

39. Algis Mickunas, "Heidegger's Origin of the Artwork and the End of Esthetics" (an unpublished paper written in 1970 at Ohio University), p. 37. Mickunas' explanations of Heidegger's concept of "language" are here expanded into the interpretation given.

40. Walter Biemel, "Poetry and Language in Heidegger," in *On Heidegger and Language,* ed. and trans. Joseph J. Kockelmans (Evanston: Northwestern University Press; 1972), p. 76.

41. Martin Heidegger, "The Nature of Language," in *On the Way to Language,* by Martin Heidegger, trans. Peter D. Hertz (New York: Harper & Row, 1971), p. 93. I capitalize "World" (including form *and* meaning) in order to distinguish it from the view, set forth in "The Origin of the Work of Art," of "world"—the meaning of the work.

42. Martin Heidegger, "The Thing," in *Poetry, Language, Thought,* by Martin Heidegger, ed. and trans. Albert Hofstadter (New York: Harper & Row, 1971), p. 174.

43. Albert Borgman, "Language in Heidegger's Philosophy," *Journal of Existentialism* 7 (1966/67): 173.

44. Heidegger, "Building-Dwelling-Thinking," pp. 149-50.

45. Biemel, p. 90.

46. Heidegger, "Building-Dwelling-Thinking," p. 149.

Chapter 8

1. This letter, from Ruskin to Rev H.G. Liddell (October 12, 1844), is included in the appendix to *Modern Painters I* (III, 667-71).

2. Ian A. Gordon, *The Movement of English Prose* (Bloomington: Indiana University Press, 1966), pp. 155-56.

3. Ibid., p. 157.

4. Salomon van Ruysdael (c. 1600/2-70), a Dutch landscape artist, was prominent during the seventeenth century, primarily the first half. William Andrew Nesfield (1794-1881), an English water colorist, painted during the first half of the nineteenth century.

5. "Mr. Ruskin's Literary Style," *Spectator* (June 28, 1890), p. 905.

6. William K. Wimsatt, *The Prose Style of Samuel Johnson* (New Haven: Yale University Press, 1941), p. 43.

7. Ibid., p. 23.

8. Wimsatt, p. 23.

9. Ibid., p. 39.

10. Wimsatt, p. 23.

11. Ibid., p. 40.

12. Ibid., p. 10.

13. Graham Reynolds, *Turner* (New York: Harry N. Abrams, n. d.), p. 177.

14. Herbert Read, *English Prose Style*, 2nd ed. (1952; reprint ed., Boston: Beacon Press, 1963), p. xiv.

15. Ibid., p. 6.

16. Robert Graves and Alan Hodge, *The Reader Over Your Shoulder: A Handbook for Writers of English Prose* (New York: Macmillan, 1943), p. 115.

17. G. Robert Stange, "Art Criticism as a Prose Genre," in *The Art of Victorian Prose*, ed. George Levine and William Madden (New York: Oxford University Press, 1968), p. 40.

18. Martin Heidegger, "Building-Dwelling-Thinking," in *Poetry, Language, Thought*, by Martin Heidegger, ed. and trans. Albert Hofstadter (New York: Harper & Row, 1971), p. 149.

19. N.N. Feltes, "The Quickset Hedge: Ruskin's Early Prose," *Victorian Newsletter*, No. 34 (Fall 1968): 21.

20. Wimsatt, pp. 53-54.

21. Herbert Spiegelberg, *The Phenomenological Movement: A Historical Introduction* (The Hague: Martin Nijhoff, 1960) II, p. 658.

22. Stange, p. 40.

23. Ibid.

24. Reynolds, p. 181.

25. Stange, p. 40.

26. "Building-Dwelling-Thinking," p. 149.

27. Ibid.

28. Here, as the basis for scansion of Ruskin's irregular but discernable meter, I have relied on Marjorie Boulton's analysis of prose rhythm presented in *The Anatomy of Prose* (1954; reprint ed., London: Routledge & Kegan Paul, 1962), pp. 55-57.

Chaper 9

1. This letter, by Ruskin, to Rev. H.G. Liddell (October 12, 1844), is included in the appendix to *Modern Painters I* (III, 667-71).

2. E.T. Cook, "Introduction to Vol. IV," in *Modern Painters,* II, by John Ruskin, ed. E.T. Cook and Alexander Wedderburn (London, 1903), xliii-xliv. The quotations of Ruskin given in Cook's statement are taken (respectively) from the "Preface" to the 1871 edition of *Sesame and Lilies* (§1) and from *Love's Meinie* (§130).

3. Ian A. Gordon, *The Movement of English Prose* (Bloomington: Indiana University Press, 1966), p. 82.

4. James R. Sutherland, *On English Prose* (1957; reprint ed., Toronto: University of Toronto Press, 1960), p. 43.

5. Gordon, pp. 82-83.

6. William K. Wimsatt, *The Prose Style of Samuel Johnson* (New Haven: Yale University Press, 1941), pp. 11-12.

7. Ibid., p. 15.

8. Ibid., pp. 17-18.

9. Ibid., p. 50.

10. John D. Rosenberg, "Style and Sensibility in Ruskin's Prose," in *The Art of Victorian Prose,* ed. George Levine and William Madden (New York: Columbia University Press, 1968), p. 199.

11. According to the editorial footnote appending this passage, a pholus is a type of mollusc able to pierce stone (IV, 251).

12. *The Compact Edition of the Oxford English Dictionary* (1971; reprint ed., New York: Oxford Universtity Press, 1975), II.

13. G. Robert Stange, "Art Criticism as a Prose Genre," in *The Art of Victorian Prose,* ed. George Levine and William Madden (New York: Oxford University Press, 1968), pp. 39-46.

14. Ibid., p. 46.

15. Ibid.

16. The quotation marks inserted in this passage are mine.

17. Rosenberg, p. 179.

18. Ibid., pp. 189-90.

19. Ibid., p. 187.

20. Rosenberg, p. 199.

21. Ernest L. Fontana, "Ruskin's *Modern Painters, II,*" *The Explicator* 29 (1970): Item 33.

22. H.J. Rose, *Gods and Heroes of the Greeks: An Introduction to Greek Mythology* (1958; reprint ed., Cleveland: The World Publishing Co., 1963), p. 130.

23. "The New Testament," 2nd ed., *The New English Bible* (New York: Oxford University Press, 1970), p. 124.

Chapter 10

1. George P. Landow, *The Aesthetic and Critical Theories of John Ruskin* (Princeton, 1971), pp. 14-15.

2. Ibid., p. 146.

3. Ibid., pp. 85-86.

4. Cicely Davis, "Ut Pictura Poesis, "*Modern Language Review* 30 (1935): 160.

5. Landow, p. 43.

6. Henry A. Ladd, *The Victorian Morality of Art: An Analysis of Ruskin's Aesthetic* (New York: R. Long & R.R. Smith, 1932), pp. 36-37.

7. Meyer H. Abrams, *The Mirror and the Lamp: Romantic Theory and the Critical Tradition* (1953; reprint ed., New York: W.W. Norton, 1958), p. 8.

8. Ibid., p. 11.

9. Ibid., pp. 21-22.

10. Abrams, p. 8.

11. Ibid., p. 39. Abrams quotes from Reynolds' Eleventh Discourse, *Literary Works,* II, 22.

12 In fact, Ruskin differs from Reynolds not so much on the level of detail in representation as on its purpose. For the latter, representation should be typical of general aspects of nature; but for the former, representation should express the painter's emotional and conceptual responses to nature.

13. Edward Alexander, *Matthew Arnold, John Ruskin, and the Modern Temper* (Columbus: Ohio State University Press, 1973), p. 141.

14. Meyer H. Abrams, *Natural Supernaturalism: Tradition and Revolution in Romantic Literature* (New York: W.W. Norton, 1971), p. 411.

15. Ibid.

16. Abrams, *The Mirror and the Lamp,* p. 22.

17. Landow, pp. 257-58.

18. Jerome H. Buckley, *The Victorian Temper: A Study in Literary Culture* (New York: Random House, 1951) pp. 153-54.

19. Ibid., p. 143.

20. Landow, pp. 116-17.

21. Ibid., p. 146.

22. Ibid., p. 93.

23. Abrams, *The Mirror and the Lamp,* p. 22.

24. Ibid., p. 175.

25. Ibid.

26. Abrams, p. 119.

27. Ibid., p. 221.

28. Monroe C. Beardsley, *Aesthetics From Classical Greece to the Present: A Short History* (New York: Macmillan, 1966), p. 253.

29. William Wordsworth, "The Prelude" (VI, 11. 592-602), in *English Romantic Poetry and Prose,* ed. Russell Noyes (New York: Oxford University Press, 1956), p. 283.

30. Ernest Bernbaum, *Guide Through the Romantic Movement,* 2nd ed. (New York: The Roland Press, 1949), p. 326.

31. Beardsley, p. 301.

32. Abrams, *Natural Supernaturalism,* p. 411.

33. Abrams, *The Mirror and the Lamp,* p. 22.

34. George Levine and William Madden, "Introduction," in *The Art of Victorian Prose,* ed. George Levine and William Madden (New York: Oxford University Press, 1968), pp. xiii-xiv.

35. Marjorie Boulton, *The Anatomy of Prose* (1954; reprint ed., London: Routledge & Kegan Paul, 1962), p. 95.

36. An aspect of style in *Modern Painters I* and *II* that is neither Neo-classical nor Romantic deserves brief mention. Harold Bloom's *The Ringers in the Tower* (Chicago: University of Chicago Press, 1971) includes his article "Ruskin as Literary Critic" (1965). According to Bloom, "Ruskin's literary taste was formed by the King James Bible, more than any other reading, and therefore from the start he associated expressive and devotional values" (p. 179). And Oliver Elton's *A Survey of English Literature, 1830-1880* (London, 1920) maintains that in Ruskin's prose cadence and language, quotations, and plain as well as imaginative idiom often derive from the prose of the Bible (p. 233). In *Modern Painters I,* for example, a passage in the section on Truth of Skies deals with the spectrum of natural possibilities realized by Turner in landscape painting. Throughout, Ruskin employs a style, a rhetorical manner, characteristic of biblical prose; that is, he relies on richly vivid imagery, on repetition of the word "and," and on a general elevation of tone (III, 415-19). And in *Modern Painters II,* discussing the Vital Beauty of man, Ruskin relies heavily on quotation and paraphrase of the Bible (IV, 176-78). But, like the instances of Hooker's style that appear throughout volume two, those of biblical style usually occur in both volumes at points of secondary importance as far as aesthetic theory is concerned; consequently, since this study is primarily concerned with the relation of style to theory, then Ruskin's use of biblical style has secondary importance for this study.

37. Oliver Elton, *A Survey of English Literature, 1830-1880* (London: E. Arnold, 1920), p. 235.

38. William K. Wimsatt, *The Prose Style of Samuel Johnson* (New Haven: Yale University Press, 1941), p. 23.

39. Ibid., p. 39.

40. Ibid., p. 23.

41. Ian A. Gordon, *The Movement of English Prose* (Bloomington: Indiana University Press, 1966), p. 146.

42. G. Robert Stange, "Art Criticism as a Prose Genre," in *The Art of Victorian Prose,* ed. George Levine and William Madden (New York: Oxford University Press, 1968), p. 41.

43. Quentin Bell, *Ruskin* (Edinburgh: Oliver & Boyd, 1963), p. 112.

44. Gordon, p. 152.

45. Kenneth Allott, "General Introduction," in *Victorian Prose, 1830-1880,* ed. Kenneth and Miriam Allott (Harmondsworth, Middlesex: Penguin Books, 1956), pp. xxxiii-xxxiv.

46. Stange, pp. 39-40.

47. Ibid., pp. 40, 50-51.

48. Wimsatt, p. 50.

49. Ibid., pp. 14-18.

50. Gordon, p. 146.

51. John D. Rosenberg, "Style and Sensibility in Ruskin's Prose," in *The Art of Victorian Prose,* ed. George Levine and William Madden (New York: Columbia University Press, 1968), p. 179.

52. Gordon, p. 158.

53. *The Compact Edition of the Oxford English Dictionary* (1971; reprint ed., New York: Oxford University Press, 1975), I.

Bibliography

Abrams, Meyer H. *The Mirror and the Lamp: Romantic Theory and the Critical Tradition.* 1953. Reprint. New York: W. W. Norton, 1958.
_____. *Natural Supernaturalism: Tradition and Revolution in Romantic Literature.* New York: W. W. Norton, 1971.
Alexander, Edward. *Matthew Arnold, John Ruskin, and the Modern Temper.* Columbus: Ohio State Univ. Press, 1973.
Allott, Kenneth. "General Introduction." *Victorian Prose, 1830-1880,* edited by Kenneth and Miriam Allott. The Pelican Book of English Prose, vol. 5. Harmondsworth, Middlesex: Penguin Books, 1956. Pp. xi-xliii.
Angus, Donald R. "The Relationship of Wordsworth's 'Ode on the Intimations of Immortality' to Ruskin's Theory of the Infinite in Art." *Modern Language Review* 36 (1941): 506-8.
Autret, Jean. *Ruskin and the French before Marcel Proust (with the Collected Fragmentary Translations).* Genève: Librairie Droz, 1965.
Ball, Patricia M. *The Central Self: A Study in Romantic and Victorian Imagination.* London: The Athlone Press, 1968.
_____. *The Science of Aspects: The Changing Role of Fact in the Work of Coleridge, Ruskin and Hopkins.* London: The Athlone Press, 1971.
Bartky, S. L. "Heidegger's Philosophy of Art." *British Journal of Aesthetics* 9 (1969): 353-71.
_____. "Heidegger and the Modes of World-Disclosure." *Philosophy and Phenomenological Research,* 40 (1979), 212-36.
Bateson, F. W. "The Language of the Victorians." In *Literary English Since Shakespeare.* Edited by George Watson. New York: Oxford University Press, 1970. Pp. 328-38.
Beardsley, Monroe C. *Aesthetics From Classical Greece to the Present: A Short History.* New York: Macmillan, 1966.
_____. *Aesthetics: Problems in the Philosophy of Criticism.* New York: Harcourt, Brace, 1958.
_____. "Style and Good Style," In *Reflections on High School English: NDEA Institute Lectures, 1965.* Reprinted in Glen A. Love and Michael Payne, eds. *Contemporary Essays on Style: Rhetoric, Linguistics and Criticism.* Glenview, Illinois: Scott Foresman, 1969. Pp. 3-15.
Bell, Quentin. *Ruskin.* Edinburgh: Oliver and Boyd, 1963.
Berg, Richard. "Heidegger on Language and Poetry." *Kinesis* (1977): 75-89.
Bernbaum, Ernest. *Guide Through the Romantic Movement.* 2nd ed. New York: The Ronald Press, 1949.
Biemel, Walter. "Philosophy and Art." Translated by Parvis Emad. In *Man and World,* 12 (1979): 267-83.
_____. "Poetry and Language in Heidegger." *On Heidegger and Language.* Edited and translated by Joseph J. Kockelmans. Evanston: Northwestern Univ. Press, 1972. Pp. 65-105.
Bloom, Harold. "Ruskin as Literary Critic." In *The Ringers in the Tower: Studies in Romantic Tradition.* Chicago: University of Chicago Press, 1971.

————, comp. and ed. *Romanticism and Consciousness: Essays in Criticism.* New York: W. W. Norton, 1970.

Bolton, W. F. *A Short History of Literary English.* 2nd ed. London: Butler & Tanner, 1972.

Borgmann, Albert. "Language in Heidegger's Philosophy." *Journal of Existentialism* 7 (1966/67): 161-80.

Bossart, William H. "Heidegger's Theory of Art." *Journal of Aesthetics and Art Criticism* 27 (1968/69): 57-66.

Boulton, Marjorie. *The Anatomy of Prose.* 1954. Reprint. London: Routledge and Kegan Paul, 1962.

Bowra, Cecil M. *The Romantic Imagination.* Cambridge, Mass.: Harvard Univ. Press, 1949.

Boyd, Zelda A. "What the Poet Sees: A Study of the Aesthetic Theories of Mill, Carlyle, Ruskin, and Arnold." Ph.D. dissertation, University of Michigan, 1972.

Bradley, John L. *An Introduction to Ruskin.* Boston: Houghton Mifflin, 1971.

Bratv, Horia and Ileana Marculescu. "Aesthetics and Phenomenology." *Journal of Aesthetics and Art Criticism* 37 (1979), 335-49.

Buckler, William E. "Introduction." *Prose of the Victorian Period.* Edited by William E. Buckler. Boston: Houghton Mifflin, 1958. Pp. xi-xxvii.

Buckley, Jerome H. *The Victorian Temper: A Study in Literary Culture.* New York: Random House, 1951.

Burd, Van Akin. "Background to *Modern Painters:* The Tradition and the Turner Controversy." *PMLA* 74 (1959): 254-67.

————. "Ruskin's Defense of Turner: The Imitative Phase." *Philological Quarterly* 37 (1958): 465-83.

————. "Ruskin's Quest for a Theory of Imagination." *Modern Language Quarterly* 17 (1956): 60-72.

Carey, Edward S. *Imagining: A Phenomenological Study.* Bloomington: Indiana Univ. Press, 1976.

Chatman, Seymour, ed. and trans. *Literary Style: A Symposium.* New York: Oxford University Press, 1971.

————. "On the Theory of Literary Style." *Linguistics* 27 (1966): 13-25

————. "The Semantics of Style." *Social Science Information* 6 (1967): 77-99.

————, and Samuel R. Levin. "Linguistics and Literature." In *Current Trends in Linguistics, X: Linguistics in North America.* 2 vols. Edited by Thomas A. Sebeok. The Hague: Mouton, 1973, I, 250-94.

————, eds. *Essays on the Language of Literature.* Boston: Houghton Mifflin, 1967.

Chianese, Robert L. "The Development of *Modern Painters:* The Growth of the Critic's Mind." Ph.D. dissertation, Washington University, 1972.

Collingwood, Robin G. *Essays in the Philosophy of Art.* Edited by Alan Donagan. Bloomington: Indiana University Press, 1964.

Collingwood, William G. *The Art Teaching of John Ruskin.* London: Percival, 1891.

The Compact Edition of the Oxford English Dictionary. 2 vols. 1971. Reprint. New York: Oxford Univ. Press, 1975.

Conner, Patrick R. M. "Pugin and Ruskin." *Journal of the Warburg and Courtauld Institute* 41 (1978): 344-50.

Cook, Sir Edward T. *Studies in Ruskin: Some Aspects of the Work and Teaching of John Ruskin.* 1891. Reprint. Port Washington, N. Y.: The Kennikat Press, 1972.

Culler, A. Dwight. "Method in the Study of Victorian Prose." *Victorian Newsletter,* No. 9 (Spring 1956), Pp. 1-4.

Cunningham, J. V., ed. *The Problem of Style.* Greenwich, Conn.: Fawcett Publications, 1966.

Curtin, Frank D. "Ruskin in French Criticism: A Possible Reappraisal." *PMLA* 77 (1962): 102-108.

Davis, Cicely. "Ut Pictura Poesis." *Modern Language Review* 30 (1935): 159-69.

De Lattre, Floris. *Ruskin et Bergson: De l'Intuition esthétique à l'Intuiton métaphysique.* Oxford: Clarendon Press, 1947.

Dellamora, Richard J. "The Revaluation of 'Christian' Art: Ruskin's Appreciation of Fra Angelico 1845-60." *University of Toronto Quarterly* 43 (1973/74): 143-50.

De Man, Paul. "Intentional Structure of the Romantic Image." *Romanticism and Consciousness.* Edited and compiled by Harold Bloom. New York: W. W. Norton, 1970.

Dolk, Lester C. "The Aesthetics of John Ruskin in Relation to the Aesthetics of the Romantic Era." Ph.D. dissertation, University of Illinois, 1938.

Dooley, Patricia. "Aspects of Style in Ruskin's *Modern Painters I.*" Ph.D. dissertation, Yale University, 1976.

Ellis, John M. "Linguistics, Literature, and the Concept of Style." *Word* 26 (1970): 65-78.

Elton, Oliver. *A Survey of English Literature 1830-1880.* London: E. Arnold, 1920.

Enkvist, Nils E. "On Defining Style." In *Linguistics and Style,* edited by John Spencer, Pp. 3-56. London: Oxford University Press, 1964.

Evans, Joan. *John Ruskin.* New York: Oxford University Press, 1954.

Feltes, N. N. "The Quickset Hedge: Ruskin's Early Prose." *Victorian Newsletter,* No. 34 (Fall 1968): 18-22.

Fishman, Solomon. *The Interpretation of Art: Essays on the Art Criticism of John Ruskin, Walter Pater, Clive Bell, Roger Fry, and Herbert Read.* Berkeley: University of California Press, 1963.

Fontana, Ernest L. "Ruskin's *Modern Painters, II.*" *The Explicator* 29 (1970), Item 33.

Fowler, Roger, ed. *Essays on Style and Language: Linguistic and Critical Approaches to Literary Style.* London: Routledge and Kegan Paul, 1966.

_____. "Linguistics, Stylistics; Criticism?" *Contemporary Essays on Style: Rhetoric, Linguistics and Criticism,* edited by Glen A. Love and Michael Payne, pp. 165-74. Glenview, Illinois: Scott Foresman, 1969.

Frye, Northrop, ed. *Romanticism Reconsidered: Selected Papers from the English Institute.* 1963. Reprint. New York: Columbia University Press, 1968.

Gelven, Michael. *A Commentary on Heidegger's "Being and Time": A Section-by-Section Interpretation.* New York: Harper & Row, 1970.

Gerhard, William A., and Brijen K. Gupta. "Literature: The Phenomenological Art." *Man and World* 3, no. 2 (1970): 102-15.

Gilbert, Katherine E., and Helmut Kuhn. *A History of Esthetics.* 2nd ed. Bloomington: Indiana University Press, 1953.

Gleckner, Robert F., and Gerald E. Ensco, eds. *Romanticism: Points of View.* 2nd ed. Revised by Robert F. Gleckner. New York: Prentice-Hall, 1970.

Goetz, Sister Mary Dorothea. *A Study of Ruskin's Concept of the Imagination.* Ph.D. dissertation, The Catholic University of America, 1947. Washington, D.C.: The Catholic University of America, 1947.

Gordon, Ian A. *The Movement of English Prose.* Bloomington: Indiana University Press, 1966.

Graves, Robert, and Alan Hodge. *The Reader Over Your Shoulder: A Handbook for Writers of English Prose.* New York: Macmillan, 1943.

Hale, J. R. *England and the Italian Renaissance: The Growth of Interest in Its History and Its Art.* London: Faber, 1954.

Hardman, M. "Ruskin's 'Massy Common Sense.' " *British Journal of Aesthetics* 16 (1976): 137-43.

Harris, Jack T. "Ruskin, the PRB and Daisy's Shadow: Pre-Raphaelite-Brethren." *Pre-Raphaelite Review* 1 (1978): 33-44.

Harrison, Antony H. "Ruskin Against Traditon: Two Theories of Landscape Painting in Early Victorian England." *Victorian Institute Journal* 5 (1976): 1-15.

Harrison, Frederic. *Tennyson, Ruskin, Mill and Other Literary Estimates.* New York: Macmillan, 1900.

Harrison, Robert. *John Ruskin: The Argument of the Eye.* London: Princeton University Press, 1976.

Harrold, Charles F., and William D. Templeman, comps. and eds. *English Prose of the Victorian Era.* 1938. Reprint. New York: Oxford University Press, 1966.

Harvey, Hazel L. J. "Wordsworth and Ruskin: Aspects of Relationship and Influence." Ph.D. dissertation, University of Michigan, 1973.

Heidegger, Martin. *Being and Time.* Translated by John Macquarrie and Edward Robinson. New York: Harper & Row, 1962.

――――. "Building-Dwelling-Thinking." In *Poetry, Language, Thought.* Edited and translated by Albert Hofstadter. New York: Harper & Row, 1971.

――――. "The Nature of Language." In *On the Way to Language.* Translated by Peter D. Hertz. New York: Harper & Row, 1971.

――――. "The Origin of the Work of Art." In *Poetry, Language, Thought.* Edited and translated by Albert Hofstadter. New York: Harper & Row, 1971.

――――. "The Thing." In *Poetry, Language, Thought.* By Martin Heidegger. Edited and translated by Albert Hofstadter. New York: Harper & Row, 1971. Pp. vii-xxx.

Herbert, Robert L. "Introduction." *The Art Criticism of John Ruskin.* Compiled and edited by Robert L. Herbert. New York: Doubleday, 1964. Pp. vii-xxx.

Holloway, John. *The Victorian Sage: Studies in Argument.* London: Macmillan, 1953.

Hough, Graham. *The Last Romantics.* 1947. Reprint. New York: Barnes and Noble, 1961.

――――. *Style and Stylistics.* New York: Humanities Press, 1969.

Houghton, Walter E. *The Victorian Frame of Mind: 1830-1870.* New Haven: Yale University Press, 1957.

Ingarden, Roman. *Das literarische Kunstwerk.* Halle: M. Niemeyer, 1931.

Inman, Billie Andrew. "Ruskin's Reasoned Criticism of Art." *Papers on Language and Literature* 13 (1971): 372-82.

Ironside, Robin. "The Art Criticism of Ruskin." *Apollo* 101 (1975): 163-72.

Jaeger, Hans. "Heidegger and the Work of Art." *Journal of Aesthetics and Art Criticism* 17 (1958/59): 58-71.

Johnson, Lee M. "Art Criticism as a Genre of Literature: Baudelaire, Ruskin, and Pater." Ph.D dissertation, Stanford University, 1971.

Kaelin, Eugene F. *Art and Existence: A Phenomenological Aesthetics.* Lewisburg, Pa.: Bucknell Univ. Press, 1970.

――――. "Notes Toward an Understanding of Heidegger's Aesthetics." *Phenomenology and Existentialism.* Edited by Edward N. Lee and Maurice Mandelbaum, pp. 59-92. Baltimore: Johns Hopkins Press, 1967.

Ladd, Henry A. *The Victorian Morality of Art: An Analysis of Ruskin's Aesthetic.* New York: R. Long and R. R. Smith, 1932.

Landow, George P. *The Aesthetic and Critical Theories of John Ruskin.* Princeton: Princeton University Press, 1971.

――――. "J. D. Harding and John Ruskin on Nature's Infinite Variety." *Journal of Aesthetics and Art Criticism* 28 (1969/70): 369-80.

――――. "Ruskin and Baudelaire on Art and Artist." *University of Toronto Quarterly* 37 (1968): 295-308.

Langan, Thomas. *The Meaning of Heidegger: A Critical Study of an Existentialist Phenomenology.* 1959. Reprint. New York: Columbia University Press, 1965.

Lawry, Edward G. "The Work-Being of the Work of Art in Heidegger." *Man and World* 11 (1978): 186-98.

Leon, Derrick. *Ruskin: The Great Victorian.* London: Routledge and Kegan Paul, 1949.

Levine, George. "Nonfiction as Art." *Victorian Newsletter,* No. 30 (Fall 1966): 1-6.
————, and William Madden. "Introduction." *The Art of Victorian Prose.* Edited by George Levine and William Madden. New York: Oxford University Press, 1968. Pp. vii-xxi.
Love, Glen A., and Michael Payne, eds. *Contemporary Essays on Style: Rhetoric, Linguistics and Criticism.* Glenview, Illinois: Scott Foresman, 1969.
Lovejoy, Arthur O. "On the Discrimination of Romanticisms." In *English Romantic Poets: Modern Essays in Criticism.* Edited by M. H. Abrams, pp. 3-24. New York: Oxford University Press, 1960.
Machann, Clinton J. "The Prose Style of a Victorian Sage: An Analysis of John Ruskin's *Modern Painters I, Unto This Last,* and *Praeterita.* Ph.D. dissertation, University of Texas, 1977.
Macomber, W. B. *The Anatomy of Disillusion: Martin Heidegger's Notion of Truth.* Evanston, Illinois: Northwestern University Press, 1967.
Merleau-Ponty, Maurice. *The Essential Writings of Merleau-Ponty.* Edited by Alden Fisher. New York: Harcourt, Brace & World, 1969.
Mickunas, Algis. "Heidegger's Origin of the Artwork and the End of Esthetics." Paper, Ohio University, 1970.
Milsand, Joseph A. *L'Esthétique anglaise: Étude sur M. J. Ruskin.* Paris, n. p., 1864.
"Mr. Ruskin's Literary Style," *Spectator* (June 28, 1890), pp. 905-6.
"The New Testament." 2nd ed. *The New English Bible.* New York: Oxford University Press, 1970.
Nichols, Marie H. "Rhetoric and Style." *Patterns of Literary Style.* Edited by Joseph Strelka, pp. 130-43. University Park: The Pennsylvania State University Press, 1971.
Noyes, Russsell, comp. and ed. *English Romantic Poetry and Prose.* New York: Oxford University Press, 1956.
Nwodo, Christopher. "The Role of Art in Heidegger's Philosophy." *Philosophy Today* 21 (1977): 294-304.
————. "The Work of Art in Heidegger: A World Disclosure." *Cultural Hermeneutics* 4 (1976): 61-74.
Ohmann, Richard. "Methods in the Study of Victorian Style." *Victorian Newsletter,* No. 27 (Spring 1965), pp. 1-4.
Peckham, Morse. *The Triumph of Romanticism: Collected Essays by Morse Peckham.* Columbia: University of South Carolina Press, 1970.
Penny, Nicholas. "John Ruskin and Tintoretto." *Apollo* 99 (1974): 268-73.
Perotti, James L. *Heidegger on the Divine: The Thinker, the Poet and God.* Athens: Ohio University Press, 1974.
Pike, Helen M. "John Ruskin's Critical Theory and Practice." Ph.D. dissertation, City University of New York, 1974.
Read, Herbert. *English Prose Style.* 2nd ed. 1952. Reprint. Boston: The Beacon Press, 1963.
Reynolds, Graham. *Turner.* New York: Harry N. Abrams, [1969?].
Richardson, William J., S. J. *Heidegger: Through Phenomenology to Thought.* 2nd ed. The Hague: M. Nijhoff, 1967.
Rose, H. J. *Gods and Heroes of the Greeks: An Introduction to Greek Mythology.* 1958. Reprint. Cleveland: The World Publishing Co., 1963.
Rosenberg, John D. *The Darkening Glass: A Portrait of Ruskin's Genius.* New York: Columbia University Press, 1961.
————, ed. *The Genius of John Ruskin: Selections from His Writings.* 1963. Reprint. Boston: Houghton Mifflin, 1965.
————. "The Geopoetry of John Ruskin." *Etudes Anglaises* 22 (1969): 42-48.
————. "Style and Sensibility in Ruskin's Prose." *The Art of Victorian Prose.* Edited by George Levine and William Madden, pp. 177-200. New York: Oxford University Press, 1968.
Rosetti, William M. "Ruskin as a Writer on Art." *Broadway,* n.s. 2 (March 1869): 48-59.

Rudnick, Hans H. "Roman Ingarden's Aesthetics of Literature." *Colloquia Germanica* 8 (1974): 1-14.

Ruskin, John. *Modern Painters.* In *The Works of John Ruskin.* Edited by E. T. Cook and Alexander Wedderburn. Library Edition, 39 vols. London: George Allen, 1903-1912. III and IV (1903), V and VI (1904), and VII (1905).

Sanderson, David R. "English Prose of the Romantic Age: The Matter of Style." Ph.D. dissertation, University of California at Davis, 1970.

Schweik, R. C. "Method in the Study of Victorian Prose: A Criticism." *Victorian Newsletter,* No. 10 (Autumn 1956): 15-16.

Seigfried, Hans H. "Art and the Origin of Truth." *Man and World* 11 (1978): 45-58.

Sendaydiego, Henry. "Heidegger's Thoughts on the Aesthetic." *Journal of the West Virginia Philosophical Society* (Spring 1976): 14-16.

Shapiro, Harold I. "The Poetry of Architecture: Ruskin's Preparation for *Modern Painters.*" *Renaissance and Modern Studies* 15 (1971): 70-84.

_____. "Progressions of Discovery: Ruskin's Early Criticism of Painting." Ph.D. dissertation, Yale University, 1962.

Sherburne, James C. *John Ruskin, or the Ambiguities of Abundance: A Study in Social and Economic Criticism.* Cambridge, Mass.: Harvard University Press, 1972.

Smart, William. *A Disciple of Plato: A Critical Study of John Ruskin.* Glasgow: Wilson and McCormick, 1883.

Spiegelberg, Herbert. *The Phenomenological Movement: A Historical Introduction.* 2 vols. The Hague: M. Nijhoff, 1960.

Sprinkler, Michael. "Ruskin on the Imagination." *Studies in Romanticism* 18 (1979): 115-39.

Stack, George J. "The Being of the Work of Art in Heidegger." *Philosophy Today* 13 (1969): 159-73.

Stange, G. Robert. "Art Criticism as a Prose Genre." In *The Art of Victorian Prose.* Edited by George Levine and William Madden, pp. 39-52. New York: Oxford University Press, 1968.

Starzyk, Lawrence J. "Towards a Reassessment of Early Victorian Aesthetics: The Metaphysical Foundations." *British Journal of Aesthetics* 21 (1971): 167-77.

Stein, Roger B. *John Ruskin and Aesthetic Thought in America, 1840-1900.* Cambridge, Mass.: Harvard University Press, 1967.

Strelka, Joseph, ed. *Patterns of Literary Style.* University Park: The Pennsylvania State University Press, 1971.

Stulberg, Robert B. "Heidegger and the Origin of the Work of Art." *Journal of Aesthetics and Art Criticism* 32 (1973/74): 257-65.

Sutherland, James R. *On English Prose.* 1957. Reprint. Toronto: University of Toronto Press, 1960.

Svaglic, Martin J. "Method in the Study of Victorian Prose: Another View." *Victorian Newsletter,* No. 11 (Spring, 1957): 1-5.

Tennyson, G. B. "Victorian Nonfiction Prose." *Victorian Newsletter,* No. 43 (Spring 1973), pp. 3-8.

Thorburn, David, and Geoffrey Hartman, eds. *Romanticism: Vistas, Instances, Continuities.* Ithaca, N. Y.: Cornell University Press, 1973.

Townsend, Francis G. "John Ruskin." *Victorian Prose: A Guide to Research.* Edited by David J. DeLaura, pp. 219-48. New York: MLA, 1973.

_____. *Ruskin and the Landscape Feeling: A Critical Analysis of His Thought During the Crucial Years of His Life, 1843-56.* Illinois Studies in Language and Literature, 35, No. 3. Urbana, Illinois: University of Illinois Press, 1951.

Tuveson, Ernest L. *The Imagination as a Means of Grace: Locke and the Aesthetics of Romanticism.* Berkeley: University of California Press, 1960.

Van de Water, Lambert. "The Work of Art, Man, and Being: A Heideggerian Theme." *International Philosophical Quarterly* 9 (1969): 214-35.

Wellek, René. *The Age of Transition: 1750-1950.* A History of Modern Criticism, vol 3. 1965. Reprint. Yale University Press, 1972.

———. "The Concept of 'Romanticism' in Literary History." *Comparative Literature* 1 (1949). Reprinted in *Concepts of Criticism.* New Haven: Yale University Press, 1963.

———. *Discriminations: Further Concepts of Criticism.* New Haven: Yale University Press, 1970.

———, and Austin Warren. *Theory of Literature.* 3rd ed. New York: Harcourt, Brace & World, 1956.

Wesling, Donald. "Ruskin and the Adequacy of Landscape." *Texas Studies in Literature and Language* 9 (1967/68): 253-72.

Wetherill, Peter M. *The Literary Text: An Examination of Critical Methods.* Berkeley: University of California Press, 1974.

White, David A. "World and Earth in Heidegger's Aesthetics." *Philosophy Today* 12 (1968): 282-86.

Wilenski, R. H. *John Ruskin: An Introduction to Further Study of His Life and Work.* London: Faber & Faber, 1933.

Williamson, George. *The Senecan Amble: A Study in Prose Form from Bacon to Collier.* 1951. Reprint. Chicago: University of Chicago Press, 1966.

Wimsatt, William K. *The Prose Style of Samuel Johnson.* New Haven: Yale University Press, 1941.

———, and Monroe C. Beardsley. *The Verbal Icon: Studies in the Meaning of Poetry.* Lexington: University of Kentucky Press, 1954.

Wood, Andelys. "A Study in Purple: The Function of Poetic Prose in *Modern Painters.*" Ph.D. dissertation, Indiana University, 1974.

Woodring, Carl R. "Introduction." *Prose of the Romantic Period.* Compiled and edited by Carl R. Woodring, pp. xi-xxi. Boston: Houghton Mifflin, 1961.

Wright, William C. "Hazlitt, Ruskin, and Nineteenth-Century Art Criticism." *Journal of Aesthetics and Art Criticism* 32 (1973/74): 509-23.

Zabel, Morton D. "The Romantic Idealism of Art, 1800-1848." Ph.D. dissertation, University of Chicago, 1933.

Index